Perpetual Motion

PARALLAX RE-VISIONS OF CULTURE
AND SOCIETY

Stephen G. Nichols, Gerald Prince, and Wendy Steiner
SERIES EDITORS

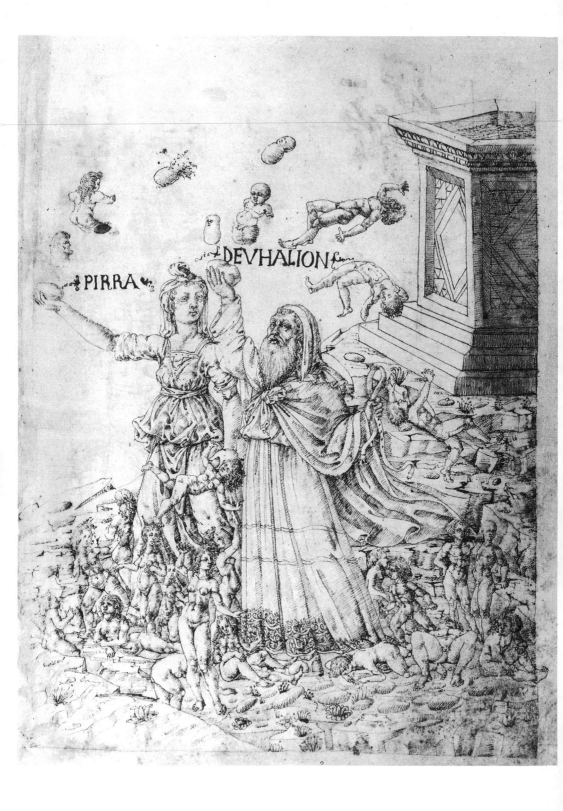

Perpetual Motion

Transforming Shapes in the
Renaissance from da Vinci to Montaigne

Michel Jeanneret
Translated by Nidra Poller

The Johns Hopkins University Press
Baltimore and London

This book has been brought to publication with the generous assistance of the University of Geneva and the French Ministry of Culture.

Originally published as *Perpetuum mobile: Métamorphoses des corps et des œuvres de Vinci à Montaigne,* © 1997 Éditions Macula, Paris

The Johns Hopkins University Press
2715 North Charles Street
Baltimore, Maryland 21218-4363
www.press.jhu.edu

Library of Congress Cataloging-in-Publication Data

Jeanneret, Michel.
 [Perpetuum mobile. English]
 Perpetual motion : transforming shapes in the Renaissance from da Vinci to Montaigne / Michel Jeanneret ; translated by Nidra Poller.
 p. cm. — (Parallax)
 Includes bibliographical references (p.) and index.
 ISBN 0-8018-6480-1 (alk. paper)
 1. Aesthetics, Modern—16th century. 2. Change—History—16th century. 3. Philosophy, Renaissance.
 I. Title. II. Parallax (Baltimore, Md.)
 BH 162.J4313 2001
 001′.094′09031—dc21 00-009534

A catalog record for this book is available from the British Library.

Frontispiece: Maso Finiguerra (1426-64, Florentine draftsman and goldsmith), *Pyrrha and Deucalion.* London, British Museum

Contents

Contents

Illustrations

Translator's Note

Unless otherwise indicated, translations of quotations from French and Italian authors are by Nidra Poller. Jacob Vance provided references for quotations from English and classical authors. The author and translator thank him for his help.

Perpetual Motion

Introduction

Matter endures, form is lost. —*Ronsard*

This study argues for a sixteenth century swept up in change and fascinated by genesis and metamorphosis. We now know that the Renaissance was not, or not only, that culture admired for centuries, praised for its devotion to order and perfection expressed in stable, harmonious, closed artistic creations.[1] Renaissance thinkers, far more sensitive to emerging forces than to rigorous forms, placed their confidence in movement and exerted an expansive creative energy that is the source of our modernity.

At the origin of this investigation is a surprising observation: so many great literary works of the Renaissance are presented as works-in-progress, workshops in activity. A book is published? It would seem to be finished? No, publication was just a transitory phase of a work to be corrected, supplemented, transformed. Words that seemed firmly set on the page start to move as if escaping from the realm of inert objects to return to the still flexible stage of their genesis. We might think that the printing press, as an improvement over precarious oral and manuscript methods of transmission, contributed to the stabilization of texts. On the contrary, variation was deliberately kept as the order of the day. Chapters 9 to 12 describe various aspects of this mobility in the ongoing development of literary texts and, to the extent that strategies and finalities are comparable, in the visual arts. Transformation could come from the author, who felt free to go back over his work and continue the process of gestation; from imitators or translators, who transmitted the text in altered form; from readers, invited to redesign the work along their own pathways or

reactivate it by personal interpretations, thus participating in and modifying its composition.

In the first eight chapters, this same metamorphic sensibility is discerned in various sectors of sixteenth-century science and culture; the broad context in which the literary phenomenon operated is traced and some answers to the initial inquiries provided. The research is centered first on theories drawn from natural philosophy (chaps. 1 to 5); it shows how the cosmic and geological imagination, speculations on biology and physics, find an almost universal explicative model in the principle of transformation in mutation of matter and the dynamics of creation. A study of two key cultural fields confirms the same tendency at work in anthropology (chap. 6), with representations of man as protean, and linguistics (chap. 8), in the mode of development of the French language. This gives us a comprehensive vision of homologous theories of nature, the nature of man, language, and literary practices. We find these same parallels exposed and developed in a treatise by Louis Le Roy (chap. 7) on "the vicissitudes and variety of things in the universe," which by its thesis and structure validates the general approach adopted here.

It would appear that an initial explanation is granted: Renaissance texts mimic in their flexibility the conditions of reality as perceived by science or conceived by the imagination during that period. What is *said* in knowledgeable or imaginative discourse is *done* by the texts; their mobile structure embodies the prevailing transformist philosophy.[2]

This response can be further refined. Scholars and writers were fascinated not only by transformation itself but also by the aptitude of an object to turn into another. The paradox is fully extended: things are all the more perfect in that they remain imperfect and perfectible; they are attractive as potential to be actualized, beginnings of a future development. The quality of an object is judged by the reserves of energy it contains and the thrust of its impetus. Reflections on metamorphosis are also meditations on the charm of origins, the privileged moment when anything can be invented or fashioned anew because everything seems possible. If creation, and preferably the ever-renewing continuous creation, mobilized Renaissance thought, it was precisely because it crystallizes the magic of the inchoative. The fascination with chaos partakes of the same logic: the primordial magma is a formless potentiality waiting for its form, the wellspring where the seeds of life are nestled, the symbol par excellence of the desire for transformation.

The appeal of metamorphosis is definitely associated with an attraction for beginnings—birth and rebirth—and a determination to perpetuate the dy-

namics of the miraculous creative gesture. In fact, many literary or artistic creations of the period deliberately portray the impulse and labor that brought them into being. Signs of invention and activity, of euphoric or painful emergence, invade the artistic space, superimposing the spectacle of the representation on the thing represented. Attention to the activity and personality of the author, exhibition of the genius at work, and interest in psychological mechanisms of creation become major components of aesthetic curiosity; henceforth creation would be indissociable from the creating subject.

The humanists, partisans of change, sought to distinguish themselves from their predecessors and consolidate the historical rupture that would guarantee their modernity. To this end they constructed an image—assuredly oversimplified and misleading—of medieval thought enslaved to rigid dogmas and immutable essences in a rigidified culture that conceived the universe as an invariable, rational, closed system. The judgment was summary, but it served as a foil that allowed the sixteenth century to reject a reputedly static world vision and emancipate the mind from an order deemed reductive and inhibiting. Renaissance thinkers not only rejected this world view, they gave a positive value to change and celebrated the alteration of things and the flux of contingencies as a promise of renewal without denying that they are symptoms of sin, stigmata of mortality. They accorded veritable epistemic and aesthetic status to variation, accepted that ideas and forms fluctuate, that they live normally in temporality, and that it behooves art and thought to integrate these mutations, no matter how capricious they might be.

Is this transformist sensibility that I think I discern in the sixteenth century nothing more than an abusive projection of our own intellectual instability? Since poststructuralism rendered their rights to imperfection and differentiation, assigning an essential role, as much philosophic as aesthetic, to the mobility of forms, we have been immersed in representations dominated by instability and fracture. Further, we give them a positive value. Why deny the fact that we inevitably perceive the past from the point of view of our present? And after all, why shouldn't we use our concepts and references as heuristic means in the service of history?

The retrospective view can be enlightening, but it can also lead to misleading comparisons and the worst anachronisms. The analogies we think we discover are illusory because the associated phenomena pertain to different cultures and different intellectual conditions with no common measure. Totally different meanings can be hidden under the same name; the same image can

stand on distinct intentions. "The same word is not the same concept."[3] If natural transformations are explained in sixteenth-century thought by animism, and if the literature conceived as a metamorphic system is based, as we will see, on the poetics of imitation, this is sufficient proof that their project is radically dissimilar from our own inclinations. Empathy is certainly a necessary condition for initiating research, but if it telescopes periods and scrambles ideas it destroys the very object of history: the sense of difference.

To grasp a specific configuration, we must set clear chronological limits. The arguments developed here apply to the period 1480–1600. If I frequently cite the ancients or some Italian precursors and occasionally reach into a more distant past, it is to recall the models that were constantly present to the humanist mind. The investigation is nonetheless focused on the sixteenth century and relevant only for the 120-year period delimited above. It is true that I often use, and perhaps abuse, the general term *Renaissance:* you will recognize this as a habit of historians of French literature, for whom the Renaissance coincides with the sixteenth century. The Quattrocento, with its intellectualized aesthetics, rational idealism, and harmonious geometric forms, corresponds to another facet of the Renaissance that will not concern us here.

The chronological period and some of the manifestations studied here would coincide with the field ordinarily associated with mannerism. If I do not employ the notion as such, it is because my vision of the sixteenth century presents few affinities with the culture and aesthetics of mannerism; on the contrary, it is widely divergent or even antinomic.[4] The mastery of nature by art and the control of instinct by style, the subordination of force to form, the exaltation of culture, artifice, and technical virtuosity as values in themselves—these essential components of mannerism are miles away from the naturist thought and metamorphic sensibility at the center of my research.

The simultaneity of disparate or even contradictory tendencies should not be surprising. It would be vain to seek any sort of unity of thought or style in a period as troubled and uncertain as the sixteenth century, precipitated from one intellectual crisis to another. A polyphonic culture in full mutation cannot be reduced to a unique principle. Ends and means were divergent from one milieu to another, one art to another, according to varying projects and circumstances. For example, we will note that the attraction of mobile structures did not affect all sectors of thought and art to the same extent:[5] strongly influential in literature, it had a variable effects in the sciences of nature and of man and was quite limited in the visual arts. The vacillation extends right into the works of one and the same artist: Leonardo da Vinci or Ronsard might

sometimes give in to dizzying transformism and at other moments opt for closure and stability.

Such plurality would no doubt have called for a more dialectical approach, more sensitive to tensions and uncertainties that influenced forms and ideas. And there would have been more frequent reminders of the resistance provoked by the attraction of change; mobility and stability, openness and closure, diversity and unity are simultaneous postulations, necessarily compensatory principles. It would be naive to believe that some works were absolutely accomplished and rigid in their perfection while others were absolutely versatile, open to all and any interventions. Total immobility is death and total mobility leads to undifferentiation; literary and artistic activity must necessarily be exercised between the two extremes. No matter how open and malleable a text, it has to hold together and accept the reader's imposition of a certain order, a temporary fixation. Though the author leaves his readers a margin of freedom to ensure the continuous rebound of the work, he also attempts to orient its reception and set limits on the interpreter's initiatives.

And however strong the attraction of metamorphosis, it should not make us forget that Renaissance thought remained attached to an ontology that associated change with a defect of being. Whether Platonist or Christian, a deeply rooted metaphysics denounced the inconsistency in inconstance, considered it to be a sign of the imperfection of human things, their contingency and mortality. Many humanists accepted or even rejoiced in their protean condition, sensing a fantastic potential to exploit in the mutability of things. Yet we should remember that in their view the reign of variations only covered a part of reality; we should not be surprised that some thinkers did deliberately choose immanence, but others, captivated by permanence, reversed the hierarchy.

Another objection could be raised. Transformation is a fundamental aspect of experience and a constant of the imaginary construct; all cultures meditate on mutation and variation and, by empirical observations or rationalizations, by theoretical fictions or the mediation of art, negotiate compromises with transformation. So the configuration I present here is not exclusive to the sixteenth century. The ample citations from Greek and Latin archetypes, from Pythagoras to Ovid, from pre-Socratic cosmogonies to myths of metamorphosis, are sufficient proof that on this point, as so many others, the Renaissance is not a world apart but a part of the world. I am perfectly aware that protean mobility, transformation of bodies and matter, instability of structures, though they have a rightful place here, figure just as well among the

properties of the baroque period. Furthermore, I agree that Enlightenment philosophy and then romanticism, reflecting on the laws of evolution, exploring and exploiting natural energies, placed mechanisms of generation and processes of development at the heart of their research. Nor do I forget our present-day tendency to value otherness and alteration; as I said, I willingly admit that this might have influenced the orientation of my project.

I am aware of but not troubled by these coincidences because I do not claim any exclusivity for the Renaissance in the representations or techniques analyzed here. I am satisfied to observe a particularly dense network of these phenomena in the period studied. On a basis of nonspecific paradigms, I have recomposed a historic constellation that is itself singular and relevant, a system whose different elements derive meaning from their internal relationships. I am not concerned with proving that the sixteenth century is more or less transformist than some other period. However, I do want to establish, or reaffirm, three points: the ideas and practice of transformation are constitutive of humanism; the sixteenth century is not, or not only, the Appolonian harmonious classic culture that, since Wölfflin,[6] has been so often invoked; the metamorphic sensibility attributed to the baroque was widespread in the period 1480–1600.

In this book I bring together disparate information and upset the traditional separation of disciplines; this calls for explanation. I have brought together philosophers and poets, writers and artists; I visited books, but also gardens and grottoes, added an aesthetic dimension to my historical research, touched on theology or natural science. Sometimes I took byways or shortcuts, cutting across space to bring Frenchmen together with Italians, but also across different languages, verbal and visual, scholarly and fictional, whose mechanisms and problematics, though comparable, are governed by distinct laws. Yet the various paths taken do intersect and reveal at junctions a common object or at least objective. One constant—the penchant for transformism—stands out and henceforth claims its place in the cultural history of the Renaissance.

Should we also be reminded that in the sixteenth century disciplines were not divided up in the same way as today? Classifications were not as strict, lines of cleavage were different; the application of modern methodological distinctions not only entails the risk of anachronism, but might obscure pertinent relationships. Though art was beginning to acquire independent status, it was still closely connected with the intellectual environment and historical conditions and often subordinated to a scholarly project or engaged in a specific de-

bate of ideas. We have to reconstruct the countless affinities that existed between scholarly and poetic research, between messages in images or words. Even if the exercise of universal curiosity and the ambition to achieve global knowledge were progressively undermined, they still remained central to the project of many humanists. If this inquiry had been confined to the narrow field of one specialty, it would have betrayed their true scope and freedom.

When traveling over such a vast territory, there is a risk of looking at everything and seeing nothing. It is true that this deliberately selective study deserves to be filled out in certain areas. It lacks a chapter on alchemy, the science of transformation par excellence; I could have included an analysis of Spenser's *Faerie Queene,* exploited several works by Béroalde de Verville, referred to Paracelsus, Cardan, and so many others. Readers will add their own examples and raise their own objections. These deficiencies, inherent in such a project, have the merit of supporting one of its major theses: I have given full enough treatment to the Renaissance notion of the reader as collaborator to desire the same active participation in my own work. Even if I do not, like Henri Estienne (see chap. 12), leave blank pages for the reader, I willingly indicate that there are gaps to fill and propositions to debate. Though I have composed this introduction, I will not write a conclusion. This is my way of respecting another fundamental idea defended in the pages that follow: we can always begin; we never finish.

References for the most frequently cited authors are inserted into the text; the references to Montaigne's *Essays* indicate book, chapter, and page numbers of the P. Villey edition. All other references appear in an abbreviated form as endnotes with the author's name and a short title. Complete bibliographical details for all of these references are found in the bibliography.

Universal Sway

1 | Form and Force: Du Bartas

[handwritten annotation: → Instantly, or just very quickly, Manotine for initial distribution]

Geneses

In *La Sepmaine,* Du Bartas takes no fewer than 6,494 lines to cover the first chapter of the Book of Genesis. How is it possible to go from the ultimate in ellipse—the sublime fiat of creation—to such a verbal outpour? The undertaking is certainly paradoxical.

In six short days and very few words, the biblical text goes from nothing to everything: the miracle of creation *ex nihilo.* Things come forth from nothingness and, second wonder, immediately achieve perfection. God constructs space and time instantaneously and gives to each species its definitive form, name, and place. Then, satisfied with his work, he rests: "And God saw that it was good."

But the poets and theologians who pen full-blown commentaries and amplified recitals of the six days never rest; they untiringly compose entire works out of what the Bible leaves unsaid. This verbal profusion is particularly vigorous in the late sixteenth and early seventeenth centuries. Du Bartas's poem (1578) met with incredible success; countless editions and translations were published throughout Europe over a period of fifty years. And as if this initial and more than ample dilation of Genesis weren't enough, other authors came along and multiplied *La Sepmaine:* scholars attached commentaries to Du Bartas's lines, and imitators, carried away with the genre, wrote new poems in the same style. Major texts on the creation left by the Church Fathers—*Hexamera*

Fig. 1. Thomas de Leu (1555–ca. 1612), "Le Cinquième Jour de la création" (The Fifth Day of Creation). From Du Bartas, *La Sepmaine* (1578), 1611 edition.

and other variations on the first six days—were also being published, glossed, and occasionally translated since the early sixteenth century.[1]

If the original version of the creation is all the more sublime for being succinct, what is the use of scribbling hundreds and thousands of lines? Wouldn't such inflation adulterate the transcendent and submit the perfection of the divine gesture to human temporality? Or, even worse, imply that the biblical text is imperfect, the Creator's work unfinished? On the contrary, giving voice to the silences of Genesis would be a way to celebrate the wonders of the universe. Let us see how Du Bartas chooses to give grace.

The event, as it dilates, stretches out in duration, becomes more complex, livelier. In the hexameral tradition the sudden upsurge is replaced by a gradual unfolding of things and beings. Should the poet have told a tale of instantaneous, definitive birth? Instead he describes continuous gestation, the difficult victory of order over disorder, form over formlessness. Genesis seems to be involved in history instead of preceding it. This shift from instantaneous movement toward movement in duration is an excellent illustration of the program followed throughout this study. I would like to point out some signs of the shift in *La Sepmaine.*

Let us begin with the ending. The sixth day of creation draws to a close. God has fashioned man; his work is done and he is about to contemplate the accomplishment. The poem too should come to rest. But how can it stop there, just when man steps onto the stage? So the story leaps ahead to sketch briefly the future of humanity. This could have been the broad outlines of the creature's story, along the same path traced in the Bible, but that would be the subject of *La Seconde Sepmaine.* It might have been a survey of man's activities, his accomplishments in the arts and sciences, modeled on Maurice Scève's *Microcosme.* Du Bartas is certainly interested in *homo faber,* and yet, after pronouncing a few generalities, he takes a most unusual perspective:

> But human artifice does not produce only
> Mass without soul, motionless body,
> But peoples the airs with a flying squadron
> Of motley animals. (6.833–36)[2]

We must be dreaming! Man tosses birds up into the sky and animates them as if he were creating life. But the following lines explain that these are mechanical animals, wonders built by craftsmen, seemingly gifted with the same powers as the Creator, who make such marvelous imitations that they can be mistaken for God's living works. Du Bartas, speaking of men's accomplishments,

is interested in techniques that give the illusion of reviving, *hic et nunc,* the up-surge of the first days. He pays tribute to the inventors of flying machines and three other engineers: a Persian king, Archimedes, and a servitor of Emperor Ferdinand. Each one constructs an immense model of the celestial system, a glass sphere where the planets turn as in their natural cycles (6.859–904):

> But good God, who could believe that mortal dexterity
> Would new heavens make, and make new stars? (6.875–76)

This might seem to be the familiar story of Babel and the temptation of pride; human industry in rivalry with divine sovereignty, inviting punishment. But that is not how Du Bartas sees it. He admires the creature who imitates the Creator and strives to identify with him. Carried away with enthusiasm, Du Bartas actually upsets the hierarchy, crying out to man words that would have been addressed to God:

> O perfect creature! who knows how to move
> The starry circles, that your divine power
> Extends over the heavens, and who holds the bridle
> Of the wigg'd Sun and humid Moon. (6.905–8)

The Protestant Du Bartas seems to have forgotten the severe lessons of Calvin's catechism. He is closer to humanists like Nicholas of Cusa or Maurice Scève and comes dangerously close to the inordinate alchemists who attribute to industrious man powers that are almost equal with divinity. Fashioned by God in his image and destined to be his representative on earth, man is all the more worthy of his origin because he pursues the work of creation. Instead of the closure of the six days and the catastrophe of the Fall, Du Bartas prefers the idea of a transfer: man-made machines are of course mere semblances, but they inspire admiration because they perpetuate the dynamics of beginnings (see chap. 6). With this approach, Genesis is less a metonymy—a distinct stage in history, a beginning—than a metaphor, an exemplary scene, destined to be repeated.

Men with their savoir-faire are not the only ones who receive and reproduce the divine impetus; nature also remains active and capable of inventing, as if to ensure continuity and creation. This is what Du Bartas affirms, at the limits of orthodoxy, in the continuation and conclusion of his "Sixth Day."

Once they have left the Creator's hands, men and beasts begin to multiply, each within its species: "Ever since that time bears engender bears, / Dolphins dolphins . . . " (6.1021–22). "The immutable order" (6.1023) imposed by God on living beings is perpetuated. Here the poet follows the canonical ver-

sion. But he hasn't said his last word. To indicate clearly that nature continues to produce novelty (whereas man is limited to reproduction), Du Bartas upsets the Creator's classifications, giving two examples that specifically belie the invariable division of the species:

> Often two animals, of different species,
> Against the common order that rules the Universe,
> Heat up, mix together their seed
> Form an animal . . . (6.1029–32)

an animal, the poet adds, "Whose bastard body / Keeps many features here and there" (6.1033–34). Monstrous births and crossings are evidence that God did not exhaust the multiplicity of possibles, and so new varieties can come forth. Along with crossbreeding, which disturbs the primordial categories, Du Bartas cites spontaneous generation, which goes against the ordinary laws of genealogy: "With no Venus" (6.1037) inanimate bodies give birth to living beings.[3] Water produces salamanders, and an insect, the *pyrauste,* comes out of fire. The list of wondrous transformations in a nature where matter is matrix extends to the most unusual births:

> And so an old piece of a boat turns into
> Flying ducks: oh such strange change!
> Same body long ago green tree, then sailing vessel,
> Recently mushroom, and now bird. (6.1051–54)

"The Sixth Day" ends on these words that, far from marking the term of an active week, suggest that with nature capable of the most curious gestations, the movement continues. And Du Bartas pens yet another hybridization concerning the diversity of sources: the lesson of the Bible is contaminated by memories of pagan cosmogonies or vestiges of popular beliefs that credit nature with the same powers as God. It is as if the *Metamorphoses* of Ovid crossed themes with Genesis,[4] and the ideal of a stable, compartmented world were submerged by the imagination of perpetual movement.

Continuous Creation

Instantaneous or continuous creation? If we follow the full trajectory of *La Sepmaine* from the first to the seventh day, the overall impression is hesitation on this point. Witness the vacillations in the temporal system.[5] The story of Genesis is told in the past tense, but the present tense is often employed, and this is not so much a historical present as an abiding present or, here and there,

an immediate present: God, in other times, did so, writes Du Bartas, but just a bit further on he says that such is, today or eternally, the course of things. Comparisons are drawn throughout the text, accentuating the movement back and forth between past and present. An impetus given long ago repeats itself now or has liberated forces that continue to act. In "The Third Day," for example, the separation of the land and the waters is told in the imperfect tense and the *passé simple,* followed by a long, lingering explanation of hydrodynamics in oceans, rivers, springs. When Du Bartas reaches the chapter on thermal springs, he slips in a little publicity for the tourist attractions of Gascogne and the virtues of its baths (3.297–346). From the great primitive undertaking to local color, from the present management of running water to the general hustle and bustle of creation, the poet does not see a solution of continuity. Do developments in the present, like so many prolepses, break the narrative line of a recital that would normally be in the past or, on the contrary, is the memory of the original scene exposed to contemplation by the world *hic et nunc?* The action in the past is still so present that the question seems idle.

Du Bartas's God does not rest. He is still occupied today with the correct operation of things he set in motion long ago.

> The powerful voice that built the Universe
> Still still and endlessly rings out in this world:
> The voice that year after year the world renews . . . (3.695–97)

The word *creation* has two meanings: the act of creating and the result of this act, the totality of things created. But this distinction does not operate in *La Sepmaine;* the first value overflows into the second. Natural phenomena as described by Du Bartas in the present tense still bear the dynamics of their gestation. They are created and creating, accomplished but endowed with extraordinary energy. The poet is attached to forces rather than stable forms and to everything that suggests an active nature capable of mutations: cycles of fertility, influence of the stars, potential of currents. In his description of the universe, Du Bartas more often traces vectors than lines and proposes sequences of events, ongoing stories instead of static tableaux

The to-and-fro movement between past and present tense manifests a hesitation between two literary genres: *La Sepmaine,* of course, belongs to the tradition of amplification and commentaries on the recital of the six days, but it also pertains to the encyclopedia, or what would be called today *scientific poetry.*[6] This contamination of a historical and a descriptive paradigm might best find expression in our concept of natural history: the interaction of memory

and observation, phenomena in the ambient world studied as consequences of evolution. Without realizing it, Du Bartas is writing natural history because he speaks of origins inasmuch as they animate things in the present and things in the present insofar as they perpetuate the initial upsurge.

The fundamental mechanism of this account can be reduced to a principle that, as we will see, Du Bartas shares with many of his contemporaries:

his concept of primordium

> The matter of this world is a formless wax,
> That, without changing, takes all sorts of forms. (2.193–94)[7]

Just a short time later, Ronsard would write, "Matter endures, form is lost."[8] Everything is encompassed in the dynamic relationship of same—the constant mass of matter—and other—the series of transformations that animate and modify it. Two qualities determine the existence of matter: created by God before all things, matter remains constant in quantity and coincident in duration with that of the world; coextensive with the action of the Creator, matter shares most of his properties:

> But only matter immortal endures,
> Tableau of the Almighty, true body of the Universe,
> Common receptacle of myriad accidents,
> All like unto him, all in him contained,
> Neither increased nor diminished by the flight of time,
> Immutable in essence, mutable on the face . . . (2.202–7)

Astonishing words coming from a Christian poet! Fascinated by the persistence of matter, he qualifies it as Being par excellence, to the point of confusing it with God himself; this veritable "temptation of the sprit" comes close to assimilating the Creator with his creation.[9] As this study progresses we will often encounter such germs of heterodox thought, somewhere between pantheism and materialism.

The shift is all the more surprising in that matter, the most constant of substances by its invariable mass, is also the most inconstant because it undergoes metamorphoses. The most stable base, almost identified with transcendence, is in fact destined to perpetual mutations; alteration infiltrates into the heart of the unitary principle, the one is dispersed in multiple avatars. Du Bartas is captivated by the idea of this malleable magma that can take all shapes and change without perishing. A body integrates, then disintegrates, returning to the common crucible, before taking part in new configurations. To account for this instability, the poet draws on a principle of antique physics, still applied in Renaissance cosmology, in which matter is composed of a mixture of

the four elements, assembled according to variable, precarious balances. An object proceeds from the combination of the four elementary substances; it holds together by the discordant accord of its parts and, as such, will soon begin falling apart:

> Bodies mixed of earth, air, fire and water,
> Are constantly agitated by civil war,
> Causing with time their life and death,
> Their increase and decrease: under the horned star
> Not even a quarter of an hour, in one same
> Subject can the same form endure. (2.909–14)

"Nothing in this world is constant" (2.199); that is how things are in the sublunar world, caught up in transformations of matter. Du Bartas could have expressed this plaintively or dizzily; in fact, he delightedly admires the spectacle of nature in constant change and renewal. His oft-lyrical style, with scattered exclamations, signs of enthusiasm and subjective participation, is part of a concerted strategy to reinforce the idea that the creation is still unfolding before his eyes. By repeatedly intervening to express wonder, the poet gives an impression of constant upsurge:

> In short, my eyes, lost in such divine spectacles,
> Find in this single miracle a sea of miracles. (4.747–48)

Du Bartas's descriptions are conveyed in the voice of a spectator dazzled with joy at the marvels he sees, sustaining an illusion of things actually coming to birth, virgin and vigorous as in the beginning. "This day," he says, "God creates the fish" (5.29); is it this day that I recount as historian, or this day today that I see before my eyes? Surely both. Because in the exalted perspective of Du Bartas, every day is creation day.

Shaping the Clay

Right from the opening lines of *La Sepmaine*, the victory of form over formlessness mobilizes the poem and propels the original scene at a dynamic pace that will be maintained throughout. Far more than the biblical God, Du Bartas's Creator is a craftsman faced with the challenge of the primitive magma, who kneads, fashions, and transforms matter. Several metaphors aligned near the beginning of "The First Day" (1.205–438) modulate a theme that we will find often in the following pages: the prestige of working to fabricate, the visit to the workshop.

The poet distinguishes from the start two fundamental stages of creation. Out of nothingness God brings forth matter, a formless mass of which the duration, as we have seen, coincides with that of the world. But this matter is chaos. So, in the second stage, it has to be given form. Here Du Bartas uses the word *ornament* (1.206 and passim), based on the *ornatus* of Latin cosmogonies, itself a translation of the Greek *cosmos*. After confusion comes order, and out of ugliness, beauty.

The image of the dense, vague primitive heap is, in fact, essentially negative:

> This first world was a form without form,
> A jumbled pile, a misshapen mixture,
> From the abysses an abyss, an irregular body,
> A Chaos of Chaos, a lumpy lump. (1.223–26)

The blind mass is characterized as the privation of positive qualities: without, mis-, and, further on, not yet. It is dominated by the battle of the elements, the confusion of opposites. This faceless world is bad because it is imperfect, but its imperfection is also the gage of its value. Infirm, it is in a state of expectation. Lying there like a potential asking to be actualized, it will be the opportunity for the plasmator to give the full measure of his art. And that is precisely what Du Bartas passionately recounts; the passage from chaos to form, the gesture that plucks out distinct bodies from the resistant mass of the undifferentiated. Life was latent, slumbering, and now it is gradually taking shape. The poet takes pleasure in finding analogies to express this mystery, such as these biological images that celebrate the charm of giving birth: matter is a "seed bed" (1.260), the granary of seed from which all comes forth; it is also an "embryo" (1.261), a lump of flesh "engendered, misshapen, / In the maternal womb" (1.264–65), and gradually fashioned into a singular being; it is an "egg" (1.298) that God, like a brooding hen sitting on the abyss, seems to cover "From such a heavy heap to extract such a beautiful world" (1.304).

Though these symbolic variations on germination and fecundation suggest the potential energies latent in matter, they are inappropriate to the extent that they suggest a spontaneous natural process to the detriment of the idea of work, voluntary action. The beauty of creation is in the effort that goes into it:

> And the world would never have changed its face,
> If from the great God unrivaled the almighty language
> Had not as if injected into its dead members
> I know not what Spirit that moves this great body (1.271–74)

God animates chaos by the power of his Word, the divine *logos*. Thus speaks a religion that conceives of the creation as an almost personal act, or at least a gestation by the power of the spirit. Later in the poem, as we said, Du Bartas gets caught up in visions of continuous creation and spontaneous generation, but here the emphasis is on activity proper to the great Worker. This could be mistaken for theological confusion but can in fact be explained by a perfectly coherent intention to seek out manifestations of transformation wherever they can be found and whoever—God or nature—is the agent.

So we find, side by side with metaphors of fertility, others that logically imply manipulation and effort. The raw material is a "formless wax" on which God stamps his seal, engraves his imprint (2.193–98).[10] Elsewhere the Creator is seen as mason, sculptor, or architect, a worker who takes something and makes it into something else. What captures attention is not so much the finished product—a stabilized, harmonious world—as the productive gesture and the handwork taking shape before our eyes, laboriously extracted from the blind mass. The modeling of man unfolds in a sequence of precise actions:

> . . . you [God] took the dust,
> Stuck it, pressed it, beautified it by your hand,
> And from a formless body the human body formed. (6.490–92)

In a rich accumulation of verbs, the poet gives a step-by-step description of a complex operation that extends over a long duration to arrive at perfection. The rule of perseverance and the *topos* of filing apply to God as to the craftsman. Don't rush through

> The task undertaken, but long waiting
> To and fro a thousand times the patient file goes
> Over the cherished handwork, making haste slowly (1.435–37)

For Du Bartas, to credit God with instant conception would mean sacrificing exactly what gives the event its value—the process, the scene-by-scene account of an ongoing operation. We are just at the beginning of the first day, but already the time of the story stretches out as if to display the secrets of fabrication before the advent of the finished work. Another comparison extends and multiplies the act of gestation to the extreme: God, *plasmator*, resembles the mother bear whose cub comes out "a misshapen mass" (1.410):

> And then by licking then she fashions
> Hands that tear, then felon's head,
> Then feet, then neck: and from an ugly lump
> Her industry animates a perfect animal. (1.411–14)

The bear cub, like the world, achieves its form slowly: rough matter, pure potential that for thirty days the mother in her den continues to fabricate. The mother's womb and the cavern are analogous sites, suggesting that the same process continues before and after birth. We are far from creation *ex nihilo.*

Du Bellay also uses the analogy of the properly licked (polished) bear cub in a literary context: he says that the writer should carefully finish his text, "set it aside, reread it often and like a bear lick (polish) it to give it shape and members."[11] This common resemblance to the artist-mother, who makes up for nature's defects by sculpting her child, brings God and the writer closer together. Du Bartas himself draws the parallel between the supreme Creator and the human creator: each lives in symbiosis with his work, carefully planning the task, concerned with its laborious gestation. A lovely comparison:

> Like a good spirit who engraves on the altar
> Of learned memory an immortal work,
> In company, at table, in bed, every day, all day living,
> Discourses on his discourse and floats on his book:
> So the Spirit of God seems as it frolics,
> To float over that floating heap. (1.289–94)

The masculine principle comes to spread its seed on the primitive matter; chaos, presented here as a liquid aerial mass, is both amorphous and fertile. Little by little the contours take shape within the maternal fluid just as the forms of a work gradually come into being in the artist's mind. The finished work seems to be engraved for eternity, but it went through a stage when it had been soft and malleable like clay and was patiently modeled. The formless fascinates because it bears the seed of beauty.[12]

An unusual hierarchy is established in the lines quoted above: instead of God serving as model for the artist, it's the artist who stands as model for God the plasmator. In fact, the interest shown for the artist's labor is highly significant. These themes of slow, patient crafting, continuous creation, projection of the constructor to center stage, were frequenty applied in Renaissance aesthetics and poetics. *La Sepmaine,* in the perspective in which it is seen here, could be read *en abyme* as the symbolic scenario of artistic creation. Humanists, in their imaginary representations of the origins of the world as in meditations on the work of art, were attached to the process of transformation. What particularly appealed to them about beginnings was the immense concentration of promising energy that nourishes dreams. We will frequently come back to this dimension of Renaissance thought: the idea of nature and art as gradual unfolding and actualization.

Fixed and Mobile

However, the metamorphic perception of the world that informs *La Sep-maine* is not absolute. On the question of flexibility and the dilemma of a fixed order within a situation of continuous genesis, Du Bartas vacillated. His position was more subtle and less assured than may have seemed thus far. The tension underlying his vision, taken with all its subtleties, should be made clear.

Signs of allegiance to the theory of a limited, partitioned, finished world are not lacking. The fixist tendency is expressed, for example, in "The Seventh Day:" God does remain present and active in the world, says the poet, to hold it "in spite of the effects of time / In its first state so many hundreds of years" (7.137–38). The Creator guarantees the upkeep of the "machine" (7.148), he makes "all the little mechanisms play diversely" (7.146), but he doesn't renew it.

Du Bartas also adopts the principle of creation *ex nihilo;* against the pagan doctrine of the eternity of matter, he maintains that the Word, or the potential of the Spirit, marks an absolute beginning:

> But having nothing but a Nothing to sculpt upon
> Such a beautiful masterpiece . . . (1.193–94)

The upsurge of the Whole out of nothingness is in fact a double miracle: not only does matter come from nothing, but to "decorate" it God disposes of no previous model. Here Du Bartas is in net opposition to Plato's teaching that the demiurge fashioned the world after permanent archetypes, the Ideas.[13] But if the world comes from nothingness, it will return to nothingness because only God is immortal; he precedes his creation and will survive it. Du Bartas is so careful to respect this point of Christian orthodoxy (at least at certain times)[14] that he has hardly begun the story of Genesis when already he speaks of the end of the world:

> One day from top to bottom the rocks will collapse:
> The mountains furrowing with fear will dissolve:
> The sky will burst . . . (1.353–55)

This is followed by a magnificent scene of Apocalypse: the agony of nature, followed by the resurrection of the body and the Last Judgment. Should this be seen as one more turnabout in the chain of mutations that punctuates the world's continuous becoming? On the contrary, Du Bartas uses this ultimate convulsion to illustrate the Christian principle of the finitude of matter.

It is also limited in time and in space. On this point, too, the poet is defi-

antly opposed to adventurous cosmologies that speculate, without biblical authority, on the plurality of worlds and their free movement in an infinitely vast universe. He refutes Copernicus in passing,[15] emphatically supports the old theory of concentric spheres, defends geocentricism, and argues for a fixed, immutable cosmic order. Hostile to the idea of infinity and generalized movement, he also rejects the atomist doctrine according to which several worlds integrate and disintegrate within empty space. He condemns the theories of Leucippus (1.309–34) who, as Simon Goulart explains in his commentary, "made all things infinite and changing one into the other: saying that the universe is an emptiness full of bodies, and from their encounters came new worlds, etc. The poet refutes such errors."[16] God did not leave things to chance; "He carries / To perfection that which he began" (6.46–48); he imposed on the dance of the stars, as on the reproduction of living beings, laws that preclude disorder.

The world is fixed, the world changes; God regulated the machine once and for all, God delegated to nature infinite creativity. These two voices alternate and contradict each other throughout *La Sepmaine.* But the same vacillation can be found in the Bible. As told in the first chapter of Genesis, God created the world in six days and on the seventh, his work accomplished, he rested. Space was organized, time established, and every class of living things, distinguished "according to its species," given its properties. Everything was set up at the first stroke; everything seems accomplished. Then comes the second chapter, and God seems to go back to work as if the task had not been so perfectly done after all. Not only does the biblical text give a second account of the creation of man,[17] completed this time with the creation of woman, but it goes back to the beginnings of plants and animals, with emphasis this time on nature's fecundity. So two versions come one after the other—the first fixist, the second transformist or evolutionist. The exegetes attribute this to two different traditions, the first, designated as "elohist" or "sacerdotal," "with its logical exhaustive classifications of living things,"[18] is more abstract and intellectual; the second, "yahvist," is more ancient and obeys a naturist or craftsmanship model.

This uncertainty would have repercussions on Judeo-Christian representations of the creation and influence various commentaries on Genesis. A brief survey of sixteenth-century Protestant theologians illustrates this diversity. Melanchthon,[19] Calvin,[20] and others who were faithful to the account of the six days rejected the hypothesis of a changing universe endowed with creative faculties. They believed that God stamped things and beings with a perfect

form from the beginning. He alone has the power to model the world and define the different species, and he has no reason to modify in the course of history the system he established once and for all. If, in fact, the original harmony has been altered, this is the consequence of sin and evil, but the structures of the universe and the mechanism of life cannot change fundamentally. The idea that matter keeps on evolving and can of itself engender new forms comes dangerously close to magic; it attributes powers to the created that belong only to the Creator and, in the opinion of strict Reformists, shows signs of paganistic naturism. We will note that this representation of a stable world destined to a fixed order was all the more influential in Renaissance thought because it ties up with the cosmology of Aristotle and perpetuates the closed immutable system of the Middle Ages.[21]

Nevertheless, it can't be said that the Reformed exegetes unanimously accept a static theory that seems to ignore history and compromise the freedom of living beings. Luther,[22] for example, left room for evolution; he said that God continues to work in this world and is constantly perfecting things by changing or renewing them. Bernard Palissy, Protestant writer and craftsman, carried the transformist thesis further. In *Récette véritable,* which is a debate between two characters, Palissy's spokesman maintains that even the most resistant objects, like stones, dissolve into other bodies. His interlocutor reproaches him for forgetting the biblical lesson: "From the beginning when God made Heaven and earth, He also made the stones, and none were made since. . . . Everything was made from the beginning of the creation of the world." The rebuttal, probably endorsed by Palissy, rejects this immobilism:

> I know that it is written in the book of Genesis that God created all things in six days . . . but God did not create them to leave them slothful . . . but each one does his duty, according to God's commandment. . . . The sea goes from side to side, and works to produce beneficial things; the earth, similarly, is never slothful; whatever is naturally consumed, it renews and reforms just as fast, if not in one sort, it remakes in another.[23]

The resistance of fixist representations does not prevent the proliferation of images vibrant with change. A vacillation manifest from the first pages of the Bible resurges in the commentaries and determines the tension we have observed in *La Sepmaine.* We will encounter in other contexts this tension, which is integral to the epistemological and aesthetic field encompassed here. No matter how powerful the attraction of metamorphosis, it is tenable only when placed within a dialectic of variability and immutability. It just happens that

the balance swings more often toward the pole of change than previously be-lieved, and transformist theories occupy an important place in the Renaissance mental landscape that we will discover further on.

Form and Forms

With the central role accorded to change in a vision of uninterrupted cre-ation, Du Bartas not only impugns the fixist variant of Christian cosmology but also weakens a pillar of the traditional philosophic edifice: no less than the Platonic and Aristotelian notion of *form,* a reference that was still omnipresent in the intellectual baggage of the period.

A refrain, largely tempered by the poets, was quoted above: "Matter en-dures, form is lost," "matter is always seeking new form,"[24] and so on. Du Bar-tas joins in the choir: the mass of matter, synchronous with the duration of the world, is constant, but it can take countless shapes. So the possible forms are multiple, ephemeral, contingent, and probably infinitely renewable. This the-sis is a departure from the basic principle of the Platonic tradition, relayed by Aristotle. The opposition is terminological, but the semantic shift in the usage of *form* says much about the displacement of ideas.

Eidos in Plato, *forma* for the Latins, ordinarily designates the abstract ideal model from which individual beings and objects are copied. It is the perfect archetype, the permanent principle that ensures the identity of things. These essential forms, explains Cicero in a gloss on Plato, "do not 'become'; they ex-ist for ever, and depend on intellect and reason; other things come into being and cease to be, they are in flux and do not remain long in the same state.[25] This, indeed, is the fate of matter, according to that tradition—indeterminate, principle of corruption, it constitutes multiple evanescent bodies. The rela-tionship between the two terms is a reversal of the aforementioned opposition: matter is lost and form endures. Only form is eternal and veritable.

It is true that *form* changed meaning from one statement to the other: sub-stantial form, of a metaphysical nature, in the Platonic version, and accidental form, of a physical nature, in the opposing Lucretian school. One speaks of essence, the other of the visible aspect of a being or object, of its concrete con-figuration. But it is significant that the second meaning tends to replace the first. Though impregnated with Platonic heritage, the sixteenth century doesn't unanimously adhere to the theory of intelligible entities. Is reality re-ally modeled on these absolute, eternal types? A current of skepticism and growing rationalism undercut the credibility of the great ontological systems.

The slow decomposition of Scholasticism and the crisis of univerals nourished doubts about reality considered *sub specie aeternitatis.* The particular and the contingent, along with historical variations, claimed increasing space and dignity in the philosophical field; we will see further on the attraction exercised by diversity and singularity in matters of knowledge. Religious and philosophic thinking would have to integrate the increasing attention given to movement, imperfection, chance. Under the circumstances it is easier to understand how speculation on the substantial Idea or Form gave way to observation of immanent forms: not *the* Form but the plurality of forms. Montaigne, more than anyone, would precipitate the crisis of metaphysical systems and (not without hesitation) challenge the classical concept of form.[26] This or that form, he seems to say, is not the reproduction of an immutable, a priori object but the synthesis of a multiplicity of particular forms:

> I do not know better school . . . to form life than to incessantly offer diversity of so many other lives, fantasies and usages, and let it taste such a perpetual variety of forms of our nature.[27]

A new form arises from the diversity of precedent forms; consequently it is contingent and mutable.

However, an important trace of the Greek theory of the Idea or ideal Form remains, which not only agrees with the idea of transformation but can stimulate it. Aristotle, as we know, contested the separation introduced by Plato between essence and things. Form, he says, is not separate from but united with matter; the intelligible and the sensible are not opposed, they belong mutually to each other, they need each other to constitute by interaction the concrete substance, the only reality. Matter, indeterminate, aspires to form, while form strives to realize itself in matter. Aristotle explains this dynamic as the necessary complementarity of potential and the act. Matter is potential, pure virtuality awaiting its form; and form, by ensuring an effective reality for matter, operates the passage from potential to actual.[28] The actualization of matter, the path of potential being toward actuality, constitutes a mutation. The quality of matter is to desire form—*materia appetit formam;* it tends to self-realization, aims at perfection, is consequently subject to becoming and capable of transformation.

This is how Aristotle filled the breech opened by Plato between the physical and metaphysical. Generation, the production of things, the movements and alterations that animate nature are expressions of the desire of matter and manifestations of its own aptitude to create a viable being. Becoming, in that

it results from the attraction exercised by form on matter, is the normal condition of life. Of course, not all mutations are indifferently possible, but change was henceforth endowed with philosophic status for thinkers in the Aristotelian tradition. The Naturalist School of Padova, with the support of Averroes, pushed Aristotle's interpretation to outright rejection of the principle of a transcendent model: "Act and form, instead of directing potential and organizing matter, become the ideal term and the end result of the movement of nature and the immanent vows of things."[29] If even Aristotelians could upset the Platonizing hierarchy and liberate movement, all the more reason for other currents, more sensitive to nature's dynamism, to clarify and amplify the trend. This will be the subject of the next chapter.

2 ■ *Natura naturans*

Variations on the Notion of Flux in Antiquity

Cosmogonies, speculations on the vicissitudes of form, myths of metamorphosis go back to the earliest times. Arguments for a changing universe underwent the same fluctuations, transformations, agglomerations as the world view they express. This labile, polymorphous corpus, a confused mixture of oral tradition and folklore interwoven with multiple intermingled scholarly sources, is too variegated to classify or even encompass in a coherent survey. We will simply follow a few traces of these composite currents in Renaissance thought, drawn from so many different sources, conveying images of continuous creation and flexible matter. Let us begin by pulling on two or three threads in the tangled network of sources from antiquity.

The pre-Socratics, with their theory of metempsychosis, their physics based on flow and transmutation of matter, were great poets of cosmic movement. Though the original texts were unknown in the sixteenth century, the ideas were available through intermediaries such as Plato, Aristotle, Plutarch, and the compilers.[1] Heraclitus, champion of generalized mobility, is often quoted, sometimes with critical commentaries on his radical ideas: "Protagoras and Heraclitus claimed that motion is the sole cause of living beings, which is why they thought that all things changed from minute to minute, so that nothing could absolutely be this rather than that."[2] Plato's *Timaeus*, easily available to Renaissance readers, gives an extraordinary repertory of metamorphic ideas concerning constant mutations in the physical world by transformation and

mixtures of the four elements, successive phases of creation, or transmigration of souls.

Lucretius explicitly rejected the idea of creation: "No thing is ever by divine power produced from nothing," and nothing goes back to nothingness; the mass of matter is constant but inscribed in an endless cycle of exchange and conversion: dead organisms nourish the living, insensitive substances produce animated beings, species are crossed. "Rivers, leaves, luxuriant pastures change into animals; animals change their substance into our bodies."[3] Everything is constantly changing by way of circulating atoms; bodies integrate and disintegrate, elementary particles leap across the void seeking new combinations. The fascinating plasticity of the Lucretian world inspired the rough beginnings of materialism and transformist intuitions in the sixteenth century, intimated in the theme already cited: "Matter endures, form is lost."[4]

In *De rerum natura* the flight of atoms and the vitality of nature are advanced to invalidate superstitious beliefs and undermine fear of the gods. But the image of the universe as a changing organism could, on the contrary, serve religious ends. *Pimander,* a collection of hermetic treatises (second or third century A.D.) widely distributed during the Renaissance, belongs to this tradition.[5] Here the conception of metamorphosis as the very principle of life relates to occult metaphysical thought. Everything is animated, everything is connected by correspondences and vital flow that renews things by transforming them. The soul of the world, diffuse and benevolent, ensures the renewal of energies within a magical economy where nothing is lost. Death is the condition of life, individual destiny takes part in the great cycles punctuated by mutations of nature, so that change in this world is the paradoxical sign of permanence. Many thinkers—doctors, alchemists, and Neoplatonic philosophers—attracted by hermetic theories on the life of matter and the becoming of regenerated man, succumbed to the charms of this vitalist image and gave echo to the incantations of Pimander until quite late in the sixteenth century.

Ovid's *Metamorphoses,* certainly one of the most influential variations on the theme of metamorphosis in antiquity, was omnipresent in Renaissance culture: manual for students of Latin, repertory of marvels where artists and poets found their myths, inexhaustible source of stories and images. In a magnificent 400-line discourse (15.75–478) at the end of the poem (which we will come back to later), Pythagoras presents the outlines of a theory of transformation, providing a posteriori an ideological framework for the fables in the preceding fourteen books. This text is a treasure house of commonplaces widely exploited by the humanists, filled with sayings that would be constantly

repeated in later times: *Omnia mutantur, nihil interit* (All things are changing; nothing dies); *Cuncta fluunt, omnisque vagans formatur imago* (All things are in a state of flux, and everything is brought into being with a changing nature); and the famous *tempus edax rerum* (O Time, thou great devourer).[6]

"Pythagoras"—the Pythagoras of Ovid—connects his thought to the idea of metempsychosis and the prohibition against animal nourishment. The vital breath, he says, can live successively in several bodies: "The soul is ever the same, though it passes into ever-changing bodies" (15.170–71), like wax, he adds, that receives new imprints, changing constantly while remaining the same (168–70).[7] But transmigration is just one particular aspect of a law that governs universal becoming: everything passes away, grows and shrinks, dies and is reborn, like the stars, the seasons, and individual lives. This meditation on natural rhythms is completed, at the end of the speech, with a lesson on the historical dimension of time. Empires also fluctuate. After the fall of Troy, all the Greek cities tumbled one after the other like a house of cards. Then Rome, Troy's offspring, rose up in their place, soon to become the capital of the universe: "She therefore is changing her form by growth" (434). Ovid, like his contemporaries, celebrated Latin grandeur in passing, but what value should be given to this praise put in the mouth of "Pythagoras?" The transfer of power from east to west now carries the Romans to the height of glory, and yet the very logic of the context suggests that fortune will soon change again. Simply saying that all things pass away would be insisting on the obvious. But Ovid's text goes further: Denying the slightest stability to living beings, inert objects, and institutions, he defends the paradox that inconsistency and otherness are normal ways of being. "Pythagoras" could have said: I change, thus I am.

Things are not only dispersed on the temporal axis, but also structurally unstable, subject to endless variations. Here Ovid adopts a theory that goes back at least to the pre-Socratics, reiterated all through antiquity: the physical world is made up entirely of the four elements. And these elements, by their very nature, are constantly changing: earth liquefies, water vaporizes, air enflames. "Nothing retains its own form" (252), and certainly not the mixtures of elementary qualities that are like labile compositions of substances in fusion.[8]

Under the combined effect of passage and internal fermentation of matter, the earth itself as a living organism changes shape and seems to slip away beneath our feet. The geography lesson of "Pythagoras" is a vertiginous, high-speed dramatization of telluric accidents, where we see the relief undergoing radical changes before our eyes. The waters of the ocean roll in, roll out, and

the face of the earth is transfigured; here an island joins the continent, there a piece of land breaks off to become an island; a city is swallowed up in the waters, a river eats away the mountain, a volcano pierces the earth's crust. At Trezene a hill popped up in the plain like a pimple on a man's face; "Pythagoras" explains how captive winds in subterranean caves, unable to find their way out, made a swelling in the earth's surface (296–306). Now, after so many books filled with tales of transformed bodies, the earth itself undergoes metamorphosis, and here the convulsions are continuous. Macrocosm and microcosm share the same properties, the same flexibility.

Below the surface level of change and movement, the earth's entrails are churning with animation, a veritable matrix where inert matter generates life. "Slimy mud contains seeds that produce green frogs" (375). This soft, warm belly gives rise to varied phenomena of spontaneous generation: the putrefied corpse of the bull produces bees, the horse's cadaver gives hornets, the crab, scorpions. We have already encountered these metamorphic fantasies, widely held in antiquity, in the work of Du Bartas:[9] the same crossing of species, the same fascination for the passage from the formless to form,[10] the same musings on the fecundity of primitive matter. When "commonplaces," as blasé scholars call them, have such a strong imaginary charge, repetition is less a sign of lassitude than enchantment.

Though antiquity did give the humanists an abundance of ideas on and images of variations in the physical world—matter, bodies, the cosmos—the anthropological and ontological aspect of change in the Greco-Latin intertext is no less rich. Each in their way, Epicureans and Stoicists, would testify. On man in universal changing, I will retain just one page of Plutarch, a page so beautiful and powerful that Montaigne copied it almost word for word from the recently published Jacques Amyot translation and made it his own.[11]

The person invited to dinner one evening is no longer invited when he arrives the next day: he is not the same person. What we call the man, someone, the same one, is only a series of discreet moments. We contain in ourselves as many instances as instants, as many psychological states as accidents that affect us. Only God *is,* say Plutarch and Montaigne. He is, because he escapes from time; yesterday, today, and tomorrow are the same for him. But man never coincides with himself; he has hardly become aware of being this than he is already that, become other, then the "other of an other" (603). Our natural space is a limited point, a crest that can't be grasped—the present—where the past is tumbling into the future. For lack of a unitary place where, *hic et nunc,* I could be myself, I am in the between; I myself and the time I inhabit

are the unstable and constantly variable equilibrium between two poles; our existence consists in negotiating contradictions at every moment.

According to the concept of existence as becoming, we are constantly being born or, what amounts to the same, dying: "Plato said that bodies never have existence, only birth. Everything is either becoming and not yet being, or starting to die before it is born" (601). Not only are we endlessly running ahead of ourselves, but we are always at the beginning of something new. Plutarch and Montaigne, as Du Bartas in his way, define life as perpetual genesis where, with regard to man, every day is creation day. This recurring idea of the inchoate is the foundation of a philosophy of *naître* (being born) as opposed to *être* (being): being born again and again means existing in the precariousness of the unpredictable, or *n'être* (not being):

> *Ce qui commence à naistre ne parvient jamais jusques à perfection d'estre, pourautant que ce naistre n'acheve jamais, et jamais n'arreste, comme estant à bout. Ains, depuis la semence, va tousjours se changeant et muant d'un à autre. Comme de semence humaine se fait premierement dans le ventre de la mere un fruict sans forme, puis un enfant formé.*

> That which begins to be born never achieves perfection of being, inasmuch as this being born never is reached, never stops, as coming to an end. But from insemination keeps changing, turning into something else. Like the human semen first gives a formless fruit in the womb of the mother, then a formed child. (602)

Amyot's style, faithfully borrowed by Montaigne, admirably mimes in its rhythms and sonorities the idea of passage: the paronymy of the opposites, *naistre* (being born) and *estre* (being), resolved in the resemblance of the homonyms, *naistre* (being born) and *n'estre* (not being). The movement of two series of assonance, *è* and *an*, throughout the passage suggests that words are engendered by physical attraction and seems to apply the principle of continuous motion, where a given signifier is itself but at the same time an echo of the preceding and a germ of the following. The discourse is self-generated by the sequence of linked sounds and presented, in the image of its subject man—like a constantly expanding potential, amplifying as it goes. The same movement operates in the sentence and in the page as a whole, carrying traces of its former existences and phases of its genesis: Montaigne transcribes Amyot, who translates Plutarch, who does no more than quote or comment on other authors. A poetics of transformation responds to a philosophy of existence as becoming. We'll come back to this later (in chaps. 9 to 11).

The humanist practice of literary borrowing is carried to the ultimate degree in this passage because everything in it is taken from other writers. But Montaigne uses mediation and dialogue to construct his own image; he colonizes the life and thought of other writers the better to know himself, whether by agreement or disagreement. The well-worn skeptical maxims of Plutarch are absorbed into the tissue of the *Essays* and so powerfully reinvested that they come out reinvigorated. Montaigne reappropriated the upsurging, drifting world described by Plutarch and made himself completely at home in it. Among the sayings he had chosen to be painted on his library ceiling was a quotation from Sophocles: "all of us who live are nothing but ghosts, or a fleeting shadow."[12] Almost the entire text of the *Essays* could be read as a meditation on the inconsistence of things and beings. Everything—whether it is awareness of the self or reflections on history and the hazards of knowledge—is conditioned by universal flux. Montaigne, like all literate people in the Renaissance, lived in such strong symbiosis with antiquity that this detour did not really take us out of our way.

"No, we do not die, we only change": Ronsard

Mosaic creation, once and for all, or transformism according to the ancients? Ronsard, like Du Bartas, hesitates. Regimented nature, subject to fixed laws, or expansive vivacious nature? The poet does not subscribe to any unitary doctrine. In many of the passages on cosmology—especially in the *Hymnes*—he allows the different voices heard in those days to speak out and even contradict each other. In some lines he seems to accept the traditional vision of the regimented universe from the first chapter of Genesis and the harmonious geometry of the celestial spheres according to Aristotle.[13] But in others he takes pleasure in images of a flexible world, the idea of eternal matter vibrating with regenerative energies. In spite of some rigidity and vacillation, his natural penchant carries him in this direction, and I would like to focus on this attitude of the spectator gazing in wonder at the dynamics of an animated world. Ronsard, like Montaigne, drawing on the same voices from antiquity, sees nature in motion and transformation. And he is no more frightened by it than they were.

Though he lives in a period of disenchantment and civil war, rife with clamors of decline and apocalyptic visions, Ronsard thinks of the Fall only in terms of a cycle where matter, quickly reborn from its ashes, passes through formlessness to come out transformed. God, forever present in the world, may

wish to chastise it. But would he play with his creation like a child with a sand castle?

> But to see your castle made, remade, unmade
> Would be like child's play on the seashore
> Building sand castles to destroy the castle built.[14]

No, answers Ronsard, "because destruction / Does not suit God, but generation."[15]

The threat of annihilation brandished by the prophets of doom does exist but is brushed aside. Ronsard remembers the myth of Deucalion in a desolate land ravaged by the deluge, throwing stones that metamorphose into men and women. Twice he celebrates this regenerative gesture when, in "the desert of empty wastes,"[16] living beings shoot up, and everything begins again. A promise of fertility lay in the barren plain: the inert is animated; hard, dry matter changes into a maternal womb. Even if he chooses again to express himself through Ovid, the poet crystallizes a fundamental aspect of the vitalistic sensibility in such a symbol. Nature as he experiences it—*natura naturans*—is inhabited by forces and currents through which life forever rebounds. Within the negative—sterility, conflict, destruction—broods the seed of the positive. Discouragement, resignation, or arrest is rarely the last word in Ronsard's poetry. Even in situations that seem blocked, potentials exist, waiting to be realized. We can understand better the dynamic way the poet develops his work, in constant motion, when we have measured the energies that, for him, make the world turn.

The "Discours à Maistre Juliain Chauveau" gives a good example of that potential for rebound that Ronsard seeks traces of everywhere, in the hazards of private life as in the vicissitudes of history.[17] Meditation on universal flux is stimulated by the spectacle of contemporary events; the poem opens on a catastrophic note; change is perceived as decline, degradation of the spiritual and political climate. But soon the idea of transformation replaces the notion of loss; what seemed to perish was only changing and taking on a new incarnation. Ronsard conjures the anguish of ruin by moving the perspective from the human social realm to that of nature; situating personal or collective destiny within the cycle of biological mutations means understanding that the loss of a form brings about the liberation of a force:

> This brooding worm, bored to be himself
> Suddenly changes and flies over prairies
> Turned butterfly with dappled wings
> In red, green, blue and carmine (72–75)

For human beings, alteration follows a descending slope, whereas in the alchemy of nature it ensures the renewal of energies. "Rotten and adulterated," the eggs "Turn into birds" (84–86). Recalling the discourse attributed to Pythagoras in *Metamorphoses,* the poet recognizes in the flexible reliefs of the landscape the sequence of mutations that, from the hardest objects, make a malleable dough:

> Look up, Chauveau, look left and right,
> See those rocks bold standing in their might,
> That once were waving fields of grain:
> See those high waves on ocean's plain,
> Where once on solid earth outspread,
> Grazing in green pastures herds were fed,
> So form in other forms is made to change,
> And is it not marvelous and strange,
> Because the law of God and Nature ordains,
> That nothing in same place the same remains (95–104).

Geological traumas are nothing more than undulations in a harmonious curve, normal episodes of a natural evolution. From that point forward, an optimistic philosophy of history counters the initial pessimism of the poem. The great empires of antiquity collapsed, but power moved on, and with the fall of Rome "The Kings of Europe . . . are rich with its losses" (121–22). The grieving cries of *ubi sunt?* are answered with a reassuring pursuit of *translatio imperii.*

The treatment of the theme of death fits into this logic:[18]

> No, we do not die, we only change from
> Form to other form in a change called
> Death, when other new form we take (56–58).

The vicissitudes that mark a human life, says Ronsard (even if by precaution he recognizes the survival of the individual soul), follow the same law as the ups and downs of matter, going from one form to the other without ever perishing. The dead body, reintegrated into the natural cycle, becomes a wellspring of life; a being disappears but another appears, in a never-ending chain. Rabelais's account of the birth of Pantagruel belongs to the same intuition. When Badebec dies in childbirth, Gargantua, the father, doesn't know if he should laugh or cry. But he quickly makes his choice for pleasure and, instead of going to bury his wife, turns to his son.[19] This theme is widespread in pagan religions, popular traditions, and ancient philosophy from Pythagoras to

Lucretius, from Seneca to Plutarch. There are magnificent pages in Montaigne on the universal rhythm that draws us from death to life, from life to death.[20] But Ronsard, more than any other writer, used literary style as a way to exorcise the danger: if the cadence of his lines follows the very rhythms of cosmic harmony, the poetic evocation functions as a denial of the outrage of death by absorbing it into a higher order. This reversal operates in the "Hymne de la mort":

> *Que ta puissance (ô Mort) est grande et admirable!*
>
> *Ce qui fut se refaict, tout coulle comme une eau,*
> *Et rien dessous le Ciel ne se void de nouveau:*
> *Mais la forme se change en une autre nouvelle,*
> *Et ce changement là, VIVRE au monde s'appelle,*
> *Et MOURIR, quand la forme en une autre s'en va.*[21]

> How great and admirable (oh Death!) is your power
>
> What was is remade, all things like water flow,
> And nothing new under the Heavens can appear so:
> But form into other new form is changed
> And this change, LIVING in this world is named,
> And DYING, when form into another goes.

If life and death are so much alike that one follows the other without a rupture, then couldn't one contaminate the other? And make us into walking corpses? This macabre terrorism haunts religious literature and rings out in the baroque poetry of the Counter Reformation. Ronsard's approach is the opposite: death, seen as a promise of life or latent life, is disavowed, expropriated, and recycled in the circuit of positive energies.

The poem goes on, naming the forces that confront death:

> And so with Venus Nature found how
> By long and varied changes to reanimate,
> Remaining matter, all things that you eat.

The antidote lies in the complicity between nature and love, the two agents of fertility par excellence. Here the poet remembers the Venus of Lucretius, life-purveying, great generating Mother. The conflict of love against death resonates in countless love poems by Ronsard, resolved with the grace of poetic language in the triumph of life, because poetry disposes of almost magical means to conjure death: lyrical incantation and the alchemy of metaphors that

transfer the transitory into the order of the everlasting. The extraordinary sonnet on the death of Marie, "As on the stem in Maytime the rose,"[22] puts all the poet's stylistic resources in the service of this resurrection, which functions on the base of an analogy between the young woman and the flower, between human mortality and plant renewal. The rose was young and beautiful, then died a natural death, and the lady, young and beautiful, is dead:

> For obsequies take my cries and my tears,
> This vase full of milk, this basket of flowers,
> So your body, alive and dead, will be roses just roses.

Adding to the web of symmetries associating the young girl with the plant and making her death a normal event, the poet's offering inserts the symbols of life into the realm of death. The body is transported by the play of metaphors into the world of nature, where everything is reborn, where it can be both "alive and dead."

Ronsard frequently resorted to this strategy of fantasied denial of mourning, aging, and sentimental problems by the ruses of poetry. To chant death is to enchant it, using the lyre's charm to neutralize the horror of death. This demands mastery of figurative language to accomplish the imaginary transfer of man's destiny into the realm of natural process. The poetry of Ronsard is a treasure house of tactics used to find a way out from despondency, to escape from despair and liberate energies dried up in one place so they can flow again in another.

Flexible Bodies: Ronsard

In his reveries about a world destined for transformation, Ronsard dwells on the contemplation of mobile structures and flexible, malleable objects: water and smoke, undulating dance movements, the floating veil. Like so many artists and poets, he is fascinated by the kinetic effect of the ever-changing shapes of clouds and the evanescent figures they design.[23] These images can be interpreted as symbolic representations, scale models, a condensed vision of the metamorphic world. From all these emblems I choose the demons, to which Ronsard dedicates a poem of more than four hundred lines.[24]

Demons are light, airy bodies that inhabit the region between earth and sky, like the clouds that they resemble. Participating at the same time in matter and spirit, in the human and the divine, they circulate between two realms and act as mediators. Messengers of the supernatural, they are like sorcerers,

divines, who transmit to men the secrets of the other world; they spread pre-
dictions, provoke prodigious phenomena, and, in the heart of a world satu-
rated with magical correspondences, function as agents of the occult. Ronsard
mixes an abundance of scholarly materials in his poem,[25] most of it borrowed
from the esoteric tradition. What are the origins of the demons, their effects
and powers? How can they be classified and the good distinguished from the
bad? The didactic project is obvious, but the profuse, eclectic exposé is often
submerged by bizarre, picturesque scenes, fantasmagorical stories, and trou-
bling metamorphoses. The attraction of fleeting forms and polymorphous
bodies is at its height.

Inconsistent and capable of all possible configurations, the demons

> Soon change form, and their agile bodies with ease
> Transform suddenly in whatever they please (93–94).

Whatever appearance they take on—inert object or animal—they operate the
change by their own will and remain constantly available for other effigies.
Whereas Ovid's characters submit to metamorphosis in spite of themselves
and remain prisoners of their new bodies, the demons, like the atoms of Lu-
cretius, can experiment with multiple combinations. If they sometimes take a
recognizable form and create a perfect illusion, they may just as easily take on
the appearance of monsters, with terrifying hybrid anatomies against nature.

Plasticity of airy bodies, chimeric temporary combinations: the unstable
condition of the demons seems to belong to a world in gestation, where all
possibles are realizable. No sooner do these vaporous creatures take shape than
already they evaporate:

> But they, their forms, for shortest time enjoy,
> And of a sudden vanish into nothingness,
> As if the Waves in colors had been tinted,
> Or Air and Wind in colors painted,
> Because their body is not solid, or by nature
> Apt to long keep a figure once taken (147–52).

Like clouds, the demons pass from one appearance to another, never being
identified with any of them. In themselves they are nothing; their property is
to be vacant, phantasmogoric, indeterminate and to fulfill themselves by tak-
ing on the appearance of something they are not. Doomed to parasitic activ-
ity, permanent candidates for metamorphosis, they can be themselves only by
becoming other. For a transformist sensibility like Ronsard's, what better sym-
bol of existence than this otherness that begins over and over again?

"Masked in vain shams" (119), the demons construct fictitious identities. Their histrionics are morally reprehensible because they live on the illusion of others; they are deceiving "liars" (385). But Ronsard is fascinated by their aptitude to project themselves into other existences, their liberty to change their lives. In another poem, he makes this surprising confession:

> I am like the Demon, who does not want the
> Burden of a body, or only a body light as air,
> Like those fine subtle vapors,
> Dried by Sun from summer's warm days.[26]

Where does the resemblance lie? Their migrant condition, says Ronsard, forces the demons to adopt "true-seeming shams" (108). In other contexts the same expression is applied to the poet who concocts fables that are not truth, but verisimilitude. Perhaps that is where the affinity lies: the demons operate like the imagination that fulfills its desires through fiction; like fiction they invest the unreal but believable forms they have created. By their plasticity, their corporal evanescence, they represent the very mechanism of the imagination, its freedom, its charming chimeric productions.[27] Like demons, the poet is fictively incarnated in other characters and constructs fantasied effigies to fulfill his dreams by procuration.

The hymn of the *daimons* testifies to Ronsard's protean inclinations and corresponds to an essential theme of his love poems: metamorphosis.[28] The lover imagines himself turned into a rock, a bee, or a god; the lady's body changes into a plant or stretches out like a landscape. Dreams of transformation are plentiful and, ever since Petrarch, omnipresent in love poetry. The distance between metaphor, ever present in lyrical songs, and metamorphosis is often imperceptible. It is enough for an analogy to be invested with desire and serve as germ of a story with a before and after, and what was a simple resemblance can become a change in identity. The survey here will be limited to Ronsard and metamorphoses in which he himself or a masculine character is present as subject. This episode of love psychology is hardly a digression, because the lover who dreams himself other and projects himself into borrowed figures is playing his part in the broad circulation of forms within nature.

The Petrarchian narrative is a story of privation and suffering at the hands of a cruel, rejecting, unattainable beloved. Against this background the metamorphic fantasy intervenes to compensate for failure and, in the optative mood, quench frustrated desire. The lover will experience by transfer what he cannot obtain in his humiliated body. Because the erotic pleasure refused to

him exists elsewhere, he will appropriate it by changing identity. The formula is applied in the admirable sonnet of couplings by the intermediary of mythologic doubles, "How I would like richly yellowing . . . "[29] I would like to become Jupiter and, like him, turn into a shower of gold to fecundate Cassandra; like him, turn myself into a bull; like Narcissus, plunge into the fountain of love. The rhythms and sonority of the poem capture the slow, voluptuous drift of the lover who slips into the body of another, the better to penetrate the body of his mistress. The height of sensuality coincides with the summit of otherness.

The poet turns as readily to objects as to divine or human mediators to support his desire. The beloved refuses carnal contact with him but grants it to things in the surrounding world, inspiring fantasies of thingification:

> Water would I be
> Your body to wash . . . [30]

The privileged substitutes with which the lover dreams of identifying are light, flexible, volatile substances—"Hey, can't I be a flea!"[31]—flexible bodies that embrace all the better for being inconsistent. To favor this dream of transformation into formless objects, nothing could be better than water, the perfect medium for intimate contact. The lover of "Voyage de Tours" imagines himself a river softly embracing his sweetheart, who floats in the water:

> I would go all over, and my loving waters
> Would kiss her hand, kiss her frank mouth.[32]

Liquid is the symbiotic metamorphic element par excellence; changing into water is taking on all possible shapes, all conditions.

Another solution for maintaining the chain of transformations is to multiply imaginary changes. In the sonnet "Je vouldroy bien," the same verb is used four times to express four different wishes. Like demons the amorous subject delights in seeing himself pass from one incarnation to another. In "Fantaisie à sa dame,"[33] Ronsard represents himself as cloud, rain, rock, fountain, swan, marigold, shadow, and boat. He expresses the flight of desire in a formula so often used that it is almost a cliché: not one but "a hundred metamorphoses," "a thousand metamorphoses." In the works of Petrarch or other poets, this dispersion of identity is perceived as exile, a sign of permanent frustration. Ronsard experiences the dilation and dispersion of the self as a playful or joyful occasion to explore different modes of being. Goodness lies in opening and dissemination, not in concentration. Whereas love ordinarily moves to seek

union, the trend here is to multiply the one and project it out toward other lives. As a result the priorities are nearly overturned: instead of metamorphosis being in the service of love, love serves as a pretext for metamorphosis.

Demons are latent beings that can fulfill themselves only by pirating other existences; in the same way the subject of amorous fiction is all the more himself as he becomes more diverse. His will to otherness is heightened by the fact that he often represents himself transformed into an animal or a natural object—element, plant, landscape—rather than a human double. Yet these imaginary migrations do not imply danger or sacrifice. For Ronsard, transporting oneself into other realms is connecting with the life of the macrocosm; becoming other is a way of reaching a superior unity, the unity of nature, where all things interact to regenerate.

Everything Is Alive

The notion of nature that serves as a conceptual framework for all the phenomena that interest us here is as fundamental as it is vague. Unlike the Protestants, careful to distinguish the creating from the created, most humanists describe nature as a diffuse potential, a benevolent, active force suffused in all things, ensuring the maintenance of life:

> . . . The great universal mass
> Would see by death its members discord,
> If not for the spirit within,
> Everywhere infused, that makes it move.[34]

Nature encompasses the totality of bodies—the mass of matter in its multiple incarnations—but it is also a spirit, an animated animating principle. It follows that things, indissociable from the soul of the world, are living and, reciprocally, the spiritual instance is indistinct from matter. To the personal transcendent God of Judeo-Christian orthodoxy responds, in the more intuitive eclectic thought of many humanists, a total indeterminate power, something like the mana of primitive religions. More or less confused with nature that absorbs him, God loses his distinction and is dispersed among things.

The opening lines of a Ronsard poem, "Le Chat," with its resolutely pantheist profession of faith, incited endless commentary:

> God is everywhere, everywhere God mixes in,
> Beginning, end, and in between
> Of what is living, what the Soul encloses

Every where, and invigorating every thing
Like our Soul infused in our body
Already the members would be dead
Of this great Whole, if that divine Soul
Was not mixed in all the Machine,
Giving it life, strength, and motion.[35]

Notions of God, the Soul, the great Whole, Nature become interchangeable, and hierarchies of spirit/matter, creator/creation, eternal/transitory are lost. This declaration by a poet who elsewhere stands as a defender of Catholicism might seem surprising. But taken in the intellectual framework of the times, it is perfectly normal. Before strict order was imposed by the Council of Trent, syncretic thought penetrated with animism was still widespread; far from setting himself apart, Ronsard expressed an intuition shared with the majority of his contemporaries. Far from establishing a systematic doctrine, he reflected ideas that were circulating, without necessarily composing a coherent program.

Many people believed in this nebulosity of animated matter connected by the same vital flux within which all things communicate, interpenetrate, or exchange forms. Thinkers known as Neoplatonists—a rather vague concept itself—invoked the soul of the world—*Anima* or *Spiritus mundo*—and indistinctly related all manifestations of life to this diffuse substance, one and universal.

In its simplicity, this spirit general
Triple unity, is animal, plant, mineral.[36]

This is a quite heterodox trinity, which associates three realms in the same body and tends to efface the frontiers between them. Apparently inert objects, elementary as well as more elaborated forms of life, are integrated into the magical network in which every part is united with all the others. The spirit circulates, animates each parcel of matter, and, because it embraces the totality of things, establishes sympathies between them.

So everything is alive and endowed with a soul; every object is capable of sensitivity and movement. Animist thought speaks of the world as an animal, an organism, easily resorting to biological notions, taken literally. For Marsilio Ficino the earth not only is a body that procreates like a human being, but also is endowed with intentions:

We see how the earth from particular seed engenders a multitude of trees and animals, feeds them and makes them grow; we even see the earth grow stones like teeth, and plants like hair as long as they stick to their roots, but

stop growing if we pull them out. How can it be said that the womb of this female is not living? This womb that spontaneously gives birth and cares for so many offspring, that sustains itself and carries teeth and hair on its back?[37]

Where is the limit between the literal and the figurative in such a representation? Where does science end and the imagination begin? The question is not phrased this way because, in the animated universe of the Neoplatonists, the essential is hidden, pertains to intuition, and defies rational distinction. From magic to medicine, from poetry to philosophy, from religion to natural science, there is no sharp separation. For Ficino, but also for astronomers like Copernicus and Kepler, doctors like Paracelsus, and philosophers like Campanella, the representation of the earth as a mother or an animal endowed with feelings and sensation is far more than a metaphor. Maternal nature replaces Providence; a naturistic religiosity tends to encroach on the territories of the church and science.

Whatever part God or the Spirit of the world plays in this animated organism, the basic conviction remains that everything is alive. So we must speak of vitalism as much as animism, without trying to distinguish doctrines that were in fact confounded. The search for secret manifestations of life went so far, was inspired by such intense curiosity, that Ficino in the quoted text gives stones as one of the earth's organs—beings that grow, shrink, and transform. He is not the only one in the Renaissance to treat mineralogy as a branch of zoology; stones engender their own seed, nourish and alter themselves, participate in the generalized animation. When Cardan observes gems he notices "cavities, pores, vessels, fibers, and white streaks altogether similar to living tissue, that must be the mineral's digestive organs."[38]

Bernard Palissy's *Recette véritable,* a description of a learned project for an ideal garden, is also a chemistry manual that presents elements of a resolutely transformist natural philosophy. The earth, which Palissy also calls nature, is a "matrix,"[39] in which substances circulate and combine in an incessant labor that, as we mentioned, belongs to continuous creation. The principal agents of this activity are the salts spread throughout matter. Both transformed and transforming, they are reduced, dissolved, and redistributed; by passing from one body to another, they improve fertility, provoke all kinds of germination and mutations. Palissy also chooses stones to illustrate this constant recycling, without even seeing the paradox, because it is so obvious to him that the apparently inert, insensitive object really trembles with the movement of life. The hardest element takes part in the generalized softness and mobility of

matter, forever carried from one composition to another. One of the possible circuits, from stone to stone, serves as an example:

> Humidity of air and pounding rains dissolve the salt that is in the stone, and the salt so dissolved and reduced to water leaves the other parts to which it was attached and that is how the stone is reduced to earth once more, as it was before, and being reduced to earth is never idle: because, if not sown it will work to produce thorns and thistles or other kinds of grasses, trees or plants, or when the proper season comes, it will be reduced to stone once again.[40]

Do such dynamics obey laws? Can the mutations that animate the body of the universe be systematized? Scholars give varying answers. The world comes close to being destined for anarchy. Nature in its intelligence produces its own regulating force; it maintains the vital cycles and presides over the renewal of forms according to more or less discernible rhythms; it controls fusion and transmutation of matter; it maintains concord among adverse elements—the humanists would not have produced so many treatises in natural philosophy if they weren't striving to discover or confirm principles of order.

Though they were all seeking to capture the secret life of the universe, their confidence in the possibility of constructing rigorous knowledge and methods varies. Some, attentive to the regularity of vital rhythms, tend to discern rules and endeavor to compile encyclopedias, in the belief that it is possible to cover all phenomena. Nostalgia for a perfect, immutable universe along the medieval model still dominates countless studies, and the dizzying notion of perpetual motion inspires more than one case of resistance.[41] Thinkers starved for order can look beyond the sublunar world, doomed to flux and discordant concord of elements, and focus on the harmony of the higher spheres. My emphasis on transformist imagination in the sixteenth century necessarily neglects the importance of partisans of stability—or those who thought that motion can be reduced to an ensemble of recurrent principles.

Other thinkers, troubled by the diversity of the world and its unpredictable mutations, rush ahead and put their knowledge into collections of miscellany.[42] There is a significant contrast between the construction of knowledge in the pre- and post-Renaissance periods. Scholasticism, building on Aristotle and the Bible, edified a coherent world system based on truths reputed to be permanent. Later, the seventeenth century would perfect mathematical physics. In between the two, Robert Lenoble speaks of an "interregnum of law" and regression of science that prefers the poetry of Platonism, of animist and vitalist speculations, to the rationality of Aristotelians.[43] The demand

for systematization, whether by theology or by calculation, was subordinated to curiosity, an admirative, receptive attitude that collects phenomena and perceives the world as a reservoir of marvels rather than an organized whole. As we will see further on, scholarly manuals belonging to this tendency are limited to accumulation of information without any attempt at criticism, strict classification, or general conclusions.

Conceived this way, science adopted a discourse that reflected its purpose: how can the field of knowledge be fixed or closed as long as the work of creation continues? Nature, dynamic and unpredictable, forever capable of novelty, defies the frameworks that would tend to immobilize it. One of the virtues attributed to nature by learned people is the extraordinary variety of its productions; they marvel at the diversity of nature's inventions and the fantasy displayed within the order of things.[44] Added to the uncertainties of a fluctuating world is human ignorance, as the Skeptics remark, confronted with processes that escape us. Gradually, discovery and explanation of natural phenomena advance or deviate, modifying the structure of knowledge as they go. Montaigne carried this one step further: Nature changes but so does the observer's point of view; the multiplication of these two movements sustains research, sharpens curiosity, but destabilizes the edifice of knowledge.

Between those who subordinate change to immutable principles and those who take note of the surprises, there are, of course, many intermediate positions. It would be a mistake to neglect this tension and think that Heraclitus completely obliterated Parmenides in Renaissance thought. If I dwell more on the tenants of perpetual motion, it is to highlight what is perhaps the most singular, adventurous aspect in the sixteenth century. Galileo's answer to faithful Aristotelians was that the heavenly bodies, traditional guarantee of invariable order, undergo mutations. As for the earth, he said, I consider it "noble and admirable for the many diverse alterations, mutations, generations that occur. And if it were a vast solitude of sand, or a solid mass of jasper where nothing changed I would consider it a *corpaccio* useless to the world, lazy and superfluous. . . . And I would make the same distinction as between living and dead animals."[45] The enemies of change are gravediggers.

Infinite Motion: Bruno

When Galileo discovered "generations and corruptions" in the heavens, he relied on the authority of his telescopic observations. When Giordano Bruno sent the whole world, with all its stars and planets, spinning in a whirlwind of

motion and transformation, he spoke like a visionary, followed his intuition, looked back to the pre-Socratics and atomists, extended the speculations of Nicholas of Cusa on infinity, and then, when the astronomers were formulating the basic questions of the new science, took a rather regressive position. Expressing himself during the last decades of the sixteenth century as the most audacious heir of vitalism in the Renaissance, Bruno pushed the logic of metamorphosis to its extreme limits. I will attempt to isolate some of the main points of a dense, complex work that cannot be easily summarized, trying my best to avoid oversimplification.[46]

In fact, Bruno's passion for kinesis is counterbalanced: like other fervent advocates of the concept of mobility, he needs fixed anchorage and finds it in what he calls the universe, that is the whole, one, immutable, and infinite, containing all things and identified with God. Sole perfection, this absolute inspires nostalgia and can serve as ideal model of a stable, harmonious world where the cosmos triumphs over chaos. Bruno was against disorder; he dreamed of reconciling force and form and sought to balance the dynamics of flux with the solidity of connections. Which doesn't change the fact that the universe contains worlds in continuous movement and transformation, just as unstable as their envelope is stable. Exiled from the One, Bruno is captivated by the dynamics and diversity that govern life within the plurality. And the cosmos goes into a spin.

Bruno posits a situation in which everything from atoms to human beings, from the simplest to the most complex organism, is saturated with life. A universal soul moves all the worlds that make up the universe and, within these worlds, all the bodies that inhabit them and, within these bodies, every tiny parcel. The driving principle—soul, spirit, or nature—propagates in such a way that it is everywhere, and under its impulsion life proliferates: here animism and vitalism attain their broadest scope. It follows from this notion of radiation from a vital nucleus that all things, even the most humble, possess their own energy and move by themselves. The soul that inhabits beings has endowed them with perpetual motion. They move naturally, propelled by their own internal force, and don't need any push from the outside. Inertia and death exist only in the falsified perspective of fearful minds.

Beings not only move, they change and transform, because they want to live and there is no life without alteration. The innate élan that animates creatures corresponds to an instinct of self-preservation: they move, grow or diminish, modify their complexion in order to perpetuate themselves by regeneration. Passing from one state to another is a vital reflex; moreover, the

universal law of desire imposes on us this condition of seeking pleasure and satisfaction in an endless alternation of need and fulfillment. Perfection for living beings lies in the endless quest for the other; if, as learned men often say, perfection is the state of rest, everything would be dead.

The same vital process can be explained differently. The internal force that animates all bodies makes them beings in potential and sustains a demand for perfection that leads them from one transformation to another. Things, by the presence within themselves of a fragment of the universal soul, aspire to go beyond what they are and lift themselves to a higher degree of fulfillment. They are endowed with potential that surpasses their limits as objects in action and pushes them to germinate the virtualities they contain. Bruno rallied to the principle, upheld by many other thinkers, of the permanence of matter and multiplication of its forms. Matter is constant but, animated by the desire to realize the latent powers residing within it, it tries out all possible configurations. Matter renews itself endlessly, actualizing a form only to bounce on toward another. Only such a creation capable of endless regeneration could be worthy of God.

The heavenly bodies are also animated desiring beings that participate in the universal soul. Thus, it is important for Bruno to define a universe in which they can freely expend their energy; space has to be opened out. The cosmos as conceived by the ancients, following Aristotle and Ptolemy, is ordered like an intelligent machine and places all sorts of obstacles against the motion of the heavenly bodies. The stars are firmly attached to the firmament that encloses the world and carries them in its circular course; within the globe the heavenly bodies are set in encased spheres, each planet turning regularly around the earth. To Bruno the harmony of these orbs and the beautiful geometry of these figures were like walls that turned the heavens into a prison. He replaced this rigid model with a system so exuberantly mobile that it defies representation.

In an infinite universe that has neither center nor circumference, countless worlds gravitate; each world has its own sun with planets circulating around it in prodigiously varied curves. The shell of the Greek and medieval cosmos that Copernicus had conserved by maintaining the principle of concentric spheres is smashed to pieces. Too much symmetry, too many limits, would bring God down to our measure and make his creatures slaves of mechanical trajectories unworthy of them. The planets are sensitive and endowed with intelligence; they move through space on itineraries dictated by their vital needs, instincts, or pleasure. According to Bruno, astronomy is more the observation of ener-

gies than structures, pertains more to biology than mathematics. Might this lead to widespread anarchy on the avenues of heaven? Bruno waves away this objection by replying that the supreme liberty of heavenly bodies determines a higher harmony. Spontaneity and change imply uncertainty and entail risks, but they are the necessary conditions of life.

3 | *Earth Changes: Leonardo da Vinci*

Illustrating Transformation

"Movement is the principle of all living things."[1] Whatever the object of his studies—biological processes, comparative anatomy, telluric forces—Leonardo da Vinci was searching for signs of the forces that alter forms and carry nature into successive metamorphoses. His notes, sketches, and paintings—the limits are often indistinct—are filled with research on the birth and transformation of bodies, observations of mutations of the earth's surface, meditation on the flow of energies and changing matter. With Montaigne, who echoed these themes at the end of the century, Leonardo is certainly one of the most radical Renaissance thinkers on the subject of motion. In words or images, as artist or scholar, he struggled to grasp—sometimes with utmost precision, sometimes by stunning intuition—the laws of change as life's basic principle.

Leonardo shared with his contemporaries the great transformist ideas covered in the preceding chapter. He bathed in an intellectual climate saturated with images of labile matter and continuous creation, drawn from memories of Pythagoras, Ovid, and Plutarch.[2] He himself perceived traces of life circulating through all things and related this to a universal unifying principle. The earth, he said, has a vegetative soul. It is animated and functions like a living organism in its rhythms as in its morphology. Man and the world, microcosm and macrocosm, associated in the life of the great whole, are composed of the same matter—a mixture of the four elements—and their physical organization is symmetrical:

A man has a bony frame for his flesh; the world has rocks to hold up the earth. Man contains a lake of blood where the lungs, when he breathes, contract and dilate; the earthly body has its ocean that rises and falls every six hours with the respiration of the universe. The lake of blood flows through veins ramified throughout the human body, the Ocean fills the body of the earth through countless aqueous veins.[3]

The unity of forms and analogy of structures in the whole scale of being determined Leonardo's method and led to frequent comparisons between the skeleton and physical geography and among medicine, zoology, and botany. In his drawings of organs, muscles, and vascular systems, he aimed at anatomical exactitude and illustrated resemblances with other realms. For example, to show that the vessels branch out from the heart (and not the liver, as Galien claimed), he drew them ramified like the roots of a plant bursting out from the seed (fig. 2).

The similarity between the organs of the vast and the small body may also suggest that one is turning into the other: vestiges of external nature subsist in man, or man is slipping toward a reunion with nature. A drawing of an old man shows a bald, lumpy head like arid earth and a full beard flowing like a river (fig. 3).[4] Other profiles of old people—a recurrent figure in Leonardo's rough sketches—show them undergoing slow petrifaction, with prominent foreheads, hooked noses, and jutting chins, as if the faces were turning into rocky landscapes. Whatever the analogy, man in these sketches is captured in the process of losing signs of humanity, changing form, slipping toward another existence or returning to elementary matter (figs. 4 and 5).

Leonardo's drawings offer numerous variations on the same theme as he explores affinities between different species—human, animal, vegetable, inert—and captures the moment where one turns into the other. Significantly, these experiments are often made in portraits of the face, site of identity, the distinctive sign of the individual or species, precisely where indications of resemblance or possible metamorphosis stand out. In the image of a head, the features of a man or woman are superimposed on an animal, monkey, or fish as if to reconstruct the history of living things, the direction of evolution or regression and progressive transformation (fig. 4). Another study of physiognomy shows that expressions of fear or aggressivity can make the faces of a horse, lion, and man look almost alike (fig. 6).[5] A passage in the notebooks suggests the existence of subhumans who occupy the space between humans and beasts or things:

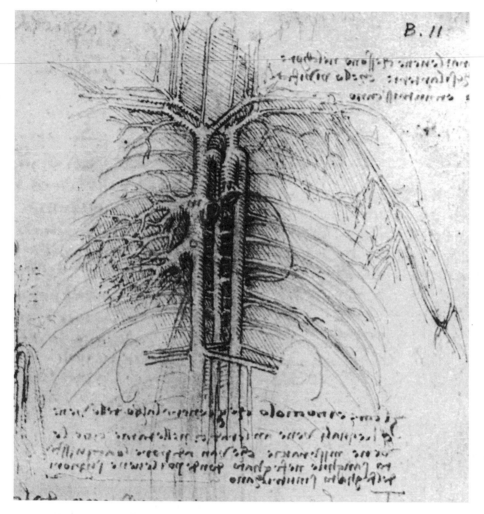

Fig. 2. Leonardo da Vinci, *The Main Arteries and Veins of the Thorax* (detail), ca. 1508–9. Pen and ink, 191 × 140 mm. Windsor Leoni Volume (19028).

See, many of them could be called simple food canals, manure producers, latrine fillers, because they have no other use in this world, practice no single virtue; all that's left of them is latrines filled to overflowing.[6]

At the other end of the social ladder, Leonardo studies a warrior and there, too, finds strange associations. The portrait of a superbly trussed up lord displays the full range: his face is like the lion engraved on his breastplate—con-

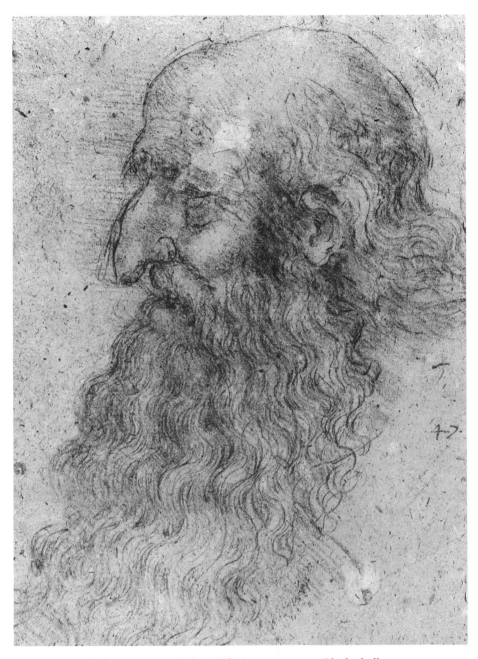

Fig. 3. Leonardo da Vinci, *Head of an Old Man,* ca. 1514–15. Black chalk, 253 × 182 mm. Windsor Leoni Volume (12500).

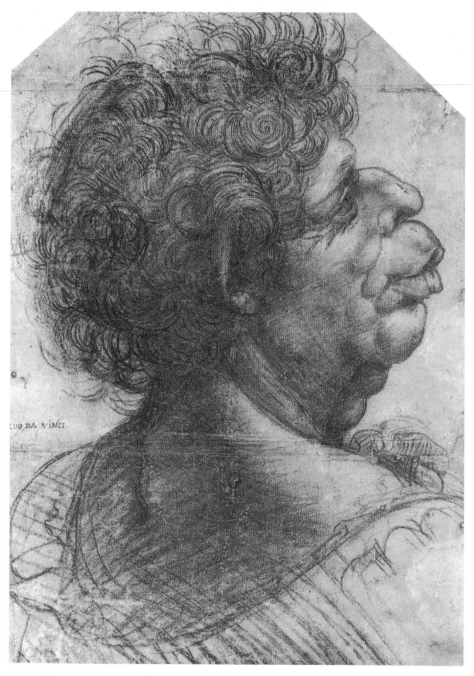

Fig. 4. Leonardo da Vinci, *A Grotesque Head,* ca. 1504–7. Black chalk, 382 × 275 mm. Christ Church, Oxford. Compare the treatment of the hair with that of the deluge (fig. 5).

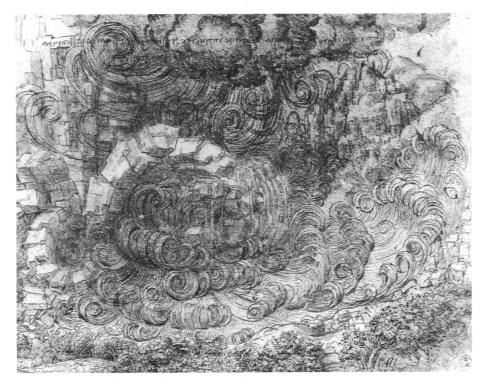

Fig. 5. Leonardo da Vinci, *Deluge Study*, ca. 1515. Black chalk, pen and ink, 162 x 203 mm. Windsor Leoni Volume (12380).

tinuity between man and beast, animate and inanimate; the helmet, like the armor, is decorated with flowers and foliage and has a sort of bird's beak and wings—further affinities between the living and the object (fig. 7).[7] Is the human animalized or thingified, or have things that are supposed to be dead come to life? The stratification of categories and their mutual attraction suggest that the passage from one state to another takes place indistinctly. Unlike monsters, which are products of a former crossing, the characters in these drawings might be situated on the verge of transformation. Caught up in the cycle of natural mutations, they will soon take on a different appearance.[8]

Misshapen, changeable bodies, signs of humanity effaced, frontiers between species trespassed—these experiments in the realm of the grotesque (we will go into this in chap. 5) are all the more intriguing because on other occasions Leonardo painted harmonious figures, closer to those of Botticelli, Perugino,

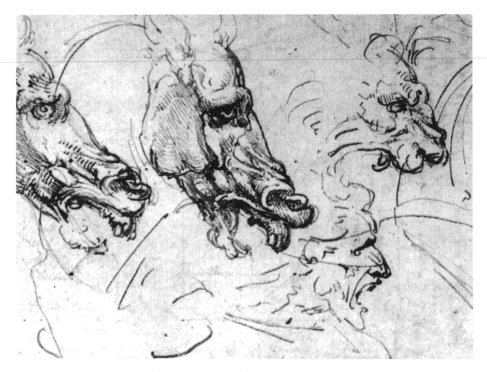

Fig. 6. Leonardo da Vinci, *Studies of Horses with the Heads of Horses, a Lion, and a Man* (detail), ca. 1503–4. Pen and ink and wash with traces of red and black chalks, 196 × 308 mm. Windsor Leoni Volume (12326).

or Raphael in their search for classic beauty, ideal images of human beings striving for perfection. We also know from passages in the notebooks,[9] and from the famous figure of a man inscribed in a circle and square, that Leonardo was interested in the Vitruvian canon and probably adhered to the classical theory that the geometric measures of the human body follow the proportions of the cosmos. On the one hand the accomplished, exemplary being, summit of creation, and on the other the coming to be, a cog in the works of the vital cycle. In the first series time seems suspended; in the second it flows as if Leonardo wanted to observe the body in all phases of development.

Another drawing can be read as an allegory of aging: a handsome young man with a straight nose, rounded chin, and thick curly hair is face to face with a caricature of an old man similar to the one mentioned above, with hooked nose, pointed chin, bald head. This time the two conditions are jux-

taposed instead of superimposed, but they still illustrate transformation of physiognomy under the effects of aging, the signs of passing time (fig. 8). Aging has made such an enormous difference between these two human beings, as great as the difference between a man and an animal, a face and a landscape. Time erodes the skeleton as water carves the rock; senescence and death are normal phases of the natural process.

Leonardo's notebooks are full of passages on the unity and continuity of life and death, like two stages of the same metamorphic cycle. "While I thought I was learning to live, I was learning to die." Already death inscribes traces in the living body; the dead are not really dead because their vestiges are matter that will be recycled into new organisms and continue to live. The stomachs of the living are a "sepulchre for other animals, hostels of the dead, that sustain their lives by the death of others."[10] Putrefaction and regeneration succeed each other, the cadaver and the living body interpenetrate in the digestive tube: here Leonardo adopts one of the major themes of transformist thought.[11] In fact, going beyond simple exorcism, he presents death as an object of desire, in the name of the vital instinct:

> Consider what hope and yearning draw a man (like a moth to the flame) to repatriation and reunion with primordial chaos. With sustained desire he joyfully awaits each new springtime, every coming summer, and the new months and the new years. Impatient, for things awaited are too slow to come, he doesn't understand that he is impatient for his own destruction. But this yearning is the quintessence of the spirit of the elements captive in the life of the human body, perpetually longing to return to their mandator.[12]

Chaos here is the temporary site of indifferentiation, primitive hearth, universal crucible where matter rests in a potential state awaiting a new incarnation. By regressing to an elementary stage, the dead body rejoins the magical moment of creation where all possibles can still come into being.

Eaux fortes / *Etchings*

Water runs like an obsessional theme all through the writings and sketches in Leonardo's notebooks. The artist never tired of observing its movements and effects, whether as agent or object of change. Firmly convinced of the central role of water as motive force in the universe, he believed that, if we could understand its action on earth and in the sky and formulate the laws of the physics of liquids, we would discover some of the fundamental mechanisms of

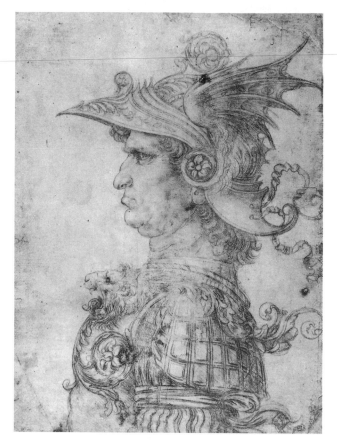

Fig. 7. Leonardo da Vinci, *Bust of a Warrior,* ca. 1472. Metalpoint with white on paper coated with a cream-colored preparation, 285 × 208 mm. Trustees of the British Museum, London.

nature. He studied water in the context of his research in physics and geology, but his engineer's mind was fascinated by its practical dimension: he designed projects for irrigation and drainage, schemes for diverting or channeling rivers to prevent floods. Leonardo dreamed of water on a cosmic scale, drew water with an artist's hand, studied and experimented in hydraulics, traced water in its myriad manifestations, and yet always maintained a unified vision of the phenomenon.

Water is fascinating for its inconsistency. It infiltrates, mixes, clogs, vaporizes. Because it has no form, it can take on all forms. "Just as the mirror bor-

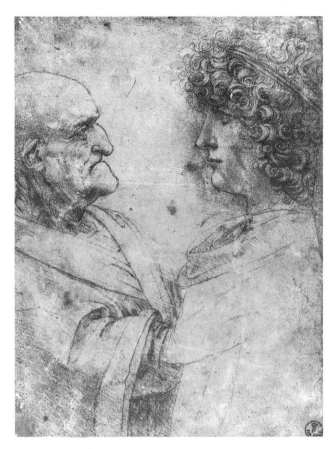

Fig. 8. Leonardo da Vinci, *Profiles of an Old Man and a Youth,* ca. 1495. Red chalk, 208 × 150 mm. Gabinetti Disegni e Stampe degli Uffizi, Florence.

rows the coloration of objects that pass in front of it, having no character of its own water agitates or receives all things, adopting as many different natures as the different places where it passes "[13] Water is a formless, bodiless force; like matter, it is a potential available for multiple uses that adapts to all molds and every imaginable movement.

Leonardo was captivated by the dynamics of water: not only does it take all forms but it gives them. He passionately analyzed the trajectories and actions of liquids and observed seas, rivers, marshes, and cascades to understand the mechanisms of water. With infinite patience he decomposed the shock wave of water as it falls and splashes up; observed its reaction to an obstacle as it

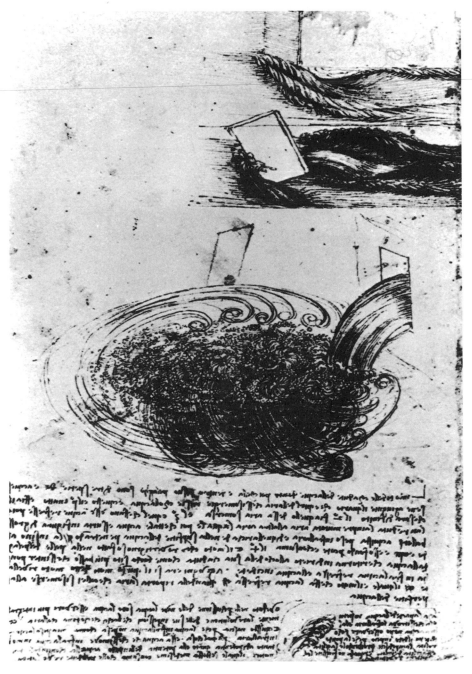

Fig. 9. Leonardo da Vinci, *Studies of Water Passing Obstacles and Falling into a Pool,* ca. 1508–9. Pen and ink over traces of black chalk, 298 × 207 mm. Windsor Leoni Volume (12660v).

spreads, breaks, or dissipates in foam (fig. 9); marveled at seeing it "rise up from the deepest ocean depths to the highest mountain peaks,"[14] as if escaping the laws of gravity. Every possible aspect of hydrodynamics is explored in notes, often illustrated: how water moves in water, on earth, then into the soil and below; how it moves through the air; water in waves, ebb and flow, currents and whirlpools, eddies and bubbles. Gombrich points out a passage "that is simply a list of the incredible number of words that can be used to describe the circulation of water—*risaltazione, circolazione, revoluzione, ravvoltamento, raggiramento, sommergimento, surgimento*—going on to include another sixty-six entries—*veemenzia, furiosità, impetuosità, concorso, declinazione, commistamento.*"[15] The relevance of these distinctions will soon be apparent.

Fascinated by this prodigious expense of energy and its influence on other bodies, Leonardo considered water the most important motive force in the great transformations of terrestrial morphology. In the contours of a landscape, he deciphered the tale of interactions between water and earth over the ages. His geological readings of the relief unfold in a dramatic sequence of excavations, swellings, and redistribution of mass on the surface of the globe. Here, for example, he looks at fossil imprints, the memory of vast convulsions inscribed in rock: "Ancient sea beds have become mountain chains."[16]

Further research on the causes of geological transformations takes Leonardo back to a story that he never tires of narrating and illustrating, expanding and refining.[17] Mountains start to crumble, undermined by rivers that eat away at their flanks and by wind and rain that erode the surface, sweep away the earth, and uproot trees (figs. 10 and 11). The mountain top is sliced off, leveled, laid bare, and gradually caves in. There are landslides and the formation of sediments. Then the action continues in the plain: earth, shrubs, and debris fallen from the slopes choke up the rivers or thicken the mud. Some rivers become marshes; others change course, form lakes, or provoke floods. Other mountains in turn are eaten away, and the cycle continues.

Leonardo had ambivalent feelings about the tremendous power of water. Beneficial, it fecundates the earth and sustains life, and the upheavals it causes can even contribute to the regeneration of matter. However, Leonardo doesn't stop at this optimistic traditional vision; his notes abound in relentless denunciations of the ravages caused by water—natural calamities and human disasters described with vivid exaggeration:

> Of all irremediable destructive catastrophes, floods caused by tumultuous raving rivers should be placed first among dreadful horrifying devastations. In what language, with what words describe the terrible destruction, the un-

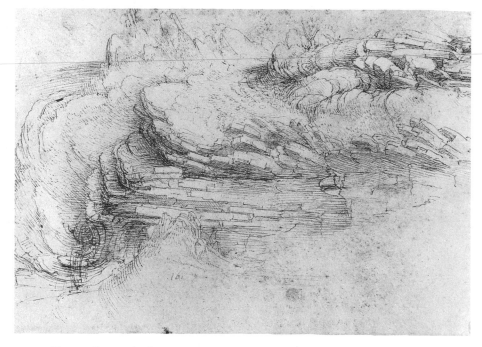

Fig. 10. Leonardo da Vinci, *Horizontal Outcrop of Rock,* ca. 1510–13. Pen and ink over black chalk, 185 × 268 mm. Windsor Leoni Volume (12394).

speakable merciless ravages caused by deluges from devouring rivers that man is powerless to conjure?[18]

Sublime or morbid, such eloquence is rare in the notebooks. What accounts for this pathetic tone in an enterprise where physics and technology predominate?

The contrast is striking but not clashing. Calm observation of water's action and temperate appreciation of its benefits could account for regular cycles, normal variations within a stable system. But Leonardo observed water on the rampage and excitedly described its violence because he was looking for crucial moments, signs of radical mutation. His studies in hydrodynamics are not simply oriented toward practical results and certainly are not disinterested. They confirm his image of the world as a flexible living mass, a molting animal. The wrinkles and bumps traced by water on the surface of the globe are indications of prodigious activity. The macrocosm has its convulsions, and Leonardo avidly tracks down the symptoms.

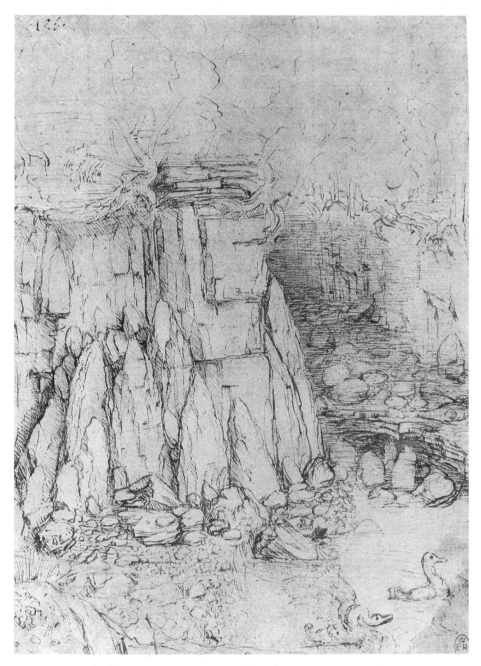

Fig. 11. Leonardo da Vinci, *A River Flowing through a Rocky Ravine with Birds in the Foreground,* ca. 1483. Pen and ink, 220 × 158 mm. Windsor Leoni Volume (12395).

Cataclysms

The research on water is pursued and amplified in another series of notes and drawings on the theme of deluge, cataclysm, tempest. These texts, which are exceptionally coherent from a thematic point of view, compose a serious study project and also serve as advice to fellow artists. The sketches are some of Leonardo's most captivating, and the texts that go with them are also particularly complete, precise, and carefully constructed.[19] Obviously, natural disasters touched a sensitive chord in Leonardo; they inspire some of his most personal work and, when his imagination submerges analysis, some of the most visionary. The tone is the same as before—destructive nature—but here all the elements conspire with water to defigure space and spread terror.

The text entitled "Description of the Deluge" begins with a sober analysis of the causes of the catastrophe: the mountain slopes are gradually laid bare; roots, shrubs, and soil tumble down, obstruct a river, and make it overflow.[20] We have already encountered this sequence. But the tension mounts rapidly. The swollen waters roll over the plain, destroying a city as they go; the waters gush up in a whirlwind, fall back, and pursue their wild course. Waves, mixed with rain, soon fill with air, earth, flotsam and jetsam, wood; it all turns into a "gooey foam," spreading in a thick, opaque mass over the land. The water "turns into a thick fog and mixes with the wind currents like a whirling cloud of smoke or sinuous cloud, then rises into the air and turns into a cloud." Waters of the sea, debris, winds, and mist all mix together in the howling hurricane. The narrator goes on in slow motion as if he doesn't want to miss a single detail, fascinated and horrified by this tremendous catastrophe.

The drawings, executed in the same apocalyptic vein, concentrate more on atmospheric disturbances and the destructive power of wind, from gust to tornado. We see whirlwinds shoot up into the sky, churning clouds that look like they spurt out from the collision of clashing winds. Elsewhere the windblown rain spins into gray spirals, whirling and changing before the eyes (see fig. 5). In a burst of violence, the tempest rips up stones and branches, crushes and grinds objects, raising clouds of dust. A compact mass of wind and water, earth and shapeless debris covers the whole surface of the drawing: heavy and light, solid and liquid, opaque and transparent lose their natural properties and place. Matters are confused, lines are blurred, until no clear composition can be distinguished; the line of the horizon is erased, the eye finds no vanishing point, cannot see where the earth ends and the sky begins.

These drawings are almost abstract images of motion and transformation;

they do not show objects but vapors of particles passing from one place to another, one form to another. The old order is wiped out, the new has not yet appeared. Disintegrated by the tempest, things are only matter in suspension, without shape or identity. They seem to return to chaos or pass through limbo, where new bodies will perhaps emerge.

To complete these apocalyptic tableaux, Leonardo sometimes throws into the heart of the torment men and animals in perdition. Tiny silhouettes of cavaliers scooped up by the wind and water are dimly visible in a corner of the drawing in a magma of jumbled shadows under huge, heavy clouds (fig. 12). The written equivalent of this scene is found in "Divisions," a text for artists that lists the motifs in a deluge scene: the four elements in pandemonium and people swept away by wind and water, barely perceptible in the imagined scene as in the space of the text:

> Gloom, wind, tempest at sea, deluge, flaming forests, rain, celestial lightning, earthquake, landslide, razed cities.
> Whirlwinds swooping water, branches, and people up into the air.
> Tree limbs with people hanging onto them ripped off by the wind and carried away with the wind.
> Broken branches with people clinging to them.
> Ships broken into pieces pounding against the reefs.
> Hail, lightning, whirlwinds.
> Herds.
> People trying to hang on to trees, losing their grip. Trees and rocks, towers, hills covered with people, boats, tables, troughs, anything that can float. Hills covered with men, women, and animals. And everything is lit up by lightning bolts from the clouds.[21]

Overwhelmed, humiliated, deprived of all dominion, the master of nature becomes the victim. This disproportion is constitutive of the theme. In his recommendations on "how to show the tempest,"[22] Leonardo advises the artist to show men lost in the midst of the turbulent elements, "lying on the ground, rolled up in their clothes, covered with dust, almost unrecognizable."

Descriptions of tempests, especially storms at sea, had been prevalent in the literary tradition ever since the shipwrecks of Ulysses and Aeneus; they took on new interest in the Renaissance with accounts of voyages of exploration. "Believe me, we thought we were in ancient Chaos, with fire, air, sea, earth, all the elements in insubordinate confusion," says the narrator of Rabelais's *Fourth Book,* describing a hurricane that terrified Panurge.[23] The tempest undoes what creation had done; nature regresses from cosmos to chaos, from sep-

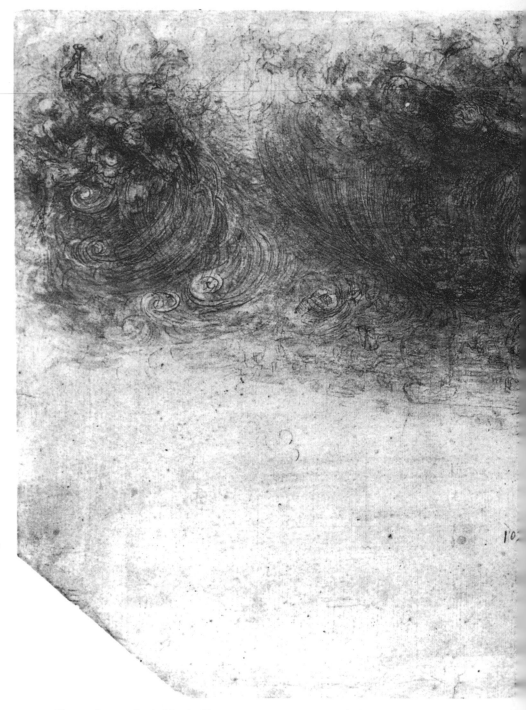

Fig. 12. Leonardo da Vinci, *Hurricane over Horsemen and Trees,* ca. 1518. Pen and ink over black chalk with touches of wash and traces of white on gray-washed paper, 270 × 410 mm. Windsor Leoni Volume (12376).

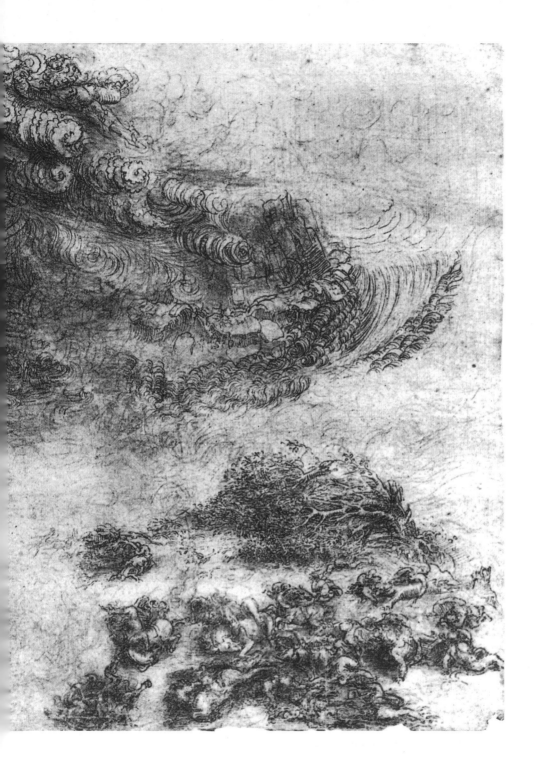

arated elements to a lump of compact matter, revealing a wild, archaic world churning with malevolent forces. Torment is fascinating because it is not made to man's measure; it symbolizes a hostile, irreducible universe completely foreign to the humanist ideal. It confronts man with the incommensurable, contests his supremacy, and defies his powers.

A duel between the engineer and adverse nature, or the artist and confusion, can be seen as the fundamental motif in the works by Leonardo that interest us here. The same question underlies accounts of tempest in Rabelais or Shakespeare: Who is stronger, man or the sea? Panurge is dumbstruck and multiplies external anarchy with the internal cataclysm of his passions; Pantagruel resists by virtue of his faith and courage and triumphs over chaos. Prospero orders the tempest with his magical skills; King Lear recognizes his impotence. Does man stand at the center of creation, model and master, or will he be annihilated by reconquering elementary nature?

In another text, "Deluge and Its Illustration in Painting,"[24] Leonardo exploits the same tragic material but goes far beyond the limits of technical observations and memorandum; in two highly eloquent pages, he recounts the debacle of an entire population, as if he were moved by a sadistic need to go over and over all possible images and horrors of dread catastrophe. The scene opens on the same décor as before, describing people and animals huddled in refuge on the mountain peaks. Then the artist turns to share his emotions with an interlocutor: "You could also see groups of armed men trying to defend their meager shelter against lions, wolves and other beasts of prey who come looking for safety." Other victims try to save themselves on makeshift rafts: "Men, women, and children together, moaning and wailing, terrified by the fury of the winds. Winds of tempest that make the waves roll and tumble with the dead and drowned." Then psychological observation takes over, with an analysis of the signs of terror and despair. The artist will show people covering their ears, closing their eyes, trying not to see "the cruel torture dealt to the human species by the wrath of God. . . . Others with desperate movements took their lives. . . . Some took their own children and threw them violently to the ground. . . . Another clasped her hands and biting bloodily devoured her fingers." The drift of the text is startling: As if intoxicated by his invented images of suffering, Leonardo accumulates scenes of horror until he forgets the limits of pictorial representation and slips from description to pure narration. At the beginning, verbs in the future and future perfect tense (*vedeasi, vedevasi*) and in the present or past conditional (*aresti potuto vedere, aresti veduti*) evoke the vision as a possibility. But the verbs progressively move to the

narrative present, then to the imperfect: they start telling a story in which the characters acted, had feelings, shouted and screamed. As if the spasms of the globe were not enough for him, Leonardo constructs a fiction and then, he himself showing the signs of terror, fully exploits the resources of pathos.

This technique of portraying the worst and fully exploiting the emotional charge by slipping from a visual to a narrative mode is confirmed in another group of texts, enigmatic letters about calamities—probably imaginary—that occurred in the Orient.[25] The use of the first person raises the emotion to a higher degree of intensity: I am writing to you from Armenia, says Leonardo (in fact a fictive narrator) to tell you, from the depths of the abyss, the disaster that has befallen us. The series opens with the description of a wild country, with particular emphasis on the Taurus, highest and most terrifying mountain chain in the world. It is in this setting that "we were assailed by the fury and violence of the winds, followed by avalanches on the steep snow-covered peaks." A flood has submerged the city, the recital continues, and a fire "that is still raging" is destroying the land. "The few remaining survivors are in such a state of fright and terror that we hardly dare to speak to each other, as if struck dumb; renouncing all aid, we hide in the ruins of a church, men and women, young and old, huddled together like goats."[26] The narrator, pretending he was caught in the catastrophe, piles up the realistic effects and precipitates his reader right into the midst of the disaster.

Three other epistolary texts in the same oriental cycle carry the horrifying fantasies of destruction even further. This time chaos is caused by a monster: a black, repugnant, terrifying giant who storms out of the Libyan desert. The people try to defend themselves, but he flings them up into the air, crushes them, massacres them. Sparing no details of panic and slaughter, the narrator reaches the absolute in delirium when he notes at the end of a letter that his voice is coming from deep inside the body of the giant who has swallowed him.

These two macabre fables should probably be read as political or moral allegories.[27] Whatever the author's intention and exact meaning, they stand as variations on the theme of the end of the world. The choice of site—Armenia and the Caucasus—might indicate a reference to the biblical deluge, suggesting that these texts and perhaps the whole collection of drawings and descriptions of cataclysm are a replay of the biblical drama. A reign of violence and radical alterations of the earth's surface plunge the world into a disorder similar to the original chaos. Except that this time there is no Noah's ark; there is nothing but dread, terror, and despair at the harrowing spectacle of the universe crashing into ruin.

We can measure the broad span of Leonardo's images of change, from mutation as élan vital to upheaval as mortal convulsion, from regenerating nature to murderous nature, from transformism to catastrophism. What remains at either extreme is the image of a malleable or precarious world and dizzying instability.

Mobile Cartography

Giordano Bruno imagined worlds that multiply and transform. Leonardo watched the earth's crust trembling. Others observed the surface of the globe and thought they saw shifting frontiers, countries appearing or changing place. The conception of nature as an animate being is related not only to cosmology and geology, but also geography, leading to strange mutations in the shape and disposition of lands on the map.

"It seems that there are movements, some natural others feverish, in these huge bodies as in ours" (1.31.204). Montaigne is referring here to islands and continents, perceived as living, animate organisms capable of transformation. The microcosm-macrocosm analogy, with its charge of animism, has repercussions even in the *Essays,* though the work is so critical on other questions. The earth has its illnesses and mutations; it changes with age. Reviving the cliché of nature as a mother that has just given birth, Montaigne says that America "Was a child world . . . living on what its nursing mother provided" (3.6.908–9). The force of life and renewal contained in the heart of things is so intense that Montaigne and his contemporaries discover signs of it even among the hardest, most inert objects. "The world is but a perennial swing and sway. Everything in it is forever swaying: the earth, the rocks of the Caucasus, the pyramids of Egypt" (3.2.804).

What should we make of these examples? Does Montaigne employ rhetorical affectation and suggest figures of the impossible? While we must allow for a bit of paradox, we should recognize here the expression of transformist thought that encompasses the whole of reality. Montaigne was so acutely sensitive to every kind of motion and mutation that he even distinguished traces in territories considered to be totally stable. The same intuition guided his reading of the myth of Atlantis. Long, long ago an immense continent was swallowed up by the deluge, and the consequences of the disaster can be still seen in the fractures of our world: "It is most likely that these extreme ravages of water provoked strange changes in the earth's habitations" (1.31.203), separating Sicily from Italy, Cyprus from Syria, Eubea from Beotia, and other

lands were joined together by the tidal wave that filled up the sea between them. Montaigne saw the globe as a flexible mass that dilates and transforms. Our illusion of immobility is based on an error of perspective, an impression engendered by ignorance: "If we could see as much again of the world as we do not see, we would discover, as it would seem, perpetual multiplication and transformation of forms" (3.6.908).

In fact, we don't have to go back over the centuries or look at things from the point of view of Sirius to see the earth's morphology changing. During his lifetime Montaigne watched from his doorstep as the Dordogne River took over territory and gobbled up houses "with extraordinary agitation" (1.31.204). A bit further away, "in Medoc, my brother, Sieur d'Arsac, saw his lands buried under the sands and vomited up by the sea" (1.31.204). Today our property; tomorrow a beach; the day after tomorrow, ocean. Montaigne joins in the grandiose kinetic vision attributed to Pythagoras by Ovid at the end of *Metamorphoses* (see chap. 2), adapting it in his typical style; reducing the sublime and doing without cosmogony, he keeps his observations on the level of everyday life. Judging by the examples he chose—islands in antiquity, river, ocean—he shared Leonardo's recognition of water as agent of great geographical mutations. But the difference is significant: Leonardo's *Deluge* series is rife with impressions of catastrophe, while Montaigne calmly senses the earth slipping out from under his feet and is not alarmed. He doesn't share Leonardo's dread or Bruno's enthusiasm but, like many other Renaissance thinkers, serenely takes note of change. My river sometimes overflows to the left, sometimes to the right; the motion is not regular or predictable but neither is it anarchic; it is part of the normal respiration of the universe because nature is benevolent and keeps the vital potential intact. "All that sways does not fall" (3.9.960).

To underline the extent of our ignorance, Montaigne portrays "an image of the world that flows while we stand on it" (3.6.908). The construction of the sentence is ambiguous: Is it the *image* or the *world* that flows? Is it the earth itself that changes, or our representation of it? All the more difficult to say when we know that change, for Montaigne, affects the object as much as the subject of knowledge; the way we look at the world is just as labile and unstable as the world itself: "And we and our judgment and all mortal things are endlessly flowing and rolling. So nothing certain can be established from one to the other, and judge and judged are in continuous mutation and sway" (2.12.601).

This principle, which sums up Montaigne's skepticism, casts new light on the question. The earth transforms, but our discourse simultaneously transforms, and the two are not necessarily correlated because science can postulate

all sorts of fantasies. Two movements, one no less complex than the other, compound in a vertiginous whirlwind. Montaigne has as much pleasure pointing out signs of change in the depths of reality as multiple contradictions and flux in opinions in cosmology, geography, or other fields of knowledge. In *Apology for Raymond Sebond,* he establishes an ironic catalogue of theories and beliefs upheld over the ages, sooner or later contested, transformed, and forgotten, to show that reasoning about things, like the things themselves, is in constant motion. The ancients "established the boundaries of our world" (2.12.571), and their abusive authority stood as proof for more than a thousand years. Along comes America and their edifice collapses. So if yesterday's certainties are disqualified today, how can we not see that today's truth will be overturned tomorrow?

> Geographers of those days didn't miss assuring that henceforth everything was found. . . . It remains to be known if Ptolemy was wrong at that time in the foundations of his reasoning, if I wouldn't be stupid now to trust what they said about it; and if it's not more likely that this vast body that we call the world is something very different from what we think (2.12.572).

Our knowledge is always a step behind reality, and the discovery of the New World is not only a symptom of our ignorance but also a stage in an endless process of broadening knowledge.

So the only reasonable science is one that refuses rigid systems in favor of a flexible discourse. Within Montaigne's skeptical perspective the structure of the encyclopedia is just as mobile as the subjects it treats. It takes a step forward here, a step backward there, haphazardly groping along an uncertain path. The history of intellectual constructions as sketched out in the *Apology* is a succession of refutations, shifts, and crises. The path is erratic but testifies in its way to the fertility of nature, which produces not only a variety of things but also a variety of ideas that can endlessly take new turns. The *Essays* are a repertory of changing images that can be read as the book of mental metamorphoses.

Whether transformations intervene in the world or in our knowledge of the world, the geographical facts have to be constantly revised. Montaigne, as he often did, radicalized an idea that was widespread in the sixteenth century. A comparison of maps dating from 1480 to 1600 is enough to measure the scope and rapidity of change, and the more distant the countries the more varied the boundaries. New lands appear, outlines are modified, proportions are revised, and distances are corrected. The curve of North America, for example, appears

extremely flexible; sometimes it's joined to Asia, sometimes it's an island; the passage from the Atlantic to the Pacific does or doesn't exist; the continent stretches, shrinks, and widens (figs. 13 to 15). Looking over a collection of maps is like watching an animated cartoon. Outlines fluctuate from one version to the other, testifying to the earth's instability in the minds of the observers. Of course, human knowledge changes, but the object that changes on paper is the world itself. A skeptical Montaigne doubts that we will ever arrive at a stabilized representation of the globe, while professional geographers postulate progress and an end point to research. But they all agree that the forms of the earth are uncertain and its image malleable.

A good example of this mobility is recurrent conjecture during the Renaissance about the Southern Hemisphere.[28] Vasco da Gama's voyage to India and Magellan's trip around the world stimulated geographers' interest in the hypothetical existence—already posited in antiquity—of a vast territory in the southern part of the globe. Vague suppositions about islands like Australia, New Zealand, New Guinea, and Java, actually visited or extrapolated from rumors, were added to established realities—Terra del Fuego and the Cape of Good Hope. Since information about these regions was scarce, there was a tendency to put together in one big continent around the Antarctic all the lands stretching into the Atlantic and Pacific on either side of the Magellan Straits. From about 1515 until the middle of the seventeenth century, there were spectacular differences in the size and cartography of this continent in the Southern Hemisphere (figs. 16 and 17).

Several factors encouraged speculation. The ancients had taught that the earth was divided into five zones, three of which were uninhabitable: a torrid zone between the two tropics—that was too hot—and two zones, the Arctic and Antarctic, that were too cold. But explorers soon discovered that the equatorial region was inhabited. From then on there was great temptation to declare that the polar zones were also habitable and to focus new reseach in that direction. Another line of reasoning was based on the idea of balance: the old world—Asia, Europe, Africa—being essentially located in the northern hemisphere, plus America, increasing the disproportion, it seemed logical to postulate a counterweight in the south, which argues for the austral continent.

Over the centuries, credit was given to an idea that the land mass was divided into three equal parts: the Old World, the New World, and Antarctica, the latter remaining to be discovered and exploited. Which is exactly the point of *Les Trois Mondes* (1582), by Henri Lancelot de La Popelinière, a beautiful example of expansive vision and metamorphic geography.

Fig. 13. Joachim von Watt, map of the world, 1534 (detail).

Fig. 14. Map of America, in *Ptolemaeus* (Basel, 1540).

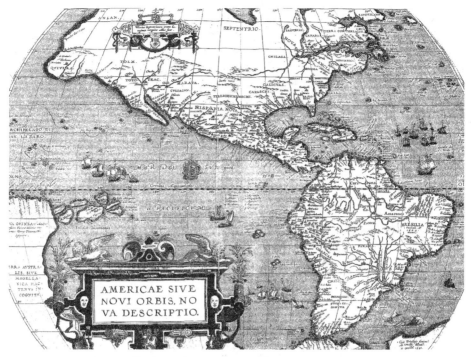

Fig. 15. Abraham Ortesius, map of America, 1584.

The only map in the book shows the four known continents, approximately in their present proportions and arrangement and, to the south of the Antarctic Circle, the *Terra Australis nondum cognita,* with the same surface as each of the other two worlds, old and new. The message is clear: The globe is much bigger than we think, "there is much more left to discover . . . than our moderns have shown."[29] The map promises as much unknown as known territory, but the text has more to say about past voyages than future explorations. Until suddenly, in a few short pages vibrating with impatience at the end of book, an incitation to discovery, expressed in the exhortative mood, functions as the work's telos: "We know nothing at all about this country so big and beautiful that could not have less wealth nor other curiosities than the Old and New Worlds: and all because of our laziness."[30] Having stigmatized the learned men, notably the "Roman Stoicists," who by indolence or resignation had left the efforts of research to posterity, La Popelinière invites his contemporaries to do everything possible to prospect the third world and increase

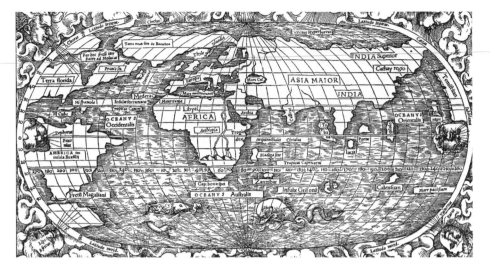

Fig. 16. Map of the world, in *Ptolemaeus* (Basel, 1540), showing no sign of the austral continent.

the space of known lands. Motivated as much by political as scientific ambitions, he reminds his countrymen that this is a chance for France to catch up in the colonization race and recuperate in the Southern Hemisphere the supremacy conceded to the Spanish and Portuguese in other regions. The imagination of a dilating world coincides with dreams of colonial expansion.

Uncertainty about the Antarctic leaves an opening for numerous hypotheses and justifies considerable differences in the way it is represented on world maps: from total absence of the slightest trace to presentation of a vast territory, with various intermediate degrees and contours. The ill-defined, elastic mass spread out around the pole changes appearance from one map to the other. Three stages of the Mercator map, as presented by A. Rainaud, illustrate this.[31] The 1538 version traces a limited surface with arbitrary shape and dimensions, as indicated by a note: *Terras hic esse certum est, sed quantas quibusque limitibus finitas incertum.* Three years later the southern continent has expanded and, explains Mercator, occupies one-fifth of the globe, if not more. In 1569 it has become one among three worlds, with the same surface as the other two, the old and the new. To attain this dimension, Mercator draws a vast, vaguely defined territory that extends from New Guinea in the west to Java in the east, but goes off the edge of the map to the left, right, and below.

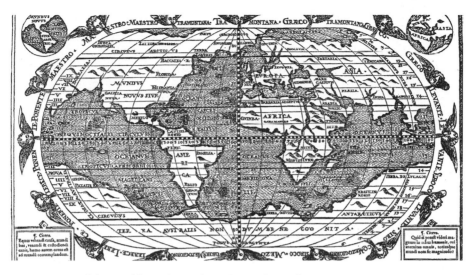

Fig. 17. Map of the world, in *Opusculum Geographicum* by Joannes Myritius (Ingolstadt, 1590). From the first third of the sixteenth century, the austral continent appears on some maps and globes, mainly Portuguese; by the 1550s it is a regular feature and increases in area.

"This leaves the representation of the third world, about which you will know nothing more than to know nothing at all," writes La Popelinière.[32] All cartographers are faced with the same challenge: represent the unknown. The author of one atlas faces the problem squarely, admitting that, as far as the austral lands are concerned: "What I marked and depicted is only from imagination," which however didn't keep him from "marking and naming some promontories or capes while waiting for fuller knowledge."[33] Whether they were drawing unexplored lands, fixing their positions, or naming the parts, the cosmographers constructed fictions. They elaborated possible models and, for lack of greater precision, pictured the world not as it is but as it could be.[34] Though they were motivated by practical aims, subordinate to political and economic ends, they behaved like poets, who create verisimilitude to free themselves from the constraints of reality, and opened a space for their imagination and, simultaneously, for variations in the represented object. The world as conceived in their cartographic fictions is an unfinished world captured in the course of gestation, as unstable and flexible as the world of Leonardo's cataclysmic visions. The cartographers envisaged a mysterious, faraway continent

that seemed to dilate; the artist thought he saw the earth's relief changing before his eyes. In the seventeenth century the beginnings of modern science would define the laws and limits of movement according to the principles of mathematical physics. For the Renaissance, an intuitive magical perception of the world still prevailed, leaving room for rich dreams of metamorphosis.

Primeval Movement

4 ∎ *Chaos*

The Potential of Indeterminacy

Were Leonardo da Vinci's visions of dreadful cataclysms an imagination of the end of the world? Perhaps not. Of course, nothing would be the same after the tempest; the form, consistency, and position of everything would be changed. Yes, things would be modified. But they wouldn't disappear. The end point of crisis was neither a final catastrophe nor progress but a return to origins, a new beginning. The destruction of forms and the mixture of matters restore the conditions of primitive chaos, which the ancients defined as the confused mass of the four elements, the cradle from which the world would come forth. When nature in upheaval regresses to the primordial stage, it is preparing for rebirth.

The conception of natural disaster as a stage in the regeneration of matter was all the more credible to the Renaissance mind, still widely influenced by the Greek theory of a cyclic history of the universe. Leone Ebreo, integrating and ratifying Plato's thesis, taught that the sublunar world is renewed every seven thousand years.[1] After an initial stage of germination and production that lasts six thousand years, matter is corrupted; it dissolves and returns to its primitive state for a thousand-year period of rest and regeneration before starting on a new cycle. Beyond these revolutions in the lower world, another, longer cycle of seven times seven thousand years of activity, followed by a thousand years of latency, measures the ongoing existence of the entire universe, the heavens and all that is in them. Each temporary interval when mat-

ter returns to chaos is a period of reanimation of the germinative forces that give life a new beginning.

First start or fresh start, chaos is the space-time where nothing exists but everything can emerge. We will see here and in the next chapter the fascination exerted on sixteenth-century artists by this crepuscular universe. As we saw in the works of Leonardo, vast, vague chaos is awesome because it is utterly beyond human proportions. But it is also the wellspring of life's promise, the negative that bears seeds of the positive. Chaos is fundamentally ambivalent: absolutely terrifying yet bearing all hopes. To adapt to the infinity of possible "formations," wrote Louis Le Roy, chaos has to be "formless and naturally deprived of all the forms that it must receive."[2] Chaos, perfect manifestation of nonbeing by its total absence of qualities, is also the assurance of new, unencumbered beginning. Placed by most cosmogonies at the origin, chaos figures also in periods when humanity needs to be regenerated (biblical deluge, myth of Deucalion and Pyrrha, Platonic cycles, etc.) because the indifferentiation it symbolizes is a state of expectation and represents, as such, the inaugural moment par excellence.

Indetermination is the choice springboard of artistic revery and imagination because it is the necessary passage for determination, the vacant site where new forms take shape. At this stage things do not yet exist, their shape is not fixed, their genesis is still a pure project. Kneading formless matter does not necessarily mean subjecting it to finality or precise models, but letting the fingers of thought freely explore the available resources, trying out possible creations. This vagueness, which paralyzes the geometric spirit, stimulates the creative imagination. Reveries on chaos have a magical appeal because they place the subject on the limits between being and nothingness, at the point where the virtual is offered without restriction, rich with all that could be, there where we lay the foundations for creation and explore the fields of the possible without trying to fashion permanent objects.[3] Proteus, the formless monster who takes all shapes, was interpreted in Renaissance thought as emblem of raw material, capable of all incarnations.[4]

Proteus, "omniform"[5] matter or chaos appealed to sixteenth-century thinkers not only as an open metamorphic series but also as potential, rich in energy reserves, representing impetus, the promise of movement. The chaotic holds the charm of the inchoate.

Leone Ebreo, representative of the Platonic tradition, made an extensive argument for the dignity of chaos: everlasting, like God, it is anterior to the

world, which is itself cyclic and transitory. The story of the cosmos is played out between two actors: chaos, identified with matter, and God, who is form, the model that configures all things. The world is born of this original couple: "And from God and Chaos the World is formed, and each of its parts formed, and such divine formality takes the place of the father, and chaos the place of mother."[6] Elsewhere, Leone Ebreo invokes Plato to advance a slightly different version, according to which God, first and alone, created those who begat the world: "The intellect is pure act and form, Chaos is pure potential capacity and matter without form; the first is universal father of all things, and the second common mother of all."[7]

In both versions, matter is mother and matrix—*mater, materia, matrix*—as confirmed by etymology. Though chaos is passive and receptive, able to receive all sorts of imprints, it is not inert; it fructifies the seed and accomplishes the ideas of its partner, form. Ebreo uses abundant metaphors of parturition to describe chaos: germination, generation, childbirth, engendering, pregnancy. Because chaos aspires to produce life, it acts as a desiring force: it covets form or, rather, all possible forms, all of which it wants to actualize, "none of these forms being enough to bring contentment and satisfaction to its insatiable love and appetite." Moved by such intense desire, matter is more like an adulterous woman than a mother; some "have even called it Whore." This explains the infinite diversity of the world, constantly renewed by the creative instinct of chaos. But we will especially keep in mind that this frenetic sexuality carries things into an endless series of metamorphoses: "Hungering each of the said parts [of matter] to enjoy all and every form, they must continuously change from form to form."[8] The insatiable love of matter for form determines the basic instability and mutability of the world.

At the beginning of *Microcosme*, a long, learned poem on man and knowledge, Maurice Scève evokes God before creation:

> Mass of deity in itself amassed,
> Without place, without space in limits encompassed
>
>
>
> Essence self-fulfilled, in itself alone contented
> Not acting, impassable, immutable, invisible (11–19)

In the beginning the divine power reigns solitary and self-sufficient, unique and concentrated in itself, the primitive seed still undivided, wellspring of energy at rest, awaiting action. This virtual center already contains, latent, all the creations to come, the archetypes of the real:

> . . . knowing all things,
> Like all of itself, by itself, in itself enclosed. (9–10)

Cosmogonies generally make a distinction between God and matter: God as in the Bible, who precedes the matter he creates or, according to Leone Ebreo, imprints on matter the forms from which the world is born. In Scève's originary monad, on the contrary, God and all the latent forces of the creation are concentrated; nothing exists, yet it is all there, enclosed in the immensity of the central point.

Then comes the moment when pure possibility is going to be realized:

> But so pregnant was of his triple unity,
> That, when He wished, suddenly by His divinity
> His great Chaos unfolded in light visible
> To show what was his primal power (23–26)

The compact mass unfolds in rays of light, passes from immobility to movement, from concentration to expansion, and soon from unity to multiplicity. We will note that Scève found no better symbol than chaos to represent potential at the instant of blossoming. Chaos opens like a womb giving birth, and the whole of creation comes pouring out. The poem itself dilates under the impetus of the opening lines, telling how the original models were gradually realized. After the envelopment of chaos comes development, the propagation of unity that diffuses into the plurality of things. God accomplishes in Adam an idea he had meditated all through eternity; from Adam comes Eve and from their couple comes mankind and, still following the same process of dilation, from mankind will come knowledge, inventions, creations. The microcosm, theme and title of the poem, receives potential from God and actualizes it. From the first movement—chaos opening—by a series of relays, the totality of human activities are derived.[9]

We will recall that Du Bartas, contrary to Scève, clearly distinguished God and matter from the beginning (see chap. 1, this volume, under "Fixed and Mobile"); as opposed to Leone Ebreo, Du Bartas emphasized that matter, being created, came second. A good Protestant doesn't succumb to the heresy of confusing God and chaos. But the notion of the formless mass is there: the "first world" (1.223) was

> Chaotic Chaos, a lumpy lump:
> Where all the elements were bundled in a jumble (1.248, 251)

and the description of the initial confusion extends over a hundred lines. Because it is not primordial, chaos could have been left out. In fact, thrown out

the door, it comes back through the window and occupies a long transitory phase between the primeval nothing and the accomplished world. Du Bartas made an interesting compromise: While accepting the principle of *ex nihilo* creation in opposition to the classical cosmologies, he borrowed their concept of chaos, which is almost totally absent in the Bible.[10] In his commentary on *La Sepmaine,* Simon Goulart explains: "Chaos is understood as the original matter that God created out of nothing and after gave form, drawing from it the works he made in six days."[11] The interval that Goulart leaves unexplained ("created . . . and after . . . gave it") is precisely the place where Du Bartas pauses to contemplate the vegetating magma.

The space occupied by chaos in the text seems inversely proportional to its ontological status. It is presented as pure negativity: "All was without beauty, without order, without flame" (1.269). Du Bartas says it is possible to speak of these tangled, imperfect elements, "Not as they were, but as they were not yet" (1.284). The reign of opaque matter—chaos as antithesis to cosmos—is a vague, nameless space that inspires a sort of sacred horror:

> Tangible blackness of Memphitic shadows,
> Dreary thick airs of Cimmeric fogs,
> Rude vapors of the infernal manor (1.301–3)

This image of an abyss of inert substance is based on the description of chaos at the beginning of *Metamorphoses.* Ovid had already accumulated negations to evoke the "rough, unordered mass of things" (7); he presented primitive matter as a knot of discordant forces, doomed to disorder and war, characterized by the absence of all positive attributes. *"Nulli sua forma manebat"* (17): *forma,* this "quality that nothing conserves," means both form and beauty. According to Ovid, and later Du Bartas, the primordial is perceptible only by default, like a bottomless pit plunged in expectation of the demiurge that will give it order and shape.

The fact remains that this nothingness stands on the threshold of *Metamorphoses* and takes up several pages in the "First Day" of *La Sepmaine.* Such is the attraction of indeterminacy: It is the ultimate negative, which makes it the occasion of creation. The imagination is absorbed in contemplation of nothingness because there it senses unlimited fecundity, still totally available. "God conserved this mass as seed of all things," explains Simon Goulart,[12] probably to justify the lengthy variations on the theme of chaos in Du Bartas. As for Scève, the indistinct lump reconciles the opposites within itself and, "fertile body," embraces virtually the totality of things to come:

> That long width, that deep height,
> That finite infinity, that great world without world
>
> Was the fertile body from which celestial essence
> And the four elements would be born. (2.47–52)

Metaphoric variations on the themes of conception, germination, and parturition (see chap. 1 under "Shaping the Clay"), as in the works of Leone Ebreo, are abundant in the semantic wake of chaos. The revery inspired by indeterminate matter corresponds with meditation on the mystery of birth. A series of transformations lead from nothing to an amorphous seed, then from the formless to form, and from initial creation to multiple offspring. Once the creative impulse is set in motion, it doesn't stop propagating: Man the craftsman takes over from God the creator; the living produce more life. Of course, chaos is the opposite of all that, but it is also its cradle. This will help us understand the fascination exerted on the sixteenth-century mind by the inaugural churning: It is the moment of all possibles and the beginning of the metamorphoses that carry the world forward.

Menocchio, a miller from Frioul, was sentenced by the Inquisition in 1600 (the same year as Giordano Bruno) to burn at the stake for believing that chaos is at the origin of life. Carlo Ginzburg's study of this simple man's beliefs, most likely perpetuating old peasant traditions, shows to what extent ideas about creation were inseparable from the image of chaos, in both popular and learned culture.[13] Menocchio unwittingly adhered to a materialistic cosmogony closer to Ovid than Genesis. Confusedly defending the idea that the mass of matter is anterior to everything, he was easy prey for his judges. Far from admitting that God created out of nothing, he simply dispensed with creation, believing that everything, including the divinity, is derived from chaos. In the beginning there was a sort of elastic matrix,[14] from which the first beings emerged. Here's how the miller explained it to the court:

> I said that, according to what I thought and believed, everything was a chaos . . . and this volume gradually made a mass, like cheese in milk, and worms appeared and turned into angels, and his most holy majesty wanted them to be God and the angels. God was there, among these angels, he too was created of this mass at the same time. (53)

The peasant Menocchio used a homely comparison—the birth of worms in molding cheese—to explain his conception of genesis by spontaneous generation. Not only does the living proceed from the inanimate without divine intervention, but God himself seems to be a pure product of nature. As for the

precise relationship between God and chaos, which particularly interested the inquisitor, Menocchio was rather vague. Were they contemporary? Did matter come first? In any case they seem interdependent: "They . . . were never separated. . . . I mean neither chaos without God, nor God without chaos" (54).

In his analysis of Menocchio's depositions, Carlo Ginzburg is particularly attentive to the curious, makeshift combination of popular representations with vestiges of erudite culture. Bookish concepts and terminology were grafted onto a basis of half-pagan oral mythologies, giving the miller's world view a superficial appearance of learned theory without profoundly influencing it. The distribution of knowledge in printed form and public debates on theological questions conferred increased authority and immediacy on the beliefs of illiterate people. But from another point of view, we could say that this crossing of cultures brings to light the common ground between learned cosmogonies and popular superstitions, particularly the materialistic, pantheist, and transformist tendencies. Erudite knowledge did infiltrate popular beliefs in social classes formerly excluded from scholarship, and a reciprocal influence can also be demonstrated. There is good reason to believe that the persistence of theories such as continuous creation, spontaneous generation, and animism in learned philosophy was sustained in varying degrees by the substrate of unwritten traditions and rural religions. Speculations on chaos stand precisely on this common ground.

War and Peace

Chaos was also an immediate element of everyday life in France during this period of bitter civil war. People described the anarchical situation as "the chaos of our troubles" and the "pell mell chaos of all affairs."[15] Religious conflicts that emerged in the 1560s led to steady deterioration of the political and social climate, culminating in a major crisis under the reign of Henri III that affected all aspects of life. In those tumultuous times of guerrilla warfare and terrorist attacks, violence overflowed from the battlefields into cities, palaces, and cottages. It was the law of might makes right, when feudal rivalries compounded religious struggles and different Catholic factions tore each other apart, moderates against league members, Gallicists against Vaticanists. The legitimacy of the monarchy was contested, and the state was threatened by dissention. In the 1580s observers reported "a feeling of approaching collapse; a political, social, and moral apocalypse."[16] The extent of distress can be measured in texts such as De Thou's *Mémoires* or L'Estoile's *Journaux*.

The situation was all the more ominous in that the "wormy, warty body" of France, as Montaigne described it,[17] was suffering from an illness that seemed to reflect a problem of cosmic proportions. Analogous thinking established a connection between the health of society and the universe; either the corruption of humanity was projected into nature and disturbed its harmony or altered nature contaminated the course of history. Whichever, it seemed like the cosmos had gone wild. That's the meaning of the word *morocosmie* coined by Joseph Du Chesne and used as the title of a collection of poems about those calamitous times (1583). The prophets of doom recognized dangerous presages and signs of natural disorder in the proliferation of unlikely phenomena—monstrous births, meteors, epidemics. Similar phenomena could be observed in all directions, on all scales; whichever way one turned, the world seemed to be rushing headlong toward catastrophe.

This chaos had all the appearances of a fatal illness. However, some poets took a different position, in spite of the prevailing anguish, or perhaps because of it. It is interesting to see how they attempted to exorcise the current troubles, working from the classical myth of primitive confusion and the symbolic values pointed out here.

The analogy between war and chaos is a commonplace that goes back to Greek and Latin cosmogonies. According to Ovid, total disorder prevailed in the heart of the original magma: "within one body cold things strove with hot, and moist with dry, soft things with hard, things having weight with weightless things."[18] The elements were still mixed together, coexisting in discord: Water trespassed on land, land invaded the air. The world in its beginnings is seen without a trace of primitivist nostalgia as foreign to all laws and distinctions, prey to anarchy. Du Bellay takes up the traditional tableau in a sonnet alluding to the conflict between Henri II and Holy Roman Emperor Charles V:

> *Dedans le ventre obscur, ou jadis fut encloz*
> *Tout cela qui depuis a remply ce grand vuyde,*
> *L'air, la terre, et le feu, et l'element liquide,*
> *Et tout cela qu'Atlas soustient dessus son doz,*
>
> *Les semences du Tout estoient encor' en gros,*
> *Le chault avec le sec, le froid avec l'humide,*
> *Et l'accord, qui depuis leur imposa la bride,*
> *N'avoit encor' ouvert la porte du Chaos:*
>
> *Car la guerre en avoit la serrure brouillee,*
> *Et la clef en estoit par l'aage si rouillee,*
> *Qu'en vain, pour en sortir, combatoit ce grand corps.*

> Within the dark womb where long ago was enclosed
> All that since then fills the great void,
> Air, earth, fire and the liquid element,
> And all that Atlas holds on his strong back,
> The seed of All was still whole,
> Warm with dry, cold with wet,
> And the accord that since has bridled them,
> Had not yet opened the door of Chaos:
> Because war had spoiled the lock,
> And the key was rusted with the ages,
> So in vain this great body struggled to come out.[19]

The seeds of the world, jumbled together and captive in the obscure mass, make war against each other. But the poet suggests that the cure lies in the illness. The metaphor of the womb filled with seed introduces the perspective of birth into this archaic scene. Verbs *ouvrir* and *sortir,* adverbs *jadis, depuis, encore* announce that the enclosure will be broken and forces long doomed to sterile combat will be liberated. As in the work of Scève, chaos is a matrix ready to give birth. In an analogous context Ronsard evokes the gesture that will open "the huge womb of the great Whole, to give birth to the obscure burden of its charge."[20]

Once again the inert mass reveals its ambivalent nature as a site of conflict and crucible of life. The agents of transformation that convert chaos to cosmos, varying with different myths, are all more or less clearly defined hypostases of the divinity: Plato invokes the demiurge, Ovid vaguely points to "God—or kindlier Nature,"[21] others speak of the Soul of the world. Ronsard, commenting on current events or describing his own moods, often used these metaphors of chaos but looked to another tradition to identify the force capable of operating the transmutation:

> *Avant qu'Amour, du Chaos otieux*
> *Ouvrist le sein, qui couvoit la lumiere,*
> *Avec la terre, avec l'onde premiere,*
> *Sans art, sans forme, estoyent brouillez les cieulx.*

> Before Love, of lazing Chaos
> Opened the breast, where light brooded,
> With the earth, with the first wave,
> Artless, formless, were mixed up the heavens.[22]

Hesiod in his *Theogony,* Plato, and many others after them had celebrated Love as the most ancient, most powerful of all divinities.[23] Eros coexisted with

chaos from the beginning but acted as an independent force, imprinting desire for form on elements and substituting order and beauty for anarchy. "Love accompanies the chaos, precedes the world, wakens the drowsy, lights the obscure, revives the dead, gives form to the formless, and finishes the incomplete."[24] The Love of the Platonists is the first of the gods because it symbolizes the innate élan that inhabits all things, animates them, and pushes them to excel and unite. Love with harmony transfigures horror, creates affinities throughout the world, ensures the perpetuation of life, and makes concord reign between members of the universe.

Love that vanquishes primordial confusion and coordinates the cosmos is often associated with Peace, another unifying agent attributed by myth with powers to organize the world and guarantee its survival. In fact, the two powers are hardly distinct. "For wherever the beauty went, / Love went with her," writes Ronsard in his *Ode de la Paix*.[25] Understandably, Ronsard, like Du Bellay, grants a special role to Peace among the various forces traditionally opposed to primitive disorder. Both poets, choosing the ideal of peace to exorcise the horror of chaos, consolidate the political significance of the myth and place their discourse on contemporary events in a universal perspective. According to Ronsard, restoration of peace in the kingdom would be a repetition *hic et nunc* of the gesture that transfigured chaos into cosmos.

We had to wait for Joyce to invent the word *chaosmos*. But sixteenth-century minds dreaming of the conversion of obscure forces knew that the movement can be reversed, that the frontier between order and disorder is fragile. The world they inhabited, on this side of chaos, stands in a state of precarious balance. The elements have been pacified and archaic brutality neutralized, but a cosmic harmony governed by the accord of opposites—*discordia concors, concordia discors*—can be disrupted at any moment, by any excess. Just as the correct proportions of humors in the organism can be imbalanced, causing illness, the division of roles among various estates of society can be transgressed. So the affinities established throughout the world by Love and Peace must be constantly reconquered over the primitive instincts of violence and death. In moments of melancholy Ronsard thought that the thin film that separates us from chaos was about to tear and God, to punish men, might well "Make another chaos and His works destroy."[26] We can understand that the political conservatism of Ronsard and Montaigne, their hostility to Protestants, was in part the fear that the unstable plateau on which society stands would topple over.

In chaos germinate the seeds of cosmos, which itself bears the principle of

its own destruction: Ronsard, like da Vinci and other tenants of transformist thought, seemed to inscribe history—natural or human—within a succession of alternations. Whether or not the cycles are regular, whether they are necessary or contingent, is of no great importance. What remains is the fundamental idea that every condition is a stage, that all things tend to alteration and may metamorphose in a series of mutations with no fixed term. The mechanism of this forward thrust already lies coiled in the heart of primitive chaos, the active core from which *perpetuum mobile* springs into action.[27]

The comparison that follows will clarify the specificity of this flexible vision. *Les Tragiques* by Agrippa d'Aubigné, nourished with biblical memories and Calvinist theology, includes one of the most fascinating scenes of chaos ever written. It is already significant by its position—the scene doesn't open the work, as in the cosmogonies, but prepares the conclusion—in the seventh and final book of the poem, where the end of the world is recounted. After the resurrection of the dead and the Last Judgment, the old world—heaven and earth, created and perishable—still has to be destroyed:

> The sun dresses in black the gold of its fires,
> The beautiful eye of the world is blinded;
> The heart of so many flowers no longer blossoms,
> There is no more life in the heart of life:
> And, like a human body is dead erased
> As soon as the least blow to the heart wounds it,
> So the world must die and confound
> At the slightest wound to the sun, heart of the world.
> The moon loses the silver of its clear white complexion,
> The moon upturns its face of blood;
> Every star dies: the faithful prophets
> Of destiny will suffer eternal eclipse.
> Everything hides in fear: fire flees into the airs,
> Air into water, water into earth; in the funereal mixture
> All beauty loses its color. (7.917–31)

The blinded, tortured body of the sky is swallowed up in the final convulsion as the light of heavenly bodies is extinguished; the scrambling of the elements and the death of beauty are unambiguous signs of the return to chaos.

As in the metamorphic tradition, the vast confusion leads to a fortunate event—a parousia. The upheaval of the cosmic order was necessary to make room for celestial Jerusalem and substitution of the Kingdom of God for the realm of Evil. The major difference is that, once this celestial beatitude is attained, the motion (and the book) come to an end:

> Then matter will find rest, find pleasure,
> The end of motion and the end of desire. (7.393–94)

Here the *tohu-bohu* is not one stage in a series of ups and downs, it is the next
to last stage in a process leading to stability and the ecstasy of eternal rest. *Per-
petuum mobile* implies forever unsatisfied desire, but the Christian author ex-
pects his wishes to be fulfilled. The last lines of *Les Tragiques* are an eloquent
expression of the simultaneity of the vow and its fulfillment; potential and ac-
tual coincide within divine plenitude:

> In the breast of Abraham will our desires flower,
> Desires, perfect love, highest desires without absence,
> Where fruits and flowers all at once are born. (7.1206–8)

Ten short lines on the mystical contemplation of God, and the poem comes to
an end, like history, like motion.

And yet all that precedes in the seven books of *Les Tragiques,* rising slowly
from the depths of misery to this apotheosis, is saturated with motion and
transformation. Generalized instability characterizes the human order; men at
war overturn the foundations of society and act against nature, kings become
tyrants, and parents torture their children—this world, in which no identity
and no law is guaranteed, is overturned; people, institutions, and values vacil-
late, constantly on the verge of collapse. God also, but for opposite reasons, is
a destabilizing agent. He unmasks impostors, intervenes to reestablish justice,
punishing some and rewarding others, disrupts settled situations to turn this
upside-down world right side up.

Does this mean that the kinetic world of *Les Tragiques* is a Christian version
of *Metamorphoses,* an edifying polemic adaptation of prevailing transformism?
On the contrary, stability is the sole aspiration valued in this work, where
everything is in constant motion. The only positive movements recognized are
those that restore the order perverted by evil men. The mutations operated by
God are simple, regulated, and permanent, as opposed to the disorderly wan-
derings of Fortune. God raises up the dead and assigns them an irrevocable
fate; he doesn't abandon them to the hazards of metempsychosis. He destroys
the world he had constructed; he doesn't let matter enter into an endless
process of transformation. Change is legitimate only if it intervenes to correct
the abuses of changing; it is subordinated to the promise of permanence and,
paradoxically, culminates in the instant when it is abolished. When God
speaks, writes D'Aubigné, "everything turns into eternal beauty" (7.879).

Roman Ruins: Du Bellay

For the Renaissance, Rome was to be read as a palimpsest on which the vestiges of the ancient city are inscribed. Countless artists and architects, like Raphael, explored the ruins and underground passages while they were designing the forms of the new city. They built the city of the future on top of or next to the ancient one, integrating the remains or imitating the models. This creative archeology also figures in Du Bellay's *Antiquités de Rome;* in spite of the prevailing melancholy, he outlines a meditation on the exploration of chaos and recycling of wreckage.[28]

Rome, the ultimate in beauty and form, was still subject to the law of transformation and tumbled into formlessness:

> The body of Rome to ashes is fallen,
> And her spirit parted to reunite in
> The great spirit of this round mass. (5.9–11)

The phantom of the devastated citadel returns to the core of the Universal Soul, the *spiritus mundi* that redistributes the seeds of life. Elsewhere the fall of Rome is compared to the closure of a great 36,000-year cycle, at the end of which the "natural accord" of the elements ruptures and "the seeds that are mothers of all things" return to the "womb of Chaos" (22.11–14). Scrutinizing Roman antiquities was the equivalent of a descent into hell for Du Bellay, like Orpheus, looking for traces of bygone days and trying to tear chunks of the past out of the indistinct debris where dead things lie. The text is steeped in this attraction for lower depths and vague zones, conveyed by a lexical network organized around images of "dust," "shadow," "ruin," "relics," "lumps," "cloud," "vapor" and rhymes of "powdery," "ashy," "dreary," "shadowy" (15). The ironic spectacle of the eternal city struck down by the ravages of time, with the forceful contrast between monumental ancient structures and the dusty remains of the present, add a troubling charm to the exploration.

If, indeed, Rome's destiny was to slump finally into indifferentiation, a reading of the city's vestiges would seem to relate continuous brushes with chaos throughout the history of a city perched on the crest between harmony and anarchy. The barbarians who destroyed the empire are compared to the giants of Greek myth, savage chthonian forces that rise up out of the earth and, their destructive work accomplished, return to the underworld (11.9–12). These primitive beings, symbols of "the antique horror that violated law and order" (17.8), are both products and artisans of chaos. But when the Romans

too are assimilated with the "children of the Earth" (12.1), the reassuring opposition between order/disorder, reason/instinct falls apart. "The city whose peaks rose above the stars" (4.1) also belongs to the powers of darkness. In fact, in other sonnets, the city itself generates the forces that destroy it: Romulus begins by killing Remus (24.10); then the city's own soldiers kill each other. The theme of civil war, charged with menacing echoes for French readers, resonates all through the text, hammering on the idea that the Romans, at the height of their glory, dug the abyss into which they would fall.

Rome, wrote Du Bellay, was always "that Chaos where all good and evil were contained" (19.9–10). The seeds of violence and disorder lay in the heart of Roman culture, like the monsters of Bomarzo hidden in the bushes in the countryside, like patches of wilderness in cultivated parks, reminders of the proximity of the primordial (see chap. 5, under "Gardens: Archaic and Primitive"). In fact, the history of Rome is not presented as a decline from life to death, from form to formlessness, but as a succession of troubled times interrupted by transitory episodes of order. If the fate of humanity is to be extrapolated from this example, it would seem inextricably tied to chaos: a veneer of civilization, constantly threatened by archaic impulses.

At times the poet's entire discourse spins dizzily at the prospect of possible disasters or pours out in grief over ruins. Chaos is fascinating as pure negativity but even more appealing in its ambivalence. For Du Bellay and many others, chaos contains "all good and evil," so lamentation is often just one of the terms of a dialectic where death alternates with renewal and the contemplation of formlessness with the vague perception of gradually sharpening outlines. Throughout *Les Antiquités,* as in other works treated in this chapter, indetermination and vague outlines act as challenges. In the "powdery ashes" (1.1) the imagination searches out the shape of the object that was or will be; in the inert mass it senses vibration and the possibility of regeneration. The oxymoron expresses this hope of reversal. The poet addresses the city, saying, your destructors will not keep "The grandeur of the nothing they left you from marveling the world once again" (13.13–14). In this nothing lies its opposite and the beginnings of a process that will fertilize the future. From the very first sonnet, the poet presents himself as necromancer torn between "holy terror" (1.13) and refusal of death, who goes down into the tombs to pluck out vestiges of past glory. He scrutinizes chaos to find signs of life, searching all the more intensely as the hardness of the opaque, stony lump resists. Further on we will find the idea that the formless, a stain, a blur can operate as catalyzers of artistic creation (see chap. 12).

Fragments of the collapsed city and effigies of the dead initially provoke a retrospective movement. Memory recomposes scattered bits, imagination animates them, and the specters of the past regain consistency for a moment:

> Pale Spirits, and You powdery Shades,
> That basking in the clear light of day
> Brought out that proud sojourn,
> Whose ashy relics now display'd (15.1–4)

Shades of lost glory signify both absence and presence: They are the hollow witnesses of the past, semblances through which the outline of reality can be discerned. Lines 1 and 4 sketch an impalpable décor with evanescent characters by whose mediation emerge, in the two middle lines, the memory of grandeur. Marks of positive action are opposed to signs of inconsistency, with the glorious foundation of Rome and triumph of radiance over the powers in the shadows. Like saintly relics these remnants still have power; they pluck the past out of oblivion—here the constructing fathers, elsewhere marble monuments and the splendor of the metropolis. The shadow is fruitful and, in the space of a vision, liberates its prey.

Exploration of the past can also be dynamic and contribute to the edification of the future; archeology then becomes a branch of architecture and the retrospective view a means in the service of creation. The ruins are not only vestiges, they can also function as models; descent into the excavations and contact with the ancient force reanimate energies and irrigate the builders' works.

> For these old fragments as models yet stand
> And serve these most industrious workers. (27.7–8)

Du Bellay speaks as an eyewitness; he saw Rome reborn like the phoenix from the ashes. The modern city was being built on the remains of the ancient. Not only were blocks of stone taken from the Colosseum and reused to build Saint Peter's and the Farnese Palace, but the forms were also reborn in figures that "as models . . . serve," stand out from the debris. As expressed by Thomas Greene, Amphion the constructor takes over from Orpheus the necromancer; the regressive movement and descent into the underworld does not respond to a death instinct but answers a demand for regeneration. The model of biological reproduction infiltrates the meditation on art with this image of resurgence from deep roots. A now-familiar image is confirmed: Chaos is a deep womb; the passage through indetermination is a preparation for rebirth.

Renaissance architecture, sculpture, and poetry show that the study of ru-

ins as foundations underlying future monuments was not just an exercise of the imagination but a genuine guide for artistic activity. The to-and-fro movement between excavations and constructions, reading and writing, became a working method. In drawing the plans of a church, Palladio would always begin by reconstituting the style and structure of classical temples:

> I will show in this book the form and ornaments of several antique temples whose ruins can still be seen and for which I drew up the plans, so that everyone may know in what form and with what ornaments churches should be built. And though for some of these temples very few traces subsist on the surface I was able, by addition of a study of the visible foundation to the vestiges, [to] reconstitute what they were when they were whole.[29]

Du Bellay himself participated in these dynamics, starting with the dedication of *Antiquités* to Henri II, where he expressed the wish that his own example, "Drawing the dusty relics of old Romans out of their tombs" (7–8), would encourage the king "to reconstruct in France such grandeur" (10). Renaissance artists were aware that, despite the extraordinary ambition of their projects, they fed on the spectacle of death. Like nature swept up in the cycle of regeneration, their culture flowered in fields fed with cadavers.

This is exactly how the poems in *Antiquités* function, illustrating by a reflexive effect how the work springs from the experience of absence and confusion. The geometry imposed by a strict sonnet form and rigorous alternation of decasyllables and alexandrines from one poem to another contrasts sharply with themes of shadows, cinders, and evanescence. A sturdy work composed of solid rhythmic blocks reproduces "with a quill compass" (25.13) the monumental edifices of the distant past, but there had to be a passage through formlessness so that form could be reborn. And this form, no matter how precise, is vulnerable, laboriously extracted from chaos and already threatened by aging. Du Bellay, better than anyone else, intimated the fragility of his enterprise and its unity with nothingness.

The retrospective/prospective gesture we have observed is emblematic of the prevailing mechanism of literary creation: imitation. Imitation that looks back and ahead, destroys in order to build, operates in a field of transformation and regeneration. We will come back to this in chapter 11.

Internal Chaos: Montaigne

Montaigne finds chaos within the human mind. When he looks inside himself, he sees a magma of heterogeneous forces, "such a formless varied contexture that each piece, each instant, plays its own game" (2.1.337). As within primal matter, doomed to the war of the elements,

> it contains all contrarieties. . . . Shameful, insolent; chaste, lustful; talkative, taciturn. . . . I have nothing to say about myself, completely, simply, and solidly, without confusion, without mixture. (2.1.335)

Discordant qualities are organized without order or hierarchy in unstable psychological complexes. The inner life, seen as a fluctuating, amorphous mass in which constellations of passing humors assemble and fall apart, resembles the original chaos. If a human being is such a floating wreck, it is no surprise that the thoughts he produces are also inconsistent: "My cogitations," says Montaigne, are "a formless subject" (2.6.379). Whether he observes himself in action or in thought, he finds the same fundamental indetermination, stumbling against opaque zones, aggregates of mental life that defy the enlightenment of reason. Awake or dreaming it's all the same because we are creatures of the shadows: "It is always gloom, and Cymerian gloom" (2.12.596).

Chaos, transposed by Montaigne to the psychological and intellectual realm, still remains a primal state; it is the elementary stage of self-awareness, the founding experience that will give momentum to the writer's activity. According to a schema similar to what we encountered in the cosmogonies and meditations on history, the intuition of chaos, here too, has inchoative value; the shadowy mass is like a terrifying black hole, but it functions as a springboard to creativity. I would like to show how chaos confronts Montaigne with two challenges and entails a double postulation that determines and structures the enterprise of the *Essays*.

As we have seen, the first stimulus can be formulated in Aristotelian terms.[30] Deprived of form, aspiring to form, amorphous matter is an absence seeking satisfaction, which creates expectation. Formlessness is a potential that should be actualized by giving it form. The very perception of this lack will be an attempt to bring something to accomplishment by acting to bring it out of indetermination into full realization. So it is with events in their raw state, which call for intelligence to give them meaning: "This is the naked formless matter of history; each of us can draw profit from it to the extent of his understanding" (2.10.417).

Montaigne experiences in a personal register this provocation addressed by the formless to the mind. When he feels disturbance and flux of contradictory dispositions within himself, he must look for stable footing, "his own form, a master form" (3.2.811). The perception of the self as a nebulous being must only be a first stage and should be supplanted by a solid identity that has conquered, as well as possible, against confusion: "I made every effort to give form to my life. Here is my loom and my creation" (2.2.811). The individual, starting out with a vision of himself as an undifferentiated mass, works like a sculptor bringing out distinct lines from a block of stone. He fashions himself, his life, his character.

It is urgent to shape one's personality but just as important to put one's thoughts in order and give consistency to confused ideas, those volatile intuitions that cross the mind, constantly in danger of slumping into indetermination because they are uncontrolled. This control is the mission of writing, a way of extracting precise reflection from vagueness and imposing an articulated structure on the indefinite.

> In order to discipline by some order and project my fantasy to dream, to keep it from wandering off and raving with the wind, I have to enroll and give body to all the little thoughts that come to mind. (2.18.665)

Evanescent thought, captured in words, solidified in the framework of a discourse, embodied, goes from potential to actual. The writer functions like the demiurge, drawing out cosmos from chaos. And writing resembles the operation of the mind, as Montaigne explains with reference to the treatise of Raymond Sebond; it confers great scope and persuasive power on ideas, even if they have already been articulated:

> Our human thoughts and reasoning are like heavy sterile matter; the grace of God is their form. . . . Our imaginations and reasonings . . . have a sort of body, but it is a shapeless mass, not fashioned, not come to light unless combined with faith and the grace of God. (2.12.447)

Montaigne would seem to believe that thought is in constant danger of indifferentiation or regression back to primary indetermination; it must be continuously retrieved by a form that will allow it to actualize its potential. Vagueness, fuzziness, inertia are at our heels and demand unfailing mental vigilance.[31]

In the chapter entitled "On Idleness" (1.8), the program is announced and placed in precise relationship with the genesis of the *Essays:* The origin of the book coincides with an experience of inner chaos. Montaigne tells how he re-

tired from active life with the intention of working at home, dedicating himself to reflection and introspection. But he soon found that when he was left to himself his mind wandered. His determination to find inner peace and cohesion, the apprenticeship of meditation, was a failure. Montaigne admits that

> [I] give birth to so many chimeras and fantastic monsters jumbled together in total meaningless disorder, that I started enrolling them so I could calmly contemplate their strangeness and ineptitude. (1.8.33)

This is the birth certificate of the *Essays:* The solitary subject discovers division and disturbance within himself. Strange forces—wild products of the imagination, dread and delirium—invade his mental space and threaten his equilibrium. Fantasies that had been suppressed rise to the surface, defy reason, and provoke distress. How can he handle this crisis?

Earlier in the chapter, Montaigne opposed the rectitude of form to the invasion of the formless. Unbridled spirits "toss and turn in disorder in the vague field of imagination. . . . And what folly, what revery will they not bring forth in this agitation" (1.8.32). So we must reign them in, constrain them, "give them a subject to work on." Two comparisons reinforce this determined project. "Idle fields" may produce "a hundred thousand kinds of wild useless plants," so we must "dominate them and use certain seeds in our service." In the same way, "a woman all alone produces lumps and pieces of formless flesh," but "to make a good natural generation, she has to be worked with a different seed." Again, the paradigm of original chaos generates analogies. Fields and women awaiting the seed to become fertile are like primal matter that receives the imprint of form to go from potential to actual. All of these sterile, inert bodies need to be inculcated with a finality that will transfer them from *otium* to *negotium,* withdraw them from morbid proliferation, and impose on them a positive project. "The soul that has no stable purpose is lost" (ibid.).

What is most interesting about this schema, based on the Aristotelian model, is that it falls short.[32] As long as Montaigne keeps to general terms—fields, women, the human mind—he calls for discipline. But when he comes to his own experience—my mind—he doesn't say any more about correcting the drift or imposing a positive orientation on "chimeras and fantastic monsters." Is he raising doubts about the choice of delirium-producing idleness? Is he trying to censor the "vague field of the imagination?" To remedy it by some "seed" that will neutralize its negativity? No, as he puts it, he will be satisfied to "enroll" these things so he can "contemplate" them and, as the case may be,

feel ashamed. So the aim is no longer to restrain the mind but to explore its lower depths. The wanderings of the imagination are perhaps sterile and inept, but they deserve to be exposed, as the book drawn from this descent into the wastelands of the mind will testify.

The vacillations displayed in the chapter "On Idleness" are significant: Rational mastery of psychic extravagance is not the only solution and may not be the one Montaigne prefers. In other chapters he repeatedly admits that, confronted with his internal chaos, he is content to set it down as it comes: "It is a registry of varied and mutable accidents, irresolute and perforce contrary imaginings" (2.2.805). What accounts for this apparently slothful method, this capitulation before the formless? The reason is that life is a dream:

> We dream awake and waking dream. . . . As for awakedness, it is never truly pure and cloudless. . . . It is never so awake that it can purge and dissipate the reveries that are waking dreams, worse than night dreams. (2.12.596)

A large part of our existence is invaded by confused representations, vague somber images that, as much or more than night visions, haunt our days. For Montaigne, dreams are not an opening onto another world but rather the closest approximation to ordinary mental activity. The "chimeras and fantastic monsters" are natural productions of the mind; folly is an integral part of the mystery of human beings. To show yourself without dissimulation, you have to restore the shadowy side of psychic life. The self-portrait that would reduce the self to its clear ideas and acknowledgable sentiments would be a cheating image, too serene to be true.

Montaigne believed that giving shape to the formless is a deception. Because he was prey to the anarchic movements of his "reveries" (3.9.962), he tried to show their singularity in his writing. As long as form remains a distant aim of research, an opportunity to act, it is good; as soon as it is taken for granted and imposed as a fixed, constraining model, it is misleading.

Aside from its mimetic quality, the exploration of inner shadows has heuristic value: "I offer shapeless irresolute fantasies . . . not to establish the truth, but to seek it" (1.56.317). The preposterous products of the psyche have no apparent meaning, but they challenge the observer and invite him to flush out the mysterious truth, there where the unspoken may be hidden. You have to go all the way to strange lands in the empire of vague ideas where some ungraspable object attracts the mind:

> My conceptions and judgment grope in the dark, stumbling, tripping, grappling; and when I have gone as far as I can, I am not at all satisfied. I see

other lands further on, but my vision is cloudy and blurred, and I can't make it clear. (1.26.146)

Keeping this cloudy zone on the horizon is good for the mind because vagueness is a reservoir where thought can grope, looking for something to supplement rational evidence: "I always have an idea and some confused image in mind, that presents as in a dream a better form than I had wrought, but I cannot grasp and use it" (2.17.637). Montaigne's epistemology functions on two tableaux: It oscillates between clear and opaque, indeterminate and determinate; it exploits the potential of confused images to enrich conscious certainties. Though the indefinite escapes from our grasp, it fertilizes thought. The Aristotelian model is turned upside down: Instead of form actualizing the potential of the formless, the formless contributes to the fulfillment of form!

Montaigne attempted to explore the other world that lies deep within the self. This was the second challenge offered by the forces of chaos: to observe confused mental states, driftings of the imagination, and find words to describe this other existence on the outer limits of reason.

The most audacious experiment of this type can be found in the author's observations on his semiconscious state after a fall while horseback riding. Carried home wounded and bleeding, he makes a calm, precise analysis of his condition in the limbo of existence, describing the strange sensations he experienced as he lay between life and death, between self and nonself, given the exceptional opportunity to go into another theater where creatures of the shadows, ordinarily inaccessible, are outlined. In that state of suspension of will and absence of reason, the habitual controls were lifted and other faculties took over. Montaigne had fainted, but he acted as if he were totally conscious, "because we harbor many motions that do not follow our orders . . . and . . . cannot be called our own" (2.6.375–76). Reflex movements carry on the work of existence as if another, ungraspable being were acting on its own. The body remains active and, strangely enough, so does the mind. From the depths of his coma, the wounded writer answers questions and even orders a horse to be provided for his wife:

> It seemed that this consideration must have come from a mind awake: which certainly was not the case with mine: it was vain clouded thoughts moved by the senses of eyes and ears; they did not come from me. (2.6.376)

Once more we see that cloudy thoughts hold surprises, but here it is not the strangeness of the images but the banality of Montaigne's words that makes them bizarre. From a confused origin comes clarity.

Taken over by another self, not responsible for his gestures, Montaigne abandons himself to the delights of passivity. While "chimeras and fantastic monsters" (1.8.33) shame and probably trouble him, the instincts manifest here reveal another, delectable side of unconscious activity. Montaigne insists heavily on the "sweetness" of the experience of being free to surrender to the empire of the imagination and discover its volatile, capricious, voluptuous inventions:

> It seemed to me that my life was hanging on the tip of my tongue: I closed my eyes as if to help push it out, and took pleasure in languishing, letting myself go. Imagination was just floating superficially in my mind, tender and weak as all the rest, but truly as this was cause of no displeasure so was it mixed with that sweetness we feel as we drift off to sleep. (2.6.374)

A vague airy impression as pleasant as it was indecisive took over his being, as in moments when the mind floats on the threshold of the night, "on the stuttering of sleep" (2.6.375). As above, Montaigne used the dream comparison, but this time the subject is not life but approaches to death. Whether driftings of the waking mind, reveries of a man falling asleep, confused impressions of agony, they all serve as opportunities to visit the confused areas, "on the edges of the mind" (2.6.375), and capture the strange symptoms of our underground existence.

Just after telling about his accident, Montaigne comments:

> What a tricky enterprise, well beyond what it would seem, to follow such a vagabond rhythm as takes our mind, to penetrate the opaque depths of its inner folds, pick out and capture all the little ripples of its agitations. (2.6.378)

The difficulty is twofold. First we must remove the censorship that blocks access to repressed images and then "capture" the images so we can see them clearly, that is, capture them by fixing them in writing. Tricky enterprise indeed, for how can clouds be fixed? And if they let themselves be immobilized, will they still be themselves? Montaigne seems to be caught in a vicious circle. If chimeras aren't taken in hand by reasoning, they remain sterile and vanish, slump into oblivion or indifferentiation. So they must be given body in writing. But speaking about them objectifies and solidifies them. The *mise en rolle* is an enrollment, an act of domination and force by reason that corrects extravagances and by the same token betrays them. Shaping up the formless annihilates it. Clearing up confusion and stabilizing evanescence are indispensable but absurd operations because they destroy what they sought to reveal.

How can we escape from this aporia? This is the ultimate challenge posed

to Montaigne by inner chaos. He has to find a way to reconcile the two sides of the mind so that, if form corrects the formless, the formless also fertilizes form. Because writing is necessary, it shouldn't be writing *about* confusion but confused writing. This is precisely what he tries to achieve in the style of the essay, using breaks in the tissue of logic, unusual associations, singular ideas and images to open a breach where strangeness can seep in. Of all forms that use language to capture and analyze ideas, the essay comes closest to the inconsistency of chimeras and the driftings of the psyche. No sooner has Montaigne achieved a balance or sketched out a form than he alters it and goes looking for others.[33] Like Penelope, he weaves and unravels what he had woven, leaving space between the threads for the artisan's uncertainties, the surprises of an alert mind. If the anarchy of chaos did not repeatedly relaunch the conquest of order, the cosmos would be frozen into soulless harmony.

5 | *"Grotesques and Monstrosities"*

Metamorphosis and the Primeval

The symptoms we have focused on—transformism, continuous creation, the attraction of chaos—can help us understand the objectives and methods of knowledge in sixteenth-century culture. Two common dichotomies should be excluded: the distinction between learned and popular traditions and the strict separation between natural and supernatural. Thus, the distinction between the rational exigencies of enlightened minds and the fuzzy beliefs of the collective imagination does not operate. The themes we have treated cover the full social scale of knowledge, like the myths of metamorphosis, originated with Ovid or similar scholarly sources, that came to share a common ground with oral tradition and prevailing animism. Their resonance supports the exclusion of the second dichotomy, between natural and supernatural. These people believed that matter vibrates with secret life; a diffuse spirit saturates and unites all things; knowledge encompasses in an unbroken continuity the physical and the spiritual, empirical facts and speculation, reasoning and projections of the imagination. They made no clear distinction between medicine or astronomy and occult sciences like alchemy, demonology, astrology. Belief in the universal action of the divine at the heart of things led to an attitude of open-minded curiosity. It is not for human beings to set limits on reality when prodigiously creative nature invents endlessly varied forms. Observers collected marvels, transcribed rumors, and delighted in extending the frontiers of possibility, like explorers discovering new lands.

This variegated culture has a basically *primitive* component—primitive both in the way it holds on to archaic beliefs, fears, and intuitions, as widely documented in the preceding chapters, and in seeking closer contact with the primeval world of origins, as we will see in this chapter. We have already considered these reveries on creation and chaos as constructs used to go back in time, grasp the core of elementary life, and follow it from the initial impulse along the chain of transformations that runs through all of human history and the unfolding existence of substances. This desire to regress to primeval forms and feel the unhindered force of originative powers before they are captured lies at the very heart of Renaissance naturism. In addition to original matter and the passage from formless to form, other archetypes contribute to this inchoative vision of a rudimentary, malleable, amorphous world in the making.

The notion of the instability and flexibility of all things is characteristic of this vision and coincides with a constant in mythical thought. The primitive world does not recognize airtight limits between species or absolute opposition between categories that are, themselves, uncertain. In the unitary organism of nature, life and death, human and divine, animate and inanimate can exchange properties, combine, transform from one to the other. Matter, only halfway organized, is distributed in molds that are easily made and broken. It is above all potential, a wellspring of energies seemingly available for endless actualizations.

This will help us understand the exceptional attraction of Ovid's *Metamorphoses*. The formative elements of the imagination of primal origins are crystallized in this work, one of the most frequently published, commented upon, translated, and imitated in those times.[1] In memorable stories with great visual impact, the poem conveys manifestations of a world delivered up to flux, continuous creation, generalized interdependence of its parts. "With all these fables he only means to make clear that in the nature of things forms constantly change, matter is nonperishable."[2] Without going back to the discourse attributed to Pythagoras, it is useful to recall some of the principles that sixteenth-century minds, faithful to Ovid, might find in this Bible of transformism.

At the beginning of *Metamorphoses*, the world and humanity are endlessly beginning. No sooner is a form or a balance attained than it starts to vary. And yet an organizing god did intervene in the heart of chaos to separate the elements and assign a fixed place to earth and water, heat and cold, and various winds. Just when the initial confusion seems to be surmounted, the deluge occurs, turning the world upside down and drowning everything. For the second time, the world has to be reconquered over chaos, and this is the signal for chronic change, complicated by the hesitant, eventful creation of man in the

same preliminary period. First he arises—fabricated by the plasmator or emanating from the earth, it's not sure—distinguished from the rest of the animals by his stature (1.76–88), but other births follow: from the blood of the giants (1.160), from stones thrown by Deucalion and Pyrrha (1.391–415). And so a long history begins in waves and continues through accidents, transformations, new beginnings—all the way to Rome rising on the ruins of Troy as the poem comes to an end.

The demiurge has left the stage and humanity has grown older, but new species are being born: "As to the other forms of animal life, the earth spontaneously produced these of divers kinds; after that old moisture remaining from the flood had grown warm from the rays of the sun" (1.416–18). Creatures spring up by spontaneous generation from the womb of the earth and grow like plants. Organisms still engaged in the process of gestation creep out of lands fertilized by the floodwaters of the Nile: "some . . . are upon the very verge of life, some are unfinished and lacking in their proper parts; and ofttimes in the same body one part is alive and the other still nothing but raw earth" (1.426–29). The osmosis of earth and water, or fire and water, produces germs, and from this discordant concord life is born. Once again indetermination acts as a generative force.

Ovid shows as much interest in the process of transformation as in the outcome of metamorphosis. Excelling in descriptions of the slow, progressive deformation of a body as it turns into another, he dwells on the transitory phase when a creature suspended between two identities, combining two species, temporarily resembles a monster. Daphne is still running but already her hair is "changed to leaves, her arms to branches. Her feet, but now so swift, grew fast in sluggish roots" (1.550–51); her heart is palpitating and already the laurel bark paralyzes her. The kinetic representation of the gradual mutation attains heights of virtuosity in an eleven-line description of stones becoming animate: they soften, elongate, little by little shape themselves in human form, and come slowly, progressively to life (1.400–410).

The poem itself, in its unfolding episodes, follows the imperceptible movement of metamorphosis. Ovid's commentators express particular admiration for his skillful transitions, the continuous unfolding of a story composed of numerous, largely independent narrative modules that are not compartmentalized and juxtaposed but rather nested one inside the other. One story contains the germ of the following: a family relationship, a spatial or temporal coincidence creates the link. The smooth, uninterrupted arrangement of the text reproduces in reflection a world in which anything can come forth from

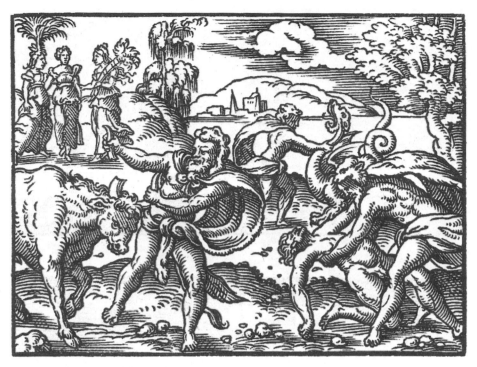

Fig. 18. *Hercules and Achelous* (*Metamorphoses* 9.1 ff.). The heroes are fighting (*right foreground*) over Deianira. Achelous, the River-God, is thrown and metamorphoses into a serpent; he pursues the battle in this form (*right background*). Just as Hercules is about to strangle him, he changes into a bull, and Hercules pulls off one of his horns (*left foreground*). Naiads grab the horn and fill it with fruits and flowers, making it into a cornucopia (*left background*). The illustration shows the story unfolding in four episodes, with four stages in the transformation of Achelous. Figures 18–25 are from Ovid's *Metamorphoses,* 1563 (German edition published in Frankfort on Main, see bibliography).

something else. In one myth lies the beginning of another fable, just as traces of the other person he was or will be lie in any character. We will see in chapters 9 and 11 that transformation is the basis of not only a world vision but also a poetics.

And it inspires a certain type of image. Sixteenth-century editions of *Metamorphoses* were often illustrated, and many artists, sculptors, and decorators borrowed subjects from the poem. Abundant iconographic material was de-

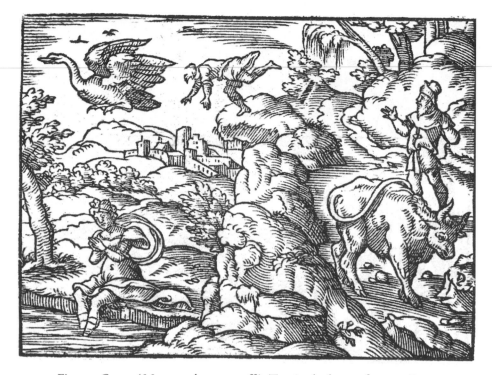

Fig. 19. *Cycnus* (*Metamorphoses* 7.371 ff.). To win the heart of young Cycnus, Phyllius tames a bull (*right*). Rebuffed, he refuses to give the animal to the young man, who throws himself from a cliff and is transformed into a swan (*left background*). "His mother, Hyrie, thinking he was dead, cried so hard she melted and turned into a pond" (lines 380–81, *left foreground*). Three episodes in succession and two metamorphoses, each broken down into two stages (before and after transformation), for a total of five separate moments.

rived from *Metamorphoses,* but also a style. The arts were faced with a tremendous challenge: How can transformation be pictured? How can the movement of a form be captured in an immobile genre? How can a kinetic image be produced before the invention of cinema? In spite or perhaps because of the difficulties, numerous attempts were made. Eight illustrations from a 1563 German edition, chosen among many others, indicate some of the paths followed (figs. 18–25).[3]

Piero di Cosimo, a somewhat eccentric painter, tried out different variations on the theme of metamorphosis. A series of eight pictures[4]—some of the strangest and most enigmatic in the Renaissance—evokes a primitive world

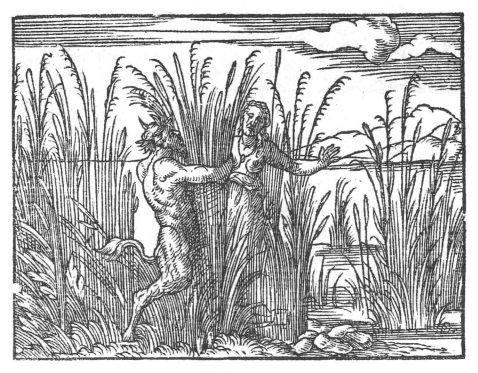

Fig. 20. *Syrinx* (*Metamorphoses* 1.689 ff.). "Pan thought he already had Syrinx in his grasp, but his arms clasped a clump of marsh reeds instead of the nymph's body" (lines 705–6). The body is captured in the course of metamorphosis, half-human, half-plant.

whose inhabitants seem to belong to races in transition. This world is peopled with composite bodies and presents side by side what are distinct stages in the evolution of species. Whether they are to be treated as parts of a whole or to be read each on its own, these different scenes are like a film of a long sequence in human history and illustrate the transformations that mark its development. Here are some of them.

Three figures are shown in the foreground of *The Death of Procris:* on the left, a crouching faun with goat's ears and hooves; on the right, a dog, same size and position; and stretched out between them the corpse of a young woman (fig. 26). Three species—monster, animal, woman—compose a harmonious ensemble. What's more, the handsome, serene faun has a perfectly human attitude of bounty and communion, and the dog seems to have a sim-

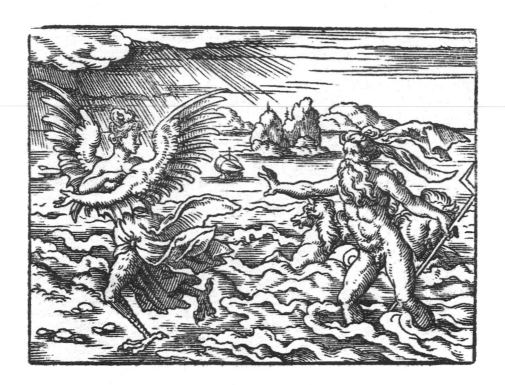

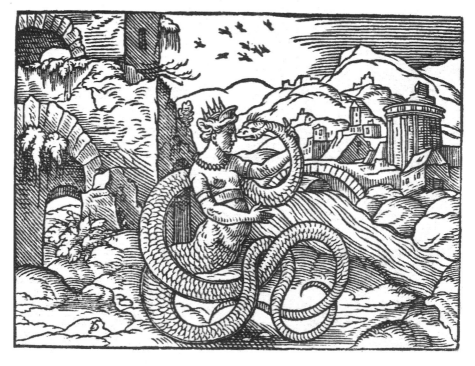

ilar posture. There's nothing monstrous about the monster, the animal isn't animal; we are in a world where the distribution of properties remains uncertain. A group of three animals in the background, symmetrical to the foreground trio and apparently playing the same scene, further defies the division of species.

This symbiosis between man and monster is the unifying theme of the series.[5] The combat of *The Battle of the Lapiths and Centaurs,* after *Metamorphoses,* takes place in a mixed society where man/horse crossbreeds battle against normal men and women, and in fact the crossbreed couple at the center of the scene show more human feelings than the humans. Two other paintings—hunting scenes where centaurs and satyrs mix with ordinary human beings—also depict a variegated population of families at different levels of development; in contrast to the stabilized anatomies of human beings, the hybrid bodies seem to be malleable forms destined for future mutations. In another set of paintings, the Silene cycle, finished beings coexist with others who look incompletely human. In *The Misfortunes of Silenus,* three groups show characters with pointed ears in contact with a basin of water that is or could be used for washing (fig. 27): here I see the image of a transfiguring liquid that would wipe out the monstrosity and allow imperfect beings to reach a permanent configuration.

The Forest Fire depicts the animal version of the same theme: familiar animals side by side with others that have human heads or composite bodies (fig. 28). Among them are a mother bear followed by three cubs, which may well give the meaning of the scene because, as we have seen (in chap. 1), they symbolize the slow passage from the formless to form and can serve as emblem of the theory of continuous creation.

Erwin Panofsky interprets these and some related paintings as studies of primitive life and the technical and intellectual progress that emancipates men from their primary bestiality to lead them toward culture and life in society.[6]

FACING PAGE:

Fig. 21. *Coronis* (*Metamorphoses* 2.542 ff.). Transformation of Coronis into a rook as Neptune tries to rape her. The young woman is turning into a bird, same solution as in figure 20.

Fig. 22. *Cadmus* (*Metamorphoses* 4.563 ff.). Cadmus has just changed into a serpent. As he holds his wife in his arms, she, too, is transformed. The image shows two metamorphoses at different stages, one accomplished, the other under way.

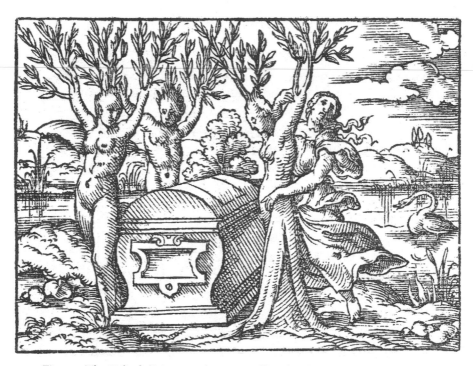

Fig. 23. *The Heliads* (*Metamorphoses* 2.333 ff.). Phaëthon's mother, Clymene, and his sisters, the Heliads, weep over his tomb. The sisters turn into trees; the mother tries to tear off the bark that covers them. Phaëthon's friend, Cycnus, turns into a swan as he watches the scene. The image shows two metamorphoses at different stages: the completed transformation of Cycnus and the ongoing metamorphosis of the Heliads, which is shown in two phases, progressing from *left* to *right*.

Countering the theory of an original paradise—golden age and primal innocence—Piero would propose a rationalist version of order acquired by effort against primitive violence and brutality. Without contesting this explanation, I would add another constant: meditation on the metamorphic world. The above-mentioned scenes portray creatures seeking their form; these works capture the world in the rough state of creation in progress, chaos to be fashioned. *The Liberation of Andromeda* (which Panofsky doesn't discuss), another juxtaposition of distinct stages of evolution, confirms my interpretation (fig. 29). The central figure—Perseus about to slay the monster—makes way for the fulfillment of humanity, represented in two phases: in the left foreground, charac-

Fig. 24. *Deucalion and Pyrrha* (*Metamorphoses* 1.313 ff.). After the flood, Deucalion and Pyrrha go to the temple of Themis and ask the goddess how to repopulate the earth (*left background*). "Leave the temple," she replies, "veil your face, undo your sash and throw your grandmother's bones over your shoulder" (lines 381–83). They understand that she means stones and throw them over their shoulders. "These stones lose their hardness and stiffness, gradually soften and as they soften take a new form" (lines 400–402). Two moments and the metamorphosis under way. (Also see frontispiece.)

ters still terrified by the horrors of the combat; on the right, musicians and joyous figures waving branches as if to celebrate the advent of culture and freedom.

Vasari, in his life of Piero, gives an insistent portrayal of a weird, wild man, "more bestial than human";[7] the artist, he says, lived in solitude, was deliberately provocative, surrounded himself with wild nature that mirrored his own wildness. Was the biographer influenced by the artist's works? Did Piero build a world modeled on his own terrors? Did he try to resemble the characters in his paintings? He would not have done otherwise if his aim was to suggest the persistence of the primitive base. In fact, in the scenes described above, he

Fig. 25. *Philemon and Baucis* (*Metamorphoses* 8.620 ff.). When they were traveling on Earth, Jupiter and Mercury could find hospitality only in the humble cottage of Philemon and Baucis. The old couple followed the gods to a mountaintop (*left*), where they watched the land swallowed up by the waters (*background*), except for their home. It is transformed into a temple, and they become the guardians. When they die they turn into trees. Two distinct episodes: a completed metamorphosis (the temple) and another under way.

played on the notion of continuity, like most of his contemporaries, suggesting that the challenge remains the same throughout the ages. Here and there we come across details of architecture, costume, and objects that are far from prehistoric. Does this mean that the primitive episodes portrayed belong to all periods or serve as allegorical illustrations of the current situation in Florence, prey to conspiracies and disorders? In both the fable of his life and the timeless images in this primitive cycle of paintings, Piero seems to indicate that the unstable world of the beginnings, subject to convulsions and mutations, speaks to the present. Metamorphic races and monsters brought forth from nature in gestation are not historical fantasies but emblems of our condition.

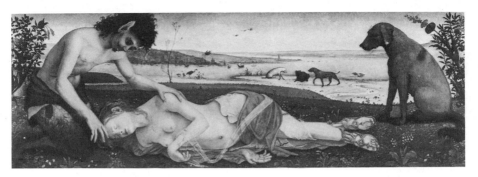

Fig. 26. Piero di Cosimo, *The Death of Procris,* ca. 1500–1510. Tempera and oil on wood, 65 × 183 cm. London, The National Gallery.

Monsters in Everyday Life

In those days, monsters—authentic or fantastic, comical or frightening—were part of the setting. A systematic investigation would lead us to Bosch and Breughel, Ariosto and his *Rolando Furioso,* Shakespeare and *The Tempest.* Leaving the libraries and museums, we would encounter hybrid bodies in the streets of Paris, in Italian gardens, and even in churches. Some of these monstrosities derivatives of carnival farce or ornamental, as we will see on the subject of grotesques—were meant for amusement; there is no reason to probe them for any deeper meaning. But monsters may have more weighty significance. "*Monstra,*" said Saint Augustine, "come from the verbs *monstrare* 'show,' because they show something by a sign."[8] They upset the order of things because they should be perceived as divinatory signs; they are accidents full of meaning, coded messages that demand explanation. Whether sent by God or Satan, they are usually perceived as dangers, signs of coming catastrophe, augurs of punishment. But the terror inspired by these dire presages is intensified by doubts about the correct interpretation.[9] Do all monstrous manifestations have symbolic value, or only some of them? How can we distinguish between chance freaks and supernatural interventions? Supposing that we can identify authentic signs, how can we be sure of their meaning?

The debate on monsters doesn't stop at the eventuality of misfortune and the hermeneutic difficulties on which Rabelais, for instance, concentrates.[10] Misshapen creatures also aroused curiosity or wonder at the exuberant manifestations of the life force. Rather than inspiring fear or confusion, they were taken as proof of the extraordinary prodigality of the Creator, who has never

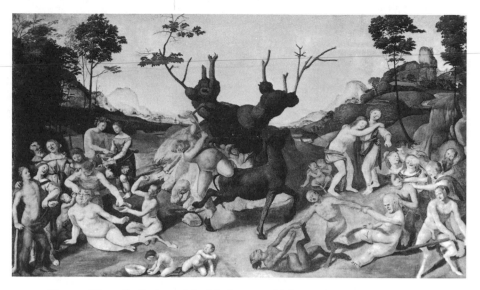

Fig. 27. Piero di Cosimo, *The Misfortunes of Silenius,* ca. 1505–10. Oil on wood, 76 × 126 cm. Cambridge, Mass., Fogg Art Museum. *Facing page:* detail.

finished inventing new configurations. This optimistic version, based on a tradition going back to Pliny the Elder and Saint Augustine, considers that exceptions and apparent anomalies, far from threatening order, reveal the vitality and variety of nature. The monster invites us to extend the frontiers of the known, to celebrate a universe in perpetual gestation that encompasses all possible forms of life, far beyond the narrow limits of our knowledge.

Humanists of this leaning collected prodigious events and extraordinary stories in their writings or images as a way of exploring the powers of nature in expansion. Religious exultation surpassed documentary rigor; hardly concerned about verifying the authenticity of dragons, satyrs, or two-headed men, they humbly accepted them as possible realities because no one knows how far the wonders of creation will go. Montaigne, confronted with the enigma of Siamese twins, chooses to suspend judgment; as with so many exceptional phenomena collected in the *Essays,* he just takes note and savors the strangeness without trying to understand because he is aware of the limits of reason. Trying to distinguish between possible and impossible, normal and abnormal, is to deny our ignorance and pridefully bring God down to our measure:

> What we call monsters are not monstrous to God, who sees in His immense works the infinity of forms encompassed. . . . In His great wisdom nothing

comes that is not good and proper and regular; but we cannot see their arrangement and relation (2.30.713).

Soon the reign of reason would impose its order and categories, separating true from false, opposing rule and accident. Seventeenth-century science be-

Fig. 28. Piero di Cosimo, *The Forest Fire,* ca. 1500–1505. Oil on wood, 71 × 203 cm. Oxford, Ashmolean Museum. *Below:* detail.

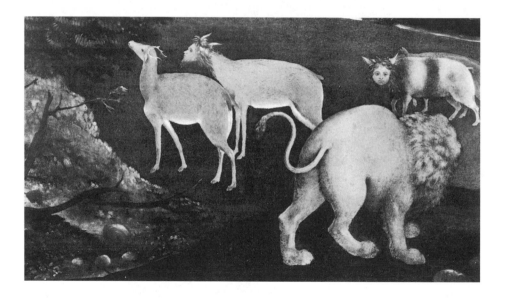

gan to classify phenomena, define the limits of the real, and relegate the irreducible to errors of nature or products of a sick imagination. But the monsters of the Renaissance belong to a prescientific mentality attentive to a world where nothing is excluded a priori. They are products, and witnesses, of a universe in which all things reciprocally influence each other, are made and unmade, enter into unpredictable combinations.

Rabelais is one of those authors who was brilliantly inspired by nature's aptitude for endless renewal and variety. The first chapter of his first book, *Pan-*

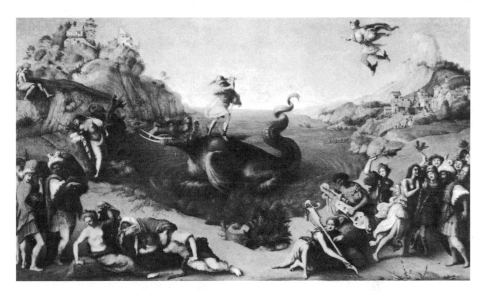

Fig. 29. Piero di Cosimo, *The Liberation of Andromeda,* ca. 1515. Oil on wood, 70 × 123 cm. Florence, Uffizi.

tagruel, goes back to the beginnings of humanity—again scenes of primitive life—to tell about the origins of the race of giants. At that time the fruits of the earth were so copious, so delicious, and the first men so gluttonous that they stuffed themselves until they were swollen out of shape. In the beginning was abundance, appetite, and dilation. In conformity with the principle of continuous creation, anatomies are flexible and take all kinds of outlines: growths on nose or stomach, humps and lumps, hypertrophied limbs. Organs transform before the eyes, and from this proliferation of metamorphoses comes forth the line of giants who, sometimes immense, sometimes human size, will keep on changing proportions as the story continues. All that disfiguring debauchery and wild outburst of grotesque organisms could inspire disgust. But the revised version of the creation as given in the beginning of *Pantagruel* breathes with the blissful energy of dawnings—a race arises, a story begins, a text takes flight—all the more expansive because at this threshold everything still seems possible.

However, not all monstrosity fantasies are so blissful. As Pantagruel and his friends go from island to island seeking the Dive Bouteille, they discover preposterous creatures who are all the more unnerving because they have a value as signs but remain incomprehensible. Nevertheless, these morphologic oddi-

ties extend the exploration of a world with elastic forms that can produce the most extraordinary combinations. Passing over Gaster, the stomach personified, with his enormous mouth to gobble food and ears to gobble sounds (*Quart Livre* 57), leaving Quaresmeprenant and the Andouilles for later,[11] let us look at another odd combination, the giant Bringuenarilles (*Quart Livre* 17) and the aerophages of the isle of Ruach (*Quart Livre* 43–44).

Bringuenarilles, "for want of the windmills he usually grazed on" (*Quart Livre* 17), devoured all the kitchen utensils he could get his teeth into—frying pans, cauldrons, pots, and dripping pans—a disconcerting diet that invades the organism with a mess of hardware, a bulky apparatus that dehumanizes the animate or places it in a hybrid space at the crossroads of two discordant realms. The giant, an amphibian creature, also gobbled up cocks and hens "that crowed and cackled inside his body, and flew around in his belly," then ingurgitated "all the Foxes in the land" (*Quart Livre* 44), who went chasing after the fowl, transforming his stomach into a farmyard or a hunting ground; here it is the animal that takes possession of the man and adds one kind of crossbreeding to another in this new alliance against nature.

The inhabitants of the isle of Ruach have a totally different but no less unusual diet: they live on air. They flutter fans, whip up a meal with weathervanes, and live in dread of Bringuenarilles, who comes every spring and gobbles down their windmills, leaving them famished. Do these air-eaters represent the revenge of frugality over gluttony, spirit over matter? Not in the least. Because they suffer from another kind of gluttony, with consequent organic malfunctions: "On that isle they don't shit they don't piss they don't spit. In exchange they copiously break wind, fart, and burp" (*Quart Livre* 43). In good health their stomach is swollen; when they are ill, their intestines are distended with gas; finally, dilated to bursting, they die farting. Doubly monstrous: not only are their swollen bodies deformed, but they have flexible outlines, a changeable configuration. Modeled to the rhythm of their flatulence, they belong to a primitive species with unfinished, malleable anatomy.

These images, as in the work of Bosch, arise from obscure, ordinarily suppressed zones—should we say the unconscious?—and push the exploration of oddity to the limits. But reality goes beyond fiction. A quick survey of period documents shows that monsters also belonged to everyday experience, where they reached a level of extravagance rivaling the artist's inventions. Let us look at a typical page from one of those compilations, a vast repertory of popular beliefs, rumors, and crime stories, that shows the interests and beliefs of common people.

Some children are born so prodigious and deformed that they don't look human but more like monsters or abominations: some are born with two heads, four legs, like one that was seen in this city of Paris while I was composing this book. Others are connected and stuck together, as was seen in our land of France where a pair of twin girls were joined at the shoulders, and one of them after living some time died, and putrefied the other. Polydorus wrote that before Marcellus was chased by Hannibal, a woman gave birth to a child with an Elephant's head. Another having four legs like a beast. In the year one thousand five hundred eighteen, modern historians write that a Roman courtesan gave birth to a boy that was half dog. The authors who wrote stories of the Indies assert that still today you often find half beast children there because of the execrable brutality of brutal men there.[12]

In past and present, on the doorstep and in distant lands, deformed creatures come forth and inhabit the mental space of learned and simple souls alike. The climate of religious wars sharpened curiosity and credulity; Pierre de l'Estoile, one of the best chroniclers of life in Paris at the end of the century, notes, for example:

> That day, the sister of the Saint-Jacques parish priest . . . gave birth in Paris to two children. One was beautiful and well formed, and the other truly a monster; he had neither arms nor legs, just a nose big as a duck's bill, and a virile organ in the middle of his belly as big as you would find on a thirty-year-old man.[13]

It would be a mistake to attribute these preposterous visions to the naiveté of illiterate people. The learned also had a passion for exceptional phenomena and aberrant forms: everything that spoke for the dynamics of *natura naturans* seemed worthy of note. Travelers, for instance, whether they had gone to the Orient or the New World, brought back fantastic stories, backed up with references to existing writings and beliefs for greater veracity. One had sighted giants or Cyclops, another saw unicorns or cynocephalces; one tells about sea dragons and fish with legs, another describes lycanthropes. Legend contaminates the travel journal, fantasy projects all kinds of imaginary fauna to stand side by side with authentic discoveries in geographical accounts. Cosmographers surpass navigators in drawing inspiration from this taste for singularity. Without even traveling they could put together secondhand descriptions of the world based on material from different narratives. Infatuated with wonders, avid for strong sensations, they drew heavily on the repertory of traditional monsters.[14]

Zoology used similar working methods. Attempts to describe and classify animals were applied to an ensemble that goes far beyond the present system. Fantastic species from medieval bestiaries; beasts cautioned by the authority of classical masters such as Aristotle, Pliny the Elder, and Isidorus de Sevilla; exotic oddities of fable and distant travels—all these curiosities were thrown together, introducing aberrations and malformations in the system of nature. In Conrad Gesner's learned treatise, for example, images of common animals are presented in the midst of a captivating gallery of morphologic freaks reminiscent of gothic monsters and Flemish art (fig. 30).[15]

When medicine studied human anatomy, it encounterd countless anomalies that it tried to inventory and explain. The most interesting source here is the surgeon Ambroise Paré, whose treatise *Des monstres et prodiges* brings together richly illustrated documentation on composites and deformed creatures—Siamese twins; men with two heads, four legs, and four arms; hermaphrodites, crosses between human and animal; dwarfs; and all sorts of infirmities, to which he adds a series of monstrous animals from sea elephants to unicorns, flying fish, lions covered with scales (fig. 31). This eclectic approach may seem incongruous in the work of a serious scholar like Paré, who, in fact, was very careful to obtain correct information. But, true to his times, he would not let rigor stifle his interest in the fullest range of manifestations of life. However surprising the absence of critical method in sixteenth-century natural science, we should recognize this avid curiosity as an attempt to rise to the fabulous proportions of prodigious nature.[16]

Gardens: Archaic and Primitive

A huge head stands in the garden, with steps leading up to its gaping mouth, inviting us to walk into the jaws of the monster—or the depths of the earth. We are in the garden of Prince Orsini, in Bomarzo. Entering the garden is like being swallowed by the statue. We are invited to explore the land of monsters and wonders, to stroll through a fantastic savage décor, discover a world dedicated to metamorphosis.

The "Sacro Bosco" spreads out over a rough terrain with steep, tree-covered, rocky slopes. The chaotic landscape evokes primitive nature inhabited with occult powers and shaken by deep convulsions. The intuition of a mobile archaic world is induced by two themes repeatedly developed along the promenade. The site is scattered with false Roman and Etruscan-style ruins—

Fig. 30. Conrad Gesner. *Above: Monstrum satyricum,* in *Historiae animalium* (1551). *Below: Ichtyocentaurus,* in *Icones animalium aquatilium* (1560).

tombs, mausoleums, temple, theater, statues, and buildings—as if it were a ghost town or necropolis, where each monument is a reminder of passing time, fragile forms. A leaning pavilion—landslide or architect's trick?—represents alteration that can strike the most solid structures. The second theme in this archaic voyage is expressed through sculpture; most of the statues refer back to a long distant past, at the origins of life, when the world was inhabited by gods—Persephone, Demeter, Pluto, Janus;[17] huge animals—tortoise, lion,

Fig. 31. Three figures from *Des monstres et prodiges* by Ambroise Paré.

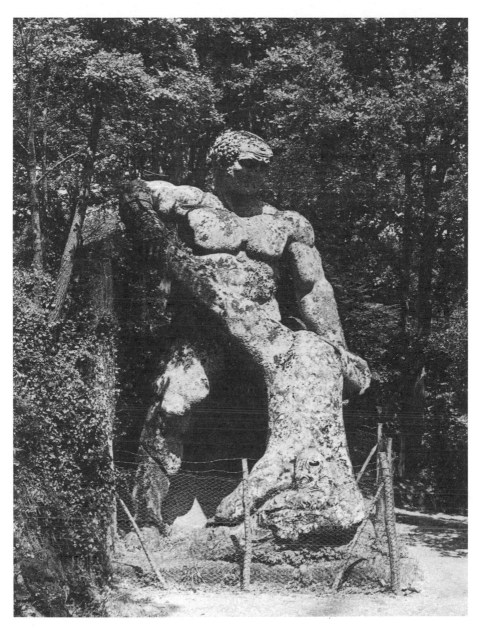

Fig. 32. *Group of Hercules,* ca. 1550–80. Bomarzo, Villa Orsini.

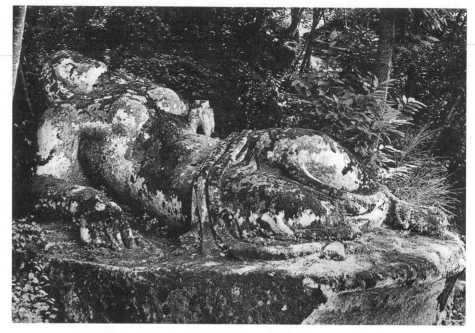

Fig. 33. *Sleeping Nymph,* ca. 1550–80. Bomarzo, Villa Orsini.

elephant; and monsters—Siren, Harpy, Dragon, Sphinx. This variegated population endowed with massive proportions, which preceded man in history, is a reminder of the law of mutations. The space of the garden itself and the gigantic bodies that live in it look unfinished and convertible (fig. 32).

Another effect in Bomarzo's project transports the visitor to an even more primitive stage. Some of the statues are hardly distinguishable, carved right in the rock as if they were just emerging, illustrating the birth of the first living things from the entrails of the earth (fig. 33). These blocks of stone, sculpted yet immersed in the landscape, also suggest an archaic art still in symbiosis with nature that laboriously imposes rudimentary contours on matter. The unfinished statues of Michelangelo give the same impression of solidarity between man and stone, form and formless (see chap. 10).

The stroller is assailed by mysterious signs, perceives multiple possible meanings, but can't systematize them. Though the garden has the usual inscriptions, it doesn't seem to impose any itinerary or interpretation. Something playful—surprises, trompe l'oeil—mitigates the gravity of the exploration. Representations are roughly made, networks sketched out, but they

remain uncertain and, like apparitions that spring up during the promenade, are enriched by their fleeting nature. We are left with a strong, undefined impression of penetrating into the crucible of elementary forces.

Not all Renaissance Italian gardens are as complex as Bomarzo's, but they do follow a plan and invite interpretation. Presented as a world in miniature, they concentrate within an enclosed space the quintessence of the universe and show nature reduced to its foundations. Many of these gardens offer the symbolic spectacle of primeval energies and matter in gestation. What could be better than a garden for such projects? A garden does not have to represent change because, by its very nature, it changes according to the time of day, the season and weather. And art, placed outdoors, is exposed to the action of wind and rain, altered by sunlight and vegetation. The garden is a privileged genre in the Renaissance because it is the ultimate expression, in both its themes and its metamorphic nature, of the principle of the mobile work of art.

These gardens act out an inchoative chaotic world but paradoxically employ highly formalized semiology and calculated effects. A sophisticated style and carefully planned code work in the service of a primitivist project. This is the particular dimension—nature naturing and the naturist dream as artistic effects—of Italian gardens that I will retain here, singling out certain aspects of their symbolism.

The most obvious signal lies in illustration of episodes from *Metamorphoses*. Most of the statues at Villa d'Este in Tivoli and Villa Medici in Pratolino are drawn from familiar Ovidian iconography, widely diffused in illustrated editions since the beginning of the century. At the sight of these recognizable scenes of transformation, these figures of gods, fauns, and nymphs, the visitor feels like he is surrounded by polymorphic mythologic creatures. Beyond these direct references, he may remember that in this same universe an animal or plant, a stone or water can result from a metamorphosis and contain vestiges of a human life. For someone who looks at the gardens with Ovid in mind, they come alive, revive memories of an archaic magical world where life travels from one body to another, one species to another.

A broad chapter could be opened here, but it is so vast and well known that I will limit myself to an allusion.[18] Performances of theater, ballet, and mascarades were often staged in these gardens, many of them based on scenarios inspired by *Metamorphoses* or featuring monsters, divinities, and magicians capable of fabulous transformations. Using new technology, stage settings changed before the spectator's eyes: an island would rise up or disappear, a rock split open, a volcano go up in flames. Everything on stage—setting and

characters, animate or inanimate—could change and startle. The larger setting of the garden as background to this kind of performance had the effect of a superimposition of evanescent forms, where one mobile universe operated within another, also mobile.

The machines that dynamized the theatrical space were also used to put water in motion. Highly perfected hydraulic mechanisms operated in a deliberately chosen landscape, animating the gardens with fountains, cascades, geysers. The ultimate in variations on running water was achieved at Villa d'Este, where water spurts up everywhere, runs, falls, occupies all levels of the space. But many other gardens also displayed the aquatic prowess of engineers. Montaigne, on his way to Rome, was in ecstasy before the omnipresent and constantly renewed fantasies of these spurting, splashing fountains.[19]

Without dwelling any longer on this fashion that quickly spread from Italy to the north, we will keep in mind two symbolic values that confirm the double theme, primitivist and metamorphic, that inspired the architects of these gardens. Water springs up from the depths of the earth (the gardens were often placed over underground springs) and spreads its fertilizing potential over the surface, a reminder of the continuous miracle of birth and restoration of vital energies. Still water in quiet pools is hardly interesting; water has to move to represent the powerful forces at work in nature. Water also serves to illustrate, in the microcosm of the garden, the founding principle of transformation, because water can take all forms but it can also give them. Often associated with rocks, it offers a sort of scale model of geological mutations that order the life of the globe. If the water were left to stagnate, it would mean that the world had reached perfection and could rest. Propelling the water, giving it the motion and speed of different shapes and conduits, is a deliberate choice of a dynamic, transformist representation, to suggest that life constantly rebounds.

Italian gardens were installed by choice on rocky, uneven terrain, preferably located on the flank of a mountain, as in Bomarzo, Pratolino, Tivoli, and many others. If rocks were not provided by nature, they were transported to the garden; if the site wasn't craggy enough, crevasses were dug. The illusion of walking through a savage, rupestral site obviously satisfied a wide demand, which confirms in several ways the perspective adopted here.[20]

"Human beings have a framework of bones to hold their flesh, the world has rocks to hold up the earth," wrote Leonardo, continuing, "the earth has a vegetative soul . . . , its flesh is the soil, its bones are regular blocks of stone."[21] Vitalist thinkers in the Renaissance appreciated the paradox: signs of life in the

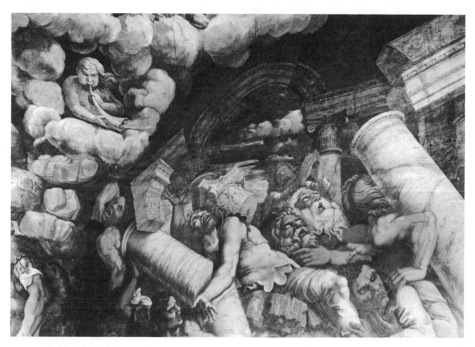

Fig. 34. Giulio Romano, *The Fall of the Giants,* 1526–35 (detail). Fresco, Mantua, Palazzo del Te.

macrocosm are manifest all the way to the apparently inert mass of rocks. This claim of an organic existence for stone was a reminder that everything changes and participates in the universal animation. Renaissance painting certainly doesn't have a monopoly on rocky landscapes and rupestral settings—they date from the early Middle Ages—but we can fairly suppose that the accumulation of rocks, peaks, and grottos in the works of Leonardo (see figs. 45 and 46) and many of his contemporaries acquires new pertinence within the context described here. They symbolize the dissemination of the spirit across the deceptive barrier that would seem to separate the animate from the inert. Placing men among rocks and rocks among men is a way of intimating the latent life force that unites them.

Renaissance artists, taking up a commonplace theme in the representation of archaic life, freely exploited the connection between rocks and giants, perhaps recalling the gigantomachy of Greek myth. The extraordinary Hall of Giants by Giulio Romano, at Palazzo del Te in Mantua, imitated by Perino del Vaga at Palazzo Doria in Genoa, shows the titans crushed under huge blocks

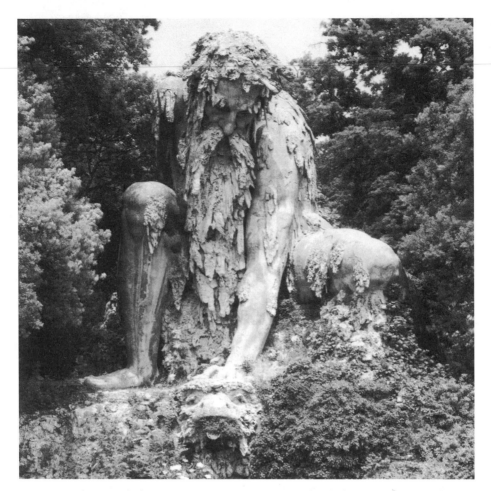

Fig. 35. Giambologna, *Appenino,* ca. 1580. Stone, brick, lava, cement. Pratolino, Villa Medici. *Facing page:* detail.

of stone in a collapsing grotto (fig. 34). The combination of two emblems of the *terribilità* of primeval ages—colossal figures and the savage, rupestral décor of rocks and caverns—creates a stupefying impression of cosmic upheaval and primitive violence. The awesome eleven-meter-tall Apennine Giant of Pratolino stands like a rock (fig. 35); is this huge mass of rough-hewn stone a mountain turning into a man or a man transformed into a mountain? Rarely has the affinity between human and primeval, the conflict of form in the grips

of chaos, been expressed with such force. The Appenine colossus could also be an Atlas, another character petrified into a mountain, found in many gardens; once again, the insertion of an Ovidian metamorphosis into the landscape.

The confusion between human and mineral in these gardens gave sculptors an opportunity to produce some of their best effects. Instead of hiding the raw material and imposing the figure to create an illusion of reality, they left the statue like a half-quarried block embedded in the surrounding rock. These images of the larval life of the origins are not rare. The Fountain of the Shepherd in the Villa Farnese gardens at Caprarola (fig. 36) resembles a huge, rocky mass

Fig. 36. *Fountain of the Shepherd,* ca. 1570. Caprarola, Villa Farnese.

with satyrs, terms, and river gods half-encrusted in the stone, their outlines blurred by the water fountain that constantly pours over them. But the ultimate is certainly attained in the Grotta Grande at the Boboli Gardens in Florence. The main room of this artificial cavern is covered with pumice stone, stalactites, and crags encrusted with sculpted shepherds, animals, and plants (fig. 38); moss and ferns grow in the rivulets of water dripping down the walls. A rustic landscape of rocks and cascades is painted on walls and ceiling. An eerie scene, vaguely perceivable in the dim light, where dampness has blurred the outlines of figures that can barely be distinguished from the rocks. In the early 1580s Michelangelo's unfinished work *The Slaves* found a rightful place among this population of stone men,[22] a pertinent addition to the spectacle of life slowly, silently emerging from matter—or returning to it.

Grottos, natural or man-made, figured in the landscape of many Italian and French gardens,[23] often serving as demarcation between the garden and the

Fig. 37. *Grotto of the Animals,* ca. 1570. Castello, Villa Medici. The parietal concretions are by Giambologna and his workshop. In the background, one of the three basins shaped like antique sarcophagi is surmounted by a group of animals.

surrounding countryside, the spaces of art and nature. Clever decorative artifices created an illusion of naturalness, using trompe l'oeil techniques to give the impression of a rough, primitive, subterranean world. The walls were covered with pumice stone and encrusted with shells, coral, colored marbles, or crystals (fig. 37).

Bernard Palissy, specialist in artificial grottos, designed fantastic rustic lairs for his landscape projects. In *Recette véritable* he describes in detail the arrangement of a garden that includes, among other wonders, eight false caverns or, as he calls them, "cabinets."[24] The outside of the first "will be built with big uncut, unpolished rocks, so that the exterior of the said cabinet will in no way resemble a building" (129). To reinforce the illusion of a savage site, shrubs will grow over the rocks and *pissures* ("pissing" water spouts) will spurt out of false

Fig. 38. Bernardo Buontalenti, *Grotta grande*. Florence, Boboli Gardens. Finished in 1584, it is composed of three parts. Decoration in spongite, figures in tartar, and pebbling against painted walls. Hydraulic surprises.

crags. But the interior is just as important as the exterior. Palissy would apply all his skills as architect, sculptor, and enamel worker to pursue the same rupestral impression. In the fifth cabinet, the rock will be "made of rough, enameled terra cotta, made to look like twisted, lumpy rock, in various strange colors" (139). The walls could be covered with tortoises, serpents, lizards, and, to perfect the appearance of an underwater habitation, trompe l'oeil plants, mosses, frogs, crawfish, and crabs.

The constant element in all these grottos is the combination of rocks and water. The mineral will be worked over by dripping and seeping and by colors that animate it and cover it with the strange germs of dull vegetation. The types of stone used for decoration accentuate the impression of dampness: porous and pumice stone, chalk concretions, tuff, and stalactites, sometimes brought from a distance. Philippe Morel gives a good explanation of the symbolic coherence of this combination.[25] It represents the birth of stone, engendered by petrification under the effects of dampness, plant and animal substances, or, according to common belief in those days, the mixture of earth and water:

> All of this—the symbiosis of earth and water, solidified mud, congelations of petrified water partially covering the dripping grotto walls, water trickling from stalactites by the artist's will—functions like a veritable mise en scène of the generation of mineral nature.[26]

Once more attention is focused on the process of formation, the birth and initial rough state of mineral substance. As Philip Morel writes, "imitation is displaced from the object to its genesis."[27] There is no doubt that the grotto symbolizes the earth's womb, the matrix in the heart of matter where life gradually takes shape; workshop of *natura naturans,* it constitutes on a small scale a cosmogonic scenario and plays out the spectacle of generation of elementary forms.

Images of classical mythology rich in caverns—grottos of Kronos, Ocean, Demeter, Protheus, aquatic nymphs, or sibyls—were still vibrant in Renaissance minds. A modest treatise by Porphyrius (third century A.D.), *De antro Nympharum,* offers a symbolic interpretation.[28] The ancients, he says, consecrated their grottos to the cosmos because of their analogous relationship. The universe is composed of matter; this matter is in perpetual flux and has no stable configuration; the cosmos (in spite of its name) is basically fluid, opaque and formless, so it follows that the cavern as emblem of confusion and chaos is an appropriate symbol. The grotto puts man in contact with primeval forces and acts as a theater of the obscure mutations that work the globe.

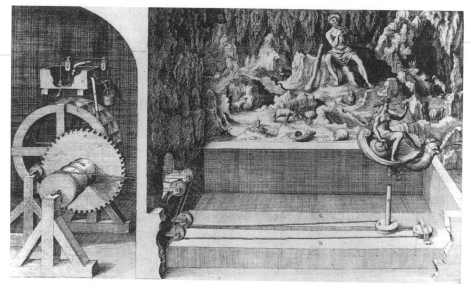

Fig. 39. Cyclops and Galatea, hydraulic machine. Excerpt from *Les Raisons des forces mouvantes. Avec diverses machines tant utilles que plaisantes,* by Salomon de Caus (Frankfort, 1615).

In a letter written in 1552, Annibal Caro recommends certain motifs to heighten the charm of grottos, such as singing shepherds and dancing nymphs, fauns and other fantastic species, or, even more appropriate in a sub-terranean site, Vulcan and his forge, the rape of Proserpine, Ulysses blinding Polyphemus, and Circe transforming men into beasts.[29] Such animated scenes were made possible by the development of hydraulically operated automatons. Statues moved, made music, created illusions all the more appreciated because the technique was new. Visitors to Pratolino discovered countless surprises from one grotto to another: the god Pan playing the flute for his mistress, the Good Samaritan coming to a well and filling his jug, a whirling windmill. Sal-omon de Caus, a French specialist in hydraulic wonders, gave an explanation of the physical principles that regulate the operation of the machines and then suggested how they could be applied. For example, he described "a machine representing a Galatea drawn straight across the waters by two dolphins and coming back by herself, while a Cyclops plays the shepherd's flute."[30] The ac-companying illustration shows, on the right, the scene as spectators would see it and, on the left, mechanical details of the water wheel and pulley that make the figures move (fig. 39). These machines could be installed in all sorts of set-

tings, but the combination of a subterranean site and a mobile assembly was ideal.

The joint attraction of the primitive and metamorphosis is crystallized with particular clarity in these assemblies. The association of the grotto with mythologic scenes peopled with gods and monsters pertains doubly to an archaic time at the dawn of the world and history. But the fascination they exert is intensified because a magical movement emerges from a background of inertia. Matter is animated, the rock is humanized, as if one could see the first stirrings of life in the womb of the earth. The spectator feels like he is reliving the passage from chaos to cosmos. He revels in two strong sensations: the spectacle of primal origins and, by virtue of a mechanical exploit, an exorcism, a demystification, the triumph of playful enjoyment over frightful shudders.

The "Grotesques" Controversy

At the end of the fifteenth century, humanists with an interest in archeology excavated underground Roman dwellings and came upon antique frescos. They discovered fine decorative motifs of landscapes and mythologic or pastoral scenes combined in a rich display of graceful symmetries with ornamental structures of garlands of fruit and foliage, acanthus and rosettes, columns and spirals. Here and there interlaced arabesques were punctuated by fantastic hybrid bodies. This curious combination of half-geometric, half-figurative forms, known today as the Pompeian style, was named *grotesques,* after the *grottes* where they were discovered.[31]

The style was soon adopted by artists attracted by its beauty and prestigious Latin authority (fig. 40), starting with Raphael and his studio, directed by master decorator Giovanni da Udine. Frescos with a wealth of classical motifs spread over walls and ceilings in palaces and churches. Ornamentation spilled over from the heavily charged framework onto vaults and corners; wherever there was an inch of free space, it was covered with grotesques. The technique soon went from architectural decoration to engraving and crafts—tapestry, crockery, fashion—spreading far and wide with the use of stucco. The fashion went from Italy to northern Europe, influencing, among others, the Fontainbleau School.

The vogue for grotesques would undoubtedly have been short-lived or restricted to an élite of classical inspiration if it had not been reinforced by medieval survivals: illuminations, gargoyles, deviltries, and clowning, decorated with fantastic ornaments and monstrous figures and deeply entrenched in

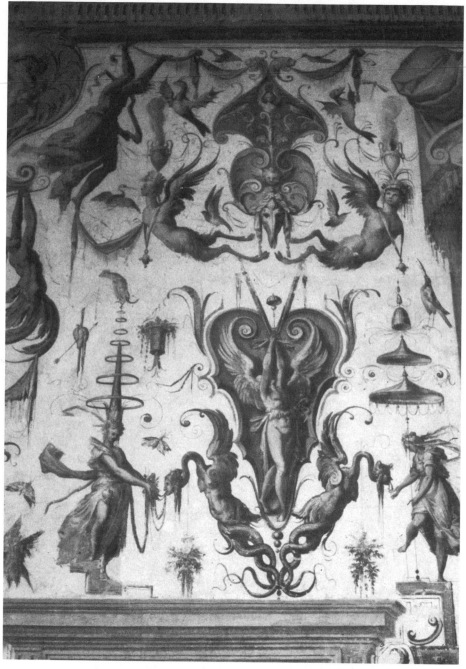

Fig. 40. Giovan Antonio Paganino and Cesare Baglione, grotesques décor in the Salon of the Jugglers, 1585 (detail). Parma, Castello de Torrechiara. Photograph by Philippe Morel.

popular culture and traditions. The two currents fused, with varying proportions of classical chimera and medieval demons, Pompeian geometry and gothic festoons, crisscrossed and cross-fertilized, giving a style that uncustomarily cut through a wide range of different genres and cultural levels.

Its success is all the more surprising given the strong disapproval by art theoreticians. A fierce controversy broke out in Italy in the second half of the sixteenth century; authors of grotesques were accused of being ridiculous, if not absolutely pernicious and reprehensible.[32] Abundant flows of critical ink had no effect on the vitality or increasing popularity of the style; nevertheless, the pious reprobation of scholars and critics deserves our attention, inasmuch as it reveals the anxiety provoked by this strange fashion, all the more appealing for some and suspect for others because it opens onto the troubled world of the primitive.

Not all commentators were hostile. In his dialogues on art, Francesco Doni treated the proper uses of the imagination.[33] "Fantasia," as he calls it, produces all sorts of wildly proliferating images unbridled by the rules of truth. He places the grotesques in this category, similar to the optical illusion of unreal forms, animals, heads, castles that we see in a stain or a cloud. Doni calls these unstable effigies engendered "in the chaos of my brain"[34] *chimeras,* giving them the same status as dreams. In this realm, oddity and eccentricity become guarantees of authenticity and, contrary to most theoreticians, Doni seems willing to defend them on the grounds of the legitimacy of imagination in art.[35]

It is precisely the affinity between the grotesques and this ordinarily repressed register that provoked anxiety and reprobation. Vasari views with circumspection a genre without rules where "the person with the wildest imagination passes for the most talented."[36] Refusing the term *grotesques* Benvenuto Cellini prefers the designation *monsters,* more appropriate to the style's characteristic crossbreeds.[37] Whether or not this choice is meant as a criticism, it is revealing: categorizing these Roman-style decorations as monstrosities emphasizes the fact that they are not innocent decoration. Real or imaginary, the hybrid bodies of the grotesques suggest couplings against nature and defy the normal classifications of living species. Even to those (numerous, as we have seen in chap. 2) who recognize the infinite creativity of nature, grotesques show the somber, irrational side of life with its unsightly protuberances and extravagances. When serpent is crossed with man, column with flowers, bird with foliage, the door is open to any and all alliances. People cut off from religious and magical thought might see the grotesques as amusing, ornamental

caprices; to the sixteenth-century mind these composite figures represent a world animated by continuous metamorphosis, where all parts communicate and combine: whether delighted or horrified by this nature deprived of stable structures and predictable evolution, they certainly did not disqualify it.

So the descent into the Roman underground, the imitation of little monsters on antique frescos, is more adventurous than it might seem. It liberates dark forces, starts a regressive movement toward the universe of myth, and opens on a primitive world before Christian creation, before the Aristotelian order. It is precisely because the grotesques touch on this elementary source that they inspire pleasure or repulsion, attracting many people and disturbing theoreticians who, it should be mentioned, were often closely allied with the moralists. Without going into all the different arguments here, I will review some of the most significant lines of defense.

Using the same analogy as Doni, Daniele Barbaro took a resolutely critical attitude: the grotesques are "dreams of painting" because, like the sleeper's imagination, they produce absurd figures. They are the visual equivalent of the art of the sophist who, unhindered by the truth, "engenders monsters."[38] Barbaro was the editor and commentator of Vitruvius's *De Architectura.* Already in the first century B.C., in his chapter on mural painting, Vitruvius condemned the decorative style that later developed into the grotesques, using arguments that would be abundantly reappropriated in the Renaissance.[39] Vitruvius's position is simple and forceful. Painting, he says, should depict "what is or can be."[40] We recognize here the Aristotelian principle of art as mimesis of reality, or verisimilitude; art conforms to nature and builds on a basis of things that are certain. Then this aberrant practice comes along. Artists compose impossible creatures that have never been seen—*monstra*—and invent motifs that subvert the laws of nature—houses on candelabras, statues with half-human, half-animal heads perched on the rooftops. These images of an upside-down world are contrary to what is rational, proper, and moral. They should be banished.[41]

This thesis is a concentrate of classical aesthetics: art is subordinated to the task of representation and subject to the strict control of reason by way of rules of verisimilitude, decorum, and clarity. Gratuitous fancies of form and excess novelty are denounced, limits are imposed on imaginative deviation, complaisance with fantasy is disapproved. When art goes too far in exploring the primitive, classical aesthetics can be used as a safeguard; sixteenth-century tenants of order and restraint did not hesitate to invoke its authority.[42]

Another strategy amounts to neutralizing the grotesques by giving them

hidden meaning; monsters are only signs of something else, and the imagination, far from being a threat to reason, works in its service. This theory is defended by Pirro Ligorio in an unpublished collection and by Giovan Paolo Lomazzo in his treatise on painting.[43] Their shared point of view can probably be explained by the fact that they both belonged to Counter-Reformation culture and as such subscribed to the moralizing didactic program that tended to reduce art, and especially painting, to its allegorical value. I will just point out here the broad outlines of their position.

The so-called scandal of the grotesques, say Ligorio and Lomazzo, is due to a misreading. Only ignorant people who don't understand the true meaning can be frightened by them. Because, in fact, chimeras are not vain and even less reprehensible; they are symbols, they compose a coded language whose deep meaning is clear to initiates. Proper people are shocked by a certain satire? In fact, it is a denunciation of lasciviousness; the siren represents female nastiness, and the sphinx stands for prudence.[44] Such moral interpretations are certainly the most reassuring, the most apt to exorcise the monsters but, for these theoreticians, they do not exclude other semantic registers, such as the symbolization of natural laws or divine secrets. The codes, not at all haphazard, are derived from a venerable antique code based on mysterious analogies. Hermetic thought misappropriated the grotesques, diverting them into the family of myth, fable, or hieroglyphics, where ancient philosophers hid knowledge and wisdom behind a frivolous appearance. According to Ligorio and Lomazzo, the grotesques are similar or even identical to "emblems," a very prestigious genre in those days: emblems and grotesques are both enigmatic images that reveal their authentic meaning when subject to the right set of codes. The initial surprise gives way to certainty and mental tranquillity; the savage sign has been domesticated and the troubling strangeness conjured. So the grotesques are rehabilitated into an inoffensive, edifying, noble language. But at the price of what recuperation!

Cardinal Gabriele Paleotti, not just a representative but a protagonist of Counter Reformation ideology, engaged a frankly militant crusade against the grotesques, allowing them no mitigating circumstances.[45] His treatise appeared in 1582, at a time when fashion had brought the antique-style decorations all the way into the churches, where they spread over walls, altars, and liturgical objects and garments. According to the cardinal, these frivolous objects are absolutely incompatible with the dignity of sacred places. Worse, they introduce into the heart of Christianity the very emblem of paganist error. Paleotti, apparently unconcerned by the paradox, didn't hesitate to invoke Vit-

ruvius and the Aristotelian principle of mimesis as authorities: submission of art to nature and reason, limits of verisimilitude. Classical theoreticians denouncing imaginative extravagance and the priest fulminating against the profanation of the temple used the same arms. Taking even one step away from nature was giving free rein to fiction, rendering any and all fantasies legitimate.

But what is most interesting about Paleotti's vituperation is the hypertrophied obsessional image of the grotto. Fascinated by the connection, however tenuous, between grotesques and grotto, moved by a mixture of repulsion and attraction for the forbidden object, he used it as a pretext for a long dissertation on the symbolism of the cavern that becomes, *a contrario,* supplementary proof of the attraction it exerted in those days.[46]

Paleotti, like many others, relies on etymology, tracing the word *grottesco* back to *grotto,* which comes from the Greek *kryptè,* itself derived from the verb *krypto,* to hide (2640); so it is a dark, secret place. The learned bishop begins with a balanced definition of the *grotto-cripta* complex. Then, gradually carried away by his imagination, he explores subterranean sepulchres and a variety of funerary crypts and cites the famous passage in which Saint Jerome tells how, still a child, he was frightened to death when he went down to the catacombs to see the skeletons. Pagans used these places buried in the "earth's entrails" (2642) for all sorts of doubtful activities: magical rituals, "obscene and dishonest" practices (2648), conciliabules "to speak in secret and with greater freedom against princes or important people" (2648), and cool baths. Shuddering at the thought of such horrors, the bishop concludes by explaining that the ancients interpreted the grotto as a symbol of night and its attributes,

> which are motion in the airs, chimeras, the most extravagant fantasies and oddities; that is why they imagined that night was the daughter of Chaos and the wife of Ereb, [whose sons] changed themselves into various forms, savage beasts, birds, serpents, stones, tree trunks, and other fantasies as told by Ovid.[47]

Dream visions, phantoms, chaos, monsters, metamorphosis—once again we find all the images of primitive transformation reunited in the figure of the grotto. But here the fertile womb is replaced by a sinister limbo, a ghostly, nightmarish hole.

So that is the baleful cradle of the grotesques. At this point, moved by historian's scruples, Paleotti admits that the rooms where the Roman frescos were discovered were not necessarily subterranean in ancient times; the association might be gratuitous. But he immediately brushes away this obvious objection

that would compromise the intrinsic relationship, central to his argument, between grotto and grotesques and instead proves the constitutive link. First hypothesis: artists decorated the grottos with chimeras, wild obscure images, precisely because grottos symbolize night and dreams. But he seems to prefer still another explanation: the underground rooms were sanctuaries of infernal gods, where sacrifices were made to terrifying idols. Because these places were so horrible, the ancients imagined the divinities as monsters who could assume all forms; they called them "lemures, larva" (2650). Decorators adapted their art to these superstitions, and that was the infernal, fiendish, sacrilegious origin of the grotesques.

Paleotti doesn't spare his effects. In the very act of combating the lies of fiction, he constructs his own sumptuous theoretical fiction based on fanaticism and fantasies. But he was not alone in clinging to this nucleus of primitive obsessions fixed in the image of the grotto. Grottos were fascinating to the sixteenth-century mind because they evoke a chaotic, inchoate, mobile, irrational world. The pious bishop was undoubtedly wrong from a historical point of view, but as spokesman for the imagination of his times, he was absolutely right.

PART THREE

Culture and Its Flow

6

"We Are Never in Ourselves"

Self-made Man

Pico della Mirandola's "Oration on the Dignity of Man" is one of the most forceful and influential humanistic manifestos.[1] The first part—and the only one that concerns us here—vibrates with optimism and abundant praise. Taking up the chant of generations of thinkers, Pico declares that man is a matchless wonder in the world. What is the reason for his superiority? The cause of his grandeur? Pico replaces the outworn reasoning of age-old theological and moral traditions with his own personal arguments; giving a highly original turn to the story of the creation of man, he lays the foundation, in a few brilliant pages, for the most radical metamorphic anthropology. Not content to repeat the commonplace litany of man's fundamental instability, Pico affirms the aptitude for change as the height of dignity. This text created in one of the centers of European humanism opens a new perspective in our investigation; the principle of transformation not only explains movements in nature, it also is an essential key to human existence.

The Book of Genesis teaches that man came last in the order of creation. Pico takes this as the basis for an intriguing fable. As the Great Worker approaches the end of his labors, he has run out of archetypes; he has no specific features left to differentiate man. So Adam and his posterity have to make do with features already attributed to other creatures. God "decided that this creature who could have nothing for himself alone [*nihil proprium*] would share everything that had been given specifically to each of the different kinds of

creatures."[2] Consequently, Pico explains, man is indeterminate. And this would be his consolation and compensation. Having no distinctive appearance or function, he could take whatever place, appearance, and function he wanted; deprived of an identity, he would enjoy absolute freedom; given access to all possible features, he is his own architect:

> The nature of all other beings, says the Lord, is limited and restricted by laws that We have prescribed. You, limited by no restrictions, judging by your own free will that I entrusted to you, will ordain for yourself the limits of your nature. . . . This is why We created you neither of heaven nor of earth, neither mortal nor immortal, so that with free choice and honor, as if you were your own maker, you may take the form that you prefer.[3]

Such a hymn to freedom had rarely been heard: man is free to choose his destiny, construct a self, be what he wants (*id esse quod velit*). The key words in these pages are the verbs "to want," "to be able to," and "to wish," and the dominating idea is free will, with absolutely no restrictions. Aristotle and the Scholastics had attributed distinct immutable properties to the human race, postulating its basic stability; God by his grace can change man, but man himself cannot escape from his nature. Now an absolutely humanistic voice speaks out and sets free will against all types of determinism, whether divine, natural, or social.

Since man had not been completely created, he would create himself. "He himself molds, fashions, and changes himself into the form and flesh and into the character of every creature."[4] Of his own free will, he decides on his rank in the chain of being: vegetative, he will be like a plant; sensual, he'll share the fate of beasts; rational, he becomes a celestial being; intellective, he will be like an angel, a true son of God. Man, says Pico, endowed with a nature capable of such transformations, is a chameleon, a Proteus. And, he adds, we should recognize in the mythical Proteus, as in all tales of metamorphosis, the perfect emblem of the human race.

Of course, the fable of chameleon-man[5] respects a moral finality: responsible for his own destiny, the individual should use his freedom to orient himself toward goodness. But this lesson implies an ontological corollary that is more important to us here: the grandeur of human beings lies in their indetermination, the capacity to assume all possible identities. The ideal man is a man in the making, malleable matter that can take all shapes. Paradoxically, Pico's notion of man lies in the complete absence of a defined human nature. Because he has no essence, no constraining model, man is pure potential; he received "the seeds of all kinds and the germs of every way of life,"[6] and it's up

to him to cultivate them. The beginning of "Oration" is alive with the marvelous image of a creature liberated from forms, an indomitable force that nothing can check.

Another allegory in praise of man, *Fabula de homine,* by the Spaniard Juan Luis Vives,[7] was probably influenced by Pico's "Oration," though the argument is far less conceptual. Vives is satisfied to tell a charming tale, which we can take as complementary to the works of Pico della Mirandola. As Vives tells it, Juno celebrated her birthday by offering the Olympians a sumptuous meal. But the felicity of the gods could not be complete without a dramatic performance. A stage is set: it's the theater of the world where Jupiter's actors will give a play. One of the actors is particularly appealing—the human being. He's such a talented mime, he can play all the roles; here he's a plant and there, several different animals. Finally he plays himself—a courteous, knowledgeable, just, and sociable creature. But man hasn't yet reached the top of the chain of being (this reminds us of another image of the Renaissance mind, the satyr in Hugo's *La Légende des siècles*). To the utter astonishment of the immortals, man escapes from human contingencies and takes on their godly appearance. Then, in an ultimate metamorphosis, he stands majestically on the stage, displaying the splendor and might of Jupiter himself. He plays the role so well that for a second the audience is in doubt: is this an illusion, or is he really the master of the universe? To honor such a triumph, man is offered nothing less than an invitation to share the feast of the gods at the celestial table.

It is true that Vives does not have exactly the same vision of man as Pico. Vives sees the varied existences incarnated by man as a sort of theater; though man assumes all roles, he is still endowed with human properties that he conserves. Not absolutely indeterminate, he still has great scope and can embrace all conditions. Man is like a microcosm that unites all extremes from the most natural to the most spiritual, assembles all properties of physical beauty and intellectual strength. Vives, like Pico, uses the chameleon and Proteus as analogies to illustrate the fundamental idea that the grandeur of man, which is his aptitude for spiritual life, is derived from his metamorphic nature. Because, for better or worse, he can transform himself indefinitely, because he can rise to any level, he is almost an equal to the gods.

In all likelihood Pico and Vives owe their notion of protean man to the Neoplatonic theory of knowledge. They may have found the philosophic basis for their panegyrics in a chapter of *Theologia Platonica,* where Marsilio Ficino attempted to explain the mechanism of knowledge.[8] All things, Ficino recalls, exist first in an abstract form, the ideal model of which individual ob-

jects are the realization. The human mind, he continues, is a flexible, open organism that, "like matter, aspires to an ulterior form" (257). So it is easy for the mind intellectually to grasp things, or at least their intelligible idea. The mind absorbs the form of objects, and this is how knowledge works: "The intellect does not know things unless it is fitted with the forms of objects to know." Ficino compares this to eating: just as the body assimilates the nutritional substance by digestion, the soul takes in the ideal models of things. Absorbing ideas is even easier than absorbing objects because matter has physical resistance against union but ideal forms slip into the intellect without obstacles. Consequently, knowledge depends on fusion: "One whole thing comes from the union of our intelligence with the form of the intelligible object" (258).

It follows from this theory that the soul can take the form of all things. What's more, its vocation is to become all things: "The intellect almost becomes the things it understands. I mean it becomes this thing in act . . . ; this actualization is the very act of understanding" (258). Infinitely receptive, the soul can experience all categories of objects, all modes of being. To illustrate the soul's metamorphic nature, Ficino lists and classifies in ascending order, as Pico and Vives would do later, the different lives it can lead, from vegetable to God, passing through all stages of animal, man, hero, demon, and angel. And what is true for the soul is true also for human beings; thus, a theory of knowledge leads to anthropology: "Humankind tries to become everything because human beings lead all kinds of existences" (256–57). Ficino was, of course, motivated by a metaphysical purpose—to give human beings the will to become God—but the general conception of existence implied ensures maximum intellectual mobility by offering man unlimited possibilities of transformation.

Portrait of the Humanist as Proteus: Petrarch and Erasmus

Ficino, with his fusional conception of knowledge, Pico and Vives with their enthusiastic vision of man climbing up the chain of being, concocted theoretical fictions. But there is not such a great distance between their speculations and the life experience of certain humanists. Many Renaissance scholars did actually construct their lives on the basis of principles of variety, mobility, and change, as if they shared the philosophic ideal of an existence open to multiple mutations. To show how the destinies and conduct of many Renaissance men were influenced by the spirit of metamorphosis, I will sketch (and fit into our perspective) portraits of two key figures of humanism: Petrarch, at its beginnings, and Erasmus, at the zenith.

Though Petrarch lived before the designated period, he is not out of place here; throughout the Renaissance he stood as a founding father and example to be followed. What style of life did he bequeath to the humanists? Fervent erudite, he loved nothing more than the pursuit of his studies—reading and writing, philology, meditation—in a quiet, private place. Yet he never stayed for long in his ivory tower.[9] He traveled far and wide, got involved in public life, tried all different kinds of activities, but never stopped blaming himself for this versatility and bemoaning the loss of his scholarly retreat. The tension between *otium* and *negotium,* the contemplative and the active life, determined both his sense of himself and the rhythm of his activities. Yearning for stability, Petrarch was unstable in spite of himself; wishing for unity, he gave in to multiplicity. By design or in spite of himself, the father of European humanism already presented the metamorphic disposition of the chameleon.

As scholar and writer he was interested in everything, offering the profile of an astonishingly changing, varied man of letters: philologist and editor devoted to the ancients, historian, moralist, letter writer, and author of poetic works in epic, bucolic, and lyric modes. He wrote in Latin, but his love poems are in Italian, and he experimented with many very different genres and styles. Even before he strayed away from his desk, he had already shown extraordinary flexibility. But how can you remain cut off from the world when you have to go everywhere looking for manuscripts, collecting them or studying them where you find them? When you have to orchestrate the distribution of your works, then solicit and accept the official crown of poet laureate?

In fact, Petrarch was never a prisoner to his books; he was interested in current events, took a stand on burning questions, constantly broadened his scope. A rich correspondence, which would become one of his best works, shows him at the center of a vast network of friends, interested in hundreds of moral, literary, and political questions. He efficiently handled his own affairs and still found time to devote himself to public causes; charged with diplomatic missions, intimate with the powerful—emperors, popes, and local leaders—he was occasionally active in the fourteenth-century civic arena. And how could we forget the other facet of the portrait, traced in the *Canzoniere?* The lover obsessed by his passion for Laura and, through her, for the supreme good?

This polymorphic activity found its best expression in travel. In his mature years, Petrarch couldn't stay in one place. Explorer or exile, pilgrim of God, science, or politics, he followed his curiosity wherever it took him, zigzagging through Italy and Provence, pushing north to Paris, Cologne, Basel, Prague.

There is an enormous contrast between this vagabond humor and the traditional quietude of the monk or wise man that still attracted him. Everything seemed to predispose him to a smooth contemplative existence. But something broke and turned Petrarch into a multiple, variable, wandering soul, the very image for posterity of a restless man, torn from himself by the flow of events or, in a more positive way, an example of open-minded flexibility, which is the sign of freedom. Petrarch's psychological and intellectual mobility may have been an indication of the beginnings of modernity; in any case it announces a conception of life that would be widespread in the Renaissance.

We find here the outlines of a philosophy of life similar to "existential phenomenology."[10] The humanists, prefigured by Petrarch, are literally or figuratively travelers, seekers, and investigators, less concerned about constructing an identity or coherent works than pursuing the adventure of relentless search—of others and oneself. Introspection and self-portrait hardly reveal any unified continuous entity; the ardently desired and scrutinized inner self seems so vulnerable, fragmented by external shocks, vaporized by centrifugal forces. The person as composed by many humanists is a sum of variegated elements—events, humors, social pressures—in unstable equilibrium, constantly demanding redefinition. It follows that the self, far from being a distinct homogenous subject, occupies an open moving zone in osmosis with the outside world. Adaptable, permeable, exposed to contingencies, man is conceived as a system in constant mutation: a mobile. Whether the dissemination of the personal core is seen as loss, anguish, or the normal consequence of joyous expansion, the feeling of an alleatory, disjointed, changing existence is widely shared.

The itinerant destiny of Erasmus is well known. Pushed by circumstance, curiosity, or need, accepting invitations and then fleeing dependence, he was constantly on the move, and his friends, scattered all over Europe, constantly complained about losing track of him. Ambrosius Leo wrote to him from Venice:

> I heard . . . you had died in France and a few years later come to life again in Germany. Then [they said] your loss was mourned in Germany, and soon afterwards you reappeared in Italy. Lastly, I was given to understand that you had met your end in England and have now retraced your steps from Avernus and appeared in France.[11]

Vanished here, turned up there, dead and reborn; this series of migrations, adds Leo, "gives me the impression of seeing a new Pythagoras." And he goes on quite matter of factly to invoke Proteus:

You not only changed from an Italian to a Frenchman and from a French-
man into a German (like the change from a calf into a bird and from a bird
into a kind of breadcorn . . .), but you have turned from a poet into a the-
ologian and effected a transmigration from theologian to Cynic philoso-
pher, and then finally exchanged the Cynic for an orator—marvellous meta-
morphoses, which we thought the property of Proteus and no one else. For
I have seen numberless books of yours in print, in which you have rung the
changes on the different personalities or characters of which I speak.

And Erasmus's correspondent adds that so many "metamorphoses" had led
readers to think that his books "were the work of at least three or four authors."
 In his reply Erasmus betrays indecision. He refuses to be taxed with "nat-
ural inconstancy": "in all the changes and chances of my fate I have always
been the same Erasmus who never changes."[12] But he admits that an unpre-
dictable, turbulent, nomadic life is his misfortune. "My own destiny has in-
flicted on me more mishaps and more wanderings than ever Neptune in
Homer gave Ulysses!" He accepts the comparison with Pythagoras and Proteus
but, taking it as a blame, incriminates the social scene: "right away I had to
play another character." Behind masks and circumstantial roles, the wise man
prefers to remain whole and intact. But in the eyes of the public, he is Proteus.
 It would seem that for Leo the disparities in the work determine, no less
than the travels, this portrait of mobility. They thought they could pin Eras-
mus down to a specialty, but he was already somewhere else, always prospect-
ing new territory. He confided to a friend:

the man who hopes to win a reputation by what he writes should choose a
subject to which he is by nature suited, and in which his powers chiefly lie;
all themes do not suit everyone. This I have never done.[13]

Erasmus made this confession in 1523, just when he envisaged the first publi-
cation of his complete works. In this same letter he lists a catalogue of his writ-
ings up to the present date, organizing the widely diversified production into
nine groups that will compose the nine volumes of the projected summa: (1)
didactic manuals for teaching letters, (2) adages, (3) epistles, (4) treatises on
morality, (5) pious works, (6) translation of the New Testament with notes, (7)
paraphrases on the New Testament, (8) apologetics and polemical discourses,
(9) edition of the letters of Jerome.[14]
 Erasmus lived thirteen more years after completing this compilation, time
enough to add significantly to the variety and versatility of his intellectual bi-
ography. Never satisfied, he was constantly broadening and deepening his

works; inspired by insatiable curiosity he was always exploring new pathways. Tireless, hurried, compulsive worker, he was committed to a gigantic task that, as we will see in chapter 9, he compared to the labors of Hercules. The centrifugal tendency is all the more perceptible because Erasmus was operating throughout his career in two vast, difficult to reconcile territories. Erasmus was both a disciple of the ancients and a witness of the gospel, "the Christian of *Enchiridion,* the pagan of the *Adages,* and the wise man of the *Colloques.*"[15] He never made a choice between the love of literature and service to the divine Word, even if he oscillated between them throughout his intellectual life. Why neglect Greco-Latin civilization, with its models of wisdom and style that did so much to improve life and extend man's faculties? But how could he not concentrate also, and increasingly, on understanding and disseminating the Scriptures, restoring to the church the spirit of Christ without which our action remains vain and sterile? Erasmus wore these two faces, literary and theological, not to mention all the others. Luther described him as a slippery eel.

Protean in character as in his writing, Erasmus dreaded commitments, and abhorred submission to restrictive people or causes, which is one of the reasons for his peregrinations; he went from one protector to another to avoid contracting durable obligations to any one person. Quarrels of schools, nations, and beliefs were raging? Fanaticisms gaining ground? Erasmus would pull his chestnuts out of the fire. He showed absolute independence, for example, on the humanist scene. He fought for the study of antiquity but denounced the paganism of certain scholars and aesthetes; strived to restore good Latin but rejected Ciceronian purism. But his versatility was most spectacular in the religious field. Merciless critic of the Church of Rome, Erasmus did everything possible to change it but still remained faithful; he opened the way to the Reform and went a certain distance with the Protestants but refused to join a new confession. Excellent conciliator, he navigated among extremisms and was the target of the worst accusations from Luther and the Catholic hierarchy, who called him a lukewarm, pusillanimous traitor.

Erasmus, with his labile character and love of liberty, fiercely opposed Luther and defended free will as the foundation of the moral life.[16] A Proteus who stood exposed to all metamorphoses and ready for all experiences, he avowed his intellectual mobility, asserted his spiritual restlessness, and probably would not have denied the image of man according to Pico della Mirandola. Because flexibility is not necessarily a weakness, it is a means of bringing together all possible chances for improving the conditions of life in this lower world and, beyond that, climbing the ladder that leads to God.

Upbringing, Formation, Cultivation

Erasmus attributed the aptitude for change to all men: *Homines non nascuntur, sed finguntur.*[17] They are not born completely formed, determined by innate qualities, but as matter to be fashioned. Here again Erasmus rejoins Pico in believing that we are not essence but existence to construct, potential to exploit. It is logical that this dynamic conception of the individual would lead Erasmus to an interest in pedagogy. Because man is ductile, the philosopher's priority is to orient him to goodness—service to the community and love of God. The didactic fiber that runs through the works of Erasmus in his Latin manuals, a treatise on good behavior, and numerous moral precepts comes precisely from this ideal of flexibility: children are receptive, maniable personalities to be shaped.[18]

Many sixteenth-century thinkers applied this principle based on the belief that there is almost no sector of human activity where we can't intervene to educate, transform, reform. The project is implied in the very idea of the Renaissance. To restore culture and improve life, men must be prepared to face new challenges; they have to change themselves to change others, adapt themselves to neglected biblical and classical models that they will later instill in future generations. At the start of the fifteenth century, the humanist Vergerius enjoined parents to take advantage of youthful flexibility and begin educating their children very early, "while their humor is still malleable and their age supple."[19] *Mobilis aetas*—whether referring to the age of a man or by analogy to the age of society, the term expresses an important underlying idea of the humanistic project: in life as in history, certain occasions are opportune for fashioning the individual or the collectivity like ductile matter. That is when we should intervene.

It is significant that the word *culture,* in the sense of "development of intellectual aptitudes," made its first appearance in the French language at that time. Still largely confined to the vocabulary of agriculture, it was only applied metaphorically to things of the mind. Du Bellay praised the Greeks and Romans for having been "diligent in cultivating their Languages,"[20] and Montaigne spoke of "cultivating the soul" (2.17.658). Later the agricultural reference was dropped and the modern meaning took over: *"il a une grande culture"* (he's a very cultured person); *"la culture française"* (French culture). But the residual figurative dimension gave the term a strong dynamic connotation. Culture is not an attribute but an acquisition implying labor, transformation of raw material, an action on the mind.

Because the fields of mental faculties have to be labored, treatises on education abounded, some covering education as a whole, others specialized in the development of particular skills: how to prepare a young man for public life, how to become prince or courtesan, how to speak and act in society.[21] The path of spiritual perfection or religious rigor was traced,[22] trades and techniques were taught—how to use arms, the secrets of hunting, dance steps. The proliferation of this didactic production, accelerated by progress in printing techniques, measures the scope of humanistic optimism, which functioned as if human beings had unlimited capacity to acquire new skills.

Did this mean that there are no limits to apprenticeship potential? Is the individual a tabula rasa, perfectly malleable wax that will take the imprint of any figure whatsoever or, on the contrary, does he have prior dispositions, internal resistance that would reduce the scope of possible or desirable acquisitions? Should we speak of education from zero or only of transformation? The disagreement between Rabelais and Montaigne on this question shows the existence of varied doctrines concerning the scope of a pupil's conversion. A comparison of their pedagogical projects will bring out two different notions of anthropology within a common will to fashion the individual.

After vegetating under the rod of the masters of the old school, the "old codgers" of the Scholastic age,[23] Rabelais's Gargantua finally attains humanistic knowledge under the guidance of Ponocrates, the enlightened tutor. From dawn to dusk, "he didn't waste a single hour of the day but consumed all his time in literature and honest learning."[24] There is so much to learn that his overburdened schedule cracks under the weight of lessons and exercises. He has to know about everything—man, the world, God—and how to do everything—the arts, sport, experiments. Ponocrates manages to stuff everything and its contrary into the program: mental and physical hygiene, intellectual and manual activities, religion and the profane, human and natural sciences, theory and practice, work and leisure. Gargantua's frenetic days take on the allure of a catalogue *de omni re scibili, et quibusdam aliis*. Under the pretext of education, Rabelais seems to outline an encyclopedic project; he makes the rounds of subjects to be studied and assigns an unlimited territory to the pupil, as if giving a hyperbolic fictional version of ideals of readiness and comprehensiveness represented in reality by writers like Petrarch or Erasmus.

As long as we attribute to Rabelais the intention of drawing up the ideal compleat curriculum, the excesses of chapters 23 and 24 of *Gargantua* are reasonable. But if the intentions were practical, the model is aberrant. It is clear that Rabelais shows slight concern for verisimilitude and even less for psycho-

logical coherence. We see no attempt at adaptation between the active subject of apprenticeship and the objects of instruction. The pupil absorbs everything indifferently, instantly; he doesn't chew it or assimilate it, it has no effect on him. Quantity prevails over quality, the memory indiscriminately gobbles down information, leaving no room for critical judgment. Gargantua is presented to Ponocrates like a tabula rasa on which any and all possible messages can be inscribed. He is subjected to an education that can include anything and everything because he has no personal character and offers no resistance against didactic saturation. Infinitely docile and receptive, he resembles the indeterminate individual, perfect candidate for metamorphoses, designated by Pico della Mirandola as man par excellence.

When Ponocrates first takes his pupil in hand, he calls for a doctor

> who purged him canonically with elebore of Anticyre and with this medicine cleaned out all perverse habits and alterations of the brain. By this means also Ponocrates made him forget all he had learned from his antiquated tutors.[25]

Erase everything and start afresh. Gargantua, emptied of his prejudices, freed of his vicious habits, can be reborn pure and virgin as a phoenix. No past, no former experience or psychological heritage, can infringe on the new education. The purge introduces a radical rupture in the giant's existence: the before-and-after Gargantuas are two different people.

There are two Gargantuas, or even more. A backward look at his upbringing in early childhood is enough to measure the discontinuity of personality and disintegration—or total absence—of the psychological subject. There is nothing but a succession of periods that never compose a progressive, cumulative itinerary, as if he were a different person at each stage. The chapters on Gargantua's youth can be divided into three phases: early childhood, with spontaneous blossoming of body and mind (chaps. 7, 11–13); the vegetative era, under the authority of the gothic sophists (chaps. 14, 21–22); and the tutorship of Ponocrates, when the giant finally makes fantastic progress (chaps. 23–24). Is this the same young man, gradually developing? It is more like three independent episodes or three juxtaposed systems that don't seem to correspond with the development of one single individual.

An additional factor of discontinuity marks the first two stages. The stage of early childhood is divided into disparate tendencies. Gargantua gives in completely to his sensual instincts, does nothing but eat, drink, and sleep, and yet is very clever in playing with wooden horses and inventing ass wipers. Yet

no sooner does he manifest a smidgen of intelligence than he falls back into crass stupidity. Subject to a retrograde method, Gargantua stagnates, but is so good at practical jokes that people forget his stupidity (chaps. 16–20). In both of these periods, two figures seem to coexist without forming a convincing psychological unity or chronological sequence.

We find this type of fragmented character elsewhere in Rabelais. What is there in common between Panurge, the farcical adventurer of *Pantagruel,* and Panurge, the fearful sophist in the *Third* and *Fourth Book?* How can we recognize the young giant of the beginning in the wise, contemplative Pantagruel at the end? We can always find some constants, but it is the dissonance, dissimilitude, and outright contradictions that leap to attention. These ruptures in the construction of individuals, even if they are fictional, imply a very particular conception of man. The character is not conceived as a consistent uniform subject, and his life, which does not necessarily follow a linear development, is presented as a series of loosely related, distinct moments, an assembly of weakly integrated episodes and conducts that do not compose a coherent personality. Man is discontinuous because his existence is a sum of events that are themselves discontinuous.[26] Investing himself completely in the immediate act, he identifies with the role he is playing, without feeling the weight of the past or a commitment to the future. At a given period of his life, Gargantua is totally a pupil of the old codgers, a pure product of scholasticism; a bit later he will be totally the disciple of Ponocrates, a perfect son of humanism. He is like the individual as conceived by Pico: a chameleon, who blends into the background and becomes what the occasion makes him.

The history of narrative form seems to confirm this fragmentary, metamorphic vision of existence. Sixteenth-century French literature left few long novels; the ample chivalrous tales of the Middle Ages were hardly renewed, and the broad-scope heroic narratives of the seventeenth century had not yet come onto the scene.[27] There is probably a connection between this propensity for fictional characters who don't hold up over time and the absence of long, intricate narratives. In fact, the most fashionable genre was the short story—the *Heptameron* and many such collections. The short story captures an adventure, a dramatic event, a passionate experience, a moment in the life of a character; it rarely tells the story of a whole life. It doesn't elaborate a complicated sequence of events or psychological development, but captures a character in the immediacy of his act, within an exceptional configuration sufficient to itself. And, in fact, the novels of Rabelais have a modular structure, particularly apparent in the *Third* and *Fourth Book,* where the juxtaposition of

similar episodes without any cause-and-effect relationship is close to the short story formula.

Montaigne also had much to say on the question of education and transformation. Though he shared with his contemporaries several premises on student receptivity and the mutability of man in general, he soon parted company with them and went his own way to attenuate the principle of indetermination and limit the scope of metamorphosis. He looked with suspicion on the endless molting of Proteus. The chapter devoted to "bringing up children" (1.26) testifies to these reserves.

Let us begin with the points of agreement. Montaigne believed that a young man is malleable wax that the master strives to fashion in order to form judgment, will, and morals, imprinting the qualities of a gentleman. Therefore, a determined systematic action operates decisive changes on the individual. Montaigne even foresaw interventions that can bring about a double transformation:

> The parts borrowed from others, he [the pupil] will mix and transform them to make a creation all his own, that is, his judgment. His institution, work, and study aim only to educate him (1.26.152).

To sharpen his critical faculties, the pupil will appropriate the classics and alter them at will; the subject modifies himself by modifying the subject of study.[28] Elsewhere in that chapter, the combinatory of changes follows another model:

> I have often remarked with great admiration the marvelous nature of Alcibiades, to transform himself so easily in such varied ways, without concern for his health: now surpassing sumptuous Persian pomp, then exceeding austere Lacaedemonian frugality; reformed in Spartacus, voluptuous in Ionia. . . . This is how I would train my disciple (1.26.167).

By training the pupil in the strategy of the chameleon, teaching him to transform himself, education gives initial impetus to self-conversion and brings many other changes in its wake.

Here we have the widely recognized mental flexibility, the very condition of the pedagogical project. It would be naive to show surprise at Montaigne's notion of mobility in this context. What is surprising is the insistence on the demand for stability. The master, he says, does not build on a tabula rasa, he speaks to a subject endowed with an exceptional character, distinctive features, a formed personality, and yet no less receptive and malleable. Montaigne speaks of the "nature" of his pupil, his "form, inclinations, or natural propen-

sities." He postulates an inalienable solid core in the heart of the person that resists or at least sets limits to change. If the movement doesn't come up against an abutment, the self gets lost in headlong flight and vaporizes.

Montaigne, unlike Rabelais, did not believe that education operates in a virgin field. It reinforces or corrects prior dispositions, actualizes preexistent properties, develops potential. Are these attributes innate or acquired? Are they immutable or subject to change? Montaigne is not sure, but that's not what matters. Whether our "form" is fixed once and for all by God or nature or built up gradually through a lifetime, it exists and, even in an embryonic state, even exposed to contingencies, precludes the radical instability of Proteus. Significantly, in the chapter on education, Montaigne doesn't go into themes of inconstancy and discontinuity prevalent elsewhere in the *Essays*.

In man, where does the part of fluctuation end and the grip of constancy begin? This doubt, basic to Montaigne's thought, is manifest, among others, in the ambivalence (if not the vagueness) of the notion of "form." Montaigne mistrusts form in its Scholastic acceptation: "Others form man; I relate him and represent an example indeed deformed" (3.2.804). This formation, which he leaves to philosophers, postulates an essence, a universal model—Aristotelian form[29]—to which every individual should conform. But this invariable shape that transcends the accidents of history is an abstraction, an invention of metaphysicians whose theories are divorced from reality. This rigid, artificial, normative, stereotyped form denies movement and liberty and exerts on the individual a violence that Montaigne refuses. That doesn't keep him from saying elsewhere, "I made every effort to form my life. Here is my loom and my creation" (2.37.784). Whereas "others" impose an authoritarian model on man, a rigid configuration defined a priori, I feel my way empirically, looking for the central core in myself that I need in order to act and know myself. This certainly explains the apparent contradiction between the two citations. Conjugated in the first person, *"former la vie"* (form my life), meaning "self-searching, constructing yourself," is a legitimate action, the quest for an object to come, perhaps an endless process. Nevertheless, the objective is to find a form, to fix one's form, so that the subject can coincide with himself and, having acquired a clear consciousness of his "nature," progress both in self-knowledge and in the definition of coherent conduct.

This challenge and with it the ambivalence of the notion of "form" underlies another chapter of the *Essays*, "On Repentance" (3.2). Reduced to its bare outlines, the argument is simple. The text opens on the declaration of the

aforementioned "deformed," then continues with one of the most beautiful, radical evocations of universal and personal flux: "the world is nothing but perennial swinging" (3.2.804). Will the self, prey to the discontinuity of instants, slide into moral anarchy? No, replies Montaigne. Because somewhere inside of a man there is an internal consistency, a canon according to which he can regulate his actions; this norm allows him to establish a code of conduct and avoid repentance. If he has access to his "master form" (3.2.811), he can elaborate his own authentic personal ethics, free of the factitious prescriptions of the moralists. The contents of this internal substance are not defined. Under varied designations—*"patron au dedans"* (master within) (807), *"naifve assiette"* (naive base), *"inclinations naturelles"* (natural inclinations), *"qualitez originelles"* (original qualities) (810), *"forme sienne"* (personal form) (811), *"forme universelle"* (universal form)—it may be nothing more than recognition of the mobility of being: I do not have any stable form, but my instability is itself a form with which I conform.

The image of the self outlined here is certainly fragmentary and malleable, but it is neither the Proteus of Pico nor the tabula rasa of Rabelais. Again, Montaigne subscribes to Renaissance *perpetuum mobile* but seeks in himself and assigns to others a core that escapes indetermination. Experiencing his variability as a default of being, a sign of vanity, he associates human precariousness with ontological insufficiency. His position marks a distinctive step in the history of conceptions of the self. With Montaigne, and increasingly after him, internal consistency, the firmness of a person who resists change, is established among the criteria of human dignity. The Renaissance saw mobility as a privilege of man, capable of all possibles. Thereafter the person would be constructed as a solid, independent entity, a unitary center, and a fixed reference. A demand for continuity and coherence was established that would prevail for a long time, obstructing or disapproving the sixteenth-century metamorphic sensibility.

Fortunes and Misfortunes of Metamorphosis

Unlike Montaigne, when Pico and Vives invoked change to celebrate the grandeur of man, they considered metamorphosis as good fortune; it symbolizes the individual's freedom, availability, and potential. The moral interpretation of Proteus in Renaissance mythographies confirms this valorization.[30] In his *Mythologiae sive Explicationes Fabularum* (1551), the Italian Natale Conti at-

tributes several possible meanings to Proteus, which in fact he shares with many other Antique or Renaissance commentators. Proteus, for example, is celebrated as the figure of the scholar, a great authority in natural science, who

> wrote many treatises on philosophy, plants, stones, the nature of beasts, the mutual mutation of the elements, and how all creatures draw from them their beginnings and grow to become tree or plant or animal.[31]

To pass like Proteus from one existence to the other, to go through the chain of being, is to know from within the conditions of different species and understand natural mutations. The true scholar is someone who mentally transports himself to the heart of things and participates in their mobility; his instability is a gage of veracity.

"As for me," continues Conti, I would see Proteus rather as emblem of the good chief who, "in the civil administration," keeps peace among men. Society is composed of diverse temperaments, conflicting forces, that the leader must follow attentively if he wants to reconcile them:

> So the Wise man, because not every one follows the same occupation nor takes pleasure in the same exercise, insinuates himself into the friendship of people by varied disguises, and uses various means to handle affairs of State.[32]

Because he knows how to adapt himself to men and events, the sovereign-Proteus is both mediator and moderator. Knowing how to be everything for everyone, he symbolizes tolerance, mutual comprehension, and peace. But the fable, Conti adds, transcends its political application to serve as a more general model of human life. Proteus teaches us to balance contraries, avoid excess, orchestrate our activity according to a just measure. Because he passed through all types of existence, he knows that there is room for all possible experiences, tempered among themselves by the *aurea mediocritas*. Another mythograph, Vincenzo Cartari, reduces the lesson of Proteus to a nice formula: "He knew, in his great wisdom, how to accommodate himself to all things."[33] For having exploited without restriction the metamorphic powers of man, he is promoted master of life, protector of society, and guarantor of civilization.

Human accomplishment, then, lies in the multiplication of the self and appropriation of the greatest number of possible incarnations. Ronsard, too, called on the myth of metamorphosis to express this ideal of totality. He addressed this sonnet to his master Dorat:

> Aurat, after your death, the earth is not worthy
> To putrefy such a learned body, as yours really is.
> The Gods will change it into some voice: or else,
> If Echo does not suffice, will change it into swan,
> Or, into the body that lives on divine dew,
> Or, into fly that makes Hymetian honey,
> Or, into bird that sings and the ancient crime
> Of Tereus in springtime retold on a thorn.
> Or, if you are not entirely changed into someone,
> You will wear a body that will you share
> With all of those, participating together
> In all (because one for you sufficient does not seem)
> And from man will be made a beautiful new monster
> Of voice, swan, cicada, and fly, and bird.[34]

As compensation, the learned man will have the joyful experience of otherness. The disjunctive enumeration of possible transformations—*or, or*—is followed in the last line by additions—*and, and*—to indicate that the height of fulfillment is attained when the subject can multiply instead of choosing, can be simultaneously one and diverse, himself and all others. The airy lightness of his avatars—voice, insect, bird—reinforces the impression of mobility and freedom. In Ovid, metamorphosis is generally associated with violence, suffering, or passion, whereas here the body's migration represents the triumph of life. And the "beautiful monster" (1.13) confers positive value on a traditionally negative symbol, replacing with the perfection of a polymorphous existence the image of deformity as a sign of failing, disturbing presage, danger to order.[35]

The paradigm of metamorphosis widespread in profane anthropology was less frequently invoked in theological arguments, undoubtedly because of its pagan origins. Nevertheless, the concept of transformation was in the forefront during this period saturated with religious debate about predestination and free will. We have seen that Proteus, for the humanists, represents man's freedom to forge his destiny, open himself to all aspects of reality; his mutability is all the more exalting because it can give an ascendant impulse and orient him on a moral or spiritual path that leads him to surpass himself. This was the meaning of the fable in Vives: if man uses his disposition judiciously, he can share in the feast of the gods. This recognition of potential latitude is not so far from the belief of some theologians, that man has the potential to merit salvation. Catholic thinkers, particularly Jesuits under the Counter Reformation who claimed the possibility of redemption of sinners by acts and

force of will, shared the humanist optimism and might well have approved the philosophy of freedom incarnated by Proteus.

However, the Reform movement rejected the myth of metamorphosis for several reasons. Already subject to condemnation for its roots in antique polytheistic tradition and its affinity with the doctrine of free will, the myth was severely disapproved for its relationship with naturist, animist thought and for its strong magical components (see chap. 2).

It is all the more interesting to see that one of the pillars of Calvinist Reform, Pierre Viret, devoted an entire treatise to the myth *Metamorphose chrestienne,*[36] giving recognition to the vogue and influence of the model, even in an extremely hostile milieu. It is true that the good pastor never misses a chance to display repugnance for the pagan connotations of his theme. He cites Pythagoras, Ovid, and Apulaeus and recalls fables of transformation and transmigration all the better to exploit them *ad maiorem gloriam Dei* and instruct the faithful:

> I wished to write about a different type of Metamorphosis, in conformity with Holy Scripture, that contains neither fable nor fiction. Because God's word also has Metamorphoses, but altogether different from the fabrications of dreamy Philosophers and lying Poets.[37]

The humanists boast about the merits of Proteus? Viret opposes a totally different vision: Proteus is the image of the "inconstancy and violence of human sentiments."[38] So Viret will rethink the notion of metamorphosis in a Christian perspective and make it the cornerstone of a Protestant concept of Man.

Metamorphosis in its Calvinist version is the emblem of the Fall. Man, created perfect by God, was transformed by sin: "I speak of a metamorphosis that lies in the change of heart, intelligence, and mores in corrupt perverted men."[39] The angel turns into a beast. Man, subject to nature or reason, deprived of Grace, lives like an animal. "Because man has turned away from God, without whom he can have no goodness . . . , in body and sentiments he is transformed into a brutal beast, in soul and spirit he is transfigured into a devil."[40] He turns into a dog, viper, wolf, fox. Look at this warrior, says Viret, trussed up with arms and rigged out in armor as if he were covered with scales; he looks and acts like an animal. And that is the real meaning of metamorphosis: man changed into a beast portrays the abject condition of the sinner, the misery of life without God.[41]

The pagan poets were right without knowing it; they gave us a true image of our condition. Viret, in agreement on this point with humanist thought, is

willing to give them credit for indirect participation in the Revelation: "They had some dim knowledge of it."[42] Treated as allegories, tales of metamorphosis tell the truth about man. But these same pagan poets were also mistaken. Because they took their fables literally and meant them to be taken literally. They wanted us to believe that man could really metamorphose into a deer, bull, or wolf. These fictions feed the worst superstitions and are in patent contradiction with the lessons of the Bible. How can man, created by God in his own image, really become an animal? How can species that God distinguished once and for all transform one into another? Such metamorphoses are scandalous because they upset the order of creation. Viret makes it perfectly clear that man after the Fall changed in quality, not in substance: the mutation is not physical but moral.

Metamorphosis is in fact a dangerous symbol, but at least it has the merit of illustrating the mobility of human existence and, further, showing two possible directions. Not only does it signify man's debasement, it can also represent the movement toward redemption. Salvation by Grace is the answer to debasement by sin. God allowed us to deform ourselves, but he can also reform us: we are in his hands like "clay and the earthen vessel in the hands of the potter who can make, unmake and remake, form, deform and reform, smash, break and repair."[43]

The distance between Pico della Mirandola, who opened this chapter, and Pierre Viret, who closes it, is as great as that from Catholicism to Protestantism, from liberty to predestination. For the Florentine humanist, man is master of his destiny; for the Swiss Reformer, he is subject to the will of God. Renaissance anthropology fits in between these two limits. The gap is tremendous on all levels, but both schools of thought share a sensitivity to human transformations and life's vicissitudes.

The Hazards of Art: Le Roy

Vicissitudes

Many sixteenth-century French scholars felt that the world they lived in was just as precarious as their own self-image. This feeling of growing instability was fed by radical changes taking place in intellectual and religious spheres as the monarchy weakened amid military turmoil. With beliefs, certainties, and habits vacillating in such a rapid succession of events, the future seemed open to all possibilities. The work of Louis Le Roy, who was a translator of Plato and Aristotle, testifies to a correlation between protean man as previously described and a contemporary perception of historic upheaval.

In 1575, dismayed by the religious wars waging around him, Le Roy published a treatise on vicissitude and variety, *De la Vicissitude ou varieté des choses en l'univers . . .*[1] Le Roy believed that everything—the physical world and human institutions, historical developments and international relations—could be explained by the principle of change. Placing the idea of movement at the center of his argument, he intended to demonstrate the relationship between transformations in cultural or artistic spheres and mutations in the natural order. The progression of this ambitious meditation on history, an authentic illustration of sixteenth-century thought, from the discourse on the world and man to reflections on the work of art validates the organization of the present study.

De la Vicissitude takes the form of a general review of physical mutations followed by a more extensive study of various civilizations and their particular

genius. Le Roy asserts that the same key can be used to explain all of these phenomena because nations and their accomplishments, just like nature and its constituent elements, are characterized by the variety of their parts. A cultural condition, like a material object, is composed of centrifugal ferments, lives in and by disorder, is animated by the internal struggle of adverse forces contained within. In constant danger of dislocation, it makes combinations and constructs more or less stable balances, remaining intact as long as it can ensure concord within discord. Life, in any and all realms, would seem to depend on the balance of contraries, unity in diversity, stability in movement. By judicious distribution and constant circulation of qualities and matters, Providence prevents the disintegration of things and their dispersion in chaos. Everything holds together, at least temporarily, by virtue of a sustained internal dynamics. This movement is the very condition of existence and, according to a paradox that Montaigne would soon explore, the only fixed and immutable law of life.[2]

Le Roy's thesis may be nothing more than a modulation of the familiar theme, "matter endures, form is lost" (see chap. 1). The sum of available elements remains constant, but the combinations are infinitely variable. Le Roy designates as *vicissitudes* the redistribution of elements in the temporal sphere and as *variétés,* the same process when it occurs in the spatial sphere. A given configuration will sooner or later be transformed by displacement of its components on the historical axis or in the geographical dimension. Or, in the case of human beings, every individual in each of his parts is modified with time, "receiving mutation on the body in hair, flesh, bones, and blood, as in the soul, changing mores, customs, opinions, appetites, pleasures" (fol. 9v). But men also have "a changeable mind, not suffering to rest, curious of novelty. Which is the reason they never stop visiting each other's countries, exchanging mores, languages, letters, lordships, religion" (fol. 14r). Contacts between individuals, as between cultures, involve contamination, mixture, and all kinds of transfers. Le Roy gives particular attention to migrations: "It seems that men have a natural desire to change their place of habitation" so that "almost all peoples are mixed" (fol. 14r). Ideas and techniques circulate along with people and alter as they go, constantly adapting to new environments. To account for all this moving about, history must be universal and encompass the totality of times and spaces.

> God who watches over the universe in all its parts awards excellence in arms and letters now in Asia, now in Europe, now in Africa . . . allowing virtue and vice, courage and cowardice, sobriety and delights, knowledge and ig-

norance to go from country to country, honoring and dishonoring nations in varied seasons: so that each in turn will have its share of joys and sorrows, and none will grow proud from overlong prosperity (fol. 29v).

No nation or era can long maintain its particular qualities. Power, knowledge, and wisdom change hands, denying all durable pretension to hegemony and belying in advance any rigid hierarchy. The moderns know more than the ancients in one field and less in another, their civilization is superior in this, inferior in that, so in fact all dogmatic judgments tend to be falsifications. In an attitude of tolerant relativism inspired by the incessant circulation of a common patrimony, Le Roy logically outlined the rudiments of a universalist thought based on the dual premises of vicissitude and variety.

The structure of his treatise is derived from this principle. Three chapters dealing with general aspects of movement in nature, language, and the arts are followed by nine chapters of monographs on great civilizations, distinguished by parameters of time and space: major cultural periods, from Egyptian and Mesopotamian antiquity to the Renaissance, and principle centers of civilization in Europe and beyond. As he proceeds, Le Roy establishes numerous parallels, using comparison and contrast to highlight differences, illustrate mutations. He analyzes one culture as the metamorphosis of another and, typically, focuses on intermediary phases when movement and conversions are particularly apparent: transitional periods, like Roman decadence; migratory movements, like the Barbarian invasions.

Seen from Sirius, the world looks like a flexible mass shaken by perpetual transformations, but this movement cannot be reduced to a simple law that would authorize easy projections. History does not follow a linear development; it is fragmented by vicissitudes, transfers, unforeseen events. The only rule that can be posited is the principle of the harmony of contraries, *discordia concors,* that corrects excess and, in moments of decline, keeps the world from falling into chaos. What secret chemistry regulates the ponderation of life and death forces, how frequently are configurations modified, to what promised destiny? Le Roy does not hazard a guess. His analysis verifies the effect of balance in the world while carefully avoiding predictions on which trend will finally prevail. We have retrieved, he says, the culture of the ancients and even enriched it with two decisive inventions, the printing press and the compass, which guarantee a certain superiority in the order of knowledge. But this same society engenders evil powers that threaten its very existence; it discovered gunpowder and the canon, suffers from smallpox, succumbs to here-

sies, lives in dread of a Turkish invasion—the worst and the best exist side by side; we can have all hopes, all fears, and no certainty about the direction change will take.

Though the law of unstable equilibrium sustains anxiety, it also legitimates a degree of confidence because it ensures renewal and the survival of vital potential. In the eclectic spirit of his times, Le Roy looked favorably on interbreeding and recognized regenerative ferment in the intercourse of nations and cultures. From the dynamic fusion of foreign principles, a new quality emerges; from the shock of differences springs the energy of a new beginning. Beauty itself, says Le Roy in another context, is the product of movement:

> [It] is a certain concourse of varied things, to establish a third: that comes from the proper mixture, and balance of them . . . , contrary becoming unity and discord concord: so much that we can say that beauty is none other than friendly unfriendship, and concordant discord.[3]

In his aesthetics as in his anthropology, Le Roy rejected all notions of essence; there is no stable or necessary form sealed by destiny, only different forces with varied trajectories and transitory equilibrium. Order is the offspring of disorder: the fragile beauty of the world is at this cost.

Following the Movement

If he had believed in immutable substances, Le Roy would have sought indications of permanence and turned nostalgically, like the essentialist thinkers, to ideal models. On the contrary, his philosophy of movement liberated him from fixist or retrospective temptations. Since everything is changing, it is best to follow the natural progression and keep looking to the future. The universal principle of vicissitudes, far from inspiring skepticism or resignation, leads Le Roy to a dynamically optimistic vision: it makes sense to ride the wave, guide it in a positive direction, try one's best to give it a favorable orientation. This willingness to accept change and go with the times underlies a theory of progress; since things are flexible we are invited to intervene to perfect them and bring to maturity the promises of change.

Le Roy certainly did not underestimate menacing negative forces; in fact, conscious of this danger he was ever more determined to cooperate with propitious ferments. Though he clearly discerned a pattern of ups and downs on the chart of civilizations, with inevitable degenerative phases, he was no less enthused by the spectacle of progress: in spite of reverses, the quality of life

gradually improves. He notes the advent of *homo faber,* the invention and gradual perfection of techniques—agriculture, cooking, architecture, clothing, medicine. He shows that, as soon as the basic conditions for survival are assured, man "by nature moved to want learning and take pleasure in it" (fol. 28r) seeks to cultivate his mind and devotes his leisure time to acquiring knowledge, establishing various disciplines, "and studying Letters. Because men naturally desire to learn varied, beautiful, admirable, strange new things, and understand their causes" (fol. 27r).

But it is not until the end of the treatise, in a reflection on the contemporary period, that we will see the idea of progress, fully verified, fulfill its promise. The orientation is announced in the title of the last books: "If it is true that nothing is said that wasn't said before." Books 10, 11, and 12 unambiguously reply: it is fallacious to think that there is nothing new under the sun and stupid to deny that the sufferings are at least counterbalanced by "the potential, knowledge, and other excellence of this century" (title of book 10). We should recognize in this resolutely modern plea the *telos* of Le Roy's endeavor. In his celebration of progress made over the past two centuries, he outlines a definition of the new culture that surprisingly prefigures the analysis by nineteenth-century historians of what would be called the Renaissance. Not only was the antique heritage restored, it was enriched by ample new knowledge and techniques. Le Roy waxed lyrical in praise of such intellectual conquests. How many hidden things have we discovered?

> I say new lands, new ways, new forms of men, mores, laws, customs, new plants . . . new illnesses and new remedies: new paths in sky and Ocean never tried before, new stars observed (fol. 115v).

It took "people of good will" (fol. 114v), courageous pioneers, to advance the limits of established practices and knowledge, to exploit the forces of change, and from available potential create so many innovations. Le Roy gives a long list of adventurers—men of action, artisans, scholars—and particularly cites the merits of two decisive inventions: the compass and the printing press. The latter not only accelerated the dissemination of a stable corpus of knowledge, it also stimulated intellectual dynamics, leading to increase in knowledge. One century after the invention of the Gutenberg press, Le Roy still felt the shock that hit the scholarly world. With this new technology

> more labor is done in a day than several diligent scribes could do in a whole year. Because of this, once rare and costly books have become common and

easy to acquire. Which has greatly helped in the promotion of all disciplines (fol. 100r).

The compass, an equally important contribution to the advancement of science, opened the paths of East and West, giving a world that spilled over the boundaries set by the ancients and disqualified their maps.

In spite of his great tolerance, Le Roy constantly fulminated against one school in learned circles, the pedants, who penned editions and commentaries, translations and grammars in unquestioning devotion to the ancients, satisfied to be administrators of a closed, inert body of knowledge. They "use routines and repetitions" (fol. 113v), only perpetuate a sterile tradition, artificially protected from judgment, that has nothing more to give. A science that tries to escape from the tribulations of history is a science against nature. We should not conserve a dead patrimony but exploit it and make it fruitful so it produces added value. The ideal *culture,* asserts Le Roy, goes back to the etymologic meaning of cultivating the land; culture means taking capital and working it to actualize a potential, and that's how it acts on the mind. It's not enough to transmit tradition; it should be transformed, progressively expanded, and, even better, improved:

> Plato says that the Greeks improved what they took from the Barbarians. Cicero thinks that the Italians themselves invented better than the Greeks, or improved what they borrowed from them. Why don't we try to do the same: improve what the Barbarians, Greeks, and Romans left us? (fol. 118r)

Repetition without renewal, resignation to a role of epigone—everything has already been said and we came too late—is a betrayal of the example of our masters and the impetus they communicated to us. The twelfth and final book of the treatise is a plea in favor of constant "increase" of knowledge:

> [Disciplines] were little by little increased, correcting things poorly observed and filling in the omissions: and still there is nothing entirely accomplished to which nothing can be added. Nothing is begun and finished together, but by succession of time grows and improves or becomes more polished (fol. 115r).

The ancients do not have any ontological superiority; perfection is not behind us, it lies ahead, or rather, always out of our reach: "more things are left to search than have been found. And let us not be so simple as to attribute so much to the ancients, to think they knew all, said all, leaving nothing for

those who would come after them to say" (fol. 115v). Le Roy didn't dream for a second of a science not based on the classical model but, impatient with thinkers who idolize the past, he shifted the pole of culture in the direction of posterity, perceiving it less as an acquired fact than a potential promise in the course of fulfillment. We should all "consider that the future belongs to us" (fol. 118r) and labor like workers of the future:

> Wisdom has not accomplished its work, much is left and will be left, and the occasion to add to it never is lost. . . . Great things are difficult and late to come. . . . How many others will be left for posterity to know? That which today is hidden, in time will come to light, and our successors marvel at what we ignored (fol. 115v).

This was the thrust of a kinetic theory of art and ideas elaborated by Le Roy, which his contemporaries would apply in varied ways and disseminate, as we will see later.

Nature and Culture

In one of his diatribes against those pedants who know everything about Greece and Rome and nothing about the present, Le Roy declared:

> Is it not abuse of study and letters to find enjoyment only with the ancients, and not try to produce new inventions appropriate to the affairs and uses of one's times? When will we stop taking grass for wheat, flower for fruit, the bark for wood? (fol. 116r–v)

The choice of natural metaphors is significant: culture has its seasons; it is subject to the same rhythms of fertility as plants and all living creatures. This analogy is not just a figure of style; it deliberately reflects a parallel between the biological and intellectual realms, between physical and mental process. The law of reproduction applies throughout: "As other things subject to mutation require continuous generation to renew and maintain themselves each one in its species, so it behooves to provide for Letters, seeking new instead of long-lost inventions" (fol. 117v).

The postulate of a correspondence between the two realms informs the entire work and determines its structure. Treating material phenomena (book 1), then human activities and institutions (books 2–12), all regulated by the same principle of change, Le Roy intends to show that the traditional culture/nature opposition is unfounded. This was announced in the summary of book 1: "Vi-

cissitude and variety observed in the movements of the heavens and celestial spheres on which depend changes that occur in this lower world. . . . The vicissitude of the four elements among themselves and each one in itself" (fol. Aii–v); in fact, the key notions of vicissitude and variety introduced here to account for the dynamics of the universe would be applied thereafter to *perpetuum mobile* in arts and letters.

We saw previously that the transfer of intellectual capital—*translatio studii*—functions from one epoch to another like a relay of impulses and cumulative effects. Cosmic mechanisms, as described in the opening pages of the treatise, seem to obey the same principles of sequence and progressive acceleration. The argument is developed with the traditional distinction between incorruptible immutable supralunary realities and perishable unstable sublunar bodies. The movement that animates the lower regions originates in the influence of higher powers, the mysterious "spirit of the universe" (fol. iv) incarnated in the heavenly bodies—sun, moon, stars—that communicate light and warmth to matter and set it in motion. Celestial influxes descend to the lower world, first activating the elements closest to them (fire and air), which "afterwards move earth and water, and subsequently natures composed of these four elements whether men, beasts, fish, birds, or seeds, plants, trees, stones and metals" (fol. iv).

First moved by an outside force, the elements soon become causes of movement and agents of their own transformation. Engaged in constant internecine war, they mix and stir, creating bodies that are no sooner assembled than decomposed to recompose differently. As a result, primal matter is variegated—according to the principle of variety—and protean—by the law of vicissitudes. The corollary is that none of the four elements is ever found in a pure state; subject to incessant mixing, the elements have no absolutely distinct identity or property; they are always different from themselves, always out of step with essence. This is why qualifying expressions—*like* or *as*—are required to escape from the substantialist trap of language: "It is not appropriate to name it fire, but like fire, nor water, but something like water, and the same for the others, as having no stability. . . . Each of them should be called such and such according to its similitude" (fol. 3r).

Transformations, precarious balances, and mixtures settle in this narrow breech. But the dynamics of elements is not limited to microscopic (mentally deduced) operations of matter. The agitation of particles also has repercussions on the scale of visible objects and can be read, for example, in metamorphoses

of the earth's surface. Here Le Roy recalls Ovid and approaches Leonardo and
Montaigne in his description of kinetic landscapes:

> Rivers and springs dry up and new ones gush out elsewhere. Some land-
> scapes turn into ponds and marshes, others to sandy deserts, others to
> woods, then cleared and labored become fertile from sterile, and vice versa
> from fertile sterile. Mountains are flattened, plains rise up, some places are
> swallowed up by quakes or burned by ardors (fol. 4v).

Convinced, like his contemporaries, that even when the alteration of forms is
brutal it is a normal manifestation of life, he adds: "But these huge violent
calamities, far from ruining [the land], help conserve it" (fol. 5r).

At the end of the first chapter of the treatise, Le Roy explicitly marked the
articulation with the following: he would pursue the inventory of mutations,
only shifting from nature to culture, "in which will be employed all the fol-
lowing discourse dependent on the precedent" (fol. 15v). Disciplines also grow,
shrink, and disappear to come back transformed. No less flexible than living
bodies, they follow the same laws as matter and partake in the vicissitudes of
creation endlessly under construction. By situating the exposition on arts and
sciences in a direct line with his analysis of physical mutations, Le Roy posits
a principle of fundamental solidarity, precisely and deliberately placing men-
tal operations in the movement of natural rhythms. Emphasizing the depend-
ent order, he suggests that human institutions and creations participate in the
pulsations and metamorphoses that animate the cosmos. This mimetic theory
directs his work and, to the extent that it expresses a widely shared sixteenth-
century intuition, helps us understand the mechanisms of literature—works
in movement, a mobile art that competes with nature.

In the transition from the first to the second chapter, Le Roy reserved spe-
cial mention in his parallel for the lives of languages.

> Similarly languages, words, writing, letters continuously change, having no
> better condition than other human things that are ordinarily changed with
> their words. . . . They have beginning, duration, perfection, corruption, al-
> teration (fol. 15v).

Chapter 2 of *De la Vicissitude,* inserted between one discourse on nature and
another on the arts, treats languages precisely in their variety, migrations, and
mutations. Sixteenth-century French thinkers were extremely sensitive to the
mobility of their own language, carried along with everything else in the dy-
namics of forms in movement.

8 | *Language Inflections*

Babel

"The French language, our mother tongue, is . . . varied and changeable within the limits of the French territory. . . . There are in our day as many different human languages and customs in France as there are peoples, regions, and towns."[1] French was a theoretical unit, an amorphous whole with a few constants that only highlighted the extent of its instability. Charles de Bovelles, who defended this thesis in his treatise on *La Différence des langues vulgaires et la variété de la langue française* (1533), seems to announce, in linguistics, the principle of variability and the law of unstable pluralities that Louis Le Roy would soon articulate (see chap. 7, under "Vicissitudes").

Our languages, said Bovelles, are influenced by the fluctuations that affect all natural phenomena and human institutions in the sublunary zone. Subject to celestial influx, they vary from one period to another and, even more distinctly, from region to region. Two different countries, even if they are neighbors, will be subject to different ascendants, resulting in discord in all aspects: temperament, mores, pronunciation, and linguistic usage. Bovelles carried the image of a patchwork of French dialects to an extreme. Every regional community had its own way of articulating and invented its own idioms; travelers encountered linguistic differences without crossing any borders. "Yes" was *oui* in Paris, but elsewhere it was *oy, oc, ouan, oue, auy,* or *au* (91). A synchronic cross section of the French-speaking territory would reveal a totally flexible

structure: the vernacular was a mobile that shifted and changed according to local conditions.

Bovelles said it would be absurd to reduce and limit these variations by imposing phonetic and grammatical rules on French. Because all living languages fluctuate, vaporize in transitory microsystems, any attempt to impose a restrictive model goes against nature. "It would be a vain effort to explore the center or the measure of any vulgar tongue or seek to consolidate the pure archetype of its uniformity" (120). The message is clear: a language system can be described, approved, or deplored, but it can't be standardized.

The versatility of spoken tongues contrasted sharply with Latin, which had become a scholarly tool, protected from "accidents of place, time, and astral influence" (121). A language had to reach the artificial state of dead language before it could acquire an invariable uniform structure and adapt to rigid grammatical rules which, Bovelles granted, is a decisive advantage for a scholarly tongue. It is true, he adds in the last chapter of his treatise, that long ago there was a totally uniform, immutable language that was not fossilized: Adam's native tongue. The Pentecostal spirit might some day restore to humanity the universal immobile speech before Babel. But for the time being, we are creatures of the Fall and diversity.

While Bovelles was speculating on variations in the language, French-speaking people were trying their best to understand each other. Their experience did not really belie the philosopher's Babelian image. In fact, speakers had wide latitude; in addition to local variations, numerous diversifying factors, such as social distinctions and specialized vocabularies, made for an extremely rich combinatory and a linguistic extravagance that was a far cry from the pasteurized, centralized, regulated French that would prevail in the seventeenth century and thereafter. In those Renaissance days language was there for whoever wanted to take it, shape it, and mark it with his style. Henri Estienne warned:

> *Mon intention n'est pas de parler de ce language François bigarré, et qui change tous les jours de livrée, selon que la fantasie prend ou à monsieur le courtisan, ou à monsieur du palais, de l'accoustrer. Je ne preten point aussi parler de ce François desguisé, masqué, sophistiqué, fardé et affecté à l'appetit de tous autres, qui sont aussi curieux de nouveauté en leur parler comme en leurs accoustrements.*

It is not my intention to speak of this multicolor French that changes uniform from day to day, following the whims and outfits of monsieur the courtesan or monsieur of the palace. Nor do I claim to speak of that af-

fected, painted, sophisticated, masked, costumed French to the taste of all
the others, just as avid for novelty in their speech as in their accoutrement.[2]

The student from Limoges who happens to meet Pantagruel one day illus-
trates the breadth and disparity of available registers in French. He goes from
learned academic speech to his local dialect and, to show off the science ac-
quired in Paris, saturates his talk with Latinisms: *"Je me enite de le locupleter de
la redundance latinicome"* ("I try to enrich it with lavish Latin").[3] The student
indulges wildly in morphologic and lexical caprices; far from taking grammar
as the imposition of standards, he frolics in it as a field of experimentation, an
opportunity to slap together some monstrous gobbledygook. Rabelais took
full advantage of satire to draw a heavy caricature of the pedant who "disdains
the common uses of speech."[4] But was Rabelais the storyteller any different?
He denounced aberrant language and yet freely employed it, adding his own
exaggerations. No less inventive than his pedantic character, he concocted an
incredible mixture of local inflections, trade jargons, vestiges of foreign lan-
guages, and idioms of class, age, education. Going through the whole range of
language styles from the sublime to the obscene, from scholarly to illiterate
and down to pure gibberish, he displayed one of the richest, most inventive
vocabularies in French literature. He allowed himself total freedom to forge his
linguistic tool, with the minimum of respect for the elementary rules of com-
munication to make himself understood. Reading Rabelais we are like
Bovelles's traveler, tripping through richly tilled linguistic fields, capturing the
metamorphoses of a malleable body.

Claude Duret, in a summa of more than a thousand pages on "the history
of languages of this universe" (1613), devotes one long chapter to the "causes of
decadence, mutation, change, conversion, and ruin of languages."[5] He distin-
guishes three major agents that explain the incessant transformations in lin-
guistic usage: "the fatal order and course of nature" (1014), that is, the law of
aging; mixtures of people—by invasions and military occupations, in the
vicinity of fairs or in the army—who mix their languages together until they
engender a third; and differences in pronunciation that alter the cohesion of a
language. Forces that corrupt one system to give rise to a new one come from
extrinsic factors, such as temporal development and historical conditions, or
internal factors like heterogeneity of linguistic components.[6] This reminds us
of Louis Le Roy's vicissitude/variety dichotomy, which, in fact, Duret cites at
length.

Some writers, aware of the complexity and mobility of the sixteenth-

century French linguistic atlas, saw geographical mixing as the major cause of change; others, more attentive to linguistic metamorphosis along the temporal axis, observed rapid transformation of language under the effects of extraordinary acceleration. In 1529, Geoffroy Tory predicted that, if we don't take care, "we'll find the French language from fifty years to fifty years for the most part changed and perverted."[7] At the end of the century, Montaigne assigned the same life expectancy to his language, wondering if his work would still be understood by 1640:

> J'escris mon livre à peu d'hommes et à peu d'années. Si c'eust esté une matiere de durée, ill'eust fallu commettre à un langage plus ferme. Selon la variation continuelle qui a suivy le nostre jusques à cette heur, qui peut esperer que sa forme presente soit en usage, d'icy à cinquante ans? Il s'escoule tous les jours de nos mains et depuis que je vis s'est alteré de moitié. Nous disons qu'il est à cette heure parfaict. Autant en dict du sien chaque siecle. Je n'ay garde de l'en tenir là [le tenir pour parfaict] tant qu'il fuira et se difformera comme il faict.

> I write for few men and few years. If duration were the question, the work should be committed in more rigid language. Given the continual variations that ours has undergone up to now, who can hope it will be used in its present form fifty years from now? Day after day it is slipping through our fingers, and in my lifetime half has already altered. We say that now it is perfect. As each century said the same for its own. I take care not to stop there [not call it perfect] as long as it pursues this constant flight and deformation. (3.9.982)

Tory, Montaigne, and many others agreed that French was continuously changing but differed in their attitudes and prognosis. Tory was afraid that communication from one generation to another might become impossible, but Montaigne accepted it as a normal manifestation of universal movement. His *Essays* would last about as long as a man can live. Why be alarmed? Why should we want the language and the book to escape from obsolescence? Montaigne integrated this instability into his poetics of mobility: articulated in a gestating language, the work is informed with time and change and falls from expectations of permanence into the realm of the transitory.

The rapidity of linguistic mutations through the century is easily verified. Tory noted that, "We could find ten thousand" expressions used in the past and no longer current.[8] *Voir* was replaced by *vrai, tenroit* by *tiendroit, harper* by *jouer de la harpe;* just a short while ago, people were still saying *assembler à son ennemy,* and now they say *commencer à combattre,* and so forth.

A comparison of texts composed within the space of a few decades demon-

strates the rapidity of change. Some forty years separate the early works of Ronsard from early Malherbe; Ronsard wrote with dizzying syntactic freedom and an abundance of rare words, now antiquated; Malherbe's pure, simple language is perfectly comprehensible to a twentieth-century reader. The same is true in prose: Marguerite de Navarre's *Heptameron* is full of loosely articulated full-blown constructions that seem archaic and sometimes opaque today; a half-century later, Guillaume Du Vair structured his sentences on the more rational, consistent, classical model still in use. The development continued at a steady pace into the early seventeenth century. When we read Montaigne's *Essays,* we need explanatory footnotes to clear up the multiple problems of grammar and vocabulary that stump us, but we can sail right through Descartes with his pared-down, tightened-up vocabulary and stabilized syntax. D'Aubigné, who straddled the sixteenth and seventeenth centuries, wrote in an inventive, rugged, and occasionally anarchic style; the arrival of Corneille in 1630 marks the transition from Middle to modern French. Suddenly in the first decades of the seventeenth century, French was taken in hand and put in order. The spectacular movement slowed down and practically came to a halt; the change from 1650 to the present is barely perceptible. The French language would never again experience the feverish upheavals of the Renaissance.

Purists and grammarians of the classical age, guardians of proper usage, gave the orders: thin out, clear up, and trim the overblown language left by the sixteenth century. Upheld by the Academy, armed with dictionaries, grammar books, and prescriptions, they fixed up the French language so it wouldn't grow old anymore, and to a great extent achieved their purpose! The drastic turnabout from Montaigne, who followed the fluctuations of language, to the legislators who did their utmost to immobilize it is exemplary.

It is true that some sixteenth-century scholars were already troubled by the unbridled extravagance of French and determined to do something to control innovations and clear up confusion. Excessive freedom brought about an urgent need for regulation, all the more so as the gap widened between the rigorous, invariable, classical Latin model, still invested with paternal authority, and the vulgar tongue, unruly offspring, uncultured like a child. Geoffroy Tory wished that *"quelque noble cueur s'employast a mettre et ordonner par reigle nostre langage François"* (some noble heart wouldst arrange and regulate our French language).[9] He yearned for order and purity, deeming the prevailing anarchy unworthy of a nation that claimed to appropriate the prestige of the ancients. Henri Estienne—another printer, undoubtedly concerned by the survival of his books—went to war against useless innovations and unlikely

grafts. They were among the few who called—in vain—for stern measures against the frenzied machine; the rare grammar books published in the sixteenth century were satisfied to describe haphazardly, without regulating, the mechanisms of French according to an inadequate grid copied from Latin.

These scattered premature warnings did not suffice to reverse the trend. People who didn't care let the language float, and those who did care were less concerned with standardizing than enriching, experimenting, and transforming it.

Laboring the Tongue

This linguistic growth was atypical. We know that language ordinarily develops through usage, subject to forces that transcend individual initiative. Deliberate intention, whether personal or collective, does not normally influence the deep tendencies of a language. The linguistic hustle and bustle of the Renaissance, however, escaped this rule. Far from being a spontaneous upsurge, it was directed by erudites who were surprisingly effective in imposing their will on the language. From the beginnings of Middle French, in the fourteenth century, through the febrile activity of the sixteenth century and up to the domestication by classical grammarians, the French language was systematically inflected by artificial interventions of the literate, who didn't hesitate to force its natural genius and development.[10]

This determined intervention was inspired by a typically humanist belief that the language and its transformations are not fatalities to be endured but instruments to forge and potential to exploit. It was important for a scholar to make his mark on the language because that was how he became influential. His inventions gave him the opportunity to influence customs and take part in perfecting a collective property. Intellectuals discovered that there was a market for verbal innovations, as for the ideas or art objects on which they built a reputation. If laboring the language could make them powerful, they would take power over the language.

Experimenting with the language not only was a means of individual advancement but also contributed to defining the mission of erudites and writers in society, reinforcing their sense of a particular responsibility or privilege. They claimed (mistakenly) that common people used language passively and mechanically: they *"pense que noz devanciers estoyent plus saiges que nous, et qu'il les fault totalement suivir, sans rien inventer de nouveau"* (think our forebears

were wiser than us, that we should follow them obediently, and make no new inventions).[11] The dignity of scholars, on the contrary, lies in their active policy of enrichment. They liberate themselves from restrictions—the weight of tradition, the inertia of the multitude—and use their skill and ingenuity to improve the French language. This is how the intellectual elite fulfills its role. Antoine Du Verdier, at the end of the sixteenth century, congratulated their success. Our language is not

> *nee de l'indiscret usage du vulgaire (comme advient ordinairement) mais avec grand esgard [a été] renouvellee et embellie par la cure et industrie des doctes d'entre nous, [qui] forgerent avec grand jugement les propres vocables, designans proprement ce à quoy ils etoyent imposez. Ainsi nostre parler moderne a eté produit et enfanté de cerveaux pleins de tresdoctes intelligences, et formé de la fleur des belles langues.*

the fruit of indiscreet usage of the vulgar (as ordinarily occurs) but with great care [was] renewed and embellished by the attentions and industry of our learned men, [who] forged with excellent judgment the correct vocables, correctly designating that to which they were imposed. And so our modern speech was produced and brought forth from brains full of most erudite intelligence, and formed from the flower of beautiful tongues.[12]

These learned men had a simple justification for their interventionist policy: unlike the average user, they were aware of the poverty of French. Du Bellay claimed that our ancestors left us a rough language, *"si pauvre et nue, qu'elle a besoing des ornementz et . . . des plumes d'autruy"* (so poor and naked, it needs ornaments and . . . plumes from others).[13] The complaint is oft repeated: French is a graceless, primitive instrument resistant to complicated ideas, totally lacking in the finesse of Greek and Latin. Montaigne deplored the "weakness of his language" (2.10.408); it is a defective novice, a tongue with no learned tradition, particularly indigent when it comes to expressing a subtle idea or rigorous argument. The defect, says Montaigne, is not a lack of words but gaps and imprecision in the conceptual apparatus; French "ordinarily succumbs to a forceful conception. If you go tightly, you often feel it languish and bend under the pressure, and to its defects Latin comes to the rescue, and Greek to others" (3.5.874).

The logical solution would be to use Latin. Montaigne admits he was tempted, and some writers, poets, playwrights, or erudites gave in. Yet in spite of the frustrations, most writers preferred to struggle with a flexible living tongue rather than serve a rigid dead language. The Latin conserved in the

Middle Ages was certainly impure, but active and flexible. With the influence of philologists and Ciceronian purists and an awareness that a historical rupture had taken place, Latin became an untouchable relic, a monument out of reach of the moderns. Reviving that inert object would mean surrendering to the fatality of an invariable language, abdicating the freedom to act on language and adapt it to new demands. Ronsard opposed French to Latin as movement to paralysis, interaction to isolation, life to death.

> *C'est autre chose d'escrire en une langue florissante qui est pour le present receüe du peuple, villes, bourgades et citez, comme vive et naturelle, approuvee des Roys, des princes, des Senateurs, marchands et trafiqueurs, et de composer en une langue morte, muette et ensevelie sous le silence de tant d'espaces d'ans, laquelle ne s'apprend plus qu'à l'escole par le foüet et par la lecture des livres, ausquelles langues mortes il n'est licite de rien innover.*

It is altogether different to write in a flourishing tongue that for the present is welcomed by the people, cities, villages, and towns as alive and natural, approved by Kings, princes, Senators, merchants, and traders, and to compose in a dead language, mute and buried under the silence of so many spaces of years, never learned except at school, by the rod and by the book, in which dead languages all invention is illicit.[14]

Instead of digging up the corpse, it would be better to go with the times, lift French up to the place of Latin, make it sovereign, solid, and complete, as was the language of the Romans in antiquity. Scholars who promoted the vernacular saw the aging of the antique heritage as an opportunity and a challenge. The place is there to be taken, and it would seem that it was destined by history for the French language. The law of mutations and cultural transfers—*translatio studii*—dictates responsibility and demands action.

In this respect, the perfection of French corresponds to a national purpose and political project. Stimulated by the example of the Italian Renaissance, French humanists, notably at the court of François I, measured the effectiveness of cultural dissemination as a source of prestige and support for an expansionist project. This is the first manifestation of an ambition to promote French as the privileged vehicle of ideas, within a broader project of national aspirations where the superiority of the French language would ensure the predominance of France on the European scene. The strategy of the Romans is frequently mentioned as an example of a people who used their language as an instrument of conquest and "prospered more, won more victories by their tongue than by their sword."[15]

The concerted effort to perfect Latin, made by these same Romans in their day, was also imposed as a model. To enrich their indigent speech and stumbling civilization, the Romans took possession of Greek remains, making plunder a means of cultural promotion. In the first chapters of *La Deffence et illustration de la langue françoyse,* Du Bellay lingered admiringly on the method of systematic appropriation and development of patrimony that made the Romans what they were. He exhorted his readers to fight in turn for the cause of French and to broaden it by grabbing all available resources, antique and modern, local and foreign. You have to break down the doors of the sanctuary and bring home the wealth of others, cries Du Bellay at the end of his manifesto: "Pillage without mercy the sacred treasures of this Delphic temple."[16]

The choice of metaphors used to express this theory is significant. Our language, said Du Bellay, *"comme une plante et vergette, n'a point encores fleury, tans se fault qu'elle ait apporté tout le fruict qu'elle pouroit bien produyre"* (like a plant and branch, hast not yet flowered, not yet brought forth all the fruit it could indeed produce) (24). The linguistic argumentation of the partisans of French exploits the analogy with natural processes: language is a plant and the rhythms of biological growth promise exuberant development. From there on, two variants are suggested.

Peletier Du Mans, in his *Arts poétique,* celebrates nature as a Providence that provides for all needs through secret pathways known only to her. It is nature that slowly, deeply leads French to maturity after a long gestation and now brings to blossom an accomplished language that it behooves us to illustrate: "And the longer this worker takes to give birth, the better she brings forth admirable, useful, beautiful things."[17] Renaissance vitalist optimism is easily recognized here. The spirit of the universe, the diffuse powers of nature, lead all things—including the native tongue—to fulfillment.

But this is not the only version of the spontaneous flowering metaphor. Du Bellay developed it at length with modulations throughout the first part of *La Deffence* and gave it an opposite meaning. A language is, of course, like a plant but left to itself it will remain wild and sterile. Unless nature is sustained, regulated, and guided, it produces nothing worthwhile. The Romans promoted Latin, working like "good farmers" (25); they carried the seed from one soil to another, trimmed branches here, grafted new plants there. The metaphor forsakes the realm of unhindered natural operations for the deliberate techniques of gardening. The vocabulary of horticulture—clearing land, watering plants, cutting, transplanting—gives a dynamic thrust to this brief treatise on plant

linguistics. The absolute necessity of human intervention, the contribution of work and artifice, "great labor and industry" (27), are so important that the very pertinence of the analogy is undermined. "Languages are not born themselves like grass, roots, and trees, some sickly, others healthy . . . , but all their virtue is born to the world by the wish and will of mortals" (12).

An expression that has become perfectly ordinary separated from its metaphoric origin, *"la culture de leur langue"* (cultivating their language), still had all the force of challenge when used by Du Bellay: a language is cultivated like a field, the cultural is in the order of the agricultural. This figure of speech was very novel when first used, and in fact this is the first written trace of the metaphor in French—a deliberate, pertinent analogy that would soon be lexicalized and lose its vigor. And something else would be lost. In its usual acceptance in modern French, *culture* signifies a body of acquired knowledge, the result of a process, the ripe fruit already gathered. But the substantive, as Du Bellay used it, had a resolutely active meaning: the force of the verb resonates in *culture de la langue,* cultivating the language, the work of transformation, the dynamic passage from one stage to another. Characteristically, to these Renaissance minds, genesis, the process of production, was more interesting than the finished product, the created object.

The cultivator of words sets himself up as master of nature. To bring forth the fruits of his initiative, he makes a departure from the ideal of *natura naturans,* universal crucible and creative agent of multiple forms of life; the field to be labored, the language to cultivate belongs to inert nature, *natura naturata.* It is like the female receptive to male insemination, like chaos awaiting the demiurge that will fashion it. The Aristotelian model of passage from potential to actual or, if you prefer, the archetype of matter aspiring to form, fully modulated, as we have seen, in Renaissance physics and aesthetics, also informed ideas about language. Further on in *La Deffence,* Du Bellay confirms the principle that man is artisan of his own creation, with the reminder that inspiration and innate qualities are passive dispositions and, being "natural," must be relayed by effort, actualized by will and technique, if they are to engender masterpieces. There is nothing exceptional about this thesis. There are moments in Renaissance aesthetics when fervor and personal inclinations are vaunted as conditions of creation (see chap. 10) and others when the need for hard work and the virtues of patient mastery of a trade are emphasized. Ronsard oscillated from one pole to the other: art as gift, art as conquest.

The agricultural metaphor introduced by the revery on productive energy logically inclined toward another analogical system—economic returns:

Nostre langue Françoyse n'est si pauvre, qu'elle ne puysse rendre fidelement ce qu'elle emprunte des autres, si infertile, qu'elle ne puysse produyre do soy quelque fruict de bonne invention, au moyen de l'industrie et diligence des cultiveurs d'i-celle.

Our French language is not so poor that it cannot faithfully render what it borrows from others, so sterile that it cannot produce by itself any fruit of good invention, by means of the labor and diligence of those who cultivate it. (29)

The capital increment to French obtained by borrowings from other languages, wisely handled by hard-working managers, will yield significant added value. Agents of the verb get the same kind of recommendations as commercial agents: put resources to work, produce wealth, and generate power. This is why Du Bellay minimized internal language borrowing, "without profit . . . for it is none other . . . than giving what belonged to it" (4). The increase in linguistic capital being nil, the operation would bear no profits. Etienne Pasquier expressed himself in the same register. Increased productivity lies in international commerce of languages: "We must cross the Pyrenees and the Alps and trade with languages that have some community with our own, such as Spanish and Italian."[18]

Whether as gardeners or merchants, the humanists believed they were invested with unlimited power over the language. Determined to amplify, regenerate, and at all costs forge a new instrument, they thrust off all censorship: resistance of usage, ignorance of the common people, concerns of the purists. They were all the more exuberant because they thought that French was at the very beginning of its career. As Du Bartas said, it "has hardly come out of childhood."[19] The embryo was still such soft, formless matter to be kneaded that all interventions seemed possible. Here the plasmators of language joined the poets of creation and visionary geologists and historians dreaming of morphogenesis in the flexibility of beginnings (see chaps. 4 and 5).

Of course, we must allow for the part played by wishful thinking in these plantation and childbirth fantasies. The transfer of language into the area of (pro)creation, with the concomitant project of mastery, testifies to humanist dreams of power. And yet reality was not far behind these fictions. During the period stretching from the fourteenth century to the beginning of the seventeenth, with a peak in the Renaissance, erudites so skillfully manipulated the French language that they totally restructured it. It remains to illustrate this vast upheaval.

Word Factory

Vocabulary was the most mobile element, most subject to interference by writers and scholars.[20] The repertory of French words expanded as never before or since.[21] *"Plus nous aurons de motz en notre langue, plus elle sera parfaicte"* (The more words we have in our language, the more perfect will it be), said Ronsard,[22] expressing a dream of infinite growth that would hardly be contested. The creation of neologisms came to the rescue of an impoverished vocabulary; it was particularly energetic in fields of new practices and knowledge but active in all spheres. A neologism would start at the forefront, slip into current usage, and infiltrate written and oral language, moving out from the elite to ever wider, less learned circles. Every writer felt an obligation to contribute at least a few innovations. Rabelais and Béroalde de Verville reached heights of verbal invention, but no one, from the Great Rhetoricians to Du Bartas, including Scève and the poets of "La Pléiade," was at a loss for new words.

Of course, many old words were replaced by modern ones, but the trend was more for addition than subtraction, whether or not there was a real need to be filled. Some neologisms designated new phenomena or made pertinent distinctions, while others, artificially inserted, just placed a learned expression next to a traditional one, encumbering the language with a mass of synonyms. Du Verdier observed, "We have countless expressions, all saying the same thing."[23] Though it was commonly agreed that words were needed and should be created, the problem was to decide what were the appropriate means and legitimate sources. Were Latin—or even better, Greek—roots preferable, or borrowings from modern languages like Italian and Spanish? Should foreign terms be copied as is or given a French twist? What should become of the native stock? Some high points in this extensive activity will give a notion of the intensity of neologic production.

Ronsard recommended, "You will courageously compose words, in imitation of the Greeks and Latins."[24] Though the insertion of Greek was too limited to have a serious effect on vocabulary, Latin was so close, so familiar to scholars, and already so present in the language that it hardly encountered resistance. "Some novelties," said Peletier Du Mans on the subject of borrowings from Latin, "are so close to natural that there's nothing strange about them," so men of letters have a duty "to populate the French Kingdom with such supplements."[25] They would do it all the more easily in that, being more or less bilingual, they always had the Latin word at the tip of the pen, if not on the

tip of the tongue. But the process may not have been as "natural" as Peletier thought. Latinizing French served less often to fill a need than to show off one's science and connote a certain style; we know enough about neologic pressure on contemporary French to weigh the symbolic meaning of expedients used by Renaissance clerks to establish a personal voice, inscribe the mark of a school—a learned jargon stuffed with antique remembrances squeezed in next to ordinary words. The proliferation of doublets, the same word in two versions, one traditional and one artificial, illustrates this concourse: *grief/ grave, frêle/fragile, sevrer/séparer, entrerompre/interrompre* (serious, frail, separate, interrupt).

Some attempts failed, many succeeded. Pierre Guiraud notes that three-fifths of the twenty-eight hundred Latin or Greek root words used in modern French were created in Middle French, with maximum fertility in the fourteenth and sixteenth centuries.[26] A language that can assimilate such massive innovations is a language transformed from day to day. A brand new, sophisticated word would burst in, meet with refusal from the common people, and within a few short years take its place in everyday speech. Georges Gougenheim makes an interesting observation that confirms this power of assimilation.[27] Among the Latinisms used by the Limoges schoolboy presented by Rabelais as the height of pedantic novelty and stylistic snobbery, eighteen sooner or later entered current speech, including *crépuscule, féminin, génie, indigène, nocturne, origine, sexe, vénérer* (dusk, feminine, genius, native, nocturnal, origin, sex, venerate). Renaissance French integrated foreign bodies that another culture might have rejected as unwelcome intruders.

The same could be said for Italian imports. Some 460 Italian words were inserted into the French vocabulary during the sixteenth century,[28] renewing, among others, artistic terminology: architecture (*arcade, balcon*), painting (*cadre, estampe* [frame, engraving]), music (*concert, sérénade*), literature (*sonnet, tercet*), not to mention other pleasures such as food (*cervelas, vermicelle*) and comedy (*bouffon, burlesque*). It is true, not all Italianisms survived: *J'ay l'usance de spaceger par la strade après le past* (I usually take a walk after my meal), *quelque volte* (sometimes), *in case* (at home), *Dieu soit ringratié* (Thank God).[29] Someone who really spoke like that would not be understood for long, if ever. These lines are quoted from the well-named Philausone, Henri Estienne's caricature of the affected little master in a satire on Italianizing snobbery at the court. The prestige of Italian culture was so vibrant among the elite that mimics and crossbreeds made a fortune, to the point of pinching Estienne's Gaulist nerve. Convinced of the superiority of the French language,

he fought against the Italian invasion. As with expressions in English and international technical jargon in today's French, not all grafts took. But the capacity of French for assimilation, adaptation, and internal restructuration has never been so great as in those days.

The possibility of limiting Italian imports was considered, but compensation would have to be sought elsewhere. Henri Estienne had a solution: "Before going outside our country . . . we should profit from all the words and all the ways of speaking that we find here."[30] Humanists, whether for or against borrowing from the neighbor's languages, were generally inclined to make use of whatever fell into their hands and thus inclined to explore this alternative. Even the poets of the Pléiade, indifferent or disdainful of the Middle Ages, recommended reviving or rejuvenating here or there an archaic word in danger of falling out of use.[31] So terms like *s'esbanoyer, souef, souloir, celestiel, isnel* were maintained or restored.[32] But the national wealth contained another lode that most writers of verse or prose intended to exploit. Local dialects were a treasure house of picturesque words that written language, even though it "spoke" Parisian, should not disdain. Montaigne turned to them, but only as a last resort: "It is for words to serve and follow, and may Gascon come forth, if French could not go" (1.26.171). Ronsard was more positive and eclectic: "You will skillfuly choose and appropriate to your work the most meaningful words in the dialects of our France . . . and no need to frown if these vocables are *Gascon, Poitevin, Normans, Manceaux, Lionnois,* or from another province."[33] He himself occasionally remembered his native *Vendômois,* like many other poets who threw a local word into their verses to indicate their rural origins. Storytellers even more than poets, and Rabelais better than any other, obtained local color by seasoning their stories with homegrown words.

Bonaventure des Périers, an excellent craftsman in verbal material, appreciated the sonority and exotic effect of provincialisms as droll as this rhyme, which we would be hard put to translate today:

> *Ça, trincaires,*
> *Sommadaires,*
> *Trulaires et banastons,*
> *Carrageaires,*
> *Et prainssaires,*
> *Approchez vous et chantons,*
> *Dansons, saultons,*
> *et gringottons.*[34]

Though dialects were starting to lose their literary status, centralization and standardization of French had not yet reached the stage where the slightest infraction against the rules would be proscribed. For literate people in the Renaissance, the value of the national language lay not so much in its unity or purity as in its wealth and variety. Peletier advised poets to look carefully for "Picard, Norman, and other words that are under the Crown. It is all French, because they come from countries of the King."[35] French cultural policy would not always be so open as in those days, when serving the language did not mean strangling or barricading it but extending the frontiers as far as possible, finding and exploiting all available resources. It is true that, when the theoreticians went to help themselves at the buffet of local speech, their eyes were bigger than their stomachs. Their recipes, stimulated by ravenous appetite, never really took hold; they were applied on a limited scale and, by their very excesses, led ultimately to rejection.

Other techniques were used to exploit native sources and contribute to expanding the dictionary. Words that had been asleep, solitary, and unproductive were revived and, with a bit of tinkering, made new from old. Taking two banal epithets and putting them together gave a new adjective: *doux-fier, doux-grave, dousucré, doux-cruel* (proud-gentle, serious-gentle, sweetly gentle, cruel-gentle). The poets of La Pléiade indulged heavily in these hybrids, and Du Bartas went one step further and combined a verb with its complement—*aime-bal, aime-musique, chasse-mélancolie* (like-dances, like-music, chase-melancholy), a substantive and its qualificative—*front-cornu, pied-vite* (horned forehead, swift foot).[36] For a few decades poets indulged in the fabrication of composite words as a stylistic coquetterie, but by the end of the century it had gone out of fashion.

Another trick that was all the rage, derivation by suffixation, opened a broad career in neology. Ronsard claimed it was the way to "make words fruitful and multiply" by inventing families for them, reintroducing "old words" into the reproductive cycle:

> *Puisque le nom de "verve" nous reste, tu pourras faire sur le nom le verbe "verver" et l'adverbe "vervement". . . . Et sur les vocables receus en usage, comme "pays," "eau," "feu," tu feras "payser," "ever," "foüer," "évement," "foëment," et mille autres tels vocables, qui ne voyent encores la lumiere faute d'un hardy et bien heureux entrepreneur.*

Since we have the noun *verve,* you can make a verb of the noun *verver,* and an adverb, *vervement.* . . . And for vocables in accepted usage, like *pays, eau,*

feu, you'll make *payser, ever, foüer, évement, foëment,* and hundreds of other such vocables, that do not yet come to light for lack of a courageous and fortunate entrepreneur.[37]

And yet the suffixes used to form verbs and adverbs were just the tip of the iceberg. The French language includes about one hundred (*-age, -aille, -ois, -esse, -able*), most of them active in the sixteenth century, used primarily for creating substantives and adjectives. Scattered among the verses of La Pléiade, we find, for example, *printannal, étéal; autonnier, foudrier; angoisseux, écailleux.* Superlatives were forged on the Latin paradigm (*grandissime, bellissime*), and diminutives competed with Italian (*"Amelette Ronsardelette, Mignonnelette doucelette"*).[38] But what need for *grandissime* when you have *très grand,* or amelette for *petite âme?* Poets had their reasons that economics could not deny. And, in fact, they were not the only ones who played with suffixes to produce plentiful derivatives and create useless repetitions. *"Estez-vous des Frappins, des Frappeurs ou des Frappars?"* Rabelais asked jokingly, and elsewhere, to settle his quarrel with the oppressors, coined: *"Sorbillans, Sorbonagres, Sorbonigènes, Sorbonicoles, Sorboniformes, Sorbonisecques, Niborcisans, Borsonisans, Sanisborsans."*[39] Rabelais's neologic machine forged ahead, but common usage, invaded with concurrent series, was not far behind. There was a choice between *brouillis, brouillure,* and *brouillement; copieur, copiard,* and *copiste; arrest, arrestage, arrestement, arrestée, arrestance, arrestoison.* Where would it all end (*s'arrêter, s'arrestoit*)? The inflation of more or less synonymical variations threatened to end in indifferentiation.

That was Montaigne's argument. Vocabulary could be weakened under pressure from such dilation and dispersion. Giving priority to quantity was harmful to the quality of words, to their force and semantic dissemination. While fanatics of neologism *"se gorgiasent [se complaisent] en la nouvelleté, il ne leur chaut de l'efficace"* (indulged in novelty, caring naught for efficiency) (3.5.874), Montaigne offered a solution that was just the opposite of this headlong devaluation: instead of accumulating words it would be better to work with a limited stock and explore all possible resonances. The surface expansion of French has gone far enough; now it is time to stop the movement, time to explore and exploit the energy of ordinary terms. People who really love the language, said Montaigne, "do not bring more words, but enrich what they have, giving them weight by deepening their meaning and usage, teaching them uncustomary movements" (3.5.873). Montaigne thought that the meaning of familiar words should be deepened and their latent potential brought

up to date by unfolding the reserves of metaphoric expression, adding other values to the value of usage, drawing several meanings from a single word.

Weary of neologic excess, Montaigne pleaded for lexical stabilization. But the movement did not come to a halt, it only shifted position, pulling back from the structure of vocabulary to penetrate into the heart of words and change their meaning. "Forms of speech, like plants, are amended and fortified by transplanting," he added in the same passage (3.5.874). Here the horticultural metaphor indicates a shift from lexical addition to another semantic field and refers to regeneration of language by analogy. Montaigne believed that language, animated by metaphoric "transplants," stops expanding and is recomposed from within. This is a different but no less dynamic order of flexibility.

Morphologic Variations

Language operated malleability also on the level of forms. Here a signifier, there a syntagm, elsewhere another construction present a supple, changing morphology, subject to manipulations by the speaker. Though the phenomenon remained sectorial, it was far more common than in the present day and contributed to the idea that tools of intellectual or literary labor—here reduced to basic units—are polymorphous and subject to adaptation and modification.

Or, ore, or *ores? Avecq, avecque,* or *avecques?* Ronsard tells the apprentice poet to choose the form he prefers and the same for "hundreds of others that without fear you will shorten or lengthen as you please."[40] Rhetoric classifies as metaplasms—at the same time authorizing—all types of phonic modifications for the purpose of harmonious diction, particularly in poetry. The ancients showed the way, and sixteenth-century authors, taking advantage of the plasticity of French, followed suit: we must adopt "the freedom of Greeks and Latins who muted and changed, changed and muted letters as they pleased, to obey the sound, or the imperative law of their verses."[41] By adding a phoneme at the end of a word, the poet can obtain the required number of syllables, avoid a hiatus (*riens à*), or make a rhyme (*riens / miens*). A vowel can be introduced in the middle of a word to facilitate homophony (*chouse* for *chose, saiche* for *sache*). Du Bartas personalized his style by inventing the double first syllable: *flo-flottant, sou-souflant, ba-battant.*

Since additions were allowed, subtractions could not be denied. Ronsard

said, "If you swallow the 'o' and the 'u' for the needs of your verses, no harm is done."[42] Apocope—the elimination of a sound at the end of a word—was frequent, generally to facilitate the measure of a line. Any type of word could be abbreviated: adjectives (*plaisant' brunette*), pronouns (*qu'el vienne*), a verb (*je te supply que tu ne prenne' un mal*). Another common practice was eliminating a phoneme within the word—*don'ra*—to get the right syllable count—*Parnase* to rhyme with *Pégase,* and *sech'resse* with *Grèce.* The list of poetic licenses could be extended, for example, to the free use of synaeresis and diaeresis. In truth, all of this technical fiddling did not affect meaning. It stands at the most modest end of the scale of structural mobility. Nevertheless, in a context of metamorphosis in the cosmos as in the literary text, we may discern in this flexibility of words a common experience, a comparable transformist perception of matter. It is significant that, from the beginning of the seventeenth century, metaplasms were disparaged: vocabulary had been sufficiently dilated, contracted, and deformed. The time had come to establish stable form.

Though the general flexibility of linguistic structures was applied in poetry more than other types of discourse, morphologic variations were available in all registers. Speakers often had a choice between an old construction on its way out and a new one coming in. Should they say *tromperesse* or *trompeuse, finer* or *finir?* They might hesitate between *cestuy-cy, iceluy,* and *celui-ci; il hayoit* and *il haïssait.* This latitude also extended to gender for many words whose fate would soon be settled by the dictionary: was it *un* or *une art, un* or *une affaire, un* or *une ombre?* The gender of *comète, doute, navire,* and many other words was equally uncertain. Not all grammatical sectors were so undecided, but the margin of maneuver granted in several categories confirms the impression of a system in transformation. With so many variations in prescribed gender, termination, or other parameters, the instability was enough to make people wonder if tomorrow they would still speak the language of yesterday or the day before.

It is true that grammatical categories—morphology and syntax—were less susceptible than vocabulary to intervention by speakers and more resistant to rapid change. But precisely because of the slower pace of transformation of fundamental linguistic structures, competing doubts and solutions accumulated on these points too, confronting users with an everyday experience of an ongoing process.

It is known that the suppression of certain flectional verb endings led to increased use of the personal pronoun subject in Middle French. But the inno-

vation remained optional: one could say *ce que vous diriez* or *ce que diriez, ce qu'il faut* or *ce que faut.* At the same time another profound change was taking place. The disappearance of subject and regime case flectional endings was gradually leading to a word order in which these two functions had to be distinguished by position; the subject-verb-complement order was being established but was still flexible enough to allow many variations. Old and new turns, Latin logic and Modern French logic were equally available. Rabelais could write *"Toutes choses prenoit en bonne partie,"*[43] but he could have used the opposite order for verb and object and also added the pronoun *il.* Like his contemporaries, he put grammatical flexibility in the service of his style.

Not only word order within propositions but the entire economy of the sentence was being readjusted. The Latin model gradually replaced the less rigorously organized ancient French style. This slow process initiated in the fourteenth century by scholars with a taste for Latinisms continued through to the sixteenth century. New conjunctions of subordination made it possible to underline nuances in logical relationship between propositions; increasingly complex hierarchical structures replaced the previously dominant paratactic disposition. This would lead the French language toward well-constructed Latin-type oratory prose with sturdy classical grace. There is nothing exceptional about the simultaneity of these syntactic choices; what is significant is the appearance of a new model and the slow mutation of sentence structures.

Works in Progress

9 ▋ *On Site*

Book and Variations

When books are written in an unstable language by protean authors in and about a world that seems to be in constant transformation, their structure is itself mobile. Why should artistic compositions escape the law of change? On the contrary, the principle of *mimesis* inherent in Aristotelian poetics teaches writers to participate in the generalized movement. The deduction is easily made: form in nature is changeable, literature imitates nature, so literary forms should be changeable.

This choice of mobility is all the more striking in that it applies to printed works. With rare exceptions (Montaigne's annotations; see fig. 41), the original manuscripts have disappeared. These rough drafts, the first steps of genesis that would have added a supplementary dimension to textual variability, are missing, but the process continued in the course of successive editions. Far from immobilizing the text, the printing press was an integral element of its metamorphosis, propelling it from one stage to another.

In this chapter we will look at some works that continued to change after publication, in the image of a universe in perpetual gestation. Montaigne's *Essays,* repeatedly revised, amplified, and redirected according to a poetics of transformation,[1] would have offered the best possible illustration. However, I prefer to present some less obvious examples in other genres—poetry, learned treatises—to demonstrate the scope of the phenomenon.

A simplistic opposition attributes textual mobility to the Middle Ages and

Fig. 41. Michel de Montaigne, additions and corrections written over the 1588 edition of the *Essays,* Bordeaux copy, with notes in Montaigne's handwriting. Facsimile reproduction published by René Bernouilli, Geneva-Paris, Slatkine, 1987, vol. 1, p. 126r.

fixity to the period of printed books. The medieval work, transmitted by copyists or reciters who altered it at will, would have been subject to constant mutation, whereas from its very inception printing abolished fluctuation in favor of *ne varietur* works; publication obliterated the work's genesis, interrupted its evolution, and gauged its future. I believe, on the contrary, that sixteenth-century writers were inclined to ruse with the stabilizing affects of printing and preserve to a large extent the mobility of the manuscript era. A brief retrospective will reveal the continuity.

Paul Zumthor and Bernard Cerquiglini remind us that a considerable body of medieval literature in vulgar tongues exists in and through variations.[2] Epics and tales were public property, realized through transformations and manipulations normally contributed by those who received or transmitted them. The work consists of an invariable core—a plot, a prosodic matrix—that marks its identity and functions as an axis for a virtually unlimited suite of modifiable paradigms. In other words, a work is a rough draft, a potential actualized through individual realizations, all more or less different from each other. It is constantly coming into being or exploiting, by transformations, its own virtualities. The matter is available, flexible, elastic, and its form indefinitely variable. In most cases the absence of a known author and title reinforced the impression that these works were common property, without an owner or visible identifying marks, open to all possible insertions and diversions.

The practice of transmission in manuscript form was one of the reasons for this flexibility; each copy introduced into the work's unfolding existence another agent who inscribed, in varying degrees, traces of his passage. Contrary to the general idea upheld by generations of philologists since the nineteenth century, a copyist was not always a simple scribe, and the disparities introduced were not necessarily mistakes or signs of abusive liberties. The scribes were following the injunctions of texts presented as appeals for transformation, which already contained, virtually, room for intervention. From minor linguistic variations to structural modifications, by accidental or voluntary interference, a whole range of revisions was possible, from errors of transcription to correction, correction to gloss, gloss to amplification, amplification to remodeling or continuation.

Aside from the initiatives of scribes and modifications common to the manuscript tradition, the practice of oral dissemination was another factor of instability. Imperfect memory, pressure from the audience, all possible risks of recitation could influence the basic core. Variability in the *Chanson de geste*, often attributed to the freedom of the jongleurs, is well known. Jean Rychner

also studied transformations of fabliaux and concluded that they were the mark of storytellers who, by profession, adapted them to the audience's taste. The most audacious, he says, "cut them short or drew them out, changed the proportions by uneven development of one part to the detriment of another, or just kept the original subject and completely rewrote the tale, so that the same story traveled in a wide variety of costumes. In these operations everything was subject to alteration: style, versification, narrative organization and coherence, spirit, and intention."[3]

Except for the Bible, classics (or what was left of them), and rare authorities such as the Code, which were scrupulously respected by the clerks, medieval literature, especially in the mother tongue, could be modified. The scope of change varied with the genre: maximum for the epic, considerable in the wide field of romances and the creation of prose versions in the fourteenth and fifteenth centuries, slight in lyric poetry and signed works by authors like Chrétien de Troyes. Attempts to go back through "unfaithful" versions to find an original or archetype for the latter are justified. But in zones of greatest turbulence, the proliferation of variants belies all research for an authentic text and attempts to establish a hierarchy of various existing versions. The scale of values established by philology—an Urtext, with its different versions classified by degree of corruption—should be reconsidered and replaced by a "horizontal" model, a poetics of shifting and mobility that recognizes the legitimacy and equal merit of all realizations generated from a common matrix. This logic upsets many normal reflexes: the work does not coincide with one but many texts, it exists in its variants as well as its constants, it is to be grasped as a changeable object whose history is an integral part.

In the period of manuscript transmission, anonymity and the intervention of numerous partners who modify and develop the work were not required conditions for variation. Transformation of the written text was such an integral part of creation that it could also determine the way an author handled his own works. Petrarch is an excellent illustration.[4] This great intellectual, who was extremely attentive to the influence of his books, rarely finished them, or at least not at the first attempt: he published a book and then, dissatisfied, reworked it, went over the entire text, adding, reorganizing, perfecting. Petrarch, like Montaigne, was an author whose works lived and grew with him; we can trace his intellectual biography along the lines of their mutations.

The three major projects that Petrarch initiated at the beginning of his career—*De viris illustribus, Africa,* and *Rerum memorandarum libri*—occupied him intermittently until his death and were never finished. *Bucolicum carmen*

was started in 1346 and improved in 1357 but kept on changing up to 1366. *De vita solitaria,* started in the same year, wasn't finished until 1371. If these works, conceived as unitary compositions, remained malleable, the collections could only be more so. And that was exactly the case for *Epistolae familiares,* the collected letters published and republished by Petrarch over a twenty-year period with countless additions and revisions. The history of *Canzoniere* (the real title, *Rerum vulgarium fragmenta,* is significant) was no less eventful: nine stages of development can be distinguished, and others surely remain to be discovered. Wherever we look we find works that function as mobiles—by multiple interventions in the oral and manuscript transmission described above and, in this case, by the sole acts of the author—so that internal analysis of any given temporal layer should be supplemented by a diachronic reading. A work cannot be reduced to one of its manifestations; it also resides in the sum and the differences of its various states. The production process is as significant as the finished result. It follows that text and author are closely united through their shared experience: texts constantly manipulated by the author, authors ever present in the ongoing variations of the text.

It would be absurd to deny the innovative importance of the printing press; for the first time it was possible to reproduce in great quantity a final, immutable text in conformity with the author's intention. The versatility of the manuscript age gave way to a trend for stability and uniformity. But we cannot affirm that this possibility of multiplying invariable texts brought an end to mobility. The technical means were at hand, but old habits endured, all the more vigorous in that they were supported by the transformist sensibility evoked in the beginning of our study.

And, in fact, typographer's methods were less fixist than is often thought and, far from encouraging the massive fabrication of a stereotyped product, sustained surprising mobility in the sphere of printed books throughout the sixteenth century. The tendency was to begin with small printings and subsequently increase the quantity if the market had been favorable; this gave the author a chance to intervene and modify his text if he wished. Another practice, specific to the period and disconcerting because it is minute and irregular, stretched this elasticity in another direction: contrary to norms adapted since, all copies in the "same" edition—same title page, same date—are not necessarily identical. At any stage in the production process, anyone involved—typographer, corrector, author—could intervene and manipulate the work under press, correct a mistake or omission, with a significant risk of introducing a typographical error somewhere else in the text. An erratum in an

edition of Montaigne, entitled "Mistakes to correct in the printing of certain copies,"[5] shows that not all copies had been given the same treatment.

In light of these variants, scrupulous bibliographers today must make a distinction between an *edition* and an *issue: x* issues—copy or group of copies—share enough common characteristics to be considered part of the same edition but enough disparities to disturb the modern editor searching for the best text. The collation of even a few copies from the 1580 edition of the *Essais* printed by Simon de Millanges reveals numerous corrections in the course of printing. For example, in some copies we find *C'est beaucoup pour moy d'avoir le jugement reglé, si les deffautz ne le peuvent estre* (It is much for me to control my judgment, if not my defects), while in others *deffautz* is replaced by *effaitz* (effects); elsewhere, *vile indice* (vile sign) is changed to *vilein vice* (vile vice); and again, several volumes include *capitalement defendus* (deadly sinful), omitted from others. And the list could go on.[6]

Punctual interference on a limited number of sheets under press was possible at any moment, while other more important changes might take place at the end of a printing (replacement of a sheet or even a quarto, insertion of a page). When the book was bound, the arrangement of new and old sheets might also vary, and so on. All of this shifting and changing resulted in virtually limitless combinations of—most often slight—variables, up to certain extreme cases where every copy of the book is unique. Richard Sayce concluded, from his study of the 1595 edition of the *Essais,* "I doubt that there are two copies exactly alike; so it is often imprudent to claim this or that about the lesson of 1595."[7] This might be a cautionary note from a philologist distraught by the divergencies of a manuscript tradition. The serial production of books was certainly marginalizing the fabrication of distinct specimens, and the published object would soon lose its flexibility. Yet it is surprising to observe the strong resistance in the sixteenth century against the mechanical reproduction of a fixed text.

The author's margin of maneuver did not stop at publication. For him, the book was a growing organism, an object with a history and temporality, that should not lose its freedom even when printed. Authors didn't see their works as finished masterpieces but as potential to exploit, an open space where it should be possible, independently of typographical practices, to delete, correct, and, especially, add. Writers handled this freedom in different ways, as we will see.

Labile Forms: Ronsard

Ronsard never stopped rewriting his poems. No sooner had he composed the first form than he would break it and make a new one; usually the original cast was still recognizable, but it was partially broken, emptied, then remodeled and refilled. The poet's works blossomed by explosion, conversion, restructuration of individual components. Du Bellay advised writers to correct their first drafts, amend and transform them: "add, take away, or change at will," and treat them as rough-hewn and formless, "set them aside, go back to them often, and like the mother bear lick them to give them shape and fashion their members."[8] This comparison of unlicked cubs, which Du Bartas applied to the Creator fashioning chaos, associates the act of correcting—the height of art—with a natural process. To rework the material, articulate and recycle it, is to follow the model of nature naturing, creator of forms. In his verbal concoctions Ronsard never forgot that he was participating in the great universal movement; he pursued variation in his works out of fidelity to the essential instability that governs the world:

> I believe that no Poetry should claim to be accomplished, if it does not resemble Nature, which by the Ancients was not considered beautiful but for being inconstant, and variable in its perfections.[9]

The work progressed by large-scale modification of the choice and arrangement of poems within a given collection or small-scale changes in details of words or lines. From 1560 until his death twenty-five years later, Ronsard was publishing *Collected Works* that gradually increased in volume as new texts slipped in alongside the old. From one edition to the next, he reread, revised, expanded, and rearranged the poems. The first posthumous edition, published in 1587, still bore traces of this incessant activity: *Les Œuvres de P. de Ronsard, Gentil-Homme Vandomois. Reveuës, corrigées et augmentées par l'Autheur peu avant son trespas* (*The Works of P. de Ronsard, Gentleman of Vandome. Reread, revised and augmented by the Author shortly before he passed away*).

Any and all details were subject to variation: sonority, syntax, vocabulary, choice and density of figures.[10] Some poems came through succeeding editions more or less intact; others were profoundly altered. Thirty-two years after the first publication of *Continuation des Amours* (1555), only two lines of the first sonnet, "Thiard, chacun disoit à mon commencement" (Thiard, everyone said at my beginnings) were left untouched; the original version metamorphosed in four stages. It is true, the syntactic model, meter, rhyme, and, with

one exception, rhyming words are left untouched; the shell remained intact but the insides were thoroughly stirred up and redone.

In Ronsard's hands a model became a mobile, a modulable structure. Just as he danced and turned with anagrammatic variations on the name Marie = *aimer* (to love), he played with the words of the poem:

> *Marie, qui voudroit vostre beau nom tourner,*
> *Il trouveroit Aimer: aimez-moi donq, Marie,*
> *Faites cela vers moi dont vostre nom vous prie,*
> *Vostre amour ne se peut en meilleur lieu donner.*
>
> Marie, who wouldst your lovely name turn 'round,
> Will find Love: so love me then, Marie
> Do to me as does your name I beg thee,
> Your love could not in better place be placed.[11]

There is only one change in the first two lines of the quatrain (1.1: *"votre nom retourner,"* 1560). However, successive mutations of the next two lines show how far the exercise was carried:

1560	*Puisque vostre beau nom à l'amour vous convie,*
	Il faut vostre jeunesse à l'amour adonner.
	Since your lovely name to love invites you
	Your youth to loving must you give.
1578	*Vostre nom de nature à l'amour vous convie.*
	Pecher contre son nom ne se doit pardonner.
	Your name by nature to love invites you.
	By grace sin not against the name of love.
1584	*Vostre nom de nature à l'amour vous convie.*
	A qui trahist Nature il ne faut pardonner.
	Your name by nature to love invites you.
	Who betrays Nature no pardon shall know.
1587	*Vostre nom de lymesme à l'amour vous convie,*
	Il fault suyvre Nature, et ne l'abandonner.
	Your name itself to love invites you.
	Nature you must follow and not turn away.

The sequence of poems within the collections was also conceived as an open, flexible system with mobile units, contributing on another scale to the inscription of a temporal dimension in the spatial reality of the work. Ronsard moved poems from one collection to another, added to a series, deleted, re-shaped. A book seemed to have reached a stage of equilibrium? At any time it could be dismantled and rearranged in new combinations. The history of suc-

cessive editions of Ronsard could belong to natural science: forms grow and die, swell up or atrophy, like living organisms.

A study by Doranne Fenoaltea on the classification of the *Odes* fits into this perspective.[12] The analysis of structures in the four books published in 1550 shows rigorous, precise construction. The poems are arranged by insert or overlap to create elegant symmetries. Ronsard, working like an architect, tried to edify a monumental structure governed by the ideal proportions of Vitruvian classicism that would be as solid as a marble palace. But it soon began to move. In 1555 and in subsequent re-editions, the original balance was disturbed, the outlines broken by shifts, additions, and suppressions, as if the dream of stone could not resist the effects of time, and the neglected monuments cracked, crumbled, and finally collapsed. Ronsard seemed to switch his preference from the architectural to the garden model, from the immutable work of art to the flexible traces of nature. Disorderly vegetation invaded the space previously regulated by geometry. In the first version, the collection ended on a metaphor of immutability: "Stronger than iron, I finished my work."[13] The new ending, introduced in 1555, is a vow addressed to the nymphs of nature: "Adorn this book with ivy, / Or myrtle."[14] The young poet thought he could construct unalterable forms; the mature writer dismantled them to adopt a biological model and subscribe to a poetics of instability and transformation.

"Amours de Marie"—*Continuation* and *Nouvelle Continuation des Amours* (1555 and 1556)—also underwent modification by dispersion of series and blurring of forms. The first book, in its first edition, opened on several tokens of order and continuity: six poems (1–6) placed before the love poems, are addressed to writer friends; the first twenty-seven pieces are in alexandrines, followed by a sequence in decasyllables; and the fixed form of the sonnet prevails throughout. But this was just a temporary configuration. When the 1560 collective edition was published, everything had moved. The two books are fused, many poems are redistributed, several have disappeared (and turn up in other collections), others are added. The aforementioned sequences are dismantled, related poems are dispersed; classifications of recipient, meter, poetic form no longer function. The spectacle of variety, the choice of the composite, seems to mark the triumph of metamorphosis. In fact, the collapse of one edifice makes way for the construction of another. The three long poems—"Elégie à son livre," "Le Voyage de Tours," and "Elégie à Marie"— arranged like pillars at the beginning, middle, and end of the collection, construct a new order. One structure disappears, another takes shape, pieces remain, others are taken

away or change. The modification of subsequent editions of "Amours de Marie," or other collections, would add to the procession of ductile transitory formations, constantly seeking a balance between old and new, same and other, stable and unstable.

Euphemus, one of Jason's companions, dreamed that a lump of sod given to him by a god metamorphosed in his arms into a young woman; when he awoke, guided by the premonition, he threw the lump into the sea, and it became an island. This legend occupies a strategic position in an "Elégie" that opens the *Nouvelle Continuation.*[15] Ronsard applied it to the grandiose destiny of his work, and I would see it as an emblem of the conversions that operate throughout "Amours de Marie." In fact, transformation does not stop at the limits of this book but also transforms the preceding collection. Having followed the onward meanderings of its history, let us now go back to "Amours" (1552–53), of which it is the "continuation." Observing the passage from one to the other is like watching that lump of sod unfold before our eyes in an astonishing sequence of blooming and dilation. From *Cassandre* to *Marie,* the original matrix alters; the form is emancipated; body and sentiments, as if liberated, multiply.[16]

The first *Amours* made a cult of passion as absolute adoration of a unique woman. But the second claims the right to inconstancy, bursting open the carapace of Petrarchian submission. Now "Marie" would seem to name more than one young lady, and other feminine figures are invoked in passing. The episodic return of Cassandre and old refrains on fidelity paradoxically confirm the instability of the vision and the resolutely composite aspect of the collection. Wherever we look, the poet is emancipating himself: he explores several themes and variations on love, accumulates recipients, runs through the range of styles and genres. The tightly woven tissue of *Cassandre* comes undone; variety and mixture replace coherence and rigor. The elements of continuity help us measure the scope of change.

The transformations of poetic form are particularly striking. The poems to Cassandre (219 of the 221 included in the 1553 edition) fit into the fixed pattern of the sonnet in decasyllable, with an almost invariable rhyme scheme. An ideal model, "measured by the lyre" and seemingly endowed with metaphysical necessity, distills its harmony, canalizes the flow of passion, and reduces the mobility of discourse. Then comes "Amours de Marie" and the palinode is total; not only are the sentiments liberated, the fixed fourteen-line standard also earns mobility. The carapace of the sonnet splits wide open: line length can vary from 10 to 12 feet, multiple combinatories are allowed in the disposition

of rhymes, notably in the sizain—each of the first six sonnets in the 1555 *Continuation* is arranged differently—and there are even exceptions in the feminine/masculine alternations. But the emancipation does not stop there. Poem 56 inclines to the rules of the sonnet but contains fifteen lines; the paradigm shifts, slightly disconnects, and engenders a new form. Then in the 1556 *Nouvelle Continuation,* the sonnet has lost its exclusivity. It neighbors with "chansons" (themselves highly varied in strophic design), elegies, flat rhyme poems; added to this, a bric-à-brac of translations or adaptations from Greek, poems by other authors, a few pieces in Latin give further evidence that the canon is broken. The paradigm of the sonnet is still perceptible but as a transformed, deformed, regenerated vestige. Like a palace overgrown with vegetation, a formerly immutable structure is fractured and dilated. The poetic forms of Ronsard are animated; they are forces.

Labors of Hercules: Erasmus

A correspondent, complaining to Erasmus that he had to buy several editions of the same book because they varied so much from one to another, asked him why he didn't wait until the work was really finished before he published it. The reply was unambiguous:

> Just as we do not stop working, as long as we live, to make ourselves better, we never stop correcting and improving the works of our mind until we stop living. . . . No book is wrought such that it cannot be made more perfect.[17]

The mobile works that marked his career with their transformations were plentiful,[18] yet the example Erasmus chose was his life's work, *Adages,* a text that had been with him for thirty-six years. When *Adages* was first published in Paris in 1500, scholars may well have been struck by its apparent novelty. It was written in excellent Latin, printed in Roman characters, and opened a broader horizon on antique culture than anything known at that time in France. But it was a slim 152-page collection of 818 adages. Not much, especially compared to the 4,151 entries in the last edition published in the author's lifetime (1536), at least ten times as long as the original. This extraordinary extension is an excellent illustration of the way a humanist creation snowballed, swelling and transforming as it was carried along in the movement of research.

The project of the *Adages,* like many manuals published in the sixteenth century, was to harvest all possible vestiges of antiquity and put them at the

disposal of scholars. In this particular case, Erasmus sought to collect and explain proverbs, aphorisms, figurative expressions, all sorts of more or less enigmatic sayings, such as *Necessarium malum* (a necessary evil), *Una hirundo non facit ver* (one swallow doesn't make springtime), *In nocte consilium* (night brings counsel), *Neque caro est, neque piscis* (neither fish nor fowl). The commentary, often just a few lines, sometimes a few pages, followed the standards of the new philology, citing Greek or Latin occurrences of the adage and explaining the literal and figurative meanings. Additional information on the origin and use of the expression is provided, with references to the historical or cultural context and customs of antiquity; the author points out the stylistic value and, when relevant, the relationship to current problems.

The articles are all more or less structured along these lines, and yet the book never stops changing. Taking a look at different phases of this dilatory movement, we will see just how flexible the framework could be. The first variable is quantitative: the number of adages increased as Erasmus pursued his reading. The Parisian edition was followed in 1508 by a vastly expanded Venetian edition containing 3,260 articles, with a new title, *Adagiorum chiliades* (*Thousands of Adages*), as if to give notice that the enterprise has become gigantic. Erasmus's visits to Italian libraries, and particularly to the collections of Aldo, the publisher of this version, had given him the opportunity to study numerous manuscripts unavailable in northern Europe and to quadruple his stock. The next threshold was reached with an additional 151 entries in the 1515 Froben edition in Basel. After which the growth rate slowed down, but there were always some discoveries in subsequent editions, published up to 1528. Erasmus was then busy on other worksites but not yet satisfied; with the 488 adages added in 1533, he easily passed the bar of four thousand. Only death could stop the flow.

Two principles governed this movement of amplification: Erasmus added but never deleted and made no attempt to classify. Some kind of order—alphabetical, by subject, author—would have made the work easier to consult (ample indexes would soon take care of that). But this would have imposed a pattern on matter that should be left malleable for transformation and would have complicated the process of addition. As we will see, the major merit of a collection like *Adages* lies not in its organization but in the mobility of its parts.

If the commentaries respected a few required categories, the structure remained supple and elastic. From one version to the next, Erasmus inserted new data into the articles as the opportunity arose. He discovers this or that

adage in a previously unknown context; the semantic development is outlined, requiring explanations and perhaps revealing a little-known aspect of the antique landscape. Philology leads to history, to better understanding in situ of the thought and customs of a foreign civilization. Erasmus belonged to the current of humanists with a passion for words as a means of capturing things, who questioned the language in order to capture the specificity of a culture. This was one of the great conquests of the Renaissance: the ancients, no longer considered as contemporaries, sharpened the observer's curiosity about difference and his awareness of historical change. The only hope of bridging the widening gap between past and present lay in knowledge, a ravenous appetite for knowledge, and spiral studies like this work by Erasmus.

As the commentary swells, the imbalance between the density of the adage and the prolixity of notations increases:[19] on the one hand a terse formula and on the other what Montaigne would have called "a stream of cackling" (3.5.897). This dilation is characteristic of the humanist project of digging out and bringing to light secrets buried in a lost world, to explain them and extract their deep meaning. An adage is like a bud that contains the latent promise of the flower, an enigmatic expression, a mystery to unravel. The ancients veiled their messages, deposited clues to their culture in their language; they wrote in code. The modern reader breaks the code, opens the coffers, takes out the secrets and publishes them, even at the risk of altering their force. The author of *Adages* acted as an intermediary, made a profession of displaying and multiplying. So it was normal that his book, both cornucopia and organ of distribution,[20] would operate with centrifugal dynamics.

A seedling buried in the core of the adage bears smatterings of antique history but also holds the germ of ulterior developments. Many of the locutions Erasmus studied were still current in his time, leading him to extend the historical investigation and establish parallels between present and past, pagan and Christian worlds. This additional spiral movement amplified from one edition to the next. By 1515, fragments of current events had slipped in beside philological and archeological material. Further, a new commited, personal, controversial voice is heard, mixing into old articles or mobilizing new ones. Learned commentary became a basis for a political discourse or led into autobiographical memories. Erasmus, living in symbiosis with his book, made the same experiment Montaigne would attempt seventy years later: anonymous compilation turns into confidences, an individual takes shape and comes to occupy the center stage, to the point that some of the later adages, longer and more personal, are as much satire or morals as erudition. Themes that marked

the public life of Erasmus, such as church reform and a return to the spirit of the gospel against institutional corruption, the crusade against the war, and mistrust of the despotism of the mighty, crept into the *Adages.* The distance from philology to ethics is covered by a discourse that actualizes without belying the potential of the primary core.

The book not only includes personal ideas or anecdotes, it also tells the author's own story through various stages of its development. It is an invitation to follow the intellectual itinerary of a scholar and moralist, which reads like the result of a performance. One of the most developed essays, *"Herculei labores,"* illustrates this reflexive reading. A commentary on the expression "labors of Hercules" becomes the novel of knowledge-in-progress, the theory of a work unfolding; it outlines on the basis of a first-person narrative a poetics of perpetual motion, which, of course, also applies to *Adages* itself.

"A labor of Hercules:" what better illustration, asks Erasmus, than the endless, thankless task I have assumed?[21] In a few pages he evokes the challenges facing him. There is not a single antique text, in any genre, from any period whatsoever, that is not likely to contain adages. So he must read exhaustively and attentively because interesting sayings are often dissimulated:

> Who can fully realise how much labour is involved in searching the whole world over, as it were, for such tiny things? A life-time would hardly be enough to explore and examine (in both languages) Poets, Grammarians, Orators, Dialecticians, Sophists, Historians, Mathematicians, Philosophers, Theologians (simply going over their names would weary a man out), and not once but over and over again. . . . One must push up the stone of Sisyphus.[22]

And the research does not stop there. Besides reading the authors, he had to consult commentaries, gather fragments of lost works, pick through the compilations. And then compare various manuscripts to find the best lesson and establish a final text for quotation. My eyes are so worn out from peering into musty, worm-eaten pages, says Erasmus, that I feel like I'm going rotten myself.

Thankless labor because there's no end to it: neither collection nor commentary is ever finished. Take the expression "a sardonic smile:" a whole volume would be needed to tell about Sardinia and its herb, define the medical phenomenon, quote philosophers. And to explain "an Iliad of misfortune" must we tell the whole story of the Trojan wars? Motivated by his immense appetite for knowledge and wish to share it, Erasmus came up against the problem of setting limits to his project. If he staked out a well-defined subject, he

would have to sacrifice the complexity and dynamics of the phenomena. Decisions on when to stop one's research, finish an article, publish a book are arbitrary and contrary to the infinite motion of science.

If a single individual can't come to the end of the project, why not make it a collective endeavor? Erasmus logically inscribes a place for the reader in the empty spaces of his work and asks for his cooperation. As he goes along he points out gaps in his information so that others, more knowledgeable, can fill them. He looked first to his students for help, called on his admirers and correctors, surrounded himself with a team that could work as in an artist's studio to perfect and complete projects from one edition to the next.[23] But Erasmus was not content to rely on occasional or immediate collaborators to carry on his work; he entrusted its entire posthumous existence to his readers, making them the continuators who would keep the book moving:

> Anyway, since the job is endless, and contributes to the general good, what is to prevent our sharing out the labour and finishing our work by our joint efforts? I have done my stint and I am handing on the torch. Let someone take up the succession. I have supplied an anthology, and not a bad one in my opinion, now let others come to chisel and polish and variegate it. . . .
>
> It does not matter under what name my works are read, I shall not trouble myself about who gets the glory as long as we have given students the opportunity to possess a thing of such value. Neither shall I be in the least offended if a better scholar comes along and corrects my work, if a more diligent author fills it out, a more accurate one rearranges it, someone with more eloquence gives it lustre, someone with more leisure polishes it, some luckier man appropriates it, as long as all this is done for the good of the public.[24]

Success does not lie in accomplishment but in the impetus given to posterity. It is both sterile and regressive to enchain a work to its origin, its individual genesis; the essential pole of the book is in the future, with the recipient who will act as relay, carry on the production and pass it along in turn. And this appeal was heard: *Adages* did inspire continuators who, by additions and insertions, kept the work in progress after the death of Erasmus.

Another adage, the famous *Festina lente* to the glory of Aldo Manuzio and his presses, went back to the metaphor of Herculean labors, but this time to describe the printer's project to publish correct texts of all the classics.[25] We can extrapolate: Erasmus believed that editors and authors, translators and compilers all share the same exalting, frustrating conditions. To restore letters and, in so doing, change life, they have to catch up on a tremendous backlog;

their task is urgent, but they can do no more than grope in the dark and find provisional solutions. Erasmus does not have time to perfect his style; with no regrets he refutes the Horatian precept—"Twenty times put your work back on the loom"—and sends the aesthetes back to their ivory towers.[26] Humanists considered the exploration of a vast territory and dissemination of knowledge as moral obligations, so it followed that imperfections and flexibility were inherent to the undertaking.

Modules and Medleys

Adages, a single work by a single author, varied as it progressed. But that was not the only strategy inspired by the imperative of constant perfecting and mobility. The history of the *Rhétorique* of Ramus presents an interesting variant. A series of treatises was published over a thirty-year period (1545–75) exposing the same doctrine—continuously revised, corrected, amplified—presented in different forms and signed by different authors.[27] Three collaborators— the protagonist Pierre Ramus, Omer Talon, and, to a lesser extent, Antoine Fouquelin—worked together, and each in turn signed the works without any clear distinction of how the task was divided. The work is both collective and polymorphous: one distinct system, recognizable by its very particular conception of rhetoric, is manifest sometimes in Latin, sometimes in French; here with aspects of a scholarly manual, there by way of commentaries on Cicero or Quintilian. Everything in this editorial constellation functions as if the uncertain attribution and varied realizations were techniques to guarantee freedom for the authors and flexibility for the subject. In answer to his critics, Ramus explained that this apparent inconsistency "is commanded by God and Nature, like a steep slippery incline with steps that trace and limit the only path to knowledge of science and doctrine."[28]

There was another, more radical solution that went to the very extreme of the logic of mobility. In the style of *Adages,* many sixteenth-century works were collections of more or less connected pieces, selected and arranged according to apparently arbitrary transitory classification; they assemble separate movable units—what I would call *modules*—and invite the user to help himself. He can take this or that part, move it to a new environment, put it to different uses, combine it with elements from other sources. As we have seen, Ronsard shifted the arrangement of poems from one collection to another, treating them as pieces that could be fit into any number of mosaics. Other genres followed the same practice: the highly popular books of emblems are

temporary assemblies of images that can be taken out and circulated and even change meaning in changing context. Collections of short stories (the *Decameron,* for example) also presented narrative material in independent modules; there were dozens of works in Italy, as in France, that functioned this way, often nothing more than new combinations, more or less harmonious, more or less organized, of stories that went from one anthology to another.

Knowledge could also be handled with this technique of detachable parts. Two models were present.[29] The encyclopedia, a totalizing project that purports to make the rounds of knowledge and arrange it according to a determined, meaningful order, giving science a harmonious form believed to reproduce the order of the universe or of the mind. At the other extreme, more skeptical authors renounced all attempts at rational classification and brought out "lessons" or essays, a mass of information or opinions delivered helter skelter. It is true that these two paradigms are rarely found in the pure state, and the encyclopedic ideal, though subject to an affluence of new information and much pressure, remained active.[30] But it is the other option that interests us here.

As we saw with Erasmus, ravenous scholars submerged by the quantity of available sources, aware of participating in ongoing research, naturally used a flexible structure to stock their material. Drawing their models from antiquity, these erudites turned toward the solution of miscellanies, compilations, anthologies. There was an unprecedented vogue for the genre in the last decades of the sixteenth century; authors such as Etienne Pasquier, Pierre Messie, Boaistuau, Béroalde de Verville, and Vigenère accumulated volumes of memoranda and "lessons," vast warehouses of bits and pieces of erudition and science, ready for varied uses.

At the intersection between narrative collections and learned miscellanies, we find mixtures of stories, documentary information, didactic material, and comical bits in varying proportions. This proteiform genre, represented by authors like Noël Du Fail, Guillaume Bouchet, Nicolas de Cholières, and others, carried to its furthest extreme the practice of assembling modules. Anecdotes and erudite information, human interest stories and moral examples, tales and calembours, fragments of doctrine and bits of popular culture rub shoulders. These books are storehouses of memorable events and famous sayings, a wealth of cultural goods that belong to everyone and no one; they are anonymous archives where shoppers can help themselves from a stock of knowledge units, sayings, narrative cores.

The vogue for modular structure can be related to the printing press. When

books, which were widely distributed and easily available, began to replace oral transmission, the possibilities of conserving knowledge and the mechanisms of cultural memory changed drastically. A text read aloud goes through a succession of moments in an unchangeable order from beginning to end. When recitation and word-of-mouth transmission predominated, the reception of the message was spontaneously organized along the syntagmatic axis: a fixed place for each unit within a logic based on continuity.

But a book can function as an open space in which all parts are simultaneously available, a synoptic system where the reader can move freely backward and forward over long sequences or short selections. He opens the volume wherever he wants, selects a passage, reads, goes on or turns back, freely dividing and organizing material diffused independently of temporal duration.

The vulgarization of books by printing technology logically led to the exploitation of this spatial flexibility, which could take a text out of time and make it function like a repertory of detachable parts. Far from accidental, the flourishing of collections and compilations corresponds to the best possible use of the specificity of the book. With the development of printing, every literate person had a treasure of knowledge in hand, a mobile, elastic body of information. The principle of the dictionary penetrated into the cultural field.

We can suppose that the increased flow and modular structure of information accelerated the movement of intellectual life and influenced the development of humanist thought. Books offered a provisional body of information that not only was widely available but could be rearranged and adapted to different uses in new contexts. This aroused a concomitant interest in tools required for the rational use of these immense reserves of information. Titles, tables of contents, summaries, cross references, and surprisingly complete indexes were developed to distinguish individual units within a collection.

Scholars were not the only ones to take advantage of this new mode of circulation. Books that functioned as storehouses of information served a new audience of nonspecialists, noble or bourgeois, avid to obtain culture as a means of social promotion. So these collections proliferated because they were used as manuals of vulgarization that opened the doors of traditional knowledge to the new category of *honnêtes gens,* amateurs who would change the social landscape. Books, stuffed with information and useful lessons, became a kind of merchandise, or capital, that the user could fructify; they were stocks of facts, ideas, and words packaged in functional units that could be used to outfit the mind and adorn conversations. Printers and booksellers did not fail to exploit the demand. For producers of compilations, as for their customers,

books responded to a need to stock up and cash in on culture. The emphasis on quantity and mobility in the publishing sector clearly demonstrates a commercial mentality.

In addition, the success of miscellanies and the choice of flexible structures to arrange knowledge are significant of an epistemological crisis that shook the Renaissance, midway between two notions of truth. Thomist-inspired Scholasticism, proud of the absolute certitudes of theology, had edified a doctrine presented as a total, permanent, universal system. Descartes would soon assert the power of reason to establish incontestable truths and construct infallible science. The sixteenth century marks a sort of interregnum between these two periods of supreme intellectual assurance. Shocked by major upheavals in both religious beliefs and representations of the world, many thinkers foresook the formulation of closed structures. It is true that the dogmatic summae of religious thinkers and the encyclopedic projects of scholars were attempts to fill in the gaps and reassemble the fragments of endangered unity. But what interests us here is the sensibility that recognized the disorder of things and reflected the instability of mental operations.

As shown in earlier chapters of this work, many thinkers saw nature as a force in constant mutation and history prey to the hazards of fortune. Such varied and unpredictable things arise that seem to revolt against the laws of reason. The systems into which they should fit were submerged by the plurality of ideas, anarchy of events, abundance of novelties. No intellectual construction seemed adequate to account for the diversity of reality without mutilating it.

Such an analysis could lead to skepticism, and there was no lack of sixteenth-century thinkers who recognized, at least in the profane sphere, the impossibility of certainty.[31] But doubt did not discourage nor paralyze them. On the contrary, the suspension of doctrinal thought encouraged open-minded curiosity. If it is vain to try to understand everything and put it in order, it remains possible to admire the plenitude of things and the ingenuity of human beings. We should speak of eclecticism rather than skepticism. Confronted by the astonishing diversity of phenomena, the learned chose to observe, to gather information and opinions, denying any attempt at selection or synthesis. They took note of local beliefs, rumors, small miracles and stood attentive to all possibilities. As if the very quantity and strangeness of all this information were their compensation for the failure of doctrine.

This mentality determined the way many books were composed. They were long and diffuse, the better to encompass or mimic the proliferation of

things. They were built up by accumulation because they did not try to uniformize or organize the multiple elements. They are loosely connected assemblies derived from a poetics of *varietas,* of variegation and surprise. The form of the miscellany offered the advantage of flexibility, and its cumulative structure made it adaptable to the progressive gestation of knowledge. Montaigne based his refusal of rigid closed form on a resolutely dynamic theory of knowledge:

> Having found by experience that where one failed, the other succeeds . . . and that the arts and sciences are not thrown into a mold, but gradually formed and figured, by handling and polishing over and over, like the bear fashions her cubs by licking them: what my strength cannot discover, I don't stop seeking and trying; poking and kneading this new matter, stirring and warming it, I make it easier to use for the one who comes after me, make it more supple and manageable for him. (2.12.560)

The indecisive, ongoing nature of knowledge required a malleable structure that could receive corrections, additions, and adjustments. Montaigne gave himself a margin of maneuver and, in the style of Erasmus, turned toward his readers as successors, leaving it to them to give a new twist to the subject, rearrange the modules, and update the message. Montaigne's *Essays,* like the miscellanies and rhapsodies of his times, are books in search of an author, books in the making, to make and remake (see chap. 12).

10 ■ Geneses

The Work Is in the Worker

In the first chapters of this book, we saw how the spectacle of nature in mutation was interlaced with representation of the creative act; the image of a demiurge at work is emphatically present in the ongoing metamorphosis that regenerates the world. The primeval founding act that untangled chaos and liberated life forces continuously resurges, perpetuating the inchoative *fiat* down through the ages. This fascination with birth and rebirth and especially with transformation as driving force also influenced reflections on art. Following my analysis, in the previous chapter, of fluctuations in the literary object, I would like to suggest that the generating principle, the agent of movement, occupies a privileged place within the text. The creative work is as much an expression of its own originating impulse as of the outside world. The impact of a discourse lies not only in content but in performance: the word shows itself in the act of emerging like a force seeking form, an energy not yet stabilized by art.

"The cause is to be praised rather than the effect," wrote Leonardo.[1] The work's value lies in the intention that animates it and orients it toward perfection; it resides in a project, a progression, and consequently depends on the inscription of an active subject, captured as he works his material. If the author wants to participate in a creation that, as we have seen in chapters 1 and 2, is in ceaseless transformation, he must like the God of six days show himself fashioning his work, making the efforts that will bring forth cosmos from

chaos. When Du Bartas relates the genesis of the universe as a victory of form over the formless, he recounts *en abyme* the gestation of his poem. An ambiguity in the deictic system illustrates this:

> Reader, pardon me, if on this day you see,
> With an eye already enchanted, so many trees in my woods,
> In my field so many flowers, in my garden so many plants . . . [2]

Does "on this day" refer to the third day of creation of the world or of the text? The ambiguity of "my woods, my field," and so forth suggests that Du Bartas has so well replaced the Divine architect that he can invite us into his own creation. The great biblical vision endures, but *La Sepmaine* simultaneously shows its own origins. Signs of Enunciation infiltrate the space of the enunciated; the finished product includes and displays signs of its production.

The function of art is imitation; this approximate definition was prevalent in Renaissance treatises on aesthetics and poetics. But what is the object of the imitation? A brief survey of shifts and changes in position from early to late Renaissance will help clarify the point made in this chapter.

Captivated by the restoration of antique letters and fully occupied with appropriating their wealth, the early generations of humanists, starting with Petrarch, assigned literature the task of imitating classical texts. This was the reign of *imitatio*, when literature was conceived as adaptation and transformation of scriptural models (see chap. 11). Any treatment, no matter how circumstantial, of personal themes or current affairs would be all the more appropriate and effective if it respected Greek and Latin canons. Expression of novelty went along with the bookish regressive movement that looked back to antiquity. Intertextual dialogue determined a confined endogenous space where writing produced writing and books seemed to refer only to other books. But this philological devotion weakened, giving rise in the sixteenth century to a new priority based on a different conception of imitation: art imitates nature, attempts to represent by realistic effects a universe coextensive with the realm of experience. The closed circuit of *imitatio* opened to the more variegated practice of *mimesis*. The ancient paradigms were not rejected, their authority remained an essentially undisputed premise, but imitation, instead of being an end in itself, became the means of a discourse turned toward real things. Liberated from the grasp of what was already written, books would confront life and draw from it an external necessity. Montaigne's crusade against the tyranny of pedants, his famous protest, "I will naturalize art as much as they artalize Nature" (3.5.874), testify to the shift in objective.

Mimesis itself can be subdivided according to its choice of objects. The classical Renaissance tended to represent a finished, harmonious world; this is Raphael's conception of a controlled static reality, *natura naturata*. With mannerism, the sixteenth century would take increasing interest in an animated, active nature, more potential than essence, the transformed transforming mobile referred to at the beginning of this study.

Here again, a schematic dichotomy is possible. If imitation bears on an action, in accord with Aristotle's definition of *mimesis* in the *Poetics*,[3] it can produce dynamic images as either physical forces or human energy. Men, after God, are agents of movement par excellence, and more than any other men, artists at work are such agents. Initially turned outward, the mimetic work takes on a reflexive or introspective aspect; human nature replaces material nature to become the wellspring of action and privileged object of imitation. *Mimesis* of movement does not necessarily represent *natura naturans*—all the more difficult in a late Renaissance animist world saturated with life, defying representation—but it can exercise in the wonderfully fruitful field of *ars naturans,* art as upsurge and fabrication. The almost physical contact of an artist grappling with words or material, the performance of a gesture or a voice, the birth of a form give *mimesis* one of its mechanisms. Art reveals the process of its creation; it describes the world but also represents representation. It is composed as an event taking shape. Following etymology, the *auteur* (author) reveals the *acteur* (actor) in himself, shows himself in action, and the *poet* lets the *poiein* filter through the poem he creates.

One of the theories of art upheld by the humanists favors portrayal of the work's genesis. Aesthetic theory developed in Florentine Neoplatonic circles and then throughout literate Europe along the lines of a veritable psychology of creation, with interest centered on the person of the artist and the magical moment when he invents his project, the intrusion of the artist in the work and the irrational in his technique. These ideas, fed by Orphism and Hermetism and conveyed by the Neoplatonic mystique, are well known. I will just recall some principles here.

The gestation of a masterpiece postulates an exceptional origin, a violent mental event; it is the work of a genius marked by an exceptional destiny who signs a singular creation. Two consequences follow from this premise: the quality of the work is proportional to the spiritual or intellectual investment it entailed; and the painting or poem, both product and expression of an inner life, should reflect the spiritual movements that governed its conception. Some theories invoked supernatural intervention: the inspired artist, possessed by sa-

cred fire, is the spokesman of some divine power. From Ficino to Ronsard, the self-portrait of philosopher or poet as *esprit furieux,* a fury who acts as mediator of the other world, held sway. Another approach, in fact compatible with the first, attributed the artist's talent to physical causes. An astrological constellation, notably the influence of Saturn, determined his calling; a certain ponderation of corporal humors defined a temperament propitious for creation.

The humanist interest in melancholy is well known. The authentic artist goes through periods of prostration, devoured by the demon of impotence, followed by periods of exaltation that produce fulgurant discoveries; his familiarity with extreme psychological stages in these swings from depression to creative fury are signs of his aptitude for contemplation and predisposition to extraordinary creation. From metaphysics to the physiology of inspiration, with a wealth of speculation on the mechanisms of the creative imagination, the Renaissance passionately investigated the process of artistic conception. Art history in our day still resonates with this research.[4]

And we can trace back to the Renaissance the first large-scale elaboration of what would become the longstanding myth of the intellectual hero. Artists and intellectuals posed as predestined personalities endowed with supernatural knowledge and extraordinary sensitivity, thaumaturgists whose solitary existence or eccentric behavior affirmed their difference. Vasari's *Le Vite* testifies to this curiosity about the person of the artist and the importance of psychological events and dispositions in creation. Vasari portrayed some artists, like Michelangelo or Piero di Cosimo, as tormented and misunderstood, as if the dramatic experiences and pathos of their existence heightened the value of their work. The true or fictional story of a work's genesis, the struggle against external obstacles or internal demons, all the drama surrounding an artistic work influenced the way it was perceived and received.

The construction of this figure of the artist or philosopher as genius indicates that a vast promotional operation was under way, with claims for special dignity and a place in society. The hero of the inner life dared to compete with champions of the active life and demand equal recognition. Draped in glory, standing tall and straight, he entered princely circles with high hopes of using his exceptional talents in the service of the state. And, in fact, artists and thinkers were welcome at the Vatican, as in the royal courts of the Medici and François I.

Not only theoreticians and biographers but artists and intellectuals themselves participated in this campaign, careful to place signs of their exceptional talents and destiny in their works. Cellini gives himself an incredibly eventful,

tormented life in his autobiography. Ronsard presents himself as a nursling of the gods, now overwhelmed by inspirational convulsions, now initiated into the dance of the Muses. In fabricating a personal myth, the writer knew he would make his work more appealing. Injecting life into art, adventure into thought, he invited the reader to consider the works as an integral part of a hazardous, passionate search that totally engaged him. The work as an exceptional product or ensemble of productions by the same author, as long as it included the conditions of its genesis, acquired a history; it offered a conception of artistic activity as a dynamics in which each realization bears traces of the experience from which it emerged. A person or a performance comes on stage; let us look at a few episodes of this theater.

Leonardo and Michelangelo at Work

Vasari remarked (with some exaggeration) that Leonardo began many things but never finished anything, and Michelangelo, "in his mature years finished very few statues."[5] In fact, these two protagonists on the Florentine artistic scene at the turn of the sixteenth century made countless rough starts and left unfinished works in their studios. Vasari considered this significant enough to merit emphasis. Though the predilection for leaving things unfinished remained the exception in Renaissance visual arts, it concerns two of the greatest masters and in its way confirms the appeal of genesis.

Leonardo abandoned his works in progress, explains Vasari, because his hands could not realize what his imagination conceived. No matter how advanced the technique, it betrayed the project, so that incompletion, to the extent that it attests to the height of the idea, is *a contrario* proof of grandeur; leaving unfinished a work doomed to imperfection is perhaps a failure but also testifies to a higher exigency.[6] This negative explanation is doubtless pertinent, but Leonardo himself gave information that would suggest another positive—reason.

"Painter of composition," he wrote, "do not draw the elements of your painting with sharp outlines."[7] He recommends sketching with blurred lines, leaving vague areas with uncertain brush strokes. Why should the artist be more perfectionist than the poet in his search for the best expression? The writer scribbles on his rough draft, is careless about the elegance of his handwriting. In the same way, "then arrange roughly, artist, the limbs of your figures, and take care first to make the movement appropriate to the state of mind of the creatures in your composition."[8] To Leonardo, this research, the

Figs. 42 (*above*) and 43 (*right, facing page*). Leonardo da Vinci, *Studies for the Virgin and Child with Saint Anne and the Infant Saint John the Baptist*, ca. 1508 (two details). Pen and ink and gray wash with some white heightening in the principal study (fig. 43) over black chalk, 267 × 201 mm. Trustees of the British Museum, London.

outpouring of initial ideas and marks of work in progress, gives art its value. The surface of the work is the still amorphous open space where the artist expresses the movements of his imagination; painting, like poetry, is a mental activity, a *moto mentale,* a progressive conquest that requires the most supple language to render the fugitive intuitions of the mind.[9]

Among the paintings, drawings, and sketches that show traces of genesis (figs. 42–46), a draft for a Saint Anne carries to an extreme the logic of creation as the record of ongoing research.[10] It is a scramble of superimposed lines drawn, canceled, reorganized in the artist's march toward the ideal silhouette (fig. 43). Leonardo worked it like an artisan who endlessly reshapes the

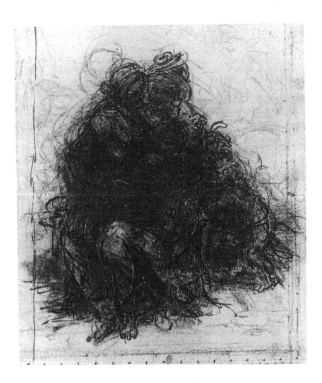

clay, except that here the jumble of lines makes the sketch illegible. The definitive image is a distant project that precisely fascinates us with the spectacle of its groping invention. Art captured in the inductive phase is live exploration of mental mechanisms.

Leonardo and Montaigne had the same view on this question. The artist expands his drawing, the author overloads his text: "I make additions, but no corrections" (3.9.963). One state of the text or image is a springboard for the next. What counts is not just the result but the process, the methods of a searching, changing mind. Artists and writers, each in their way, inscribed duration and research variations within the space of the work.

It is true that inventive wanderings and experiments with the plasticity of forms are only one part of the reality of Leonardo's sketches. Side by side with the hazy treatment of these figures, others (or the same) are subject to rigorous analysis based on precise observation of motion, anatomy, geological or biological facts. A balance was achieved between meticulous precision and exploration of the indeterminate, as if the subordination of the mind to uncertainty

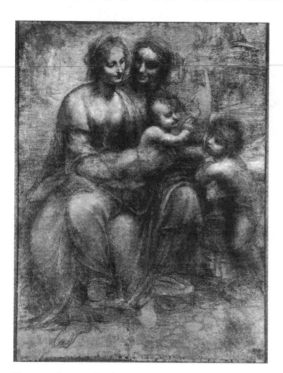

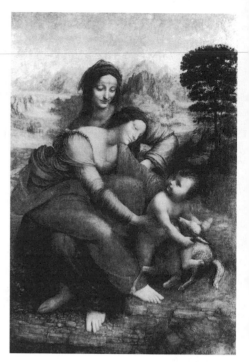

Fig. 44. Leonardo da Vinci, *Cartoon for the Virgin, Child, Saint Anne, and Saint John,* ca. 1505–7. Black chalk, 141 × 140 cm. National Gallery, London.

Fig. 45. Leonardo da Vinci, *Virgin, Child, Saint Anne, and a Lamb,* 1508. Oil on wood, 168 × 130 cm. Paris, Musée du Louvre (see detail, fig. 46).

must be compensated by unerring knowledge. Montaigne, too, oscillated between fascinated contemplation of his chimeras and a demand for intellectual discipline, avid for clarity. Nevertheless, as Ernst Gombrich shows,[11] Leonardo gave a new function to most of his drawings. The sketch was not just a preparation for the final work; it was something more than a means to an end or an imperfect version to be discarded. Nor was it an attempt to demonstrate the artist's skill in instantly capturing the exact shape of the object in sharp, clear lines. The sketch decomposed and represented the different stages of ongoing invention, a process of research that is not at all a failure but a deliberate attempt to understand the dynamics and temporality of creation.

Michelangelo's unfinished sculpture did not necessarily derive from the same conception. Though many of his statues—the Vatican *Pietà* (1497–1500),

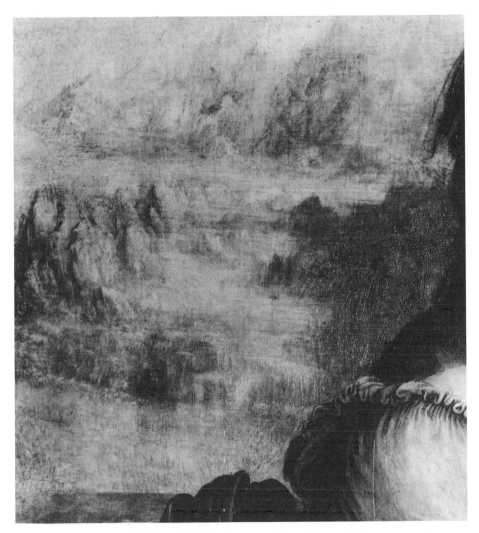

Fig. 46. Leonardo da Vinci, detail of landscape in figure 45.

David (1501–4), *Moses* (1513–16)—are finished down to the last detail, many others were left in a state more or less disengaged from the block of stone. In some works, like *Day* and *Dusk* at the Medici Chapel (ca. 1530), only very small parts are left in the rough. A youthful work, *The Battle of the Lapiths* (1491–92), and a later bas relief medallion, the *Virgin with Child* (*Tondo Pitti*, 1504–8), present varying degrees of accomplishment: some figures are perfectly

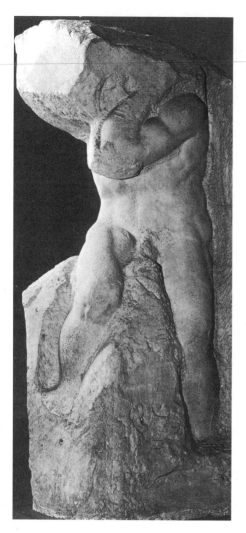

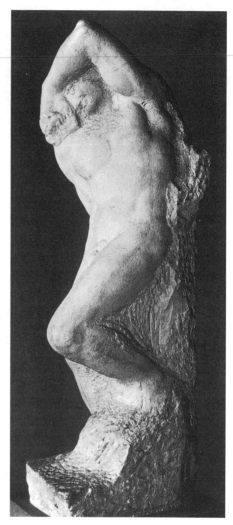

Fig. 47. Michelangelo, *Slave* or *Atlas,* ca. 1513–30. Marble, 2.68 cm high. Florence, galleria dell' Accademia.

Fig. 48. Michelangelo, *Slave,* ca. 1513–30. Marble, 3.02 cm high. Florence, galleria dell' Accademia.

finished and polished, while others, less distinct, still bear the marks of the chisel. Similarly, the group *Spirit of Victory* (ca. 1530) presents the highly finished standing figure of the victor and, bent under him, the figure of the vanquished, whose torso, arms, and legs form a compact mass, with the curves of the limbs only halfway out of the stone. Here the gestation of a single work is

illustrated in several stages—from roughed-out figures, hardly emerged from the stone, to others that stand free, with clearly sculpted outlines. We can find obviously unfinished statues all through Michelangelo's career—*Saint Matthew* (1506), the *Slaves* (1513–30; figs. 47 and 48),[12] the Academy of Florence *Pietà* (ca. 1548–56)—left in an intermediate stage between confused mass and distinct figure liberated from rough matter.

Many hypotheses have been advanced to explain this practice of *non finito,*[13] and since Michelangelo left no direct explanation, no interpretation can be considered absolute. Is the incompleteness deliberate or accidental, positive or negative? We don't know. What remains is the extraordinary attraction of these rough works that, to Vasari, as to the hordes that troop through museums today, inspire the idea that imperfection attains the state of perfection.[14] What more can we say?

A modern mind might suppose that Michelangelo wanted to offer snapshots of his inner life and, like Leonardo, exhibit himself in the throes of effort. The roughly quarried block would suggest rapid execution by a daring artist emancipated from the meticulous details of finishing, free to render the essential. The statue would show the making rather than the made, display the spectacle of the sculptor's prodigious energy, evidence of his superhuman proportions. It would be a tableau of a prodigious genius working at the heights of inspiration, driven by a transcendent force. The aim of promoting the artist, as exposed above, would make this explanation credible.

However, a different approach would be closer to the Neoplatonic ideas that Michelangelo shared.[15] Incompletion would be the sign of the tragic, insurmountable hiatus between the beauty of the ideal and the imperfection of opaque matter. The mental model, the ideal concept, confronts the resistance of stone and degenerates. The rough work would express the painful awareness of fallen man, separated from the ideals and unable to attain them. In this perspective, the famous slaves bundled in their sheaths of stone would deserve the title of *Prisoners* that they are sometimes given. Like captives in Plato's cave, they are immersed in the limbo of existence, unable to conceive its light and form. Because the sculptor perceives, however dimly, the lost ideal, he attempts to tear his statues out of the matter and sculpt them according to his inner vision. And the statues would represent this tragedy of the impossible accomplishment.

An S. Fanti engraving from the same period (1527; fig. 49) confirms this interpretation.[16] At the center of the scene, Michelangelo is kneeling on an immense block of stone and sculpting; his posture and gestures suggest violent,

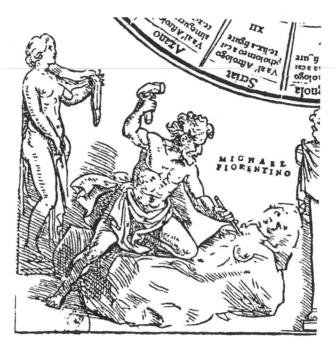

Fig. 49. Sigismondo Fanti, *Michelangelo Sculpting,* 1527.
Wood engraving.

relentless effort.[17] A head already stands out, and a woman's bust is taking
shape under the chisel; the rest of the block is left untouched. Behind the
sculptor is the graceful, perfectly finished—vertical—figure of a woman, prob-
ably the model of ideal beauty, the *concetto* that the artist wants to realize and
does not have to look at because he holds it in his mind. Can he imprint his
idea on matter? Another statue, standing across from Michelangelo and this
time within his sight, suggests that the task will be difficult: a term-god, a hu-
man torso with the undifferentiated surface of a geometric sheath in the place
of legs. The sculptor's challenge is to go from this half-petrified, legless mon-
ster to the splendid figure of his vision.

No better emblem could be imagined. By his works-in-progress, as in the
scene by Fanti, Michelangelo presents himself in motion from chaos to form,
at that unstable, dynamic moment when everything is still possible. If ever im-
mobile objects have functioned as mobiles, it is these unfinished statues.

While the 1527 engraving, as well as Michelangelo's philosophic leanings,

favor the Neoplatonic interpretation, the posthumous destiny of the *Slaves* reserves a surprise for us, still another variation on the theme of genesis. As mentioned above, Bernardo Buontalenti built a rustic-style artificial grotto in the Boboli gardens of Florence in the 1580s.[18] Everything—the pumice stone, the water fountains in the semidarkness, the statues of men and animals almost indistinct from the rock—evoked the vacillations of primordial nature, a world in gestation where the animate still lived in symbiosis with the inert, a mythical age where hardness softened, things humanized, blind matter slowly came to form. To complete the décor, Buontalenti installed the four *Slaves* in the grotto, where in fact they would remain until the early twentieth century. This is a good example of interpretative diversion: the dramatic struggle between mind and matter is effaced, perhaps not even understood. The statues, reemployed in a new cultural milieu, are endowed with a value no doubt foreign to Michelangelo's project but, as we have seen, very much alive in other circles: the pageant of life rising out of the breast of chaos, the conquest of form over indifferentiation. Metaphysical gravity is replaced by a primitivist revery, paradise lost supplanted by an Arcadia full of promise. Everything has changed except that the suggestion of movement, the image of ongoing birth, continues to exert its fascination.

Birth and Rebirth of the Word: D'Aubigné

We have seen literary texts that develop and change, artists who leave traces of the work process in their works. At the intersection of these two axes, we find writers who tell the story of their work and show the different stages of its creation. A metadiscourse invades the space of discourse, as if the stage indications that should be in the preface or a separate text found their way into the body of the work.[19] Representation of the presentation is superimposed on the presentation, and a reflection on the origins and mechanisms of narrative on narration.

Anything and everything that precedes and follows the text, from production to consumption, is worthy of comment. At the pole of fabrication, the author explains the whys and wherefores of the undertaking, his intention, the models and choices that give the text its singular profile. At the pole of reception, he turns to his readers to orient their interpretation and define the proper uses of the book. The work tells a story of intention and itinerary, of efforts to arrive at the closed, finished creation it attempts to become.

Les Tragiques by Agrippa d'Aubigné is one of the best illustrations of this condition as work-in-progress that leaves ample space for the figure of the author, his activity, the ups and downs of his undertaking. The militant design of the poem might seem imperious enough to relegate the vicissitudes of its production to the background; a cross between epic, satire, and harangue, *Les Tragiques* was written to defend the cause of the persecuted Protestants. By a providential reading of church history and the wars of religion, saturated with biblical references, d'Aubigné tried to convince his fellow Protestants that God would give them the final victory. Though the text is immersed in current events, devoted to political combat and defense of the faith, it constantly comments on its own advent and itinerary.

The poem contains the story of its birth in a detailed account of a scene witnessed by the narrator—truth or fiction, it doesn't matter here—that functions in the heart of the text as the myth of its own origins ("Fers," 1195–1446). Wounded in battle and given up for dead, the young man is transported to heaven. In a vision that lasts seven hours ("Fers," 1199), he contemplates events in a transcendent perspective from on high. This miraculous ecstasy determines his mission. Like the biblical prophets, he leaves behind the remains of his existence as a profane man—his supposed death is symbolic—to be born to a new calling; the advent of the regenerated poet coincides with the advent of the book. From there on he will exhibit the divine meaning of the story revealed to him.

Two fictions complete this primeval scene and reinforce the poem's implantation in the supernatural. Relating his celestial vision, the narrator specifies that he does not perceive the details directly, but as represented in paintings made by the angels and hung in the alleys of paradise. Battles, misdeeds of tyrants, and sufferings of victims, painted in the heavens by "holy spirits" ("Fers," 267), appear to the poet as works of art and truthful discourses already organized, filtered, and interpreted according to a superhuman vision. D'Aubigné and the blessed, side by side in heaven, read this version of events, grasp its spiritual meaning, and understand its providential finality, giving "Fers," built on this system of relays, claim to divine authority. Two other books—"La Chambre dorée" and "Les Feux"—out of the seven that make up *Les Tragiques,* contribute with a different setting to the same effect: God descends from heaven to walk on earth and measure the extent of the disaster, thus interposing himself as wellspring of the vision. By this subterfuge the poet poses as a simple spokesman for the divine, who has always held the key to events. D'Aubigné arrogates for himself the status and dignity of prophet:

> . . . I will say here
> What the spirit of God dictated to my paper.
>> "La Chambre dorée," 957–58

Following the lesson of the Bible is not enough, though it gives the author a grid for reading history. Countless claims to the "enthusiasm," "furor," "flaming tongue" ("Vengeances," 57–68) that animate his work establish continuity of inspiration between the celestial vision of "Fers" and the rest of the poem. Again we find the aforementioned representation of the artist as visionary and mediator of the hereafter, but here it is transposed into the Christian register. The spirit that breathes is different—Greek for the others, more Hebraic here—but the pride of prophecy and fascination with the creative process are the same.

One origin, sublime as it is, does not suffice for the poem. The narrator shifts position and perspective, the conditions of enunciation vary, as if the text, animated with prodigious energy, were endlessly born and reborn as it progresses. Endowed with several geneses, it rebounds and is renewed, shows its advent in one circumstance and soon afterward in another. If the transcendental authority and vertical vision determine the last books of *Les Tragiques*, an altogether different source is invoked at the beginning:

> Under an inimical Mars, there in the hard labors
> That spoil the paper and ink with sweat,
> Instead of Thessaly's lovely valleys
> We abort these songs in the midst of armies,
> Let fall our arms all rusted with filth
> That dare not part from castoff armbands.
>> "Misères," 67–72

The narrator bases his legitimacy in the contiguity between discourse and experience. Another primeval myth guarantees the poet's enterprise: his word will be coextensive with the event; it springs forth spontaneously, as if imposed by the urgent reality itself. Because the text speaks directly from experience, d'Aubigné can claim his role as protagonist, sole and sufficient guarantee:

> For my eyes bear witness to the subject of my verses.
>> "Misères," 371

Elsewhere prophetic, the voice descends here from the empyrean onto the battlefield, adding one more vulnerable human cry to the concert of lamentations. The truth it expresses comes not from a mind aware of the divine project but from a heart crying out in anger:

> Then if my breast, boiling with extreme heartbreak . . .
> "Princes," 449

Unlike the angelic observer, the soldier-poet writes under emotional pressure: indignation against tyrants, pity for the victims, admiration of martyrs, beseeching of the All Powerful become the emotional springs of his discourse. A portrayal of *pathos* situates the birth of the poem in the radically unstable conjunction of a revolted individual and a society at war. This poet handles the pen like a sword; his book is a weapon, a cry of anguish, an outburst of rage.

A mobile narrator marks the progress of *Les Tragiques* with changing self-portraits. Instead of trying to present a unified vision of himself or the world, he exhibits the movement of his thought and variations in his perceptions at different stages in the poem's gestation. D'Aubigné composed a work that is satire, apologetics, and manifesto, oriented toward others, toward history or God, and yet it is no less the record of his inner adventure traced through the work in transformation. The *je* (I) of the poet, his military action and work as a writer, stands at center stage: there are few pages of *Les Tragiques* that do not point to the character who proffers them. This invasive subject intervenes regularly in several different ways.

Montaigne speaks in the *Essays* of a "book consubstantial with its author" (2.18.665). The same could be said of *Les Tragiques,* in that statements are constantly related to the speaker and the circumstances in which they are pronounced. D'Aubigné does not write "France is an afflicted mother," but "I want to portray France as an afflicted mother" ("Misères," 97). The omnipresent narrator filters everything he reports: events as he sees them, the past as he interprets it, the future as he foretells it. He transfers the story into the sphere of discourse, the event into the order of perception. His message, inspired by Revelation, could claim permanence and take accents of impersonal truth; on the contrary, it has to be continuously reactualized by an act of speech and validated by the commitment, *hic et nunc,* of the engaged subject. Many episodes in the poem could have been written in the past tense; in fact, the majority are told in the present, so that no matter how far distant in the past, they seem contemporary, absorbed in the narrator's movement and as if reanimated by urgent necessity. Synchronic effects abound—"today," "now," and especially *voici* (here is, here it is)—situating events, however distant, in the immediate proximity of the transmitter and receiver of the text.

Not only does d'Aubigné appropriate historical facts, he puts his mark on the poem's operation with tireless comments on what he is writing and uses

various ways of reminding the reader that his moods and options determine all aspects of the text. *Les Tragiques* is not only an epic on the narrated—the war, persecution, faith—but an epic on narration, a constantly revived reflection on the origins of the work and the mechanisms that propel it from one turmoil to another:

> In the course of these furors my furor is consumed,
> I leave this subject, my hand leaves my quill . . .
> Here I will wash this page with my tears.
> <div align="right">"Princes," 1099–1103</div>

Event and interpreter, discourse and metadiscourse are so closely united that the word can never be confined to a purely referential function. It exhibits itself as it emerges in a spectacle of constantly renewed creative energy.

The performance of speech implicates not only the speaker but also the listener in an action aimed at touching, moving, shocking, attacking him. If the word bears the mark of its origin, it also postulates, if only fictively, the presence of someone who will validate it by listening. The first person pole, ever present in the poem, is logically completed by constant addresses to the second person. The effects of orality accumulate as if d'Aubigné, in need of a counterpart, is speaking directly to the audience from his chair, platform, or in court.

The listeners are countless: sometimes an individual, sometimes a group, here the victims he consoles or exhorts, there the torturers he curses or threatens. Narrative and argumentation are systematically shifted on the axis of communication and treated in the rhetorical mode. The reader himself is apostrophized, or God, or France, and even the dead—martyrs or tyrants— are dragged out of their tombs and told to listen. Episodes frequently begin in the third person and shift to the second, so great is the desire to bring forth an interlocutor, imagine him there and simulate a dialogue situation; the "other" is taken from what Benveniste calls the "nonperson"[20] and transported into the sphere of the narrator to play his role in the gestation of the discourse. The theatrical reference inscribed in the poem's title implies a confrontation and eventful interaction between parties. For example, the long imprecation against Catherine de Medici ("Misères," 727–992) alternates between *she* and *thee:* the Florentine witch is sometimes treated like an absent object and then addressed like a subject whose presence makes saying more like doing. The abundant *I*'s, *thee*'s, and *you*'s in *Les Tragiques* are as many rhetorical techniques to reactivate the word, recycle it in the circuit of immediate communication,

and anchor it, page after page, in the present instant and the place of its emergence.

"At the moment when it interests me:" Montaigne

Nothing was more foreign to Montaigne than the vaticinations of genius. Wary of the mystifications of art and the impostures of metaphysics, he preferred to attribute a contingent origin to writing. Montaigne shifted into the order of circumstance—as a psychological phenomenon, a profane mystery—the events that so many thinkers wanted to anchor in transcendence.

But the two schools of thought shared a common point: even if the genesis of the work becomes profane, it remains an important center of aesthetic interest. One of the central projects of the *Essays* was to relate how they came into being, scrutinizing the moment when thought passed from formless to form.[21] Montaigne didn't tire of questioning the mechanisms of creation, the instant when the idea arises, the process that leads from conception to concept. In the *Essays* the writer's activity is exhibited with such insistence that the approach to the work could take up the entire text. Instead of being presented as a finished monument, the book seems to be caught in the course of gestation, as if the author let himself be taken by surprise, completely engrossed in his work. Montaigne attempted to reproduce the act of a subject seeking itself in books and words, the mobility of his humors and the ever-renewed quest of the self. Not a being but a doing—or better, a being in the course of doing—who exists because he acts, who sees himself and gives himself to be seen as creative energy.

This exploration at the threshold of discourse takes place on two levels. The *Essays* contain both a theory and practice of the first draft: a metadiscourse on the status of the text as witness to its gestation and a discourse that tries to capture in its style the vigor of these initial movements. It is true that the inchoate and the instantaneous neighbor with contrary tendencies in the works of Montaigne: a heightened consciousness of the tradition and, in spite of his denials, patient work on structure and vocabulary. Here I will just show how the *Essays* incorporate the marks of their genesis.

"When I dance, I dance; when I sleep, I sleep" (3.13.1107). For Montaigne, time and existence unfold in such a fragmented way that they break up into a succession of discreet instants that give rise to singular events which follow without resembling each other. Unable to discover continuity, the subject invests completely in the experience or observation of these distinct moments

one at a time. It is as if every new day, every minute, inaugurated a new life, an adventure all the more intense in that it may well remain unique, without past or future. Montaigne wanted to capture himself watching as he acted or thought, to seize the phenomenon as he was living it in the instant when it arose, unforeseen and regenerative, before any system could recuperate and deflower it. "I want to represent the progress of my humors, so each piece will be seen as it is born" (2.37.758). A statement will always have two stages—it will concomitantly unroll the thread of an idea and the story of its gestation, the journal of research in progress: "Just as my reveries are presented so I stack them up. . . . I want to show my natural ordinary steps, no matter how crooked they go" (2.10.409).

If Montaigne were a historian, he would have written in the past tense; if he were a philosopher, he would have used the enduring present. Of course, he did use both, but the most significant tense employed in the *Essays* is the immediate present. He explains that a certain detail he mentions is not worthy of attention because of its intrinsic validity as something relegated to the past or universal, but because it shows the present state of his mind: "I cannot guarantee any certainty, if not to make known exactly to what point my knowledge of it rises at this hour" (2.10.408). I capture the object at the moment when it enters my field of awareness: "I take it at this point, as it is, at the moment when it interests me" (3.2.805) More precisely, a discourse stands at the intersection of two movements, between the object told and the subject telling, and fixes their encounter in the unique instant of its occurrence. Things cannot be apprehended outside of the particular phases of their metamorphosis, and I, who am talking about them, am absolutely united with the circumstance, itself immediate and singular, of my statement. It follows that my discourse is only true with respect to the moment when it is pronounced; it may be false tomorrow, when the object has changed and the I who validates it is not the same person.

With ideas flashing by as fast as photogram images, we might not even recognize the discontinuity, but Montaigne used his writing skill to express this segmentation. He searched for a literary form that could register the passage "from day to day, minute to minute" (3.2.805), so that the book would be a series of snapshots, true to the mental process. This project of pushing to the limit the interference of time in the space of the writing resembles a theoretical fiction. Yet it determines a combination of effective tactics, which is the broken sequences of the *Essays*. I will retain a few manifestations.

Every reader has experienced the fragmentation, telescoping, oblique li-

aisons, and contradictions that perturb the progression of many of the essays. Ideas overlap without apparent logic, and Montaigne, commenting on his pace "in leaps and gambols" (3.9.994), uses a wealth of metaphors to indicate ruptures in the tissue of a fragmented composition: "poorly joined marquetry," "patches," "rhapsody," "fricassee," "splattering," "bundling." Whether the discourse really follows the capricious flow of Montaigne's thought or mimes by calculated effects the scenario of a mental storm, the ideas wander, giving the impression that at any moment the text can go off in a new direction, and any argument put forth can retreat in the face of another. The jaunty pace of the *Essays* reflects a wish to explore thought at its origin, where it is still alive with primitive energy.

This technique, applied to the flow of individual chapters, is often used within the economy of the sentence: inserts and digressions blur the line of argument, constructions get lost, parasitic propositions extend and unbalance the syntactic flow, reproducing or simulating the rocky rhythm of thought in progress. Allogenic segments might interpose, upsetting the movement of the sentence or, as hyperbotons, extending it in an unexpected way. *"C'est luy qui ramena du ciel, où elle perdoit son temps, la sagesse humaine, pour la rendre à l'homme, où est sa plus juste et plus laborieuse besoigne, et plus utile"* (It is he who brought from the heavens, where it was wasting time, human wisdom, to render it to man, where is its most rightful and laborious task, and most useful) (3.12.1038). Montaigne did not hesitate to nuance or rectify what he had just written: Socrates "rose . . . to the highest point of vigor. Or, better yet, he did not rise at all, but rather went down" (3.12.1037). Montaigne changes his mind, corrects statements as he is writing them, takes a step back and comments on what came before, noting in the discourse the trace of a fleeting idea that came to mind at the moment when he was writing. "I was beaten from all sides: to the Gibelin I was Guelph, to the Guelph Gibelin: one of my poets did say that, but I don't know where" (3.12.1044).

In the composition of chapters as in sentences, Montaigne tended to reject the rational, premeditated structures and logical mechanisms taught in school. His poetics of instant outpouring forced him to render the flow of his thought with the least possible control, even if it be formless and anarchical. His text grows out of free association; it is an attempt to mimic the labile, disorderly march of the contents of the mind, including here and there the emergence of repressed material that troubles the smoothly coated surface of the discourse.

The inscription of time on the scale of the microtext drew on another technique that has nothing to do with syntax: a most unorthodox use of words. "I

have a dictionary all my own" (3.13.1111), admits Montaigne. And, in fact, the meaning of certain words, or even central concepts like *reason, discourse, form, essay,* changes. This can be partially explained by the prevailing instability of French (see chap. 8). Montaigne took full advantage of the situation, but the precarious language only served and augmented his own versatility. How could one expect fixed, rigorously defined concepts from someone who is no longer today the man he was the day before? The user changes, and his language changes with him. This semantic floating reinforces the impression that every distinct moment has a corresponding new enunciative situation.

Such a style in life and in writing may lead to an untenable situation, both psychologically and textually: the subject who surrenders to dispersion is playing dangerously with madness, and his exploded text may be unreadable. But Montaigne neutralized this double danger. His constituent instability did not weaken his foundations but paradoxically helped him capture the very basis of his identity: I change, and it is in changing that I realize my cohesion. And the same is true for the text that finds the principle of its unity in free flow and disparity. Judged lazily according to traditional criteria, the *Essays* are wild ravings; read as testimony of the uncommon rhythms of human time, they are truthful. "Indeed perforce I contradict myself, but the truth . . . I never contradict" (3.2.805).

Time could be manifest in the text as staccato interventions of brief moments that might change the course of the argument or modify the meaning of words, or else at widely separated intervals. Montaigne reread his essays, revised what he had written in the past, and brought out new, expanded versions. His book is an organism in perpetual growth, where each new edition showed evidence of the passage of time: 1580—first edition (books 1 and 2); 1582—already a modest number of additions; 1588—about six hundred *allongeails* (extensions) plus the first version of book 3; 1595—no new essays but about a thousand additions to the 1588 text. Montaigne restored the mission assigned by etymology to the word *author (auteur)* (from *auctor,* itself derived from the verb *augere*): he augments, he develops.[22]

The large-scale revisions functioned basically in the same way as the immediate perturbations in a particular textual layer: Montaigne could change direction, introduce new ideas, admit his doubts one minute or several years after writing something, and these modifications could operate on the level of syntactic details or on the overall trajectory of thought. Four types of intervention can be distinguished. Deletions or transpositions were rare. But in spite of the well-known "I add, but I do not correct" (3.9.963), there is no lack

of words or passages crossed out and written over. However, nothing can compare with the hundreds of additions, varied in the nature of their contribution, mode of insertion, and length, from the most modest—an example, a quotation, an accessory comment—to long passages extending over one or several pages, of a scope and substance that destabilizes the structure and gives the essay a new orientation.

Montaigne filled the margins of his own personal copy with additions that would expand the text in the following edition. The preceding version was not invalidated but outdated as it dilated under pressure of the immediate, new experiences, new readings. The manuscript, apparently stabilized as a printed book, is thrust back into duration. Characteristically, Montaigne took a supposedly finished product out of the sphere of inert objects and reintroduced it into the active cycle of production. The book that seems to have outlived its time can be updated and put out as new merchandise: "To the extent that it is renewed, so the buyer doesn't come away empty-handed, I make a rule for myself to attach . . . some excess value" (2.9.964). To make the enterprise profitable, modifications made from one edition to the next should be pointed out to readers. Was the book about to end its career in eternal fixity on a bookshelf? On the contrary, recycled, reinserted into distribution channels, it would begin a new career.

Whether the impulse springs from the author's private sphere, before publication, or from the dynamics of supply and demand, when the book is on the market,[23] the true portrait of Montaigne, Montaigne in motion, lies less in any particular layer of the text than in the passage from one to the other. The mobile subject is constructed in the difference, the *entre-deux* (in-between), the transformation. The reader who would capture this Montaigne must read the text in the light of its genesis, which is the only way to restore its mobility and appreciate the writer's endless capacity for renewal.

Creative Reading

11 ▎ *Reshuffling the Cards*

Immobile in Leaps and Bounds

The authors we saw at work in the two previous chapters showed themselves as actors. Whether giving impetus to the work in the magical moment when it comes into being or intervening after the fact to transform their books, they wrought mobile forms and conceived perfection as a far distant goal approached through multiple metamorphoses. Does this mean that the life of the work depends on the author's intervention and expires when he dies; that the book will stop changing and take a fixed form for eternity once the source of motion is inactivated? No, because sixteenth-century thinkers could not resign themselves to arrested motion. Their works were destined to an eternity of continuous change, and they counted on readers to sustain the dynamics of transformation and ensure their survival.

In the last two chapters of this study, I will try to show that the call for reader participation in the ongoing life of the work is hardly a recent discovery;[1] in fact, it was an essential element in the strategy of sixteenth-century writers. In chapter 12 I will describe some of the methods used to offer the reader a space for his intervention and associate him with the posthumous history of the book; in this chapter I will pursue my investigation of the author, but this time as reader of the source-texts he appropriates and transforms. Before inviting readers to manipulate his book, the author shows himself as an example of an active receiver who reappropriates the classics to give them new life.

Renaissance reflection on the act of writing and the acquisition of knowledge inevitably involved references to the antique heritage. Whatever the option—maximum fidelity to models or acknowledged need for distance, emphasis on continuity or change, on the possibility or impossibility of equaling the masters—all thinkers evaluated art and knowledge with regard to Greek and Latin standards. Scholars and artists were constantly confronted with this comparison and, whatever the limits of their dependence, knew their work could only be conceived and perceived as a more or less free variation of a given classic paradigm. It was unthinkable to escape from the tradition and absurd to be resigned to simple repetition, so creativity was exercised in the movement of difference and the scope of transformation from ancient to new. The omnipresent theory and practice of *imitatio* assimilated the difficulties of seeking oneself through others.[2]

The problem was intensified by a new sense of history, a deepened awareness that the past was irrevocably lost; this recognition of an irreversible evolution, whether positive or negative, is one of the great intellectual acquisitions of the Renaissance. The Middle Ages dressed antiquity in the customs and colors of feudal chivalry and saw itself there as in a mirror image, sustaining the illusion of continuity. With the flow of new documents clarified by newly developed philological methods, scholars discovered clear evidence of change. Henceforth the past could no longer be constructed in the image of the present, and imitation would demonstrate the impossibility of perfect adequation. As it was rediscovered, antiquity receded and was lost. Mourning for a lost past could nourish regressive nostalgia and inspire all sorts of archeological projects, as we will see. However, most humanists were determined to save what could be saved by inserting a measure of novelty in the hiatus. Renaissance intellectuals often had the impression they were replaying the famous encounter between Greece and Rome, in which they aspired to be both victors and vanquished, free and faithful, different and deferential like the Romans. For these Renaissance men the ancient model was an ideal both present and lost, essential but foreign.

These are the poles that staked out the field of *imitatio:* at one extreme, mimetic devotion that minimizes the effect of history; at the other, exploitation of the eclipses of the past to give the present a chance—the struggle of authors against authorities. But what were the different methods of respectful transmission or transforming intervention in the reception of classic texts? Two contrasting strategies demonstrate possible approaches.

Philology, perfected by the humanists, was closely tied to the advent of the historical consciousness. Because the antique way is forever finished and done, the philologist will serve it by restoring and conserving the tradition in its original specificity. He removes interferences accumulated over the centuries, reestablishes an authentic version of the text, eventually gives explanations on the meaning of a work in its original milieu, and goes no further. Recognizing that these authors are absolutely different and superior, he touches their works only to restore them to themselves. Soon they would be sacralized and safely deposited in the mausoleum of great classics. This was the development of the scholarly method, which made scrupulous distinctions between the original and the commentary, between literature and criticism, clearly dissociating past and present, writing and reading. Temporal distance determined two essential principles: establishment of a definitive text, effacement of the reader.

The opposite approach was to look not to the origin but to the future of the work. Rather than restoring the text in its purity and difference, the idea was to exploit its value *hic et nunc*. A new situation calls for a new reading. To bring old masterpieces up to date and discover their pertinence in a contemporary context was not a betrayal but a recognition of their potential to raise questions and bring forth newness. This is a conception of reading as committed creative dialogue, hardly preoccupied with objectivity and history. It served the classics by transposing them into a foreign environment, regenerating them by deliberate transformation.

Though the Ciceronian controversy was focused on writing rather than reading, it clearly defines the contrasting positions. On the one hand, purists like Bembo, Longueil, Dolet, and Scaliger claimed to write Latin in exactly the same language and style as Cicero. The perfection he had attained in the past defined a necessary, untouchable canon that transcends history. A rational aesthetics based on reputedly universal principles, the quintessence of classicism, ignored the effects of passage in favor of an ideal that would be the same for all, independent of time and place. Anti-Ciceronians like Poliziano, Gianfrancesco Pico, and Erasmus held a more contingent, eclectic position without renouncing Latin or classical models. They knew that their Latin was tributary to different cultural, religious, and political conditions and could not reproduce the language written fifteen hundred years before. Defending the possibility of choosing and combining several different standards, they accepted anachronism as a gauge of freedom, a space for creation and self-assertion.

Clear-cut solutions were rare; varying degrees of individuation and com-

promise could be found between the extremes of filial devotion to a cult of the father and cultural patricide. Nevertheless, there remained one rule that could be applied to all: given the necessity of striking a balance between continuity and alteration, the antique model was exposed to some measure of transformation. This is the thesis to be defended: *imitatio* was based on a metamorphic conception of the work of art.

Awareness of the rupture with antiquity had a liberating effect on both the reader and the work. Humanists, acknowledging that the conditions of reception were always different from the circumstances of conception, could logically assert the right to adapt the text's message to a new world. This freed them from mimetic regression and literal devotion. Because the master has aged, the disciple can carry on and superimpose his voice on the model. By his efforts to bring the text into the present, the writer acquires a better understanding of himself and his culture and of what distinguishes them from the past. By a close but subjective and critical attention to the classics in the search for differences, he becomes more aware of himself. In fact, his enterprise is not limited to innovative reading and fruitful diversion; if he has the right to alter the models, why not try to equal or even surpass them by creating a dependent and yet dissimilar work that stands up to comparison? The perfection of the ancients might be inhibitive, but it could also be a challenge that stimulated emulation and contributed to the writer's emancipation.

And was it not a way of honoring great authors? To startle them and put them to the test of new exigencies? By returning to them across the distance that separates us, I recognize that they are solidly implanted in my cultural universe and indispensable to my research, *hic et nunc*. Further, it is a sign of respect to deem them capable of participating in the thought and art of our day. When I bring the classical work to rebirth in a new form, I allow it to display its potential and productivity. The *Iliad* is fully realized when it gives rise to the *Aeneid*, and the *Aeneid* is accomplished through the poems that copy, modernize, or travesty it. This is how the transfer of cultural goods functions: the tradition offers a store of latent resources that ask to be actualized, the writer-plasmator imprints on them a transitory figure that will in turn be reinvested, and so on. From Homer to Petrarch, from Plutarch to Montaigne, metamorphosis and recycling are integral elements of the classical work.

Montaigne went very far as reader and theoretician of reading in this experience of regenerating texts. Whether accepting or rejecting the lesson of the ancients, whether quoting, paraphrasing, or altering their words, whether putting an idea, fact, or stylistic model back in circulation, he is the example

par excellence of an amateur who venerates but mistreats the classics, reanimates them and then uses them as living stones of his edifice. He depends absolutely on the books in his library to give form to his thought but treats them with utter nonchalance. He usually doesn't bother to cite his sources; once you've been inspired by a text, you can forget it. The antique heritage is such a rich, flexible potential to exploit that the *Essays* based on it may indeed be parasitic, but they are no less unprecedented.

Under these conditions the relevance of a work is determined at reception. The more unexpected values one finds in an author the better, and what matter if he really intended to express them. It is I, the reader, who creates meaning, not the author: "I read in Titus-Livius a hundred things that were not there as such. Plutarch read a hundred, different from what I could read and, perhaps, from what the author put there" (1.26.156). It is true, admits Montaigne, that I often cite the classics and might give the impression of being a submissive reader, a passive consumer. All the more reason to insist on his liberty and infidelity: "Among so many borrowings I surely may steal from someone, disguising and deforming for new usage" (3.12.1056). In a line that was later crossed out, he made a strange comparison with his way of citing other authors: "Like a horse thief, I paint their mane and tail, and sometimes poke out an eye" (ibid.). Travesty, mutilation: Montaigne defends himself all the more vehemently in that he is resisting the danger of total subjection.

Free manipulation of sources is also a way of advancing knowledge. It is normal, said Montaigne, that I supplement, adapt, and perfect what I find in the books of the ancients. Science is a malleable material, progressively fashioned, that changes form as it changes hands; it must be transformed as it is transmitted. What is true for knowledge is also valid for moral tradition. He draws countless examples of proper conduct or ethical principles from ancient works and takes them to guide his life, but only after he has adjusted, converted, or sometimes completely reshaped them.

Among the works in his library, Montaigne tends to prefer those that leave room for the reader's intervention and lend themselves to various operations of appropriation, actualization, transformation. Plutarch, in particular, had the finesse to abandon hundreds of "[discourses] that he only touched on: he simply points the way where we shall go if we will, and sometimes is content to just pierce the living heart of an idea. They have to be pulled out from there and put on the market" (1.26.156). The commercial metaphor is significant: such a book full of ellipses and allusions is sleeping capital; it encourages exploitation and negotiation, promises increased value. Another analogy, erotic

this time, confirms that what Plutarch left unsaid is meant to sustain the dynamics of the reading: "He prefers to leave us with desire for him than satiety" (1.26.157).

Montaigne's avowed preference for the poets and his taste for poetic style corresponds to the same demand. What he likes about these works in verse or tightly composed prose is the dense elliptical style, all the more vigorous for being enigmatic. Poetry is enchanting because it is saturated in mysteries that sustain curiosity and charged with allusions that stimulate the imagination.

Reading should be a perpetual movement in which subject and object participate in universal flux. Perplexity is better than intellectual torpor, the hunt better than the booty:

> A mind that is satisfied is a sign of shrinking, or fatigue. The generous mind never stops at itself: it is always advancing and surpassing its force; its thrust goes beyond its effects; if it doesn't go forward and hasten, bring to bay and come to grips, it is but half alive (3.13.1068).

In this passage Montaigne gives the example of the Apollonian oracles that defy us by their ambiguity or obscurity, elude us, and in this very way put our mind to work. He adds that "being satisfied with what we or others have found is weakness" (ibid.). Pursuing the research is a hopeless quest that will take us adrift, but this is our condition as thinking, writing beings.

Who invented poetry? Who is the creator of such art, such technique? Peletier du Mans in his *Art poétique* considers such questions absurd. The arts do not have assignable origins because "their seeds are in the greatness of Nature: who secretly and silently put them into mortal minds."[3] There is no identifiable beginning in the order of human productions, as in the physical world, because all things are carried along in perpetual genesis: "The great miracle of Nature is to be endlessly able to augment its things."[4] Here Peletier applied to mental functions the principle of continuous creation borrowed from the discourse of natural philosophy.[5] The forms of art blossom and alter in the same uninterrupted process as living creatures. It is easy to imagine that for many humanists this naturalization of change helped attenuate the scandal of history and repress mourning for lost antiquity.

The natural movement that carries sciences and letters in an infinite cycle of metamorphoses is manifest in the varied readings of a text and in the sequence that leads from an ancient work to a new one. Transformation is the mechanism of scriptural imitation; let us observe some of its techniques.

Putting Capital to Work

A preliminary stage of scholarly work that preceded personal creation was the preparation of traditional material for subsequent exploitation. The primary concern of erudites and pedagogues was to facilitate access to antique resources. Simple publication was not enough; the texts had to be presented in mobile units that could be recycled in new contexts. Scholars had to teach writers how to display and diversify the basic material, extract new expressions from ancient paradigms. These techniques, combined with practical exercises, made it possible to reactivate the dormant wealth in books and put it back in circulation. The goal was quantitative and could be formulated in economic terms as optimal management of the potential left by the ancients in the interest of drawing maximum returns. Linguistic and semantic goods should circulate and be put to new uses so they would be productive and profit making and generate new cultural business.

Direct access to complete versions of the original texts was, as we said, a priority in the humanist program. But this did not exclude another method, already practiced in antiquity, of cutting up the classics in bits and pieces to be used in anthologies. There was still a strong demand in the Renaissance for collections of commonplaces and all sorts of compilations.[6] By the mediation of choices, classification, commentaries they carried the antique source to the modern user, initiating a process of transfers and transformations in the destiny of the transmitted works.

Another traditional metaphor combines notions of transport, accumulation, and redistribution: the scholar who stores up commonplaces is like a bee gathering pollen from a wide variety of flowers.[7] If we are to believe Ronsard, the poet begins by gathering here and there the wealth of others, then carries it to his storehouse and arranges it in new configurations:

> My dear Passerat, I am like the Bee
> Who gathers now the red flower,
> Now the yellow: goes from field to field
> Flies where wings and wishes carry him,
> Rich stores stocking for winter's harsh:
> So I wander and dally in my books,
> So I gather, sort and choose the beautiest
> To paint in hundred colors in this tableau,
> And then in that one . . . [8]

Bees can perform other tasks; we find them later making honey, emblems of the labors of appropriation and transformation. Here they illustrate the activity of the collector and the principle of quantity: gather widely to harvest "rich stores." Theoretically the material remains intact, but who can fail to see that, placed in a new context, it has already changed?

Erasmus exposed these mechanisms at length in a treatise, *De duplici copia verborum ac rerum,* designed as a manual to provide young orators and writers with a wealth of means of expression (book 1) and semantic reserves (book 2), in which they could dip and help themselves to material for their compositions. Book 2 gives a general exposition on techniques of invention, followed by instructions to the student on how to make a collection of themes and commonplaces so that he will dispose of the richest, most varied resources possible when called upon to write or speak. The book includes helpful hints on classifying the material gathered: keeping pen in hand while reading, you dismember the original, reorganize the parts, and there you have the primordial units ready for new uses.

As if by chance Erasmus chose the theme of inconstancy to illustrate the method.[9] How should we constitute a stock of ideas and images concerning change? All branches of knowledge and all literary genres will be thoroughly searched. From the poets we will borrow descriptions of polymorphic gods, like Mercury with multiple faces, Proteus and Vertumnus with unstable bodies, Ulysses with changeable character. Science will furnish emblems of moon, heavens, and seas and all manner of chameleonic animals and changeable objects. We will dip into history, theater, fable. I could keep on adding examples, said Erasmus, but what matters is the method, because it gives the reader a chance to compose his own repertory. Nonetheless, Erasmus deliberately chose examples of metamorphic images that do what they say: excerpts and commonplaces taken out of context that change because they are transplanted. The change in environment exposes them to a change in meaning.

Erasmus was aware of this and said it; so the method apparently meant to reproduce invariable information turns out to demonstrate its versatility. In fact, the selected excerpts carry variable significations; they are like a signifier that would have several signifieds. For example, a well-known event like the death of Socrates can be used to illustrate radically different ideas: death does not frighten the wise man, virtue is useless, philosophy can be dangerous.[10] Or a semantic unit can be diverted from its usual meaning by an ironic treatment or different interpretation of a symbol, and so forth. Erasmus warned that this free usage complicates or excludes rigid classifications because a saying is al-

ways liable to jump from one thematic category to another. But without freedom, the user would be a parrot and his work nothing more than a collage of borrowed material. So the building blocks of the classical edifice also undergo metamorphosis, all the more important because their unpredictability keeps the system alive and supple.

The first book of *De copia* teaches the student how to perfect his style. To help the user find the most appropriate turn of phrase, Erasmus gives examples of a great number of possible formulations—synonymic variations, passage from one language level to another, figures of speech, exercises in compression or dilation of an idea—to show him that he has an extraordinary diversity of means available.[11] He has to express thanks for a letter? The practical demonstration gives 195 variants on the elementary core, *tuae litterae me magnopere delectarunt* (It was a great pleasure to receive your letter), with substitutions for each word taken one by one, then changes in the order, nuances of syntax, semantics, style, using all possible and imaginable figures.[12] This is followed by another example that provides 200 possible versions of the idea *semper dum vivam tui meminero* (I will remember you all my life long).

Here the mechanism of variations is the opposite from book 2: instead of a signifier generating *n* signifieds, we have a signified unfolding in *n* signifiers. The governing principle is the same as for the life of things in nature: the same matter can be poured into multiple forms. Another difference distinguishes the two books of *De copia:* while the second gives the avatars of a traditional formula down through history, the first illustrates the synchronic display of an idea within the same linguistic system. Beyond these distinctions, the same curiosity animates the work as a whole: the flexibility of the material, like unto wax,[13] handled by the man of letters. In one of several references to Proteus, patron of his undertaking, Erasmus says, I am going to turn this idea "in more forms than Proteus himself ever took."[14] Recycling traditional proverbs revives and transforms the raw material stored in the great authors; stylistic research is the singular, forever renewable actualization of a potential made available by language; from both directions the same metamorphic imagination discovers that writing operates in an elastic milieu and composes configurations that will always be temporary.

No matter how abundant the examples of stylistic variations available to the reader, they never exhaust the reserve of possible inventions. Erasmus emphasized that the illustrations he furnishes are only meant to show the dynamics of research, giving students impetus to pick up the relay. The workshop of words, as Erasmus presents it, is an experimental space that can yield

multiple finds. The method of *De copia* is diametrically opposed to the standardized rules of grammar and narrow dictionary definitions. Prospection—here is how you will look for the most appropriate expression—is substituted for prescription—say it like this, not like that. Erasmian pedagogy stimulates initiative, encourages invention, leads the student to exercise his freedom by working on the language.

The litanies of words and expressions that fill the pages of *De copia* would seem to indicate a tiresome verbal intemperance. Denying such an accusation, Erasmus explains that abundance is but a means in service of variety in style and precision in vocabulary. These pious demurs hardly detract from the exuberance of a style intoxicated with the infinite wealth of language. Like Rabelais in his extravagant lists of words, Erasmus seems to exult in the display of lexical, grammatical, and rhetorical treasures, never ceasing to marvel at the wonders that bloom from each elementary core. As in nature, a germ, a semantic cell is enough to produce a plant; mixed and disseminated, the energies stored in language generate many from one. The verbal profusion so common to sixteenth-century writers goes beyond simple pedagogical aims and animates their discourse with a turbulent potential that simulates natural growth.

This is what Henri Estienne, a learned grammarian like Erasmus, described as multiplication by "propagation." Publisher, philologist, and linguist, Estienne did research on textual budding, employed horticultural metaphors like "sowing" and "grafting," and loved to indulge in literary games. *Parodiae morales,*[15] his extensive theory of parody illustrated with practical demonstrations, came off his own presses. The essence of parody, he explained, is to take a text and dilate it by grafts and amplifications, producing an unlimited number of new versions by structural and semantic expansion of the original matrix. Apparently seeing parody as revelatory of certain fundamental mechanisms of *imitatio* and consequently of literary creation, Estienne neglected the comic effects of deviation to insist on its exemplary value. He carried his inquiry into the past—from Homer, who used lines from the *Iliad* in the *Odyssey,* to Virgil and Ovid, two other specialists in rewriting—and claimed that circulation and alteration are originary activities in literature.

Playful as he was serious, Estienne applied the mechanism in the moral realm. He borrows a line from a Latin poet that, taken out of context, functions as a proverb and plays at reformulating it in multiple styles, producing new maxims on the same theme. The parodic variations for each example are arranged in a graduated order from lightest to boldest modulation. A series of

progressive modifications unfolds before the reader's eyes in a sequence of shifts and variations from the original text. The transformations of a line from Juvenal, *Si natura negat, facit indignatio versum* (Though nature say me nay, indignation will prompt my verse),[16] illustrate this slow drift:

> *Si natura negat, verba indignatio praebet*
> > vel
> *Si natura neget, dabit ira audacia verba*
> *Si natura negat, dat saepe os ira disertum*
> *Si natura viam negat, indignatio praebet*
> > Paradiae aliae liberiores
> *Quas natura negat, pedibus timor admovet alas*
> *Quas renuit natura, timor compellit ad artes*
> *Si natura negat, mollescunt corda timore*
> *Quae natura dedit, timor excutit aspera verba*
> *Quem natura dedit, soluit saepe ira pudorem*
> *Quam natura dedit legem, indignatio soluit.*[17]

For want of genius, indignation provides the words.
> *or*
For want of genius, anger will dictate courageous words.
For want of genius, anger is aroused in a courageous heart.
For want of genius, anger often unties the tongue.
For want of genius to lead the way, indignation will go first.
> *Other more liberal parodies*
Wings that genius refuses, fear slips on the feet.
Skills that genius denies, fear will go and find.
For want of genius, hearts melt with fear.
The hard words that genius inspired, fear expresses.
The shame that genius inspired, anger often dissipates.
The law that Nature imposed, indignation dissipates.

Like Erasmus, Estienne left his abundant lists of samples open and invited the reader to continue the exercise himself. Does this kind of interference with the ancients insult their dignity? Not at all, replied Estienne. Inculcating supplementary moral values, associating the classics with contemporary didactic and literary activity, is a tribute to their enduring utility and relevance. This rigorous philologist and scrupulous publisher of Greek and Latin writers did not consider the recycling and conversion of the classics foreign to his mission.

The pleasure of textual metamorphoses was not confined to Latin. In another collection of parodic variations, *Les Premices, ou le I livre des proverbes epigramatizez, ou, des Epigrammes proverbializez,* Henri Estienne amplified

French proverbs (*lieux communs*). Arranged in six "common places"—God, man, life, youth, old age, death—the aphorisms are first quoted and then developed in poems of varying lengths that Estienne calls "epigrams." The short, often elliptical or allusive form of the proverb is like a germ waiting to propagate; the *Adages* of Erasmus are constructed along this principle. For example, Estienne notes that the proverb, "If youth knew, if age could do," is grammatically unfinished; it calls for a complement, "leaving it to the listener or reader to finish the statement."[18] Once the closed, compact core of the saying has been open, each of its elements can freely display its virtualities.

While the returns on proverbs in the last parts of the book are modest, just a few epigrams, lessons of wisdom in the first chapter are fruitful and multiply, as if to suggest that, being God-given, they are inexhaustible. "In so few hours God labors," produces thirty-two French epigrams, from a quatrain to twenty-line poems, plus eight Latin interpretations, in a single gnomic line. "Man proposes, God disposes" is transformed into fifty French variants, increasingly lengthy and free as they go. Moral or spiritual, the truths inspired by divine law seem limitless; here Estienne's technique is related to other religious genres—paraphrase, meditation, sermon—that amplify the Word by repetition and reformulation in an effort to extract its full substance. In fact, here and there we slip without rupture from the proverb and its suite of versions to a literary or moral commentary: the texts are so fruitful that they generate one form after another, carried along by an expansive force that, theoretically, nothing could stop.

From Having to Being

When erudites like Erasmus and Henri Estienne experimented with the productivity of a proverb, they were trying to put readers in a state of mind—an inventive, interventionist attitude—and give them a method—various techniques of multiplication. The method does not fully attain its goal until it goes beyond the stage of exercises to become a personal creation. Once the reader has acquired propaedeutics, he will truly be able to fertilize writing. And the mutation must take place in depth, beyond the repetitions of anonymous mechanical procedures. We go from quantitative proliferation to qualitative transformation.

How can we keep imitation from becoming duplication? And how can we use the mediation of the ancient to favor research instead of inhibiting novelty? To escape the danger of repetition and subjection, the models must pass

from the order of having to being; they must be interiorized and so intimately absorbed that they are no longer distinguishable. Then the division between present and past, the conflict between searching for one's own voice and listening to the other, is suspended. Reading leads insensibly to writing; the disciple has so well appropriated the master's example that, while continuing to exploit it, he legitimately speaks in his own name. Communion is established between the two parties; the ideal of the Eucharist, ever-present at that time, may not be foreign to this notion.

The metamorphic destiny of sources intensifies when the original text is abolished and reborn in a new form. This change of substance in the transfer from one work to the other was traditionally expressed by a network of metaphors going back to the Latins, associated with reflection on *imitatio* as transformation. When theory is at a loss to explain this mutation, symbols replace it. Two of these are particularly significant.

As the bee makes honey from all the wealth of the fields, the writer gleans goods from all his favorite books. The comparison, as we saw, can focus on the diversity of the harvest, but it particularly underscores the process of assimilation and conversion. Seneca suggested that, just as the bee transmutes a variety of pollens into one uniform product, "we should so blend those several flavours into one delicious compound" in such a way that every element undergoes complete metamorphosis.[19] Montaigne, following a host of other writers, used the analogy to express the dual role of impregnation and transformation in the development of the personality:

> The bees plunder flowers hither and yon, but then make honey that is all theirs; it is not more thyme than rosemary: and so he [the student] transforms and mixes pieces borrowed from others, to make a work all his own: that is, his judgment (1.26.152).

In a letter bringing together for the first time a group of metaphors to elaborate an authentic theory of reading as incorporation and transmutation, Seneca closely associated the model of bees with digestion. As in making honey the body transforms the nourishment it absorbs into strength and blood, "So it is with the food which nourishes our higher nature—we should see to it that whatever we have absorbed should not be allowed to remain unchanged, or it will be no part of us. We must digest it; otherwise it will merely enter the memory and not the reasoning power."[20] Quintillian also recommended assimilating what we read just as we chew and digest food.[21] From there on the theme was developed with variations from Macrobius to Polizi-

ano, from Erasmus to Montaigne.[22] Medieval monks had an even more expressive name for this process: *ruminatio.* Petrarch used it to emphasize the urgency of absolute fusion between nourished and nourishment, reading subject and subject read. I devoured the Latin classics, he said,

> I ate in the morning what I would digest in the evening; I swallowed as a boy what I would ruminate upon as a man. These writings I have so thoroughly absorbed and fixed, not only in my memory but in my very marrow, these have become so much a part of myself, that even though I should never read them again they would cling in my spirit, deep-rooted in its inmost recesses.[23]

The book is no longer just a book, it has become flesh and blood, naturalized into a real body. This fantasy of devouring is all the more powerful in that it combats the dread of becoming a vampirized disciple, invaded by the master and annihilated. The poetic arts drew on another, antithetic isotopy to denounce superficial reproduction, impersonal copying; they called the Ciceronians parrots and monkeys,[24] who rigidify the antique source and atrophy its fertilizing potential.

Criticism of word-for-word translation, prevalent in the sixteenth century,[25] was based on the same belief that literal restitution is the most sterile kind of *imitatio;* for lack of transformation it perverts the metamorphic vocation of the original, adding nothing. In a well-known passage, Du Bellay explained that the Romans opted for transmutation against translation in order to defend and illustrate their language: "[They] imitated the best Greek authors, transformed themselves in them, devoured them, properly digested and converted them into blood and nourishment."[26] He recommended the same procedure for the French language, claiming it would be all the more prosperous when it had pillaged others; good *translatio studii* implies deviation and appropriation. In the same spirit, Clément Marot, translator of Ovid, boasted of how he tried to "transmute this author who transmutes others."[27] His version of the first book of *Metamorphoses* would be one more metamorphosis, a passage to a radically distinct state, a new birth. One of Marot's intellectual models, Erasmus, had often defended various methods of free transposition in preference to literal translation; in the spiritual realm, paraphrase, meditation, and interpretation open a space where the subject can intervene, creating an intimacy with the original text that modifies both partners.

Montaigne dealt with the same problem in his dispute with the "pedants," schoolmasters who stuff the student's skull with indigestible science instead of

nourishing him. They do not transform knowledge, they just transport it from past to present, from one book to another, without profit. Instead of operating an innovative critical reading, they deposit texts in the memory, which is the most obedient and impersonal of all the mental faculties.

Montaigne often repeated that he himself has a bad memory. He can hardly remember what he has read, forgets in which book, in what form, he found this or that fact or idea. Such an admission of amnesia from a writer who quoted and borrowed from so many authors might seem unlikely. Undoubtedly exaggerated, it is, however, logical coming from an author who depended on books on the condition of being free to use them as he wished. If his memory were too accurate, he would risk apish reproduction. On the contrary,

> I leaf through books, I don't study them: what remains in me is things that I no longer recognize as belonging to others; and only from this can my judgment profit, from discourses and imaginations with which it is imbibed; the author, the place, the words and other circumstances, incontinent, I forget (2.17.651).

When texts are profoundly interiorized and treated with such nonchalance, anything can happen. Montaigne's insistence on the mobility of works that enter into his own instability partakes of the very nature of the *Essays*. If he had followed the method of the pedants, his work, saturated in foreign material, could have turned into a compilation of assorted commentaries in the margins of the classics. Montaigne took pride in reversing the erudite hierarchy: instead of working for the great authors, he made them work for him, even if they must be profoundly altered.

But the finality of reading is not only to produce writing. Why would the transformative power of the *imitatio* apply only to texts? If, as we have seen, a return to the ancients can stimulate lively creation and contemporary discourses, it is because a sensitive, alert individual operated the transmutation. The author is an integral part of the process and is affected by it. He transforms the source text and in the process of this exceptional contact transforms himself. The models have such strong radiation, such penetrating metamorphic power, that they invade a person's private sphere. The words do not necessarily reproduce in an enclosed space, they call out to a subject, they touch him, and he will never be the same again.

From this point of view, *imitatio* contributes to building identity by leading the apprentice-writer to become aware of his singularity, discover his inclinations, recognize his personal qualities. In such a way, says Erasmus,

your natural talent (*ingenium*), gorged on all kinds of foods, will of itself beget a discourse which will be redolent, not of any particular flower, leaf, or herb, but of the character and feelings of your own heart, so that whoever reads your work will not recognize fragments excerpted from Cicero, but the image of a mind replete with every kind of learning.[28]

The relationship between reader and model is not that between emptiness and fullness but a balanced relationship between two integral subjects. The danger of saturation gives way to the grace of plenitude, an abundance of learning that turns into wisdom, acquisition of experience that enriches the moral and the spiritual ego. The mind is no longer satisfied to accumulate goods, it undergoes a mutation that affects its inner being. When the reader, instead of bowing down to tradition, absorbs it into his own referential space, both parties are transformed: I look at him through a deforming prism, and it reveals to me an unsuspected dimension of myself.

Cosimo di Medici would have said *Ogni pintore dipinge se* (Every artist portrays himself). To imitate is to portray oneself. The literary version of the aphorism could be: "Every imitator speaks of himself." This epigram is the most radical expression of the paradox explored in this chapter. Reproduction of the other is representation of oneself. Artist or reader, the student appropriates the object of his study, makes a narcissistic projection, and parasitizes it the better to display himself. In varying degrees, Renaissance *imitatio* always encountered this temptation. It would be hard to go further than they did in transforming the model.

12 ■ *Works to Be Done*

The Reader's Task

"The Word is half the speaker, half the listener," wrote Montaigne (3.13.1088). He could have said the same for his book, for all books. The reader-listener shares in the construction of a discourse that cannot be fully realized without him. The work of art is a potential to exploit, an orientation more than a destination, given to the reader with a large choice of possible approaches to follow as he wishes.

This concept of reception as an integral part of the work is so common today that it would hardly be worthy of mention.[1] But it is a mistake to think that the concept is recent. Sixteenth-century artists (among others) intuitively understood that the future of their works depended on collaboration with the audience; to escape from oblivion, the work had to keep on developing. They deliberately made room in their texts and paintings for the reader or spectator and left him the task of completing, arranging, elucidating. They appealed to his intelligence, stimulated his imagination, challenged his reflexes. If the work had a smooth surface, like a saturated, inert system, it would be dead; its survival depends on the capacity to arouse initiative and enter into transformations.

In this chapter I will describe some of the strategies used in the sixteenth century to elicit this collaboration and ensure the pursuit of the creative undertaking. Between the extremes—maximum latitude exposing the work to a problematical future or maximum limitations to prevent deviations—countless transactions were made to modulate the proportions of freedom and constraint.

In an engraving by Erhard Schön, a disciple of Dürer, we see in the upper left a whale spitting out a man, probably Jonas; the rest of the surface is covered with a tangle of confused lines and elongated forms. The spectator is challenged to distinguish a satisfying image. He tries to find the right point of view and finally, placing himself on the left, distinguishes the figure of a man doing his business. The apparent scribbling is metamorphosed into a clear representation, suggested in fact by the inscription *Was siehst du* (What do you see?). The compensation for his efforts is double, and grotesque: revelation of a shameful image and a comic parallel with Jonas expelled from the belly of the whale.

This drawing is an example of anamorphosis, a technique going back to the very beginning of the sixteenth century, which gave rise to varied experiments in succeeding decades, particularly in Italy and Germany, followed by a second vogue in the course of the seventeenth century. Looked at straight ahead it shows a strange, indecipherable image, but from an angle, seen from a predetermined fixed point, it reveals an identifiable representation. Sometimes the lateral position was replaced by a view from above or from bottom to top. The trick is in the spectator's point of view: if he finds the right position, he sees clearly; from every other position he sees only a deformed or formless image. This technique is in fact a by-product, a "curiosity" or aberration of serious research on perspective.[2] Due to the illusion of perspective, the eye-to-image relation is ordinarily established without difficulty; in anamorphosis, it implies active research and goes in two stages, from illegible to legible.[3]

The pleasure of finding a satisfactory form is often doubled by the discovery of meaning. Another engraving by Schön reveals, in the initially indistinct magma of lines and scratches, superimposed portraits of Emperors Charles V and Ferdinand I, Pope Paul III, and King François I (fig. 50), with identifying inscriptions that also must be sorted out of the confusion. Other anamorphoses are based on a similar project of dissimulation of a royal figure—most often Charles V but also the English King Edward V—as if to suggest the omnipresence or omnipotence of the sovereign portrayed. There the enigma is political, elsewhere it might be moral; a death's head hidden in Holbein's famous painting *The Ambassadors* invites an allegorical reading and casts the whole scene in the allure of a vanity.

Another optical trick that attracted curiosity at that time, the anthropomorphic landscape, also functions on the spectator's difficulties and calls for his active contribution. An etching represents, horizontally, a mountain, trees, a port, some houses; turned ninety degrees it brings out, vertically, a human

profile (fig. 51).[4] Another engraving, after Arcimboldi, *Homo omnis creatura,* shows a rock that is also a giant's head. The image does not even have to be rotated: the trees are his hair, a tower his nose, a bridge the mustache, and so on (fig. 52).

Anthropomorphic landscape differs from anamorphosis on two planes: there is neither a right and wrong perspective nor a good and bad image. Two equally significant, acceptable presentations are superimposed. The famous Arcimboldi portraits exploit this ambiguity: is it a head or a pile of books? Is that thing a fish or a cheek? Is this one a nose or a pear? If I look closely I see a series of objects, and from a distance, a face. I move and the image is transformed before my eyes, but no version is more correct than the other; the uncertain perspective makes me oscillate between two perceptions (fig. 53).

As in anamorphosis, the work can be ludic and still serious. Landscapes with human form and men composed of objects belong to a universe where microcosm and macrocosm exchange properties. They reveal an underlying animist, metamorphic thought that considers nature as a unitary living organism within which species communicate and bodies pass from one form to another (see chap. 2). The superimposed images of face and mountain, ear and mushroom, speak to the secret affinity that associates living things. It's all the more striking when the anthropomorphic effigy looms up, hardly distinct from the landscape; we are reminded of the Apennine Giant of Pratolino, man and rock, amphibian being whose identity changes as the spectator changes perspective (see chap. 5 and fig. 35).

Anamorphosis and anthropomorphic landscape use different means to achieve the same finality of associating the spectator with the work's functioning. They depend on his surprise, doubts, searching. Such experiments are a radical demonstration of the belief that the image is in the eye of the beholder. The function recognized for the subject's point of view "implies a relativization of the space of meaning."[5] It is a reminder that the work is not a closed, immutable system; it is offered to the observing eye as a space to organize. The spectator alternates between studying details and grasping the whole; he pulls figures out of the confusion, chooses a coherence. Conceived this way, representation functions as a mobile, a play of forms in metamorphosis.

The observer's cooperation is indeed necessary to fulfill the work's intentions, but we must recognize that, in the aforementioned strategies, the margin of maneuver is slight. Once the spectator has found the correct angle from which to look at the anamorphosis, his mission is accomplished. There was only one image to discover; as in the enigma, the evidence eliminates the mys-

Fig. 50. Erhard Schön, *Anamorphic Composition,* ca. 1535. Example of *Vexierbild* (image with secrets), which was a specialty of Schön, Nuremberg engraver and disciple of Dürer. Baltrusaitis analyzes the illustration in his *Anamorphoses:* It represents superimposed heads of Emperors Charles V and Ferdinand I, Pope Paul III, and King François I. The observer sees just a "torrent of jumbled lines with nothing to explain them" until he finds the proper angle that brings out the figures. "The drawing," explains Baltrusaitis, "combines two pictures in one, maintaining the thematic unity": oriental figures and camels below the picture of François I (*bottom*) are a reminder of his relationship with the Turks. *Facing page:* The faces as seen from a lateral point of view.

tery, the solution exhausts the problem. The anthropomorphic landscape functions like an allegory,[6] inviting recognition of two possible readings, two superimposed meanings that, once identified, bring the investigation to an end. In both cases the productivity of the work and the scope of transformation is limited.

Anamorphic transformations may serve as models for literature when a hidden meaning is dissimulated under the apparent discourse. Béroalde de Verville affirmed this analogy, comparing his steganographic writing (a technique of secrecy) to anamorphosis:

> Under the thickened lines of its appearance [it] hides subjects altogether different from what seems to be proposed: which is practiced in painting when a landscape . . . or portrait is shown that nonetheless conceals some other figure that is discerned when you look from a certain place chosen by the master.[7]

Confronted with the enigmas of my text, said Béroalde, the reader will look for "the secret place that uncovers hidden treasures."[8] The reader is invited to shift from one perspective to another, as if he were going through a labyrinth, moving and making the text move.

Does Béroalde lead his reader toward a premeditated revelation, or does he open an unlimited interpretative field? The answer is not simple. One more step will be taken when the reader's collaboration can engender a multitude or infinity of developments. The author gives the impetus, defines the rules of the game, but, as opposed to anamorphosis or allegory, the possible extensions are

Fig. 51. Athanasius Kircher, *Campus anthropomorphus,* 1646. Engraving. Kircher was inspired by a painting representing the garden of Cardinal Montaldi, Rome, ca. 1590.

not yet actualized; they depend on the partner's creativity and to a certain extent escape from the initiator's control.

Henri Estienne, in his *Parodiae morales* commented upon in chapter 11 (above), adopted a striking formula. We will remember that in the practical part of the work he displayed a series of parodic variations on a line in Latin. But he specified that they were just examples to incite the reader to continue the exercise himself. The book functions like a manual to prepare the student's work and is only accomplished in the future, by his participation. The author says, "I did my share, the rest is up to you; reading is not enough, you have to produce." To encourage this relay, Estienne concretely inscribed the reader's space within the book, leaving all the right-hand pages blank. He explains, in the *Epître au lecteur:* "I hope that many will try the same type of exercise. . . . To them I left a blank page across from each of the quotations used for parody." And again, at the end of the manual: "I left some empty pages here, so that you can add to my examples the ones that you find." So the undertaking is left to the reader's mercy and will not be finished until all the pages have been covered with writing. And even then, the expansion of such a potential book could not be subordinated to material contingencies; the more it spills over its borders, the greater the satisfaction of its intentions.

Books that make such a visible assertion of their unfinished nature are rare. I know of only one other in the Renaissance, a superbly illustrated incunabulum, *The Nuremberg Chronicle,* a treatise on universal history and geography.[9] The work is divided into seven periods, from creation to the Last Judgment. At the end of the longest chapter, *"Sexta etas mundi"* ("The Sixth Age of the World"), which covers the entire Christian era up to the book's composition in 1492, the printer inserted six blank pages, with this explanation as a heading:

> I think that posterity may correct, supplement, and otherwise write the history of public and private men of the future. Because we are not infallible and the good Homer sometimes drowses. . . . Varied events and extraordinary phenomena arise from day to day in the world, calling for new books.

The blank page seems to confer the same function and status on both partners, producer and receiver. This marks a progression from collaboration under surveillance in a strictly programmed framework to greater freedom soliciting an altogether new contribution. And yet none of the strategies studied thus far can be said to liberate true creative energy. Either the receiver finds what is already there or brings something new but within a prescribed framework; he can apply Estienne's restrictive definition of parody or extend, as an impersonal spectator, *The Nuremberg Chronicle.*

Genuine openness requires no such gadgets. The artist counts on more secret germs to project his work into the future and draw the reader into innovative dynamics. In works of art that continue to live and transform, the artist knew how to leave room for mystery and a margin of indetermination; it is this challenge to the intelligence, this appeal to the imagination that leads the recipient to invest fully in the invitation extended to him. Then and only then is the work exposed to a virtually infinite cycle of metamorphosis.

The rest of this chapter will be devoted to exploration of a few subdivisions of that immense territory, going back to authors already encountered and questioning them in this perspective. Should we be astonished that these artists, captivated by a world in constant mutation, sought to associate their works with movement?

Indeterminacy as Potential: Leonardo da Vinci

Leonardo, as we saw in chapter 10, analyzed the mechanisms of invention and represented the process of creation; he observed himself at work and gave advice to young artists. One of his precepts, "quite useful for exciting the mind to various inventions," will particularly interest us:

Fig. 52. Hans Meyer, after Arcimboldi, *Anthropomorphic Rock,* early seventeenth century. Wood engraving. Oxford, Ashmolean Museum.

If you look at a wall covered with stains, or made of different kinds of stones, and you have to imagine some scene, you will see varied landscapes there, mountains, rivers, rocks, trees, plains, wide valleys and varied ranges of hills. You will also discover combats and rapidly moving figures, faces with strange looks, and exotic costumes, and an infinity of things that you can bring to distinct well-conceived forms.[10]

Leonardo also recommends scrutinizing "ashes, clouds, and mud"; in these amorphous masses the painter will find "marvelous ideas" because, "in confused things, the mind awakens to new intentions."[11] Dipping into the pool of the formless, the artist will bring forth the most ingenious, most beautiful figures, which his imagination will then transmute.[12] Leonardo substituted for

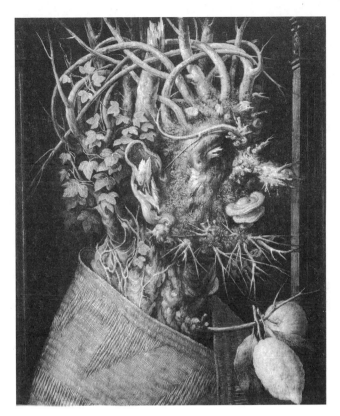

Fig. 53. Giuseppe Arcimboldi, *Winter,* undated. Oil on wood, 84 × 57 cm. Munich, Bayerische Staatsgemälde-sammlungen.

the classical principle of *mimesis,* based on observation of the object, a method that postulates the artist's intellectual independence, his capacity to conceive new configurations from apparently irrelevant stimulants. Indistinct surfaces and vague indeterminate forms are invested with heuristic value and offered like matrices pregnant with latent lines and configurations that the artist will transform into representations. Here the artistic project intersects with the familiar theme of chaos: the germ of life lies within the raw material, the formless is the crucible from which form will emerge (see chap. 4).

Leonardo could observe stains on walls or make his own stains, as we saw in the saturated sketch of Saint Anne, blackened with superimposed, barely legible lines (see fig. 43), as if blurry, indeterminate forms were a necessary

stage toward a more perfect drawing. It should be emphasized that the indefinite was then a secret of the studio, a temporary stage that would be effaced by the finished work. Imaginative speculations and the passage through vagueness did not replace conscious calculation or technique. The artist's vocation was to extract beauty from the rough sketch, repeating the gesture of the Creator who metamorphoses chaos into cosmos. Leonardo imprints a harmonious form on the stain as the sculptor, challenged by the block of stone, imposes a figure.

And yet Leonardo may have transferred the experience of the artist in the conceptual stage to that of the spectator at the moment of reception. If the painting aspires to something more than existence as an inert object, it can play on the dynamics of the formless to provoke an intellectual event, awaken inventiveness, stimulate the imagination, provoke analysis. Without necessarily being left unfinished (although so many of Leonardo's works are), the work would solicit the observer's participation.[13] Various indications in the sketches and paintings, as in passages of the notebooks, justify this hypothesis.

The series of drawings on the theme of cataclysm and deluge referred to above (chap. 3; figs. 5 and 12) illustrate the upheaval of the natural order and simulate the return of the elements to the primordial magma. Gray streaks and opaque masses offer an almost undifferentiated surface where earth, air, rain, and clouds can be vaguely perceived by the searching eye. The viewer tries to distinguish the parts, the mind tries to understand the event, but the structure of the landscape can't be grasped. Leonardo applies the procedure of *componimento inculto* (the hidden composition), which awakens attention by means of confusion in the image. And Vasari remarked that, when he worked in chiaroscuro, Leonardo used such dark colors to force the contrast of light and shadow that his "subjects seemed to be represented by night rather than clearly defined by the light of day."[14] Deciphering so many patches of darkness inhabited with forms to be reconstructed demanded an effort far beyond the aesthetic experience of that period.

Without resorting to the violent confusion of materials, Leonardo used other techniques to create vague images and achieve extraordinary results with the attraction of the indistinct. His well-known *sfumato* technique smothers in the blur of the median zones the lines that separate objects, creating vaporous contours. This veil that attenuates the sharp outlines of forms in the painting functions like the air interposed between the eye and the object that in nature blurs the vision. The effects increase with distance; several paintings have hazy, bluish backgrounds, reliefs smudged in a vague luminosity where mountains,

rivers, and clouds can barely be distinguished. In his abundant notes on *sfumato,* Leonardo described better than anyone the finely graduated nuances:

> From a town at the foot of a mountain, the dust rises up, taking the form of a cloud, and its color varies with the iridescence of the clouds. Where the rain is thicker, the color of the dust is less distinct; where the dust is heavier, the rain seems less visible; and where the rain is mixed with wind and dust, the clouds it engenders are more translucent than the clouds of dust.[15]

A chapter in the notebooks entitled "Landscapes" abounds in studies on the tonalities of fog, smoke, shadow—and at times the descriptions themselves are so subtle that they attain the same delicacy, the same mysterious atmosphere as the paintings.

Indeterminacy is too important and exacting to permit neglect of even the slightest detail. From brush to quill, Leonardo worked with meticulous attention on the effects of scrambling. If the air veils outlines, motion can also trouble lines and volumes by raising dust. The long text on "How to Represent a Battle" explains how scrambling covers the battle scene with a "thick confused mist":

> First show smoke from the artillery mixed with the air and the dust kicked up by the agitation of horses and soldiers. . . . As the smoke mixed with the powdery air rises, it will have the appearance of a dark cloud, more perceptible at the summit than the dust. This smoke will take on a bluish hue and the dust will keep its natural color. This mixture of air, smoke, and dust will look much lighter on the side where the light comes from than on the opposite side. As for the soldiers, the more they are in the heart of the tumult, the less they will be visible, and the less contrast there will be between their shadows and lights.[16]

The forms are so scrambled under the powdery curtain hovering over the battlefield that silhouettes of soldiers, horses, and arms poke out from the confusion in some places, can only be guessed in others; clear enough to orient the search, too vague to permit any certainties.

It is possible that the Neoplatonic thought in full expansion in Florence at that time provided a framework for Leonardo's aesthetics of *sfumato.*[17] Marsilio Ficino and his disciples taught that only the mind can contemplate the ideal forms in their perfection; the human eye can only perceive vestiges of true beauty because, in the imperfect world of bodies and death, we can only indirectly apprehend the intelligible models. They are captive of matter and exist only by default in this world, as altered traces of the lost origins. But the

soul does not give in to resignation; it aspires to pierce the veil and discover the clarity of essences beyond the opacity of things. The artist, more than any other, takes part in this quest; he can represent in his work the combat of matter and mind, the formless and form. As we said in chapter 10, the unfinished statues of Michelangelo probably illustrate this dramatic search for unattainable perfection.

This context could justify the hypothesis that Leonardo's vague shapes and misty backgrounds give themselves to be read as the lineaments of lost beauty. They would symbolize the phantasmagoric world where ideal forms are dimly visible through a curtain of interferences, contingencies, and illusions. So the artist, expressing his nostalgia and intuition of the universe before the Fall with techniques of chiaroscuro and smudged lines at the limit between light and shadow, is also bringing the viewer along in his quest. By showing hazy images, he commits the spectator to make the mental effort to recompose sharp, clear objects. The relative veils the absolute and the indeterminate bears traces of the intelligible, renders them sensible and inspires desire for them. Expressed in Platonic terms, *sfumato* would provoke reminiscence and the reconquest by the soul of the world of essences; it would have the same function of awakening and guidance as, in love, the beloved figure, emblem of lost perfection. If the painting suggests that the accomplished form lies latent behind mists and shadows, it is an incitation to think it, dream it, hope for it. Shadowy figures and décors would define a metamorphic world, a spectral transitory universe that the viewer is invited to transform, thus mentally projecting himself through the looking glass.[18]

Neoplatonism inspired other artistic experiments that would be widely disseminated in the Florentine milieu and then throughout Europe in the sixteenth century. A brief survey will suffice. In the same way that primordial beauty, altered and occulted, survived in the world of phenomena, the original knowledge that the first men shared with the gods has been preserved in fragments and remains accessible under the veil of secrecy. This belief is based on the conviction that the original poets—Orpheus, Homer, Pythagoras— were divinely inspired and, like the prophets, privy to supernatural knowledge about the physical world and metaphysical truths. Vestiges of this knowledge are preserved in myths, archaic poems, and a whole occult tradition, but they are coded, and only diligent seekers or the initiated can uncover their message. Philosophers like Marsilio Ficino and Pico della Mirandola were fascinated by mysteries, convinced that certain antique texts contained revelations; secrets to be decoded lay in fables, in the Bible, in traces of the most distant cultures, as

in nature. The more sibylline the sign, the more substance and depth was attributed to it.

Thus a climate favorable to symbolism had developed by the end of the fifteenth century, but in an unstable, diffuse version that complicates the problems of interpretation. The Supreme Being—the ideal One—of Neoplatonic philosophers is an absolute so perfect, so unreachable that, like the God of the mystics, he escapes all logical determination and defies the signifying power of words. He can be seized by intuition but spoken of only indirectly, by paradoxes, interposed figures, or the mediation of enigmatic signs bearing a diffuse truth that can never be more than defective substitutes, all the more appropriate for being ambiguous and opaque. It follows that these signs, which cannot possibly point to the ultimate revelation, are caught in an endless movement of cross references where this word alludes to that one, this thing implies another, and no statement or object can capture the absolute truth but only hints and glints that have to be expanded, elucidated, and so on. Further, caught in this tissue of multiple relations and testifying to an infinitely complex reality, the signs are polysemic; their plural, approximate, uncertain significations defy totalization. There is always something more; not one or a limited but an indeterminate number of significations to be found by ways that reason does not know. Unable to rely on stable procedures, reading enters into a virtually endless process.[19]

Because artists and their patrons fit into this perspective, they were tempted to transpose into their creative work the ambient semiology and resulting hermeneutic. Why wouldn't those venerators of antiquity imitate the strategies of the hermetic texts they were trying to understand and expose their readers to the same challenge? So they in turn produced mystery and encoded enigmatic messages. Recycling traditional symbols borrowed from myth, religion, and initiatory literature, they constructed complex systems obviously saturated in hidden values and meaning or meanings to be discovered but resistant to all keys, overrunning the narrative, moral, conceptual categories in which commentators would confine them. The works of Botticelli, Raphael, Titian, not to mention the mysterious allegories by Bosch or the School of Fontainbleau, demand solid knowledge of learned traditions and have to be read on a deeper level, where no attempts at explanation could exhaust their symbolic implications. Erudite research in iconography is absolutely necessary but hardly sufficient.[20]

Whatever the author's intention, the hermeneutic destiny of such dense, complex works makes them function as mobiles. Their abundant semantic

wiles ensure continuous rebound and seem to integrate into the project the perplexity of the spectator, propelled from one interpretation to another. The same would apply, it is true, to many fields of art history, but its pertinence here is related to the intellectual environment that we are investigating.

The Challenge of Strangeness: Rabelais

Rabelais went from observer to active participator and even fomentor of the Renaissance hermeneutic crisis. He played on the ambiguity of signs and exploited the reader's perplexity as a dynamic element in his works.[21] This does not imply that all his narratives are steeped in indetermination; at times the message is unequivocal or obscured by the effects of historical distance. And if Rabelais sometimes deliberately proposed plural meanings, he would also impose a restrictive perspective.[22]

The Middle Ages had elaborated a general theory of the symbol that claimed to function as a universal infallible code applicable to interpretation of the world, biblical exegesis, and, by extension, pagan works. Whatever the means, the end of the demonstration was always to discover beneath surface appearances the unique truth of the Revelation or the foundations of Christian morality. This is the function of allegory, which for several centuries determined, with variable rigidity, the production and reception of fiction. This or that message in conformity with the faith was inscribed in novels and fables; the principles of Christianity were hidden in the works of Homer or Ovid.

But to sixteenth-century minds this method was fraught with the risks of a rigid system that could atrophy the potential of signs and inhibit the reader's vigilance. Allegory postulates a binary hierarchy with clear distinctions between the material and the spiritual, the patent and the latent. It is this rigid structure that the humanists dismantled. They did not contest the presence of latent values beneath the surface of things and words. Spirit animates matter, hidden knowledge lies, as we said, in sacred and antique texts, so the search for deeper meanings remained an essential objective. But sixteenth-century scholars no longer subscribed to a monolithic conception of the truth, so they rejected preestablished reading codes that exhaust mystery and mistrusted excessively formal hermeneutics. The authentic pursuit of meaning must be a problematical quest, an intimate activity, a roundabout approach to the truth.

Progress in philology had certainly given greater technical support to the humanistic reader in the form of scholarly notes and historical glosses. But

when it came to transcending the literal meaning and grasping the spirit of a text, he was left to himself and no longer sure of the code. He had to count on his intuition or the enlightenment of Grace. Access to profound meaning implies a reading guided by affinity, personal ethics, and commitment. Nothing is fixed in advance and the result is uncertain. While Panurge, in the *Third Book,* uses so-called proven techniques to acquire doubtful certitudes, Pantagruel knows that the search for truth is a spiritual activity that involves the inner self. The Erasmian and later the Reformed reading of the Bible, as of profane works, considered interpretation as a problem; it depends on historical circumstances, may be partisan, is subject to refutation. It would be left to theological debate to demonstrate the inexistence of exegetic consensus.

Several writers developed narrative schemes to thematize problems of interpretation. In the *Third* and *Fourth Books,* Rabelais strung up a series of episodes that follow the same scenario: the characters hear someone's opinion or witness an event, then stop and try to understand what was said or done; they make comments, compare different methods, but explanations differ and nothing certain is acquired, so they start over again. This two-stage structure of a phenomenon followed by its gloss also governs the *Heptameron* by Marguerite de Navarre. After listening to a story—the collection contains seventy-two—a group of friends discuss the lessons to be drawn; but opinions clash, characters disagree, and the meaning, defracted in a multitude of possible values, remains indecisive. Using a variety of patterns, sixteenth-century narrative prose and poetry constructed representations of reading, as if fiction with its symbolic scenarios were adequate for exploring a problematic operation that had become resistant to rules and theories. When, in the course of long narratives, Erasmus, Rabelais, or Marguerite de Navarre confronted a story and its reception, when they created characters who are also readers and interpreters, they were constructing theoretical fictions or imaginary hermeneutic models that could be used to test different reading methods.

This, briefly outlined, is the context in which Rabelais planned the reception of his own works. Countless episodes in his narratives have the appearance of allegories and invite a search for "higher meaning." But the promise may turn out to be unfounded. Instructions for correct reading are often ambiguous; the author wears a comic mask that discredits his authority, and a host of parasites—farces, digressions, linguistic skids—perturb the logic of the cryptic discourse. Things spring up in a story, but we can't tell whether their status is simple amusement or serious indication of hidden meaning. Do or don't they merit interpretation? Unusual signs are given to read, but they es-

cape from familiar codes, don't fit into the patterns of traditional symbolism, and can't be deciphered. Are they slapstick or hermetic? Mystifications or mysteries? It may be that they are simply indeterminate and impossible to elucidate.

As the work progresses, Rabelais exploits the category of the *bizarre,* which is particularly effective for disorienting the reading and blocking interpretation. Because a choice has to be made, I suggest that we limit our investigation here to the category of strangeness, as developed in the *Fourth Book.*

In the course of this long story of navigation, we meet up with bizarre behavior, incongruous figures, deformed creatures that disturb us and resonate in our depths, yet no key is given to identify the contents or calm our anxiety. The Chicanous earn their livelihood by being beaten (*Quart Livre* 12–16); the giant Bringuenarilles, who usually feeds on windmills, falls ill from eating kettles and finally succumbs to a bit of butter (*Quart Livre* 17); the inhabitants of the Isle of Ruach eat wind and die farting (*Quart Livre* 43). The reader is bombarded with symbolic suggestions that defy interpretation because they are unrelated to any familiar code; they are troubling, they resonate in strong emotional vibrations that cannot be restrained by rationalization. The fascination of this *inquiétante étrangeté* (disturbing strangeness, déjà vu) provokes varied speculations and imaginary constructions that perturb the mechanisms of meaning. Some of these signs open a breech into obscure unconscious content: erotic fantasies, sexual deliriums, visions of comical bodies and perverse couplings. The noseless people of the Ennasins subvert sexual identity and family relations and treat human beings like things (*Quart Livre* 9). But the volley of troubling images that excite and destabilize the reader is perhaps even more intense in the parallel episodes of Quaresmeprenant (*Quart Livre* 29–32) and the Andouilles (*Quart Livre* 35–42); they will serve as examples.

To the reader who seeks protection in reading on a deeper level, these two stories do in fact offer some familiar, reassuring signs—paradigms of moral discourse, stereotypes of religious satire—that seem like an invitation to recognize identifiable aberrations in these monsters. The antagonistic couple Quaresmeprenant/Andouilles is apparently constructed on the model of the traditional opposition Lent/Carnival, itself an emblem of Catholic/Protestant dissension. Quaresmeprenant's meager diet and fleshless body represent mortifications and the rigor of fasting, designating by extension the bigotry of the Roman Catholic Church, literal obedience to a sectarian Pharisaic law. The fat, dissolute Andouilles represent libertinage—another type of fanaticism—and incarnate the Reform, with its refusal of observances. Avid for certainties,

most commentators isolate and interpret this type of information, reducing the narrative to the economy of a fable.[23]

With such convenient rationalizations the unknown is shifted to the realm of the known, the strangeness is evacuated, and the reading dynamics blocked. But the inadequacy of this approach is visible to the naked eye: it draws just one thread from the tangle, pulls out a few recognizable elements, censors the rest, and tries to pass off this forced interpretation as a comprehensive solution. Whole pages and masses of detail are left in the dark: the interminable anatomy of Quaresmeprenant, the complexion of the Andouilles, their somber doings, the fantasy battle against the cooks. These stories are comical, but is that a reason to deny their impact? No, because the things that are left out are neither subordinate nor innocent; they are disturbing because they lead to a system of obscure meanings—the disturbing territory of the strange and irrational—and set off an interpretative movement with no end in sight. Let us peek into this Pandora's box.

Quaresmeprenant's body, dealt out in long lists of discontinuous organs and functions, appears at first as a juxtaposition of heteroclite pieces. The unity of the person disintegrates in a tangle of disjointed parts. But the dehumanizing effect of the monster's portrait derives from yet another aberration: every part of his anatomy is compared to an object, a utensil, an apparatus. The troubling marriage of animated and inert, the invasion of hostile hard material in the realm of living things evoke the specter of the machine taking control of man. Like the thingified faces of Arcimboldi, the body of Quaresmeprenant is a montage of instruments, a blind mechanism, a carcass deserted by the mind. What's left is the nightmare of the automaton.

The strange miscegenated Andouilles also occupy a mixed, indeterminate rank in the chain of being. Sexual limits vacillate: they are female, but they make war and are shaped like virile members. Are they hermaphrodites? Do they incarnate the figure of the phallic mother? The contamination of classifications does not stop there. The Andouilles belong to three realms: their discourse and behavior are human, but their bodies have properties of animals (they resemble, among others, serpents) and objects (they are sausages). Fantasies of forbidden couplings and alliances against nature produce a polymorphic monstrous figure that forms, deforms, transforms like a hallucinatory effigy, a rough lump barely distinguished from primordial chaos.

These representations of archaic morphology, bodies in mutation, marriage of human and thing, confusion of sexes, provoke reactions in the reader that are even more powerful because they are usually repressed. More than any

other, the overdetermined image of the Andouilles brings to light fantasies of anguish or pleasure that defy totalization. These ladies look like penises, but they also resemble animated turds. Phallic and fecal, they nonetheless remain nourishment, conjugating oral, sexual, and anal orgasmic pleasures. They crystallize in themselves two habitually censured combinations: the affinity of alimentary and erotic pleasure, the secret relationship of oral and anal activities. And we could go on.

The *inquiétante étrangeté* that saturates these pages is not only an affair of vision. It derives from what is designated, the signified, but is equally manifest in the designators, the signifiers. As always in Rabelais, but here more than ever, verbal creations are so important that words and plays on words seem to take over the story, making it all the more bizarre. What status should be attributed to representations that are so obviously produced by stylistic effects? They are verbal artifices and yet they take bodily form and haunt the imagination. Should these contractions be rejected as factitious, arbitrary constructions? Or should we surrender to the troubling fascination they exert? Shallow or searching? The discomfort is all the greater in that there can be no clear answer to the question.

Further doubts arise from the mixture of slapstick and sinister, comic and violent. There is much to laugh at in connivance with an author who is having fun—incongruous inventions, culinary buffoonery—and yet we are constantly on the verge of rejecting the hideous, dehumanized carcasses, the duplicity of monstrous, aggressive figures, the onslaught of inavowable fantasies. Quaresmeprenant and the Andouilles are funny in two meanings of the term: comical and disturbing, not really this, not altogether that. The reader vacillates in a labyrinth of contradictions.

So these stories are neither serious nor futile, not true and yet not false, definitely unreal but compelling. Their meaning defies analysis, escapes all order, irritates; we don't understand and yet hundreds of possible interpretations come to mind. We read these pages like Leonardo looking at a stain on the wall. He can't see anything distinct, but ideas churn and bubble. What Rabelais invites us to explore here is a chaos of semidifferentiated intuitions, the opaque fertile hearth of indeterminate thought.

"A sufficient reader:" Montaigne

Everything changes, and what I say is true only at the moment I announce it. So I must find a way of writing that can reproduce the mobility of thought and

the discontinuity of instants in time. We recognize here the project of Montaigne (see chap. 10), who knew he had embarked on an endless undertaking:

> Who does not see that I have taken a route that I will follow, working incessantly, as long as there is ink and paper in the world? . . . When will I finish representing the continuous agitation and mutation of my thoughts? (3.9.945–46)

The answer seems obvious: a text that fluctuates to the rhythm of life will end when the author dies. But Montaigne can't resign himself to the death of motion. So he confers on his readers the task of continuing to fill in the margins of the *Essays*, to safeguard the productivity of his work: "a sufficient reader often discovers in the writings of another, perfections other than those the author put and perceived there, and lends it richer meaning and appearances" (1.24.127).

What can be done to make the reader a partner? Montaigne made countless appeals for cooperation and created numerous occasions for readers to intervene, less in the imaginative register exploited by Rabelais than by intellectual challenges. He deliberately made the reception, or rather diverse receptions that would ensure an active posthumous destiny for the *Essays*, an integral part of the book.

This applies to intentional failings in the organization of the text that leave the reader to accomplish part of the task; he has to reconstruct missing articulations, put the disorder in order. On a microstylistic scale, sentence structure may be perturbed by syntactic accidents. The erratic flow of thought may create logical problems or disconcerting sequences. Propositions follow each other in complex, unexpected associative modes. Where connections do exist, they do not respect the inductive or deductive paths of classical reasoning, with cause preceding effect, conclusion following demonstration. And the reader may stumble over a rupture in construction, a pronoun that does not refer to a precise noun, an insertion or digression that disturbs the course of the argument. Montaigne provocatively announces that the failure to indicate correlations is deliberate:

> I intend to let the matter distinguish itself. It can show well enough where it changes, where it concludes, where it begins, where it resumes; it doesn't need to be interlaced by connecting and stitching words put there for weak or negligent ears, or by my own glosses. (3.9.995)

The frequent use of parataxis is significant: pieces of the argument are juxtaposed with no explicit connections and the text unfurls like a sequence of free variations on a theme, going along like a lively conversation, sometimes skip-

ping a step, sometimes digging in, finally tossing the puzzle pieces to the reader.

On a larger scale, the fragmentary composition and capricious arrangement within individual essays open another space for audience intervention. Rather than developing a single theme, the one announced in the title, various themes are interwoven and overlapped, jostling each other on a winding path where a geometric mind seeking coherence feels totally lost. The argument veers off on a tangent, the text seems to drift aimlessly, as if the subject or object changes as the writing progresses, so that from one minute to the next we are not talking about the same thing. The author lets, or pretends to let, his thought float freely, get lost, find itself, make "oblique" relationships (3.9.994). And yet Montaigne insists that there is a hidden unity beneath the uneven or erratic appearance of his essays, based on his personal experience of the passage. This subterranean coherence governed by vague laws is certainly difficult to grasp but, says Montaigne, the reader who searches carefully will discover hints scattered along the path of my discourse: "It is the indolent reader, not me, who loses my subject; there will always be some word hidden in a corner that does not fail to suffice, even though it is tight" (3.9.994). Montaigne deliberately avoids making all the transitions explicit; he dissimulates connecting words in the corners so that the search for coherence will keep the reader alert. Better not to be read at all, he says, than to be read by someone half-asleep. To read is to connect.

Ideas caught in the course of gestation, sometimes interrupted or allusive, also call for complements. Some of the essays are left hanging with no conclusions, and it is up to the reader to draw whatever benefits he can from the store of narratives and ideas passed on to him. Montaigne was too much of a skeptic to trust generalizations or leap from observation to theory; he preferred to collect curiosities and offer several hypotheses on a given question, unashamedly displaying his doubts and uncertainties. Further, he was pleased to acknowledge the density of his discourse: I give dense allusive material, he said, and it is up to the reader to thin it out. He would have us believe that he does little more than outline projects, tracing the lines of force and offering them to anyone who wants to develop them:

> Then am I mistaken if hardly any other writer offers material where more can be taken . . . if any has sown more consistence or at least more density in his paper. To fit in more, I just stack up the texts. If I added the suite I would multiply this volume several times over. And how many stories have

I tossed out without a word [with no commentary], where he who would sift a bit cleverly will find stock for endless Essays. . . . They often carry, beyond my subject, the seeds of a more rich and hardy matter. (1.40.251)

Montaigne, noble gentleman, gives his readers an immense stock of goods to exploit. He is content to skip over subjects, leaving them for other, more laborious writers to develop! The metaphor of sowing inscribes this ideal of propagation in the movement of natural processes and takes us back to transformist thought by granting increased value to the rough draft because it operates as a generative potential.

Montaigne's self-portrait follows the same strategy: he is omnipresent but remains vague and disjointed. Whether holding himself as an example or, on the contrary, as an exception, Montaigne makes us want to know and try to understand him but creates such a complex, explosive, fugitive image of himself that we have little hope of grasping it. Details of the self-portrait scattered throughout the *Essays* sometimes coincide and fill it out, sometimes indicate change or even discord, leaving the reader to constantly readjust a changing image: "And there is as much difference between us and ourselves, as between us and others" (2.1.337). The discontinuity of my self is so great that it attains contradiction: "I give to my soul now one face now another, depending on what side I sleep on. . . . All the contraries are there by one turn or another. Shameful, insolent; chaste, lustful; talkative, taciturn" (2.1.335).[24]

It is Penelope's loom, where the image comes apart as it is woven. Just as the reader thinks he has grasped the person, that image disappears and he is faced with the discordant task of trying to construct a coherent character while recognizing that the very difficulties of such a construction may invalidate his efforts. If Montaigne's self is to such an extent labile, can it serve as guarantee for his discourse? The demolition of the author as a stable figure compromises the very authority that should validate the reliability of his statements and the self-portrait itself. Like Rabelais, Montaigne adopts an enigmatic profile that destabilizes the reader; the former, behind his comical mask, disavows yet asserts the seriousness of his enterprise; the latter, by his contradictions, limits the validity of his statements to the precise moment when they are pronounced. The ground gives way under our feet; the truth is a mobile system, an unstable equilibrium that we must try to grasp without rigidifying.

A book is presented as an open workshop; a man and a thought are under construction, they have to be completed and consolidated, knowing that their existence is temporary. But Montaigne asks for more than friendly, even if ac-

tive, cooperation. An empathetic reading reduces the reader to a secondary role, whereas the aim is to arouse a critical reaction from a full partner. The worst audience is the docile, respectful reader who swallows anything and everything. Taking the *Essays* seriously means taking them personally, judging, approving, contesting them. This is why it is so important for Montaigne to refuse all the comforts of easy approval and sharpen the reader's vigilance. If Montaigne sometimes adopts polemical or paradoxical positions, forces an idea or defends a nonconformist theory, he does it to provoke a critical riposte. The reader, inclined to agree, is knocked off balance: he has to think, clarify his position, and take risks by declaring himself for or against. This initiates a debate where two interlocutors face each other on an equal footing. In this confrontation, the reader tightens up his ideas and learns to understand himself better. Both partners are engaged in the same dynamics: by writing or by reading, each seeks himself and strives to constitute himself as a coherent subject.

The words are fixed once and for all on the pages, but their effects will vary and they will continue to generate new values as long as there are vigilant readers to take them in hand. Good readers enter into the work and make it their own, putting it to new uses that bring it continuously into the present. Montaigne understood that the gestation of meaning is a continuous, ongoing process because it depends on constantly varying parameters—the reader's psychological and subjective disposition, the historical milieu and ambient culture—that change the very profile of the work.

Montaigne believed that truth is regenerated by transformations: it has its own history. Should we see this relativism as the resignation of a philosopher, a skeptic who no longer believed in anything? No. When a book is considered as a mobile and its progressive realization inscribed in the temporal axis, it participates in the vicissitudes and transmutations that carry along all things. The principle of the flexible text stands on a naturist act of faith; it associates the activity of the thinker, scholar, artist with the great rhythms that measure the life of things and preside over their metamorphoses.

▮ Notes

Introduction

1. See works of A. Warburg, A. Chastel, and E. Battisti.

2. Though I could not avoid using the words *transformism* and *transformist*, they have no relationship here to the theories of Lamarck or Darwin and do not signify anything more than the primacy of the principle of transformation.

3. Canguilhem, *Etudes d'histoire*, 177. See also the notion of "pseudomorphosis," coined by Panofsky to designate the reinterpretation and transformation of antique images reemployed in the Renaissance (*Studies in Iconology*, 70–71; *Essais d'iconologie*, 106–7).

4. I use J. Shearman's definition, adopted and applied to literature by M. Raymond.

5. See Schapiro, *Style, artiste, et société*.

6. See Wölfflin, *L'Art classique.*

One: Form and Force

1. On this literary and theological activity, see Thibaut de Maisières, *Les Poèmes inspirés du début*, chap. 3, and the introduction to the Bellenger edition of *La Sepmaine* by Du Bartas.

2. Citations are from the Bellenger edition.

3. On spontaneous generation, see two apparently contradictory passages in the "Second Jour," 157–74 and 512–26.

4. See esp. *Metamorphoses* 15.361–90.

5. See Bellenger, "Quelques remarques à propos du temps."

6. See Schmidt, *La Poésie scientifique en France.*

7. On this image, see Pricur, "La Cire de La Première Sepmaine."

8. "Contre les bucherons de la forest de Gastine," 68, in Ronsard, *Œuvres complètes*, 18:147.

9. See Keller, *Palingène, Ronsard, Du Bartas*, 130–32.

10. Ovid uses the analogy of wax in the tale of the metamorphosis of Pygmalion's statue as it comes to life (*Metamorphoses* 10.284–86).

11. Du Bellay, *La Deffence et illustration* 2.11.170–71. The *topos* of the mother

bear licking her cub is frequent. See, e.g., Pliny, *Natural History* 8.54.126; Aulu-Gelle, *Les Nuits attiques* (Aulus Gellius, *Attic Nights*) 17.10; Ovid, *Metamorphoses* 15.379–81; Rabelais, *The Third Book,* 42, in *Œuvres complètes;* Montaigne, *Essais* 2.12.560. Titian takes it as an emblem, with the motto *Natura potentior ars*. On the mother bear in the emblematic tradition, see Henkel and Schöne, *Emblemata,* 441–43.

12. On the fecundity of chaos, see chap. 4.

13. See Platon, *Timée,* 28–29.

14. See quotation from *La Sepmaine* (1981), "Second Jour," 202–7.

15. See ibid., "Quatrième Jour," 125–36. See also the entire passage beginning with line 89.

16. Commentary of Simon Goulart in *La Sepmaine* (1583), 21r.

17. We also find a second creation of man in Ovid's *Metamorphoses,* in the myth of Deucalion and Pyrrha (1.398–415). See Brunel, *Le Mythe de la métamorphose,* 74–75.

18. Bible de Jérusalem, 9.

19. Philippe Melanchthon, *In obscurioria aliquot capita Geneseos annotationes* (1523), quoted in Dubois, *La Conception de l'histoire,* 295–98.

20. Calvin, *Commentaire sur le premier livre.*

21. See, esp., Koyré, *Du monde clos à l'univers infini,* and Tuzet, *Le cosmos et l'imagination.*

22. Luther, *In primum librum Mose enarrationes* (1543).

23. Palissy, *Recette véritable* (1563), 95.

24. The two quotations are from Ronsard, *Œuvres complètes,* 18:147, 18:268. See also 8:178, 15:155, and 18:290. See also Scève, *Microcosme:* "La forme périssant, en non point la matière" (272). On this notion see Fraisse, *L'Influence de Lucrèce,* 118–20.

25. Cicero, *Orator* 3.10.

26. See, esp., Montaigne, *Essais* 3.2, "On Repentance," a long reflection on the notion of form. See also Naudeau, "L'Expression des modes philosophiques."

27. Montaigne, *Essais* 3.9.973–74.

28. See Aristotle, *Metaphysics* 1050a, 1069b, and *On the Soul* 412a.

29. Lenoble, *Esquisse d'une histoire,* 293.

Two: Natura naturans

1. Henri Estienne published pre-Socratic fragments in *Poesis philosophica* (1573).

2. Pierre de Lostal, *Discours philosophiques* (1579), cited in Joukovsky, *Le Feu et le fleuve,* 84.

3. Lucretius, *On the Nature of Things* 1.150; 2.875–76.

4. On Lucretius in the sixteenth century, see Fraisse, *L'Influence de Lucrèce en France;* on materialist thought, see Busson, *Les Sources et le développement du ra-*

tionalisme. The same idea was adopted by Christian thinkers like Bernardus Silvestris: *"Res eadem subjecta manet, sed forma vagatur. . . . Format fluit, manet esse rei"* (cited in Gilson, "La Cosmographie de Bernardus Silvestris," 21).

5. These texts attributed to Hermes Trismegistis were translated into Latin by Marsilio Ficino, published in numerous editions, commented on, and translated twice into French (1557 and 1579). See Yates, *Giordano Bruno,* and Soulié, "La Métamorphose d'après le Pimandre."

6. Ovid, *Metamorphoses* 15.165, 178, 234.

7. Same comparison in Du Bartas; see previous discussion.

8. The mythographic tradition readily presents Proteus as the "principle of all things, and the most ancient of all the Gods, . . . the principle of universal nature" (Comes, *Mythologie, ou explication des fables,* 867). See also Bacon, *Œuvres,* 412: "The character of Proteus represents matter itself."

9. Among other Renaissance versions of the discourse of Pythagoras, see Bruno, *The Ash Wednesday Supper,* dialogue 4, and the "Mutabilitie Cantos" at the end of Spenser's *The Faery Queen.*

10. The example of the cub fashioned by its mother is found in the discourse of "Pythagoras" (Ovid's *Metamorphoses* 15.379–81).

11. At the end of "Apologic de R. Sebond" (Montaigne, *Essais* 2.12.601–3). In fact, it is a fragment of Plutarch's *Que signifiat ei.* I quote from the *Essais,* where the text is almost identical or very close to Amyot's.

12. Sophocles, *Ajax,* 124; no. 8 in the catalogue of inscriptions given by Villey in Montaigne's *Essais.*

13. See esp. "Hymne du Ciel," in Ronsard, *Œuvres complètes,* 8.140–49. On these questions, see Keller, *Palingène, Ronsard, Du Bartas,* and Silver, "Ronsard's Reflections."

14. "Hymne de la justice," in Ronsard, *Œuvres complètes,* 8:63, quoted by Keller, *Palingène, Ronsard, Du Bartas,* 92.

15. Ibid.

16. Ronsard, *Œuvres complètes,* 3:165; see also 2:161.

17. Ibid., 15:152–63.

18. See Quainton, *Ronsard's Ordered Chaos.*

19. Rabelais, *Pantagruel,* chap. 3, in *Œuvres complètes.*

20. See, esp., Montaigne, *Essais* 1.20; 3.12; and 3.13.

21. Ronsard, "Hymne de la mort," in *Œuvres complètes,* 8:178.

22. Ronsard, *Œuvres complètes* 17.2.125.

23. See "Les Nues, ou nouvelles," in Ronsard, *Œuvres complètes,* 13:267–77; the eighth of *Folastries,* "Le Nuage, ou l'Yvrongne," ibid., 5:47–52; the hymn "Les Daimons," lines 83–90, ibid., 8:120. See also Du Bartas, "Second Jour," lines 625–35, in *La Sepmaine* (1981); Shakespeare, *Antony and Cleopatra* 4.14.2–14 and *Hamlet* 3.2.367–73. On clouds in painting, esp. in the work of Corregio, see Damisch, *Théorie du nuage.* See also Lebensztejn, *L'Art de la tache,* 95–116.

24. "Les Daimons," in Ronsard, *Œuvres complètes,* 8:115–39.

25. See, among others, Schmidt's critical edition *La Poésie scientifique en France* and the study by Lafeuille, *Cinq hymnes de Ronsard.*

26. "Les Amours d'Eurymedon et de Calliree," in Ronsard, *Œuvres complètes* 17.2.146.

27. See Perry, *Another Reality,* 184–87.

28. On the amorous metamorphosis, see Barkan, *The Gods Made Flesh;* see also Mathieu-Castellani, *La Métamorphose dans la poésie baroque;* Demerson, *Poétiques de la métamorphose;* and Rigolot, "Rhétorique: Métamorphose et métaphore," in *Le Texte de la Renaissance,* 187–98.

29. Ronsard, *Œuvres complètes,* 4:23–24.

30. "Ode à sa maitresse," in *Les Meslanges* (1555), ibid., 6:259.

31. Ronsard, *Œuvres complètes,* 5:110.

32. Ibid., 10:225, lines 236–37.

33. Ibid., 1:35–39.

34. *La Franciade* 4.874–77, in Ronsard, *Œuvres complètes* 16.2.285.

35. "Le Chat," lines 1–9, in ibid., 15.1.39.

36. Clovis Hesteau de Nuysement, *Poeme philosophic* (1620), cited in Schmidt, *La Poésie scientifique en France,* 340.

37. Ficino, *Théologie platonicienne* (1482), 1:144; quoted by Hallyn, "Le Paysage anthropomorphe," 47 (Nidra Poller's translation).

38. Lenoble, *Esquisse d'une histoire,* 297–98. See the poems of Rémy Belleau, *Les Amours et nouveaux eschanges des pierres precieuses.*

39. Palissy, *Recette véritable,* 95 and passim.

40. Ibid., 94.

41. See Tuzet, *Le Cosmos et l'imagination,* 270–75.

42. See Kenny, *The Palace of Secrets.*

43. Lenoble, *Esquisse d'une histoire,* 291.

44. See Céard, *La Nature et les prodiges,* esp. the chapter on J. Cardan.

45. Gallileo, *Dialogue des principaux systèmes du monde* (1632), quoted in Tuzet, *Le Cosmos et l'imagination,* 288–89 (Nidra Poller's translation).

46. References in particular to Bruno, *The Ash Wednesday Supper; Cause, Principle, and Unity; On the Infinite Universe and Worlds; Expulsion of the Triumphant Beast;* and *The Heroic Frenzies* and also to Michel, *La Cosmologie de Giordano Bruno;* Namer, *Giordano Bruno;* Tuzet, *Le Cosmos et l'imagination;* and Dagron, "Giordano Bruno."

Three: Earth Changes

1. Leonardo da Vinci, *Carnets,* 1:75.

2. See Chastel, "Léonard et la culture."

3. Vinci, *Carnets,* 2:18–19; *Notebooks,* 45–46.

4. In a note that goes with a drawing of the movement of water, Leonardo compares it to waves in hair: "Observe the motion of the surface of water, which resembles the behavior of hair, which has two motions, of which one depends on the weight of the strands, the other on the line of its revolving; thus water makes revolving eddies, one part of which depends upon the impetus of the principle current, and the other depends on the incident and reflected motions." Quoted by Kemp and Roberts, *Leonardo da Vinci,* 124.

5. This drawing prefigures research in comparative physiognomy by Giambattista Porta.

6. *Carnets,* 1:85; see also p. 142.

7. Numerous comparable effects can be seen in the Rubens copy of *The Battle of Anghiari,* a lost fresco attributed to Leonardo.

8. Eric Lecler establishes an interesting connection between metamorphic surfaces and the aesthetics of chiaroscuro: "The body is shown as an instantaneous fluctuating vision that can change or expire at any moment in the dangers of chiaroscuro. . . . Da Vinci painted this world of indeterminate contours and possible transformations in the pictorial style (*das Malerische*) that Wölfflin says gives a fluctuating nature to appearence: 'The form goes into play, light and shadow become autonomous elements, seeking each other, joining together; . . . giving an overall aspect of movement, of incessant, infinite flux. . . . Movement remains an inexhaustible source of contemplation' (*Kunstgeschichtliche Grundbegriffe,* Bâle and Stuttgart, 1970, p. 33)."

9. *Notebooks,* 145–49; *Carnets,* 1:217–25.

10. *Carnets,* 1:68, 1:65.

11. See Rabelais, *Gargantua* 4–6, and commentary by Bakhtine, *L'Œuvre de François Rabelais,* chap. 3.

12. *Carnets,* 1:79; *Notebooks,* 276.

13. *Carnets,* 1:344.

14. Ibid., 2:107; *Notebooks,* 47.

15. Gombrich, "Les Formes en mouvement," 185.

16. *Carnets,* 1:338.

17. See, e.g., *Carnets,* 1:325–31, and *Notebooks,* 21–23, 26–35.

18. *Carnets,* 2:9.

19. See *Carnets,* 2:281–82, 287–92; *Notebooks,* 186–93.

20. *Carnets,* 2:290–92, *Scritti Scelti,* 422; *Notebooks,* 187–90; *Traité de la peinture,* 135–38.

21. *Carnets,* 2:289; *Scritti Scelti,* 427; *Notebooks,* 193, *Traité de la peinture,* 139.

22. *Carnets,* 2:243–44; *Notebooks,* 186.

23. Rabelais, *Le Quart Livre,* 18–24.

24. *Carnets,* 2:287–89; *Scritti Scelti,* 425–27; *Notebooks,* 190–92.

25. *Carnets,* 2:515–18, 520–21, 433–36; *Notebooks,* 265–71; *Traité de la peinture,* 122–30.

26. *Carnets,* 2:520–21; *Notebooks,* 268–69; *Traité de la peinture,* 130.

27. On chaos as political allegory, see under "War and Peace" in chap. 4.

28. My sources are Rainaud, *Le Continent austral,* and Lestringant, *L'Atelier du cosmographe.*

29. La Popelinière, foreword of *Les Trois Mondes.*

30. Ibid., fol. 49r–v.

31. See Rainaud, *Le Continent austral,* 312–16.

32. La Popelinière, *Les Trois Mondes,* fol. 49r.

33. Guillaume Le Testu, *Cosmographie universelle . . .* (1556), fol. 35, quoted in Lestringant, *L'Atelier du cosmographe,* 190.

34. See Lestringant, *L'Atelier du cosmographe,* chap. 5.

Four: Chaos

1. Hébreu [Ebreo], *Dialogues d'amour* (1535), dialogue 3, pt. 2.

2. Le Roy, *De la Vicissitude* (1576), fol. 3r. On Le Roy, see chap. 7, under "Vicissitudes." In his meditation on chaos and the creation, Saint Augustine made a close association between the formless and the aptitude for change: Within matter, before God fashioned it, "the changeable condition of changeable things, is of itself capable of all those forms into which these changeable things are changed" (*Confessions* 12:6).

3. On the revery of the formless, see Bachelard, esp. *L'Eau et les rêves* and *La Terre et les rêveries;* on indetermination, see Poulet, *La Pensée indéterminée.*

4. See Henkel and Schöne, *Emblemata,* col. 1794–95; see also Giamatti, "Proteus Unbound," 443.

5. Le Roy, *De la Vicissitude,* fol. 3r.

6. Hébreu [Ebreo], *Dialogues d'amour,* dialogue 3, pt. 2. Pico della Mirandola describes the *tohu-bohu* of Genesis as the association of matter with a rough outline of form: "Many Hebrews . . . interpret 'tou' as brutal, stupefying, and astonishing, which is related to the dark and deformed appearance of matter. . . . Because of the force of the word, however, many interpret 'bou' as the beginning and rudiment of form. In fact, literally, to say 'bou' is the same thing as saying, 'there is in it' or 'there is something in it.' Following this interpretation, we shall understand the rudimentary form of substance, as well as its potentiality, to be in the earth" (*Heptaplus,* 33). I owe this reference to Giovanna Calvino.

7. Hébreu [Ebreo], *Dialogues d'amour,* 215.

8. Ibid., 88.

9. See Staub, *Le Curieux désir,* chap. 3.

10. Gamon, in his own *Semaine,* makes a lengthy criticism of the importance given by Du Bartas to chaos, in opposition to the biblical text:

> O rule of our word, o light most pure,
> Source of truth, good holy Scripture,

Whose rays dispel the clouds
Of infamous Chaos' muddl'd discourse!

.

Profane doctrine of fantasy Chaos
Offense to Word Divine,
Offends the nature of a prudent Creator,
Whose work would not confusion harbor

.

The hand that in an instant all things brings forth,
Would ne'er jumble matters, to his works giving birth

.

O mutinous Chaos, begot from error,
Takes up arms soak'd in abusive lies, to war
Against the holy writings, ramparts of our soul,
And raise against God its infidel blade!
Chaos despises you, O Great Creation,
Of Great God first and most noble action! (7–9)
I owe this reference to Giovanna Calvino.

11. Goulart, quoted in Du Bartas, *La Sepmaine*, Bellenger ed., 1:13. See also Calvin, *Commentaire*, 3.

12. Goulart, quoted in *La Sepmaine*, 1583, fol. 20r.

13. Ginzburg, *The Cheese and the Worms*. The quotations are taken from this text.

14. The same metaphor is used in the *Confessions* of Saint Augustine, 7.5.

15. Expressions of Estienne Pasquier, quoted by Nakam, *Montaigne et son temps*, 170.

16. Ibid.

17. Montaigne, *Essais* 3.9.993.

18. Ovid, *Metamorphoses* 1.18–20.

19. Du Bellay, *Les Regrets*, sonnet 125, 1–11. See also Du Bellay, *Olive*, sonnet 64, 1–8.

20. Ronsard, "Ode de la Paix," 42–44, in *Œuvres complètes*, 3:6.

21. Plato, *Timaeus* 40–42; Ovid, *Metamorphoses* 1.21.

22. Ronsard, *Les Amours*, sonnet 42, in *Œuvres complètes*, 4:45. See also 12:27–28, 13:218, and 16:142.

23. Hesiod, *Theogony* 116–20; Plato, *The Banquet* 178b.

24. Ficino, *Commentary*, 129.

25. Ronsard, "Ode de la Paix," 66–67, in *Œuvres complètes*, 3:7. See also "La Paix," in ibid., 9:107 and, in Du Bellay, the aforementioned sonnet (note 19) and "Discours au Roy," 193–97, in *Œuvres poétiques*, 6:13.

26. "Ja du prochain hyver . . . ," 66, in Ronsard, *Œuvres complètes*, 18:39.

27. See the aforementioned texts by Leone Ebreo.

28. I owe the idea for these pages on *Les Antiquités* to Greene, *The Light in Troy*, 230–35. Quotes from *Les Antiquités* are taken from Du Bellay, *Œuvres poétiques*, vol. 2.

29. Andrea Palladio, *L'Archittetura* (Venise: Brogiollo, 1642), 4.4 (preface to book 4), quoted in Greene, *The Light in Troy*, 234, 331. From about 1420, Brunelleschi had found models in Rome, e.g., for the dome of Santa Maria del Fiore in Florence (see Argan, *Brunelleschi*, 8–9).

30. See chap. 1, under "Form and Forms." On this question, see Naudeau, "L'Expression des modes philosophiques."

31. Garavini, *Mostri e chimères*, places the opposition between formless and form in Montaigne in a different perspective. The productions of inner chaos— what we would call the unconscious—are fantasies, frightening, obscure forces that rational discourse tries to domesticate. For the subject threatened by folly, naming the monsters and exposing the troubling visions of the imagination are an attempt to neutralize them. This gives the formalizing activity of reason an additional therapeutic or apotropaic dimension.

32. See Mathieu-Castellani's commentary, *Montaigne,* pt. 1, chap. 1, pp. 25–43.

33. See Starobinski, *Montaigne in Motion,* chap. 6.

Five: "Grotesques and Monstrosities"

The title of this chapter, "Grotesques and Monstrosities," comes from Montaigne, *Essais* 1.28.183.

1. See Moss, *Poetry and Fable* and *Ovid in Renaissance France.*

2. Barthélemy Aneau, in Ovid, *Trois premiers livres,* preface, fol. b5v.

3. On sixteenth-century illustrations of *Metamorphoses,* see Barkan, *The Gods Made Flesh,* 175–206.

4. *The Death of Procris* and *The Battle of the Lapiths and Centaurs* (National Gallery, London), *Forest Fire* (Ashmolean Museum, Oxford), *The Hunt* and *Return from the Hunt* (Metropolitan Museum, New York), *The Misfortunes of Silenius* (Fogg Museum, Cambridge, Mass.), *The Discovery of Honey* (Worcester Art Museum, Mass.), *The Liberation of Andromeda* (Uffizi, Florence).

5. Vasari, in his life of Piero, mentions other paintings of monsters, lost today (*Les Vies des meilleurs peintres,* 5:88).

6. Panofsky, "The Early History of Man."

7. Vasari, *Les Vies des meilleurs peintres,* 5:85.

8. Saint Augustine, *De Civitate Dei* 21.8.

9. On the question of monsters in the sixteenth century, see Céard, *La Nature et les prodiges,* and my introduction to the *Songes drolatiques de Pantagruel.*

10. See chap. 12 in this volume, under "The Challenge of Strangeness: Rabelais," and Jeanneret, "Rabelais, les monstres."

11. Rabelais, *Le Quart Livre,* chap. 31. The litany of monstrous comparisons covers five full pages.

12. Boaistuau, *Le Théâtre du Monde* (1558), 104–5.

13. L'Estoile, *Journal pour le règne de Henri IV,* 1:219.

14. See, esp., the Sebastien Munster *Cosmographie,* and compare with André Thevet's more modern *Cosmographie,* which describes new monsters, except for the unicorn. I owe this information to my friend, Frank Lestringant.

15. Gesner, *Historiae animalium,* published in several volumes in Zurich from 1551.

16. On *varietas* in sixteenth-century learned discourse, see, among others, studies by Lestringant collected in *Ecrire le monde à la Renaissance.*

17. Identifications are uncertain. Aside from personal observation, I refer to Lazzaro, *The Italian Renaissance Garden;* Battisti, *L'Antirinascimento;* and Recupero, *Il Sacro Bosco di Bomarzo.*

18. See Rousset, *La Littérature de l'âge baroque,* and, as period document, the libretto of Beaujoyeulx, *Le Balet comique de la Royne* (1581).

19. See Montaigne, *Journal de voyage.*

20. Palace and villa walls worked in bossage, as at the Pitti Palace in Florence, reinforce the impression of a rustic, elementary world.

21. Ms. Arundel fol. 55v and Leicester Codex fol. 34r, cited by Chastel, "Léonard et la culture," 256.

22. See esp. Leonardo's variations on *The Virgin aux rochers,* as well as the *Mona Lisa* and *The Virgin and Child with Saint Anne.* In general, the recurrence of rocks and lunar landscapes can be noted in the numerous portrayals of Saint Jerome in the desert and Thebaïdes and also in the iconography of Christ in the olive grove, the Resurrection, and the traditional Holy Land décor, including nativity scenes.

23. E.g., Villas Medici at Castello and Pratolino, Villa Farnese at Caprarola, Villa d'Este at Tivoli. In France, see esp. the Grotte des Pins at Fontainebleau and the Grotto of the Muses at Meudon.

24. Palissy, *Recette véritable,* 127 ff.

25. See Morel, "La Théâtralisation." This article includes a rich bibliography on sixteenth-century Italian grottos.

26. Ibid., 166.

27. Ibid., 160.

28. An allegorical commentary on a passage from the *Odyssey* (13.102–12), the text is mentioned by Battisti, *L'Antirinascimento.* It was first published in 1518, with subsequent re-editions.

29. A. Caro, *Lettere familiari,* 3 vol. (Florence: A. Greco, 1957–61), 2:100; cited by Lazzaro, *The Italian Renaissance Garden,* 150.

30. Caus, *Les Raisons des forces,* bk. 1, probl. 24.

31. On the discovery and diffusion of grotesques, see Dacos, *La Découverte de la Domus Aurea,* and Chastel, *La Grottesque.*

32. The texts of the controversy are collected in Barocchi, *Trattati d'arte del Cinquecento*. See also Dacos, *La Découverte de la Domus Aurea,* 121 ff.; Ossola, *Autunno del Rinascimento;* and Morel, "Il funziamento simbolico."

33. Francesco Doni, *Disegno* (1549). On the scholarly, satirical, and burlesque writer Doni (ca. 1503–74), see Quiviger, "Arts visuels, iconographie et déraison," and studies cited in the preceding note.

34. *Disegno,* fol. 22r; cited by Quiviger, "Arts visuels, iconographie et déraison," 55. On motif of stains and clouds, see below, chap. 12, under "Indeterminacy as Potential: Leonardo da Vinci." Lebensztejn, *L'Art de la tache,* chap. 5, cites other manifestations of this *topos.*

35. In a dedication to "al Mirabil Jacopo Tintoretto, Pittore unico," commenting on *Rime* by the enigmatic Burchiello, Doni draws a comparison between Burchiello's poetry, his own works, and the style of the grotesques: "The book I am sending you . . . is worthy of a poet painter of grotesques; truly extraordinary: other minds than The Negligent's Doni have studied these Oddities: and understood nothing more than what is now understood" (Italian text in Ossola, *Autunno del Rinascimento,* 189).

36. Vasari, *Les Vies des meilleurs peintres,* vol. 1, *De la peinture,* chap. 13, p. 86.

37. Cellini, *The Autobiography of Benvenuto Cellini* 1.31.63.

38. Barocchi, *Trattati d'arte del Cinquecento,* 1634.

39. Another canonical text occasionally invoked to condemn images of monsters is the beginning of Horace's *Ars poetica* (1.1–13), where a composite text is compared to a hybrid body. Horace considers that, in poetry as in painting, the famous *quidlibet audendi . . . potestas* (1.10) does not extend to the creation of monstrous ensembles.

40. Vitruve, *De Architectura* 7.5.

41. Based on a totally different situation—abuse of hybrid figures in gothic ornamentation—Saint Bernard de Clairvaux also condemns the representation of monsters, *illa ridicula monstruositas* (*Apologia ad Guillelmum sancti Theoderici abbatem,* chap. 12, in Migne, *Patrologia Latina,* vol. 182, col. 916).

42. On grounds of verisimilitude and clarity, another critic, Giovan Andrea Gilio, adopts and amplifies Vitruvius's arguments, as well as certain principles of Horace's *Ars poetica* (see Dacos, *La Découverte de la Domus Aurea,* 128, and Morel, "Il funzionamento," 171 ff.).

43. Pirro Ligorio, article "Grottesche" of his *Libro dell'antichità* (ms. de Turin), transcribed in Barocchi, *Trattati d'arte del Cinquecento,* 2666–91; Giovan Paolo Lomazzo, "I Grotteschi," in *Trattato dell'arte della pittura* (1584), ibid., 2692–97.

44. Lomazzo, in Barocchi, *Trattati d'arte del Cinquecento,* 2694.

45. Gabriele Paleotti, *Discorso intorno alle imagini sacre e profane . . .* (1582), in ibid., 2639–65. Page references in the text refer to this edition.

46. Pirro Ligorio was also carried away by the fantasy of the grotto. Making the same historical error as Paleotti, he explained that the grotesques of antiquity

were painted in grottos. This allowed him to maintain the connection between the art and the cavern, symbol of things obscure, funereal, magic, infernal. As if bewitched by his revery, he recalled Dion Cassius's account of a banquet offered by Domitien in the underground rooms: several courses of black food were served by black men in black dishes by the light of black candles, the better to terrify the guests, while the emperor, to make matters worse, told horrible stories of torture (Barocchi, *Trattati d'arte del Cinquecento,* 2674–75).

47. Paleotti, cited in Ossola, *Autunno del Rinascimento,* 193.

Six: "We Are Never in Ourselves"

The title of chapter 6 is taken from Montaigne: "We are never in ourselves, always somewhere else" (*Essais* 1.3.15).

1. *Oratio de hominis dignitate* was meant to be the preliminary discourse in a debate (which never took place) on the nine hundred theses published in Rome in 1486, which Pico della Mirandola sought to organize with fellow philosophers. It appeared for the first time in the posthumous edition of his *Complete Works.*

2. Pico della Mirandola, "Oration on the Dignity of Man," 224.

3. Ibid., 225.

4. Ibid., 226.

5. Cristoforo Landino used the same comparison, *"come nuovo cameleonta,"* referring to Alberti and his style, but the analogy also served to qualify "the typically humanist energetic enterprising spirit of the new era" (Gorni, Introduction to Alberti, *Rime e versioni poetiche,* ix). My friend Guglielmo Gorni deserves credit for this reference.

6. Pico della Mirandola, "Oration on the Dignity of Man," 225.

7. Vives, *Fabula de homine* (1518); English translation in Cassirer, Kristeller, and Randall, *The Renaissance Philosophy of Man,* 387–93.

8. Ficino, *Théologie platonicienne* (1482), 14.3: "Sixième signe. L'âme tend à devenir toutes choses." Quotations are translated from this edition.

9. On Petrarch's mobility, see Mann, *Petrarch,* and Greene, "The Flexibility of the Self."

10. The expression is taken from Letocha, *Aequitas, Aequalitas, Auctoritas,* xii. See also the excellent article by Russell, "Conception of Self," and Greene, "The Flexibility of the Self."

11. Letter 854, 19 July 1518, in Erasmus, *Correspondance,* 3:380.

12. Letter 868, Erasmus to Ambrosius Leo, Louvain, 15 October 1518, in ibid., 434.

13. Letter to Jean Botzheim, Basel, 30 January 1523, in ibid., 1:2.

14. Ibid., 352–56.

15. L. Febvre, preface to Huizinga, *Erasme,* 8. Huizinga's biography is an excellent illustration of the versatility of Erasmus.

16. *De servo arbitrio* is Luther's reply to the diatribe by Erasmus in *De libero arbitrio* (1524).

17. Cited in Greene, "The Flexibility of the Self," 249. This study includes several excellent pages on the sixteenth-century vogue for treatises on education.

18. See, e.g., *De copia, Ratio studiorum, De civilitate morum puerilium, Colloquia.*

19. Vergerius cites *Géorgiques* 3.165, *Dum faciles animi iuvenum, dum mobilis aetas;* cited in Greene, "The Flexibility of the Self," 249.

20. Du Bellay, *La Deffence et illustration* 1.3.27. See also Du Bellay, "Ample discours au Roy . . . ," 1.754, in *Œuvres poétiques,* 6:233.

21. See, respectively, *The Prince* by Machiaveli, *Le Courtisan* by Castiglione, *Galateo* by della Casa, *La Civil Conversazione* by Guazzo, and numerous treatises on rhetoric.

22. E.g., *Enchiridion Militis christiani* by Erasmus and *Institution de la Religion chrétienne* by Calvin.

23. Rabelais, *Gargantua,* chap. 14.

24. Ibid., chap. 23.

25. Ibid.

26. Russell, "Conception of Self," contains pertinent comments on this.

27. I attempted to explain this phenomenon in "Le Récit modulaire."

28. On this operation, see chap. 11 under "From Having to Being."

29. See chap. 1, under "Form and Forms."

30. See Giamatti, "Proteus Unbound."

31. Comes, *Mythologie,* 870.

32. Ibid.

33. Cartari, *Le Imagini dei Dei,* 257.

34. Ronsard, *Continuation des Amours* 1.5, in *Œuvres complètes,* 7:121–22.

35. See also above, chap. 2, under "Flexible Bodies: Ronsard," on love metamorphosis in Ronsard.

36. The table of contents on the title page of the first part of *Metamorphose chrestienne* indicates from the start the importance given to mobility of forms: "1. L'homme naturel [Natural Man]; 2. L'homme difformé [Deformed Man]; 3. La transformation des ames [Transformation of Souls]; 4. Le vray Homme, ou l'Homme reformé [True Man, or Man Reformed]." Another treatise by Viret, *Dialogues du desordre,* is an initial version of *Metamorphose.*

37. Viret, "Advertissement," in *Metamorphose chrestienne,* fol. Aiiv.

38. Viret, *Dialogues du desordre,* 733.

39. Viret, "Advertissement," *Metamorphose chrestienne,* fol. Aiiv.

40. Viret, *Metamorphose chrestienne,* 113–14.

41. Lestringant observes the same phenomenon in *Les Tragiques* by A. d'Aubigné: "*Les Tragiques* is filled with quite strange metamorphoses: tyrants are wolves who get up from the table and pounce on people; judges are transformed

into wild beasts, lurking in dens, with human flesh hanging from their jaws; a king is disguised as a courtesan, with wig and bustle; courtesans are dogs and monkeys, the Louvre is a menagerie, the Courthouse is Hell, the churches are brothels or toilets" (preface to *Tragiques,* 10).

42. Viret, *Metamorphose chrestienne,* 114.

43. Ibid., 110.

Seven: The Hazards of Art

1. Citations are taken from the 1576 Paris edition. Louis Le Roy, known as Regius (ca. 1510–77), translator of Plato and Aristotle, was a professor of Greek at the Collège Royal. He published a life of Budé and associated with Du Bellay, another proponent of development of the French language.

2. Machiavelli shared the same ideas on this point. He believed that "fortune brings about the universal mutability of things, ruled by capricious causality. The antique hierarchical immutable cosmos has collapsed and has not yet been replaced by the mechanical world of science. All that exists is movement, generator of turbulence. Fortune is not a power outside of things that governs them arbitrarily. It is the very concept of their instability" (Senellart, *Machiavélisme et raison d'etat,* 39).

3. Le Roy, commentary on the *Sympose de Platon* (1558), fol. 108, cited by Wilson, *Ronsard,* 88.

Eight: Language Inflections

1. Bovelles, *La Différence des langues vulgaires,* 77. The citations are from the Dumont-Demaizière translation. Bovelles, or Bovillus (ca. 1479–1567)—French philosopher, mystic, and scholar—is the author of numerous works on metaphysics, morality, mathematics, and linguistics, written in Latin.

2. Estienne, *Traicté de la conformité du language François avec le Grec . . .* (1565), cited by P. Rickard, *La Langue française,* 168.

3. Rabelais, *Pantagruel,* chap. 6.

4. Ibid.

5. Duret, *Thresor de l'histoire des langues.* See chap. 88 (pp. 990–1016). In addition to this work, Duret (1565–1611) was the author of various compilations: on plants, water in motion, the decadence of empires.

6. On the causes of transformations in languages, see also Fauchet, *Recueil de l'origine de la langue,* bk. 1, chap. 2.

7. Tory, *Champ fleury . . .* (1529), cited by Rickard, *La Langue française,* 85–86. Printer and engraver, philologist and translator, Tory (1480–1533) was interested in architecture and painting. His masterpiece, *Champ fleury,* inscribes the symbolism of the letters of the alphabet in a vast network of correspondences.

8. Ibid., 86.

9. Ibid., 85.

10. This phenomenon is pointed out by Guiraud, *Le Moyen français.*

11. Ronsard, *Abbregé de l'art poëtique françois,* in *Œuvres complètes,* 14:35.

12. Antoine Du Verdier, *Bibliothèque* (1585), cited in Huchon, *Le Français de la Renaissance,* 81–82.

13. Du Bellay, *La Deffence et illustration* 1.3.23.

14. Ronsard, "Au lecteur apprentif," preface to *La Franciade,* in *Œuvres complètes,* 16.2.349.

15. Geoffroy Tory, *Champ fleury . . . ,* cited in Rickard, *La Langue française,* 87.

16. Du Bellay, *La Deffence et illustration,* 196–97.

17. Peletier Du Mans, *Art poétique* 2.5.296.

18. Etienne Pasquier to Monsieur de Querquifinen, cited in Rickard, *La Langue française,* 241.

19. "Advertissement . . . sur sa premiere et seconde Sepmaine" (1584), in *La Sepmaine,* 2:350.

20. All histories of the French language deal with this phenomenon. I draw esp. on Brunot, *Histoire de la langue française;* Rickard, *A History of the French Language;* Guiraud, *Le Moyen français;* and Huchon, *Le Français de la Renaissance.*

21. I could not find figures to prove this affirmation. For lack of other sources, the impressive lists of neologisms in Kesselring, *Dictionnaire chronologique du vocabulaire français,* classified according to year of appearance, can be consulted.

22. Ronsard, *Abbregé de l'art poëtique françois,* in *Œuvres complètes,* 14:29.

23. Du Verdier, cited in Huchon, *Le Français de la Renaissance,* 68.

24. Ronsard, *Abbregé de l'art poëtique françois,* in *Œuvres complètes,* 14:31.

25. Peletier Du Mans, *Art poétique* 1.8.270.

26. Guiraud, *Le Moyen français,* 53.

27. Gougenheim's observation reported by Guiraud, ibid., 54–55.

28. Figure provided by Rickard, *A History of the French Language,* 93.

29. Expressions taken from Henri Estienne, *Deux dialogues du nouveau langage françois italianizé, et autrement desguizé, principalement entre les courtisans de ce temps* (1578), cited in ibid.

30. Estienne, *Traicté de la conformité du language François avec le Grec . . .* (1565), cited in Rickard, *La Langue française,* 171.

31. See, e.g., Du Bellay, *La Deffence et illustration* 2.6.143; Ronsard, *Abbregé de l'art poëtique françois,* in *Œuvres complètes,* 14:34; Peletier Du Mans, *Art poétique* 1.8.271.

32. *Se divertir* (enjoy), *doux* (gentle), *avoir coutume* (be accustomed), *céleste* (celestial), *léger* (light), cited by Brunot, *Histoire de la langue française,* 184–86.

33. Ronsard, *Abbregé de l'art poëtique françois,* in *Œuvres complètes,* 14:10–11.

34. Bonaventure des Periers, "Vendanges," cited by Brunot, *Histoire de la langue française,* 178. The language is Provençal.

35. Peletier Du Mans, *Art poétique* 1.8.271.

36. These examples, as well as others in the following paragraphs, are taken from Huchon, *Le Français de la Renaissance,* 80 and passim.

37. Ronsard, *Abbregé de l'art poëtique françois,* in *Œuvres complètes,* 14:34.

38. Ronsard, "A son ame," in *Œuvres complètes,* 18:182.

39. Rabelais, *Le Quart Livre,* chap. 15, and *Pantagruel,* chap. 18 (passage eliminated in 1542 and subsequent editions).

40. Ronsard, *Abbregé de l'art poëtique françois,* in *Œuvres complètes,* 14:29.

41. Ronsard, "Advertissement au lecteur" in *Odes,* in *Œuvres complètes* 1:54. On these occurrences, see Gordon, *Ronsard et la rhétorique,* pt. 2, chap. 2, from which I borrowed several examples.

42. Ronsard, *Abbregé de l'art poëtique françois,* in *Œuvres complètes,* 14:19.

43. Rabelais, *Tiers Livre,* chap. 2.

Nine: On Site

1. See chap. 10, under "'At the Moment When It Interests Me': Montaigne."

2. Zumthor, *Essai de poétique médiévale,* 71–75, and "Intertextualité et mouvance"; Cerquiglini, *Eloge de la variante.*

3. Rychner, *Contribution à l'étude des fabliaux,* 1:132. See also Rychner, *La Chanson de geste.*

4. The information that follows is borrowed from Mann, *Petrarch.*

5. Erratum cited in Sayce, "L'Édition des *Essais,*" 119.

6. These examples are cited by Sayce and Maskell, *A Descriptive Bibliography.*

7. Sayce, "L'Édition des *Essais,*" 140. See also, on corrections under press, Gilmont, "Description bibliographique"; Veyrin-Forrer, *La Lettre et le texte,* 304–5; and Huchon, *Rabelais grammairien.*

8. Du Bellay, *La Deffence et illustration* 2.11.170–71.

9. Ronsard, "Au Lecteur" in *Odes,* in *Œuvres complètes,* 1:47.

10. See Terreaux, *Ronsard correcteur de ses Œuvres.*

11. *Continuation des Amours, 7,* in *Œuvres complètes,* 7:123–24.

12. Fenoaltea, *Du palais au jardin.*

13. Ronsard, in *Œuvres complètes,* 2:152; from *Exegi monumentum aere perennius,* opening the last poem of bk. 3 of Horace's *Odes.*

14. Ronsard, in *Œuvres complètes,* 7:110.

15. Ronsard, Elégie "A Jean Morel," in *Œuvres complètes,* 7:225–30.

16. On this contrast and aspects of metamorphosis in *Continuation* and *Nouvelle Continuation,* see Pot, *Inspiration et mélancolie,* 218–30.

17. Erasmus to John Botzheim (1523), in Erasmus, *Correspondance,* 1:36; cited by Mann Phillips, *The "Adages" of Erasmus,* xv. Part of the information that follows is borrowed from this source.

18. Another example, *De duplici copia verborum ac rerum,* begun in the 1490s,

was continuously revised, corrected, amplified, restructured up to 1534.

19. See Greene, "Erasmus' 'Festina lente'."

20. See Cave, *The Cornucopian Text.*

21. In one of his three portraits of Erasmus (Longford Castle), Hans Holbein shows the scholar seated at his table, holding a closed book bearing the words *Herakleioi ponoi* (in Greek letters) and *Erasmi Rotero* on two sides.

22. Erasmus, *Adagiorum . . . chiliades . . . ,* col. 586, in Mann Phillips, *The "Adages" of Erasmus,* 196.

23. See Jardine, *Erasmus,* 24–26.

24. Mann Phillips, *The "Adages" of Erasmus,* 206–7.

25. Ibid., 196.

26. Ibid., 202–6.

27. The distinctive quality of Ramist rhetoric lies in the way it is divided: three of the five parts of oratory art, according to the ancients, are attributed to dialectic (invention, disposition, memory), and only two remain in the domain of rhetoric (elocution, pronunciation). See Meerhoff, *Rhétorique et poétique,* and Ong, *Ramus and Talon Inventory.*

28. Ramus refers here to his *Dialectique,* also in constant transformation. See Pierre Ramus, *Dialectique,* 54.

29. See Kenny, *The Palace of Secrets.*

30. As examples of encyclopedic systems, see Gregor Reisch, *Margarita philosophica . . .* (1496); Paul Skalich de Lika, *Encyclopediae, seu Orbis disciplinarum tam sacrarum quam prophanarum, epistemon* (1559); Theodor Zwinger, *Theatrum humanae vitae* (1565); Christofle de Savigny, *Tableaux accomplis de tous les arts liberaux . . .* (1587). *L'Academie françoise* (1580–90) by Pierre de La Primaudaye and *Le Theatre de la nature universelle . . .* (1597) by Jean Bodin still belong to the encyclopedic project but in a less systematic way.

31. See esp. Henri Cornelius Agrippa, Francisco Sanchez, Montaigne, and Pierre Charron.

Ten: Geneses

1. Kemp and Roberts, *Leonardo on Painting,* 9.

2. Du Bartas, *La Sepmaine* 3.715–17; see Bellenger.

3. Aristotle, *Poetics* 1448a.

4. See Chastel, *Marsile Ficin et l'art;* Wittkower and Wittkower, *Les Enfants de Saturne;* Kris and Kurz, *L'Image de l'artiste;* and Klibansky, Panofsky, and Saxl, *Saturn and Melancholy.* For literature, see Pot, *Inspiration et mélancolie.*

5. Vasari, *Les Vies des meilleurs peintres,* 5:31, 35; 9:271.

6. See Barocchi, "Finito e non-finito," 222–23.

7. Vinci, *Traité de la peinture,* 332. See Gombrich, "Leonardo's Method."

8. Vinci, *Traité de la peinture,* 333.

9. Vasari explains why the sketches (*schizzo*) look like splotches: "We call them a first type of drawing, used to find the postures and initial composition of the work; and they are made in the form of a splotch, . . . a rough sketch that just serves as a first try. And because of the draughtsman's fury they are quickly executed with quill or other instrument or charcoal only to try the soul of what they remember, which is why we call them sketches [*schizzi*]." ("Introduction aux trois arts du dessin: La peinture" (chap. 2), in *Les Vies des meilleurs peintres*, 1:156; cited in Lebensztejn, *L'Art de la tache*, 89).

10. See commentary by Gombrich, "Leonardo's Method."

11. Ibid.

12. The same statues—four at the Accademia in Florence and two at the Louvre—are known by various names: *Slaves, Captives, Prisoners.*

13. See documents collected in Vasari, *La Vita di Michelangelo*, vol. 2. Also see Barolsky, *The Faun in the Garden.*

14. Vasari commented on the *Saint Matthew*—"This statue, so rough-hewn, shows its perfection" (*Les Vies des meilleurs peintres*, 1:23)—and the Medici *Madonna*—"Though parts are left unfinished, we recognize in the rough-hewn sculpture, in the imperfection of the finish, the perfection of the work" (ibid., 1:61).

15. See Panofsky, "The Neoplatonic Movement," and Wittkower, *Sculpture, Processes, and Principles.*

16. Reproduction and commentary in Chastel, "Le Fragmentaire," pl. 237.

17 A direct testimony by Blaise de Vigenère confirms the creative furor that drove Michelangelo in his work: "I can say that I have seen Michelangelo, though aged more than sixty years, and not so very robust, take down more scales of a very hard marble in fifteen minutes than three young stone cutters could do in three or four hours. It's almost unbelievable if you didn't see it yourself. He went at it with such impetuous furor, that I thought the whole work was going to break into smithereens." *La Suitte de Philostrate* (1602), fol. 105v; cited in Rèpaci-Courtois, "Michel-Ange et les écrivains français," 77.

18. See Chastel, "Le Fragmentaire," 36–38 and pl. 238; see also above, chap. 5.

19. See Genette, *Seuils;* Tripet, *Montaigne et l'art;* and the special issue of the review *Versants* 15 (1989): *Prologues au XVIe siècle.*

20. Benveniste, *Problèmes de linguistique générale,* 228.

21. See above, chap. 4, under "Internal Chaos: Montaigne," and Pot, *L'Inquiétante étrangeté,* esp. 7–9. The section heading is from *Essais* 3.2.805.

22. Also practiced by Erasmus: see chap. 9, under "The Labors of Hercules: Erasmus."

23. On the role of the reader in putting the *Essays* into motion, see below, chap. 12, under "'A Sufficient Reader': Montaigne."

Eleven: Reshuffling the Cards

1. See esp. works of the School of Constance, notably by Wolfgang Iser, Hans Robert Jauss, Karlheinz Stierle, Rainer Warning, Wolf-Dieter Stempel, and Hans Ulrich Gumbrecht.

2. I reserve the term *imitatio* for the strictly literary operation of rewriting, as opposed to *mimesis,* which means the reproduction of things and acts. To supplement the rapid unilateral survey of *imitatio* in the following pages, see esp. Greene, *The Light in Troy.*

3. Peletier du Mans, *Art poétique* 1.1.240.

4. Ibid.

5. See above, chap. 1, under "Continuous Creation," and chap. 2.

6. See above, chap. 9, under "Modules and Mixtures."

7. See Greene, *The Light in Troy,* 73–74, 84, 98–99, 199–200, and Pigman, "Versions of Imitation."

8. Ronsard, *Hylas,* 417–25, in *Œuvres complètes,* 15:252.

9. Erasmus, *De duplici copia,* 642–47.

10. Ibid., 639.

11. Quintilian, *Institutio oratoria* 10.5.4–11, recommends this type of exercise, notably paraphrase, to enrich the student's vocabulary and diversify style.

12. See Erasmus, *De duplici copia,* pt. 1, chap. 33, pp. 349–354.

13. Ibid., 303.

14. Ibid., 302; see also 348.

15. I learned of the existence of this book from Longhi, *Propagata voluptas.*

16. Juvenal, *Satires* 1.79; Estienne, *Parodiae morales,* 82.

17. The interest of these exercises lies in the verbal combinatory and game of prosody that can hardly be rendered in translation.

18. Estienne, *Les Premices,* 174.

19. Seneca, *Letters to Lucilius* 84.5.

20. Ibid. 84.6–7.

21. Quintilian, *Institutio oratoria* 10.1.19.

22. See Greene, *The Light in Troy;* Cave, *The Cornucopian Text;* and Pigman "Versions of Imitation."

23. Petrarch, *Epistulae familiares* 22.2, cited in Greene, *The Light in Troy,* 98–99.

24. See, e.g., the text by Poliziano cited in Greene, *The Light in Troy,* 150.

25. See Norton, *Ideology and Language of Translation,* and Buridant, "Les Paramètres de la traduction."

26. Du Bellay, *La Deffence et illustration* 1.7.42.

27. Marot, prologue to the translation of the *Premier Livre de la Metamorphose d'Ovide* (1534), cited in Weinberg, *Critical Prefaces,* 71.

28. Erasmus, *Ciceronianus,* in *Opera omnia* 1.2.652; cited in Cave, *The Cornucopian Text,* 45.

Twelve: Works to Be Done

1. The best introduction to these problems remains the Eco essays *The Open Work*. On the theory of the reception of the School of Constance, see *Poétique* 39 (September 1979) and chap. 11, note 1, in this volume.

2. See the treatise by Nicéron, *La Perspective curieuse.* Anamorphoses were often integrated into collections of "curiosities."

3. See Baltrusaitis, *Anamorphoses ou Thaumaturgus opticus,* and Hallyn, "Le Thème de l'anamorphose."

4. See Hallyn, "Le Paysage anthropomorphe."

5. Barthes, "Arcimboldo," 142.

6. On the subject of medieval allegory, Eco writes: "The reader has at his disposal a carefully determined range of possibilities, conditioned so that the interpretive reaction never escapes the author's control" (*The Open Work,* 6).

7. Béroalde de Verville, "Avis aux beaux esprits . . . ," in *L'Histoire veritable, ou le voyage des princes fortunez* (1610), cited in Polizzi, "Du 'Bal en forme de jeu d'échecs'," 196. See also Zinguer, *Le Roman stéganomorphique.*

8. Béroalde, "Avis aux beaux esprits."

9. [Hartmann Schedel], *Chronicarum Liber . . . ,* 1493.

10. Vinci, *Carnets,* 2:247; *Traité de la peinture,* 332. On stains for Leonardo, his posterity, and the tradition of accidental image, see Lebensztejn, *L'Art de la tache,* chap. 5.

11. Vinci, *Traité de la peinture,* cited in *The Notebooks,* 182. Chastel did not include this passage in his edition.

12. The notion of stains on the wall, clouds, and other formless objects as stimulation to the imagination is found in works by several Italian artists and theoreticians; some establish a relationship between works conceived this way and the grotesques. See texts by Anton Francesco Doni and Giovan Battista Armenini cited in Chastel, "Sens et non-sens." See also Dacos, *La Découverte de la Domus Aurea,* 124–26, and Quiviger "Arts visuels." Vasari attributes to Piero di Cosimo an interest of the same order in clouds and the spittle of sick people (*Les Vies des meilleurs peintres,* 5:85).

13. On the participation of the spectator and the integration of his gaze in Renaissance art (painting, sculpture, architecture), see Shearman, *Only Connect,* who nonetheless adopts a different perspective from mine and does not deal with the rough sketch, *sfumato,* or *non finiu.*

14. Vasari, *Les Vies des meilleurs peintres,* 5:85; *The Lives of the Artists,* 261.

15. Vinci, *Les Carnets,* 2:300.

16. Ibid., 2:267; *The Notebooks,* 182–83. It may be that Leonardo's fresco *The Battle of Anghiari,* commissioned for the Palazzo Vecchio in Florence, unfinished and then covered by another painting, was an attempt to accomplish this project. A copy of this fresco by Rubens survives.

17. On Neoplatonism and art, see Chastel, *Marsile Ficin et l'art* and *Art et humanisme à Florence.*

18. Other artists (Fra Bartolomeo earlier, Tiziano and Corregio later), who had no connection with Neoplatonic thought, also practiced the technique of *sfumato.* What motivates my hypothesis concerning Leonardo is the vogue for that philosophy in Florentine circles.

19. See Eco, *The Limits of Interpretation,* 8–43.

20. See, e.g., studies by Panofsky in *Studies in Iconology* and by Wind in *Pagan Mysteries* or the analysis of *Melencolia I* by Dürer in Klibansky, Panofsky, and Saxl, *Saturn and Melancholy.*

21. A fuller development of this idea can be found, along with a bibliography, in Jeanneret, *Le Défi des signes.*

22. Rabelais often expresses his mistrust of bad readers, spiteful slanderers whose erroneous interpretations he rejects (see *Pantagruel,* chap. 34, and *Le Quart Livre,* dedication to "Odet, Cardinal de Châtillon").

23. See, e.g., Saulnier, *Rabelais,* vol. 2, chaps. 13 and 15, and Screech, *Rabelais,* 367–71.

24. The contradiction, or at least the vacillation, affects everything, including the question of freedom left to the reader. If Montaigne sometimes left the reader a wide margin of maneuver, at other times he specifies that he says everything in order to avoid erroneous reading: "I leave nothing to desire or guess of me. If it is going to be discussed, I want it to be veritably and properly. I won't hesitate to come back from the other world to give the lie to anyone who would form me other than I was" (3.9.983).

Bibliography

Alberti, Leon Battista. *Rime e versioni poetiche.* Edited by Guglielmo Gorni. Milan: Riccardo Ricciardi, 1975.

Argan, Giulio Carlo. *Brunelleschi.* French translation by Alain Degange. Paris: Macula, 1981.

Aristote. *Poétique.* French translation by J. Hardy. Paris: Belles Lettres, 1975.

Aristotle. *The Metaphysics.* Edited by G. P. Goold, translated by Harold Cooke. Cambridge: Harvard University Press, 1970–90.

———. *On the Soul.* Translated by W. S. Hett. Cambridge: Harvard University Press, 1970–90.

Aubigné, Agrippa d'. *Les Tragiques.* Edited by Armand Garnier and Jean Plattard. 4 vols. Paris: Droz, 1932–33.

———. *Les Tragiques.* Edited by Frank Lestringant. Paris: Gallimard, 1995.

Augustine, Saint. *De Civitate Dei.* Edited by Emanuel Hoffmann. 2 vols. Vienna: F. Tempsky, 1899–1900.

———. *Confessions.* Translated by William Watts. Cambridge: Harvard University Press, 1988.

Bachelard, Gaston. *L'Eau et les rêves: Essai sur l'imagination de la matière.* Paris: Corti, 1942.

———. *La Terre et les rêveries de la volonté.* Paris: Corti, 1948.

Bacon, Francis. *Œuvres.* Paris: Charpentier, 1843.

Bakhtine, Mikkaïl. *L'Œuvre de François Rabelais et la culture populaire au Moyen âge et sous la Renaissance.* French translation by Andrée Robel. Paris: Gallimard, 1970.

Baltrusaitis, Jurgis. *Anamorphoses, ou Thaumaturgus opticus.* Paris: Flammarion, 1984.

Barkan, Leonard. *The Gods Made Flesh: Metamorphosis and the Pursuit of Paganism.* New Haven: Yale University Press, 1986.

Barocchi, Paola. "Finito e non-finito nella critica vasariana." *Arte antica e moderna* 3 (1958): 221–35.

———, ed. *Trattati d'arte del Cinquecento: Fra Manierismo e Controriforma.* 3 vols. Bari: Laterza, 1960–62.

Barolsky, Paul. *The Faun in the Garden: Michelangelo and the Poetic Origins of Italian Renaissance Art.* University Park, Penn.: Pennsylvania State University Press, 1994.

Barthes, Roland. "Arcimboldo, or Magician and Rhétoriqueur." In *The Responsibility of Forms: Critical Essays on Music, Art, and Representation,* 129–49. Translated by Richard Howard. New York: Hill & Wang, 1985.

Battisti, Eugenio. *L'Antirinascimento.* Milano: Feltrinelli, 1962.

Beaujoyeulx, Balthazar de. *Le Balet comique de la Royne . . .* (1581). Edited by Margaret M. McGowan. Binghampton, N.Y.: Center for Medieval and Early Renaissance Studies, 1982.

Bellenger, Yvonne. "La Métamorphose dans la 'Création du Monde' de Du Bartas." In Mathieu-Castellani, *La Métamorphose dans la poésie,* 103–12.

———. "Quelques remarques à propos du temps et des jours dans les *Semaines* de Du Bartas." *Revue du Pacifique* 2, no. 2 (1976): 94–102.

Benveniste, Emile. *Problèmes de linguistique générale.* Paris: Gallimard, 1966.

Bible, La Sainte. French translation under the direction of l'Ecole Biblique de Jérusalem. Paris: Editions du Cerf, 1956.

Boaistuau, Pierre. *Le Théâtre du Monde* (1558). Edited by Michel Simonin. Geneva: Droz, 1981.

Bovelles, Charles de. *La Différence des langues vulgaires et la variété de la langue française (Liber de differentia vulgarium linguarum et Gallici sermonis varietate).* French translation by Colette Dumont Demaizière. Amiens: Musée de Picardie, 1972.

Brunel, Pierre. *Le Mythe de la métamorphose.* Paris: Colin, 1974.

Bruno, Giordano. *The Ash Wednesday Supper.* Translated by Stanley L. Jaki. The Hague: Mouton, 1975.

Brunot, Ferdinand. *Histoire de la langue française des origines à 1900.* Vol. 2, *Le Seizième siècle.* Paris: Colin, 1906.

Buridant, Claude. "Les paramètres de la traduction chez Blaise de Vigenère." In *Blaise de Vigenère: Poète et mythographe au temps de Henri III,* 39–65. Cahiers V. L. Saulnier, 11. Paris: Presses de l'Ecole Normale Supérieure, 1994.

Busson, Henri. *Les Sources et le développement du rationalisme dans la littérature française de la Renaissance, 1533–1601.* Paris: Letouzey, 1920.

Calvin, Jean. *Commentaire . . . sur le premier livre de Moyse, dit Genèse.* Geneva: Jean Gérard, 1554.

Canguilhem, Georges. *Etudes d'histoire et de philosophie des sciences.* Paris: Vrin, 1968.

Cartari, Vincenzo. *Le Imagini dei Dei de gli Antichi* Venetia: Vincentio Valgrisi, 1571.

Cassirer, Ernst, Paul Oskar Kristeller, and John Hermann Randall Jr., eds. *The Renaissance Philosophy of Man.* Chicago: Chicago University Press, 1948.

Caus, Salomon de. *Les Raisons des forces mouvantes. Avec diverses machines tant utilles que plaisantes. Aus quelles sont adjoints plusieurs desseings de grotes et fontaines.* Frankfurt: Jan Norton, 1615.

Cave, Terence. *The Cornucopian Text: Problems of Writing in the French Renaissance.* Oxford: Clarendon Press, 1979.

Caye, Pierre. *Le Savoir de Palladio: Architecture, métaphysique, et politique dans la Venise du Cinquecento. Précédé du commentaire au "De architectura" de Vitruve (livres I: 1, 2, et 3) par Daniele Barbaro*. Paris: Klincksieck, 1995.

Céard, Jean. *La Nature et les prodiges: L'insolite au XVIe siècle en France*. Geneva: Droz, 1977.

Cellini, Benvenuto. *The Autobiography of Benvenuto Cellini*. Translated by J. Addington Symonds. New York: Reynolds Publishing, 1910.

——. *La Vie de Benvenuto Cellini . . . écrite par lui-même*. French translation by Nadine Blamoutier. Paris: Ed. Scala, 1986.

Cerquiglini, Bernard. *Eloge de la variante: Histoire critique de la philologie*. Paris: Seuil, 1989.

Chastel, André. *Art et humanisme à Florence au temps de Laurent le Magnifique*. Paris: PUF, 1961.

——. *Fables, formes, figures*. 2 vols. Paris: Flammarion, 1978.

——. "Le Fragmentaire, l'hybride et l'inachevé." In *Fables, formes, figures*, 2:33–45.

——. *La Grottesque*. Paris: Le Promeneur, 1988.

——. "Léonard et la culture." In *Fables, formes, figures*, 2:251–63.

——. *Marsile Ficin et l'art*. Geneva: Lille, Droz, 1954.

——. "Sens et non-sens à la Renaissance: La question des chimères." *Archivo di Filosofia* 1980: 183–89.

Cicero, *Orator*. Translated by H. M. Hubbell. Cambridge: Harvard University Press, 1988.

Comes, Natalis [Natale Conti]. *Mythologie, ou Explication des fables* French translation by J. de Montlyard. Revised edition by J. Baudoin. Paris: P. Chevalier & S. Thiboust, 1627.

Dacos, Nicole. *La Découverte de la Domus Aurea et la formation des grotesques à la Renaissance*. London: Warburg Institute, 1969.

Dagron, Tristan. "Giordano Bruno et la théorie des liens." *Les Etudes philosophiques* 4 (1994): 467–87.

Damish, Hubert. *Théorie du nuage*. Paris: Seuil, 1972.

Demerson, Guy, ed. *Poétiques de la métamorphose*. Saint-Etienne: Publications de l'Université, 1981.

Du Bartas, Guillaume. *La Sepmaine; De la creation du monde, avec le commentaire de Simon Goulart*. Paris: Abel L'Angelier, 1583.

——. *La Sepmaine*. Edited by Yvonne Bellenger. 2 vols. Paris: Nizet, 1981.

Du Bellay, Joachim. *La Deffence et illustration de la langue françoyse*. Edited by Henri Chamard. Paris: Didier, 1961.

——. *Œuvres poétiques*. Edited by Henri Chamard. 6 vols. Paris: Didier, 1908–31.

Dubois, Claude-Gilbert. *La Conception de l'histoire en France au XVIe siècle (1560–1610)*. Paris: Nizet, 1977.

————, ed. *L'Imaginaire du changement en France au XVIe siècle.* Bordeaux: Presses universitaires, 1984.

Duret, Claude. *Thresor de l'histoire des langues de cest univers, contenant les Origines, Beautés, Perfections, Decadences, Mutations, Changemens, Conversions, et Ruines des langues.* Cologny: Matth. Berjon, 1613.

Eco, Umberto. *The Limits of Interpretation.* Bloomington: Indiana University Press, 1990.

————. *The Open Work.* Translated by Anna Cancogni. Cambridge: Harvard University Press, 1989.

Erasmus. *Adagiorum . . . chiliades* Paris: Nicolas Chesneau, 1570.

————. *The Correspondance of Erasmus.* 11 vols. In *Collected Works of Erasmus,* vol. 6, *Letters.* Translated by R. A. B. Mynors and D. F. S. Thomson. Toronto: University of Toronto Press, 1982.

————. *De duplici copia verborum ac rerum commentarii duo.* Translated by Betty I. Knott. In *Collected Works of Erasmus,* vol. 24, *Literary and Educational Writings,* 2. Edited by Craig R. Thompson. Toronto: Toronto University Press, 1978.

————. *Éloge de la folie: Adages, coloques, lettres.* Edited by C. Blum. Paris: Laffont, 1992.

————. *Opera omnia.* Amsterdam: North Holland Publishing, 1969.

Estienne, Henri. *Parodiae morales, in poetarum veterum sententias celebriores* [Geneva]: Henri Estienne, 1575.

————. *Poesis philosophica.* Geneva: Henri Estienne, 1573.

————. *Les Premices, ou le I livre des Proverbes epigramatizez, ou, des Epigrammes proverbializez . . .* [Geneva]: 1594. Reprint: Geneva: Slatkine, 1968.

Fauchet, Claude. *Recueil de l'origine de la langue et poesie françoise, ryme et romans. . . .* Paris: Mamert Patisson, 1581.

Fenoaltea, Doranne. *Du palais au jardin: L'architecture des "Odes" de Ronsard.* Geneva: Droz, 1990.

Ficino, Marsilio [Ficin, Marsile]. *Commentary on Plato's* Symposium *on Love.* Translated by Jayne Sears. Dallas: Spring Publications, 1985.

————. *Théologie platonicienne: De l'immortalité des âmes.* French translation by Raymond Marcel. 3 vols. Paris: Belles Lettres, 1964.

Fraisse, Simone. *L'Influence de Lucrèce en France au seizième siècle.* Paris: Nizet, 1962.

Gamon, Christofle de. *La Semaine, ou Creation du monde, Contre celle du Sieur du Bartas.* Lyon: Claude Morillon, 1609.

Garavini, Fausta. *Mostri e chimères: Montaigne, il testo, il fantasma.* Bologna: Mulino, 1991.

Genette, Gérard. *Seuils.* Paris: Seuil, 1987.

Giamatti, A. Bartlett. "Proteus Unbound: Some Versions of the Sea God in the Renaissance." In *The Disciplines of Criticism: Essays in Literary Theory, Interpretation, and History,* 437–75. Edited by Peter Demetz, Thomas Greene, and Lowry Nelson Jr. New Haven: Yale University Press, 1968.

Gilmont, Jean-François. "Description bibliographique et examen d'exemplaires multiples: à propos de deux éditions de Jean Crespin (1556 et 1560)." *Gutenberg-Jahrbuch* 1971: 171–88.

Gilson, Etienne. "La Cosmographie de Bernardus Silvestris." *Archives d'histoire doctrinale et littéraire du Moyen Age* 3 (1928): 5–24.

Ginzburg, Carlo. *The Cheese and the Worms: The Cosmos of a Sixteenth-Century Miller.* Translated by John and Anne Tedeschi. Baltimore: Johns Hopkins University Press, 1980.

Gombrich, Ernst. "Les Formes en mouvement de l'eau et de l'air dans les carnets de Léonard de Vinci." In *L'Ecologie des images,* 177–219. French translation by A. Lévêque. Paris: Flammarion, 1983.

———. "Leonardo's Method for Working Out Compositions." In *Norm and Form,* 58–63. London: Phaidon Press, 1966.

Gordon, Alex L. *Ronsard et la rhétorique.* Geneva: Droz, 1970.

Greene, Thomas M. "Erasmus' 'Festina lente': Vulnerabilities of the Humanist Text." In *The Vulnerable Text: Essays on Renaissance Literature,* 1–17. New York: Columbia University Press, 1986.

———. "The Flexibility of the Self in Renaissance Literature." In *The Disciplines of Criticism: Essays in Literary Theory, Interpretation, and History,* 241–64. Edited by Peter Demetz, Thomas Greene, and Lowry Nelson Jr. New Haven: Yale University Press, 1968.

———, *The Light in Troy: Imitation and Discovery in Renaissance Poetry.* New Haven: Yale University Press, 1982.

Guiraud, Pierre. *Le Moyen français.* Paris: PUF, 1963.

Hallyn, Fernand. "Le Paysage anthropomorphe." In *Le Paysage à la Renaissance,* 43–54. Edited by Yves Giraud. Fribourg: Editions Universitaires, 1988.

———. "Le Thème de l'anamorphose." In Mathieu-Castellani, *La Métamorphose dans la poésie,* 9–19.

Hébreu, Léon [Ebreo, Leone]. *Dialogues d'amour: The French Translation Attributed to Pontus de Tyard and Published in Lyon, 1551, by Jean de Tournes.* Edited by T. Anthony Perry. Chapel Hill: University of North Carolina Press, 1974.

Henkel, A., and A. Schöne. *Emblemata.* Stuttgart: Metzlersche, 1967.

Hésiode. *Théogonie, Les Travaux et les jours, Le Bouclier.* French translation by Paul Mazon. Paris: Belles Lettres, 1986.

Huchon, Mireille. *Le Français de la Renaissance.* Paris: PUF, 1988.

———. *Rabelais grammairien: De l'histoire du texte aux problèmes d'authenticité.* Geneva: Droz, 1981.

Huizinga, Johan. *Erasme.* French translation by V. Bruncel. Paris: Gallimard, 1955.

Jardine, Lisa. *Erasmus: Man of Letters.* Princeton: Princeton University Press, 1993.

Jeanneret, Michel. *Le Défi des signes: Rabelais et la crise de l'interprétation à la Renaissance.* Orléans: Paradigme, 1994.

———. "Rabelais, les monstres et l'interprétation des signes (*Quart Livre* 1842)." In *Le Défi des signes,* 101–12.

————. "Le Récit modulaire et la crise de l'interprétation. A propos de l'*Heptaméron.*" In *Le Défi des signes*, 53–74.

————, ed. *Les Songes drolatiques de Pantagruel: Cent vingt gravures attribuées à François Rabelais.* La Chaux-de-Fonds: [vwa], 1989.

Joukovsky, Françoise. *Le Feu et le fleuve: Héraclite et la Renaissance française.* Geneva: Droz, 1991.

Juvenal. *Satires.* London: W. Heinemann, 1940.

Keller, Luzius. *Palingène, Ronsard, Du Bartas: Trois études sur la poésie cosmologique de la Renaissance.* Berne: Francke, 1974.

Kemp, Martin, and Jane Roberts. *Leonardo da Vinci.* New Haven: Yale University Press, 1989 (catalogue of the 1989 London exhibition).

————, eds. *Leonardo on Painting: An Anthology of Writings by Leonardo da Vinci with a Selection of Documents Relating to His Career as an Artist.* New Haven: Yale University Press, 1989.

Kenny, Neil. *The Palace of Secrets: Béroalde de Verville and Renaissance Conceptions of Knowledge.* Oxford: Clarendon Press, 1991.

Kesselring, Wilhelm. *Dictionnaire chronologique du vocabulaire français: Le XVIe siècle.* Heidelberg: Carl Winter, 1981.

Klibansky, Raymond, Erwin Panofsky, and Fritz Saxl. *Saturn and Melancholy. Studies of Natural Philosophy, Religion and Art.* London: Thomas Nelson.

Koyré, Alexandre. *Du monde clos à l'univers infini.* Paris: Gallimard, 1973.

Kris, Ernst, and Otto Kurz. *L'Image de l'artiste: Légende, mythe, et magie.* French translation by Michèle Hechter. Paris: Rivages, 1987.

Lafeuille, Germaine. *Cinq hymnes de Ronsard.* Geneva: Droz, 1973.

La Popelinière, Henri Lancelot de. *Les Trois Mondes.* Paris: Pierre L'Huillier, 1582.

Lazzaro, Claudia. *The Italian Renaissance Garden.* New Haven: Yale University Press, 1990.

Lebensztejn, Jean-Claude. *L'Art de la tache: Introduction à la "Nouvelle méthode" d'Alexander Cozens.* Paris: Editions du Limon, 1990.

Lenoble, Robert. *Esquisse d'une histoire de l'idée de nature.* Paris: Albin Michel, 1969.

Leonardo da Vinci. See Vinci.

Le Roy, Louis. *De la Vicissitude ou varieté des choses en l'univers . . . Plus s'il est vray ne se dire rien qui n'ayt esté dict paravant: et qu'il convient par propres inventions augmenter la doctrine des anciens, sans s'arrester seulement aux versions, expositions, corrections, et abregez de leurs escrits.* Paris: Pierre L'Huillier, 1576.

L'Estoile, Pierre de. *Journal pour le règne de Henri IV,* vol. 1 (1589–1600). Edited by Louis-Raymond Lefèvre. Paris: Gallimard, 1948.

Lestringant, Frank. *L'Atelier du cosmographe ou l'image du monde à la Renaissance.* Paris: Albin Michel, 1991.

————. *Ecrire le monde à la Renaissance: Quinze études sur Rabelais, Postel, Bodin, et la littérature géographique.* Caen: Paradigme, 1993.

Letocha, Danièle, ed. *Aequitas, Aequalitas, Auctoritas: Raison théorique et légitima-tion de l'autorité dans le XVIe siècle européen.* Paris: Vrin, 1992.

Longhi, Silvia. "*Propagata voluptas:* Henri Estienne et la parodie." *Bibliothèque d'Humanisme et Renaissance* 47 (1985): 595–608.

Lucretius. *On the Nature of Things [De Rerum Natura].* Translated by W. H. D. Rouse. Cambridge: Harvard University Press, 1992.

Mann, Nicholas. *Petrarch.* Oxford University Press, 1984.

Mann Phillips, Margaret, ed. *The "Adages" of Erasmus: A Study with Translations.* Cambridge University Press, 1964.

Mathieu-Castellani, Gisèle. *Montaigne: L'écriture de l'essai.* Paris: PUF, 1988.

———, ed. *La Métamorphose dans la poésie baroque française et anglaise.* Tübin-gen: Gunter Narr, 1980.

Meerhoff, Kees. *Rhétorique et poétique au XVIe siècle en France: Du Bellay, Ramus, et les autres.* Leiden: Brill, 1986.

Michel, Paul-Henri. *La Cosmologie de Giordano Bruno.* Paris: Hermann, 1962.

Montaigne, Michel de. *Essais.* Edited by Pierre Villey. Paris: PUF, 1965.

———. *Journal de voyage.* Edited by François Rigolot. Paris: PUF, 1992.

Morel, Philippe. "Il funzionamento simbolico e la critica delle grottesche nella sec-onda metà del Cinquecento." In *Roma e l'antico nell'arte e nella cultura del Cinquecento,* 147–78. Edited by Marcello Fagiolo. Rome: Istituto della Enci-clopedia Italiana, 1985.

———. "La Théâtralisation de l'alchimie de la nature: Les grottes artificielles et la culture scientifique à Florence à la fin du XVIe siècle." In *Symboles de la Re-naissance,* 3:153–83. Paris: Presses de l'Ecole normale supérieure, 1990.

Moss, Ann. *Ovid in Renaissance France: A Survey of the Latin Editions of Ovid and Commentaries Printed in France before 1600.* London: Warburg Institute, 1982.

———. *Poetry and Fable.* Studies in Mythological Narrative in Sixteenth Century France. Cambridge: Cambridge University Press, 1984.

Nakam, Géralde. *Montaigne et son temps: Les événements dans les "Essais."* Paris: Nizet, 1982.

Namer, Emile. *Giordano Bruno.* Paris: Seghers, 1966.

Naudeau, Olivier. "L'Expression des modes philosophiques chez Montaigne: Le mot forme." *Journal of Medieval and Renaissance Studies* 6 (1976): 179–215.

Nicéron, Jean-François. *La Perspective curieuse* Paris: P. Billaine, 1638.

Norton, Glyn P. *The Ideology and Language of Translation in Renaissance France and Their Humanist Antecedents.* Geneva: Droz, 1984.

Ong, Walter J. *Ramus and Talon Inventory: A Short-Title Inventory of the Published Works.* Cambridge: Harvard University Press, 1958.

Ossola, Carlo. *Autunno del Rinascimento: "Idea del Tempio" dell'arte nell'ultimo Cinquecento.* Florence: Olschki, 1971.

Ovid[e]. *Iohan. Posthii Germershemii Tetra Sticha in Ovidii Metam. libri XV, quibus accesserunt Vergilii Solis figurae elegantiss* Frankfort on Main, 1563.

————. *Metamorphoses,* 2d ed. Translated by Frank Justus Miller. Cambridge: Harvard University Press, 1984.

————. *Trois premiers livres de la Metamorphose . . . traduictz en vers François. Le premier et second par Cl. Marot. Le tiers par B. Aneau* Lyon: Guillaume Roville, 1556.

Palissy, Bernard. *Recette véritable* (1563). Edited by Frank Lestringant. Paris: Macula, 1996.

Panofsky, Erwin. "The Early History of Man in Two Cycles of Paintings by Piero di Cosimo." In *Studies in Iconology,* 33–67.

————. "The Neoplatonic Movement and Michelangelo." In *Studies in Iconology,* 171–230.

————. *Studies in Iconology: Humanistic Themes in the Art of the Renaissance.* New York: Harper Torchbooks, 1962.

Paré, Ambroise. *Des monstres et prodiges* (1573). Edited by Jean Céard. Geneva: Droz, 1971.

Peletier Du Mans, Jacques. "Art poétique." In *Traités de poétique et de rhétorique de la Renaissance.* Edited by Francis Goyet. Paris: Hachette, 1990.

Perry, Kathleen Ann. *Another Reality: Metamorphosis and the Imagination in the Poetry of Ovid, Petrarch, and Ronsard.* New York: Lang, 1989.

Pico della Mirandola, Giovanni. *L'Heptaple.* French translation by Nicolas Le Fèvre de La Boderie. In François Georges, *L'Harmonie du monde.* French translation by Guy Le Fèvre de La Boderie. Paris: Jean Macé, 1578.

————. "Oration on the Dignity of Man." In *The Renaissance Philosophy of Man,* 223–54. Edited by Ernst Cassirer, Paul Oskar Kristeller, and John Herman Randall Jr. Chicago: University of Chicago Press, 1948.

Pigman, G. W. "Versions of Imitation in the Renaissance." *Renaissance Quarterly* 23, no. 1 (1980): 1–32.

Platon. *Le Banquet.* Translated by L. Robin. Paris: Belles Lettres, 1929.

————. *Timée.* Translated by Albert Rivaud. Paris: Belles Lettres, 1956.

Polizzi, Gilles. "Du 'Bal en forme de jeu d'échecs' au 'Palais des secrets': Aspects de l'espace conceptuel dans la fiction de la Renaissance." In *Logique et littérature à la Renaissance,* 193–218. Paris: Champion, 1994.

Porphyre. "De Antro Nympharum." In *The Cave of the Nymphs in the Odyssey.* English translation. Buffalo: State University of New York, 1969.

Pot, Olivier. *L'Inquiétante Étrangeté. Montaigne: la pierre, le cannibale, la mélancolie.* Paris: Champion, 1993.

————. *Inspiration et Mélancolie: L'épistémologie poétique dans les "Amours" de Ronsard.* Geneva: Droz, 1990

Poulet, Georges. *La Pensée indéterminée.* Vol. 1, *De la Renaissance au Romantisme.* Paris: PUF, 1985.

Prieur, Michel. "La Cire de La Première Sepmaine: Un événement philoso-

phique." In *Du Bartas: Poète encyclopédique du XVIe siècle,* 277–92. Edited by James Dauphiné. Lyon: La Manufacture, 1988.

Quainton, Malcolm. *Ronsard's Ordered Chaos: Visions of Flux and Stability in the Poetry of Pierre de Ronsard.* Manchester: Manchester University Press, 1980.

Quintilien. *Institution oratoire.* 7 vols. Translated by J. Cousin. Paris: Belles Lettres, 1975–80.

Quiviger, François, "Arts visuels, iconographie et déraison dans l'Œuvre d'Anton Francesco Doni." *Trois* 3 (1988): 52–65.

Rabelais, François. *Œuvres complètes.* Edited by Jacques Boulenger. Paris: Gallimard, Pléiade, 1959.

Rainaud, Armand. *Le Continent austral: Hypothèses et découvertes.* Paris: Colin, 1893.

Ramus, Pierre. *Dialectique* (1555). Edited by Michel Dassonville. Geneva: Droz, 1964.

Raymond, Marcel. *La Poésie française et le maniérisme, 1546–1610 (?).* Geneva: Droz, 1971.

Recupero, Jacopo. *Il Sacro Bosco di Bomarzo.* Florence: Bonechi, 1977.

Rèpaci-Courtois, Gabrielle. "Michel-Ange et les écrivains français de la Renaissance: Grâce et disgrâce d'un itinéraire critique." *Nouvelle revue du seizième siècle* 8 (1990): 63–81.

Rickard, Peter. *A History of the French Language.* London: Hutchinson, 1974.

———. *La Langue française au XVIe siècle.* Cambridge: Cambridge University Press, 1968.

Rigolot, François. *Le Texte de la Renaissance: Des rhétoriqueurs à Montaigne.* Geneva: Droz, 1982.

Ronsard, Pierre de. *Hymne des daimons.* Edited by Albert-Marie Schmidt. Paris: Albin Michel, 1939.

———. *Œuvres complètes.* Edited by Paul Laumonier, revised and augmented by I. Silver and R. Lebègue. 20 vols. Paris: Didier, 1914–75.

Rousset, Jean. *La Littérature de l'âge baroque en France: Circé et le paon.* Paris: Corti, 1954.

Russell, Daniel. "Conception of Self, Conception of Space and Generic Convention: An Example from the Heptaméron." *Sociocriticism* 4–5 (1986–87): 159–83.

Rychner, Jean. *La Chanson de geste: Essai sur l'art épique des jongleurs.* Geneva: Droz, 1955.

———. *Contribution à l'étude des fabliaux: Variantes, remaniements, dégradations.* 2 vols. Geneva: Droz, 1960.

Saulnier, Verdun-Louis. *Rabelais.* 2 vols. Paris: Sedes, 1982–83.

Sayce, Richard. "L'Édition des *Essais* de Montaigne de 1595." *Bibliothèque d'humanisme et Renaissance* 36 (1974): 115–41.

Sayce, Richard, and David Maskell. *A Descriptive Bibliography of Montaigne's "Essais," 1580–1700.* London: Bibliographical Society, 1983.

Bibliography

Scève, Maurice. *Microcosme*. In *Œuvres poétiques complètes*. Edited by B. Guégan. Paris: Garnier, 1927.

Schapiro, Meyer. *Style, artiste, et société*. French translation by Blaise Allan, Daniel Arasse, Guy Durand, Louis Evrard, Vincent de La Soudière, and Jean-Claude Lebensztejn. Paris: Gallimard, 1982.

[Schedel, Hartmann.] *Chronicarum Liber cum figuris et imaginibus ab initio mundi*. Nuremberg: A. Koberger, 1493.

Schmidt, Albert-Marie. *La Poésie scientifique en France au seizième siècle*. Paris: Albin Michel, 1938.

Screech, Michael A. *Rabelais*. London: Duckworth, 1979.

Seneca. *Epistles*. Translated by Richard Gummere. 3 vols. Cambridge: Harvard University Press, 1920.

Senellart, Michel. *Machiavélisme et raison d'etat*. Paris: PUF, 1989.

Shearman, John. *Only Connect: Art and the Spectator in the Italian Renaissance*. Princeton: Princeton University Press, 1992.

———. *Mannerism*. London: Penguin, 1967.

Silver, Isidore. "Ronsard's Reflections on Cosmogony and Nature." *PMLA* 79 (1964): 219–33.

Sophocles. *Ajax*. Translated and edited by Hugh Lloyd-Jones. Cambridge: Harvard University Press, 1994.

Soulié, Marguerite. "La Métamorphose d'après le Pimandre." In Demerson, *Poétiques de la métamorphose,* 185–98.

Starobinski, Jean. *Montaigne in Motion*. Translated by Arthur Goldhammer. Chicago: University of Chicago Press, 1985.

Staub, Hans. *Le Curieux désir: Scève et Peletier Du Mans, poètes de la connaissance*. Geneva: Droz, 1967.

Terreaux, Louis. *Ronsard correcteur de ses Œuvres: Les variantes des "Odes" et des deux premiers livres des "Amours."* Geneva: Droz, 1968.

Thibaut de Maisières, Maury. *Les Poèmes inspirés du début de la Genèse à l'époque de la Renaissance*. Louvain, Belgium: Librairie universitaire, 1931.

Tripet, Pétrarque. *Montaigne et l'art du prologue au XVIe siècle*. Paris: Champion, 1992.

Tuzet, Hélène. *Le Cosmos et l'imagination*. Paris: Corti, 1965.

Vasari, Giorgio. *Lives of the artists*. London: Penguin, 1987.

———. *Les Vies des meilleurs peintres, sculpteurs, et architectes*. Edited, commented, and translated under the direction of André Chastel. 12 vols. Paris: Berger-Levrault, 1981–89.

———. *La Vita di Michelangelo*. Edited by Paola Barocchi. 5 vols. Milan: Riccardo Ricciardi, 1962.

———. *Le Vite dei più celebri Pittori, scultori e architetti,* vol. 1. La Spezia, Italy: Frateli Melita editori, 1991.

Veyrin-Forrer, Jeanne. *La Lettre et le texte: Trente années de recherches sur l'histoire du livre.* Paris: Ecole Normale Supérieure de Jeunes Filles, 1987.

Vinci, Leonardo da. *Les Carnets.* Edited by Edward MacCurdy. French translation by Louise Servicen. 2 vols. Paris: Gallimard, 1989.

———. *The Notebooks of Leonardo da Vinci.* Edited by Irma A. Richter. Oxford: Oxford University Press, 1952.

———. *La Peinture.* Edited by André Chastel. Paris: Hermann, 1964.

———. *Scritti Scelti.* Edited by Anna Maria Brizio. Turin: Union Tipografico-Editrice Torinese, 1952.

———. *Traité de la peinture.* French translation by André Chastel. Paris: Berger-Levrault, 1987.

Viret, Pierre. *Dialogues du desordre qui est a present au monde, et des causes d'iceluy, et du moyen pour y remedier: desquelz l'ordre et le tiltre sensuit* Geneva, 1545.

———. *Metamorphose chrestienne, faite par dialogue.* Geneva: Jaques Bres, 1561.

Virgile. *Géorgiques.* Translated by E. de SaintDenis. Paris: Belles Lettres, 1968.

Vitruve. *De Architectura.* French translation by F. Pouillon. Paris: de Nobele, 1971.

Vives, Jean Louis. *A Fable about Man.* In *The Renaissance Philosophy of Man,* 387–93. Edited by Ernst Cassirer, Paul Oskar Kristeller, and John Hermann Randall Jr. Chicago: University of Chicago Press, 1948.

Walker, Daniel P. *Music, Spirit, and Language in the Renaissance.* London: Variorum Reprints, 1985.

Weinberg, Bernard. *Critical Prefaces of the French Renaissance.* New York: AMS Press, 1950.

Wilson, Dudley B. *Ronsard: Poet of Nature.* Manchester: Manchester University Press, 1961.

Wind, Edgar. *Pagan Mysteries in the Renaissance.* Harmondsworth, England: Penguin Books, 1967.

Wittkower, Rudolf. *Sculpture, Processes, and Principles.* Harmondsworth, England: Penguin Books, 1977.

Wittkower, Rudolf, and Margot Wittkower. *Les Enfants de Saturne: Psychologie et comportement des artistes de l'antiquité à la Révolution française.* French translation by Daniel Arasse. Paris: Macula, 1991.

Wölfflin, Heinrich. *L'Art classique* (1898). French translation by Conrad de Mandach. Basel: Stock, 1970.

Yates, Frances. *Giordano Bruno et la tradition hermétique.* French translation by Marc Rolland. Paris: Dervy-Livres, 1988.

Zinguer, Ilana. *Le Roman stéganomorphique: "Le Voyage des Princes fortunez" de Béroalde de Verville.* Paris: Champion, 1993.

Zumthor, Paul. *Essai de poétique médiévale.* Paris: Seuil, 1972.

———. "Intertextualité et mouvance." *Littérature* 41 (1981): 8–16.

Index of Names

This index does not include twentieth-century authors.

Subject Index